BRITISH TRASH CINEMA

I. Q. HUNTER

A BFI book published by Palgrave Macmillan

For Elaine

© I. Q Hunter 2013

All rights reserved. No reproduction, copy or transmission of this publication may be made without written permission. No portion of this publication may be reproduced, copied or transmitted save with written permission or in accordance with the provisions of the Copyright, Designs and Patents Act 1988, or under the terms of any licence permitting limited copying issued by the Copyright Licensing Agency, Saffron House, 6–10 Kirby Street, London EC1N 8TS. Any person who does any unauthorised act in relation to this publication may be liable to criminal prosecution and civil claims for damages.

The author has asserted his right to be identified as the author of this work in accordance with the Copyright, Designs and Patents Act 1988.

First published in 2013 by
PALGRAVE MACMILLAN

on behalf of the

BRITISH FILM INSTITUTE
21 Stephen Street, London W1T 1LN
www.bfi.org.uk

There's more to discover about film and television through the BFI. Our world-renowned archive, cinemas, festivals, films, publications and learning resources are here to inspire you.

Palgrave Macmillan in the UK is an imprint of Macmillan Publishers Limited, registered in England, company number 785998, of Houndmills, Basingstoke, Hampshire RG21 6XS. Palgrave Macmillan in the US is a division of St Martin's Press LLC, 175 Fifth Avenue, New York, NY 10010. Palgrave Macmillan is the global academic imprint of the above companies and has companies and representatives throughout the world. Palgrave® and Macmillan® are registered trademarks in the United States, the United Kingdom, Europe and other countries.

Cover image: *Slave Girls* (Michael Carreras, 1966), © Hammer Film Productions
Designed by couch

Set by Cambrian Typesetters, Camberley, Surrey
Printed in China

This book is printed on paper suitable for recycling and made from fully managed and sustained forest sources. Logging, pulping and manufacturing processes are expected to conform to the environmental regulations of the country of origin.

British Library Cataloguing-in-Publication Data
A catalogue record for this book is available from the British Library
A catalog record for this book is available from the Library of Congress

ISBN 978–1–84457–415–5 (pb)
ISBN 978–1–84457–416–2 (hb)

CONTENTS

PREFACE .V

1 BRITISH TRASH CINEMA .1

2 BRITISH TRASH CINEPHILIA .15

3 TASTE THE BLOOD OF ENGLAND32

4 *MOON ZERO TWO* AND OTHER UNEARTHLY STRANGERS49

5 ZOMBIES, SLEAZE AND PSYCHOMANIA64

6 DINOSAURS AND FUR BIKINIS .82

7 NAUGHTY! .101

8 EROS EXPLODING .123

9 THE ART OF TRASH .140

10 WHAT FRESH HELL IS THIS? .164

NOTES .178

INDEX .205

PREFACE

This book began with dreams of slave girls.

For years I hankered after *Slave Girls* (1967), the second, cheapest and most obscure of Hammer's prehistoric fantasies. Quickly thrown together after the success of *One Million Years B.C.* (1966) and filmed on the same sets and with the same costumes, *Slave Girls* was the story of a rhino-worshipping tribe of Amazonian women ruled by Martine Beswick. The stills I had seen showed her stretching in seductively feline poses on couches and stroking an enormous white horn. It looked *sublime*.

Often considered one of Hammer's worst mistakes, *Slave Girls* was shown first in the US under its original title of *Prehistoric Women* and then cut by twenty minutes for its British release, retitled and dumped at the bottom half of a bill. Despite its disastrous reputation, this was a film I needed to hunt down and ensnare, for it ticked almost too many boxes for a British exploitation fan. An anticipatory cultist, I pursued this elusive film by degrees, securing a copy of the original screenplay (now signed by Beswick!) and a vast wall-filling French poster of *Femmes Prehistoriques*, but the film itself was virtually impossible to see till it turned up at the Barbican in 1996 as part of a Hammer season. At last I could revel in its gaudy colour in 'HammerScope' complete with stretched and grainy stock footage – and missed the second half because I had to rush for a plane. Not till the film came out on DVD in the US did I finally, with an admitted bat-squeak of disappointment, get to own and consume the whole marvellously camp farrago. Yet how could it ever live up to my imaginary construction of it? Now *Slave Girls* is available in Britain, uncut as *Prehistoric Women*, on pristine anamorphic DVD and Blu-ray, its aura diminished but not, for me, its talismanic fascination.

That obscure and unloved film, more than any other in its combination of rarity, erotic thrills and tantalising subtexts prompted this book's adventures in the wilds of British cinema since the 1950s. Asked to describe the kind of 'trash' I was writing about, I would eagerly enumerate the qualities and bewilderments of *Slave Girls*. And the feelings I have about this seemingly indefensible film – proud embarrassment at liking it, irritation that it is now easily accessible to 'civilians' and slightly wishing it was still just out of reach, and uncertainty about why it matters to me beyond so many other much better films – echo throughout the pages of *British Trash Cinema*.

Slave Girls sums up, too, many of the problems of defining and making sense of British trash. It is a low-budget 'exploitation film', indifferently written and acted with the exception of Beswick's imperious performance, which has earned it a minor but well-deserved cult following. The film's flamboyant high camp is compromised by budgetary

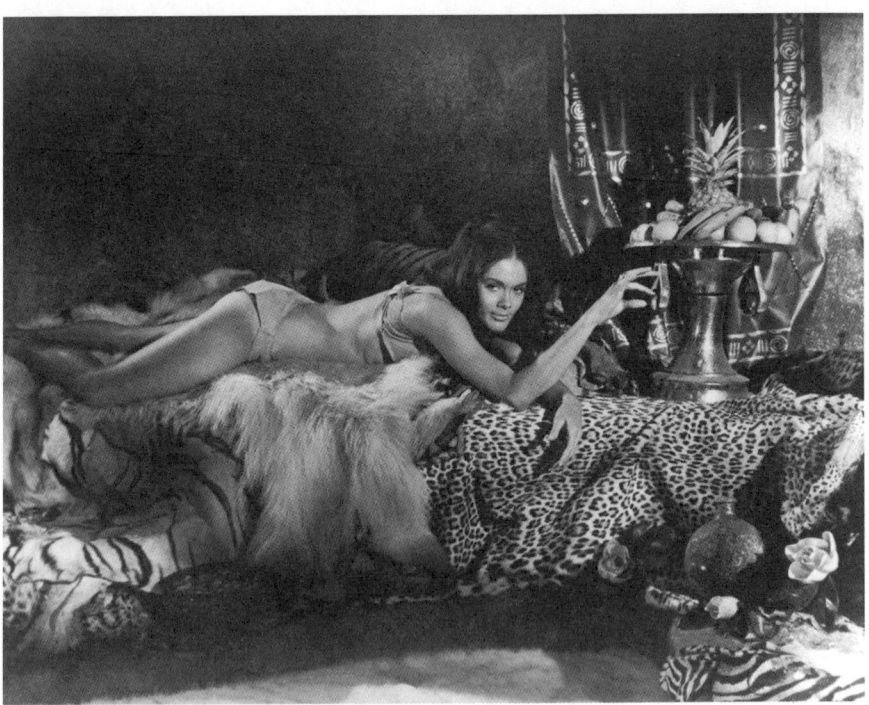

The seductively feline Martine Beswick in Hammer's *Slave Girls*

limitations, but that enforced rationing of 'paracinematic' excess itself seems typically 'British'. Full of moments of rich idiocy, *Slave Girls* is surreal in the offhand way you might call an unexpected juxtaposition surreal, and there is too, from today's perspective, a certain nostalgia in its innocent eroticism, trembling at the cusp of the Permissive Society, as well as more than a hint of self-mockery that suggests the film is not quite as daft as it looks. On the one hand, one could write about it as a laughable disaster (a '*bad-film*', as scholars of trash say) or as a prime example of the wily cynicism with which British exploitation recycled material. But on the other hand, one could attempt an irrational enlargement, as the surrealists called it, a feverish appropriation of the film's lurid interpretative possibilities in the language of dreams and poetry.

 Slave Girls is from most rational perspectives a tatty but instructive waste of celluloid, at best an example of a certain kind of impoverished and disposable pulp film-making. Far more subjectively, though, it is what trash cinema itself is all about – those precious fleeting moments when the commercial stumbles haphazardly into the erotically oneiric and avant-garde. For whatever else it is, *Slave Girls* is emphatically a *film* – and its pleasures are wholly cinematic ones, however transient, trivial or meretricious, and the very trashiness of their execution is catnip to cinephiles. Unburdened, it would seem, by intentional meaning, this innocently hapless film is perfect for obsession and flights of writerly fancy – or is that perhaps just special pleading by an over-excited 'trash aesthete' hot for the thrills of weirdness and obscurity? *Slave Girls* fails comprehensively

on a literary level, but how important, really, is that compared with cinema's uniquely magical capture of images from the past, resurrection of the dead and the dreamlike experience of a fantasy world, however tawdry, unspooling in light?

Digging a little deeper, *Slave Girls*, with its racial and sado-masochistic fixations, enables little stabs of insight into what might grandiosely be described as the Unconscious, even what the Marxist critic Fredric Jameson calls the Political Unconscious, of British culture seething with repression and coming apart in the 1960s. Or perhaps the film really is just rubbish after all, trash in its most demotic and throwaway sense, and not worth a second glance when there are so many shiny new Blu-rays of Great Films to improve the mind.

British Trash Cinema is all about films like *Slave Girls*, from the first stirrings of British exploitation in the 1950s to straight-to-DVD horror in the present day. Here are the overlooked and the begging to be reappraised, the despised and the forgotten; the crassly populist and strangely compelling; mistakes, follies, botches and bold experimental disasters. Some are genre films and some uncategorisably odd. All are candidates for cult reappraisal. The discards of British cinema, these orphaned films, like trash everywhere, are worth the effort to salvage and recycle, to be made useful once again as objects of pleasure, contemplation and even scholarly indulgence.

'Trash' is a label in this book and not a contemptuous libel, as I've anxiously explained to film-makers piqued that their beloved movies pop up in its pages. Critics have often been at odds with both popular tastes, which they cannot police and regularly despair at, and with the even more *recherché* tastes of cultists and cineastes, who revel in bizarre and undervalued *films maudits* and who, when they notice British films at all, love a different kind of British cinema and perhaps a different vision of Britain. But this book is not simply an exercise in critic-baiting nor is it intended for aficionados of trash only. It is an entry-level introduction, indebted to the research of numerous amateur and academic scholars, to the underworld of British cinema since the 1950s.

I didn't set out to write an industrial history of exploitation cinema, to compile encyclopaedia entries on every British trash film, or to replicate the bravura list-making and reviews of websites like britishhorrorfilms.co.uk and the porn review site bgafd.co.uk. This book aspires neither to the peerless comprehensiveness of the most distinguished historians of British horror, such as Jonathan Rigby and David Pirie, nor to the astonishing depth of knowledge of the doyens of sex-film scholars, Simon Sheridan and Gavin Whitaker, whose gavcrimson.blogspot is an invaluable resource on British sexploitation. Here you'll find simply the trash films I passionately wanted to write about. There is an unapologetic prejudice towards the trash I find most interesting and challenging, am offended by or protective of; films in which, for one reason or another, I have acquired an unexpected emotional investment, biased by private preferences, nostalgia and politics. In short, this book is a cinephiliac *dérive* through my DVD and video collection (I saw few of them in the cinema) in the hope I might communicate some of my love for and excitement about the 'worst' of British pictures. I have approached the films from whatever perspective and in whatever style I felt did them justice – from academic 'symptomatic criticism' (the default when exploring trash) to industrial history, guided by archive work and interviews with practitioners and drawing on numerous accounts of production histories by fan-archaeologists.

As I'll explain in more detail in the first couple of chapters, the term 'trash' is used here in a number of overlapping ways.

First, it refers, straightforwardly enough, to exploitation films – low-budget genre movies, mostly, which have sometimes gained cult reputations for their oddness and rarity. These films are trash in the sense of being designed for the built-in obsolescence of weekly exhibition cycles and the rapid turnover of video and DVD shelves. Often they are unrespectable and embarrassing films, whose attractions rely on the twin exploitation standbys of flesh and fiends, naked women and gory thrills.

But there are other kinds of trash here too, such as straightforwardly 'bad' films like *Raise the Titanic* (1980), tossed aside by cinema history and changing regimes of taste. Horror, science fiction (SF) and sexploitation, thanks to the 'New British Revisionism' which I discuss in Chapter 1, are in comparatively less need of critical survey and recuperation than when the pleasures of British trash first sucked me in back in the early 1990s. In fact, as my research went on, fascination grew for two almost entirely ignored categories of trash – kitsch crossovers between art and exploitation, such as *Boom* (1968), and *The Great Ecstasy of Robert Carmichael* (2005) and what is usually dismissed as rubbishy hack-work, like *Dirty Weekend* (1993) and *Outlaw* (2007).

The book also tracks the wider cultural influence of trash via art cinema and underground practice on film-makers such as Ken Russell and Derek Jarman, and the creation of a commercial trash aesthetic by entrepreneurs such as Antony Balch, whose activities as director, distributor and cinema programmer cut across exploitation and the avant-garde. Throughout the book I explore not only the history of trash cinema, in the many conflicting senses of the term, but also the uses and value of trash for film-makers, cultists and, for what it is worth, myself – as a style, a heritage and a metaphor for an alternative cinema and another Britain.

More covertly, this book is about the education of a trash aesthete, for whom trash cinephilia is a way of coping with the present by reimagining the past.

This book should have been written and published years ago; it is shameful to admit how many. Still, for various reasons it was not and the book reflects interests that go back through my entire academic career and life as a cinephile.

I am grateful to the following for granting me interviews and entering into correspondence: Anna Arrowsmith, J. G. Ballard, Martine Beswick, Rhys Davies, Vera Day, Mike Freeman, Richard Gordon, Ray Harryhausen, Lindsay Honey (www.ben-dover.biz), Poppy Morgan, Olivia Newton-John, Jonathan Sothcott and Norman J. Warren.

Many colleagues and friends have helped this book on its way over the years, and I extend my thanks especially to Martin Barker, Steve Chibnall and the Cinema and Television History (CATH) Research Centre at De Montfort University, Ian Conrich, Marcus Hearn, Peter Hutchings, David McGillivray, Laura Mee, Xavier Mendik, Julian Petley, Simon Sheridan, Sarah Street, Johnny Walker, Mike Weaver and the unfailingly helpful staff at the BFI Library and the BBFC. Rebecca Barden at BFI/Palgrave commissioned and supported the book wonderfully and patiently throughout its interminable gestation. Feona Attwood, Ernest Mathijs, David McGillivray, Julian Petley, Clarissa Smith, Justin Smith, Johnny Walker and Norman J. Warren were kind enough to read and comment on chapter drafts. I should stress that the book's failings and errors are of course entirely my own fault.

The Faculty of Humanities at De Montfort University granted me study leave in 2011, which allowed me finally to start drafting the book. The Media, Film and Journalism Research Committee funded numerous visits to the BFI Library and the BBFC, and enabled me to try out some of my ideas at conferences. Duncan Murray Wines in Market Harborough, Leicestershire, fuelled the last few months of writing and helped me get through much panic, boredom and indecision.

My greatest thanks by far, however, go to my beloved mother and to Elaine, the book's dedicatee, whose love and support were inspiring at a very difficult time.

The book draws on work I have published over the last fifteen or so years. Some of Chapter 4 reworks 'The Far Side of *Moon Zero Two*' in *Science Fiction Studies* vol. 85 (November 2001), pp. 355–64. Chapter 6 includes some material from my chapter, 'Take an Easy Ride: Sexploitation in the 1970s' in Robert Shail's edited collection *Seventies British Cinema* (London: BFI, 2008), which is reproduced with the permission of the publishers. The section on *Permissive* in Chapter 7 was originally published in the booklet that accompanied the BFI's Flipside release of *Permissive* on DVD and Blu-ray.

1 BRITISH TRASH CINEMA

This film is quite blatantly directed at a certain type of audience which, unfortunately, does exist.[1]

I seldom go to see British films for pleasure. I go out of duty, and invariably regret it.[2]

What is your idea of a *proper* British picture? A stiff upper-lipped romance in a railway station? A sturdy black-and-white war film with John Mills or Richard Attenborough? Something historical, perhaps, with floppy-haired Englishmen in white flannels and Keira Knightley looking soulful in crinoline? Or one of the great crowd-pleasers: Gainsborough, Ealing, Bond, *Carry On*, Hammer and Harry Potter?

It has been truthfully said that 'British cinema, with the best will in the world, is more a carefully constructed illusion than a serious industry', but the 'brand' of British cinema continues to have purchase on the popular imagination.[3] A 2012 Film Policy Review paper on the future of the industry after the abolition of the UK Film Council (UKFC), at a time when British films were more successful than for many years, quoted British respondents as citing humour ('a sort of dark humour') and authenticity ('gritty, more like real life') as the key 'British values' that marked a film as British and thereby pleasingly 'non-Hollywood'.[4] In the global marketplace, meanwhile, British films seem firmly identified with classy nostalgia, realism and modest literary ambition. In 1999 the British Film Institute came up with an uncontroversial list of the 100 'best' British films, topped by *The Third Man* (1949) and *Lawrence of Arabia* (1962) and weighted towards the 1960s.[5] Consensus was that Britain could be proud of its numerous world classics, most of which were indeed, as you might expect, literary adaptations, 'heritage films' and realist dramas in the kitchen-sink tradition. Yet there still clings to British cinema a sense of disappointment, of being, on the one hand, in Hollywood's shadow and, on the other, subordinate to and even oppressed by the great achievements of British theatre and the novel (for, as a current Waterstones promotion insists, 'The book is always better'). British cinema for all its triumphs remains awkwardly stranded between art and populism, a nubile Cinderella – to borrow a line from *If....* (1968) – sparsely clad and often interfered with.

Debate rolls on about what is meant by a proper British picture. Controversy is sharpest over what kinds of films to support financially so as to promote both commercial success and the national culture. The Eady Levy, which channelled box-office takings back into film production from 1950 till its abolition in 1985, encouraged the international investment that underpinned the sex and horror film boom of the 1960s to

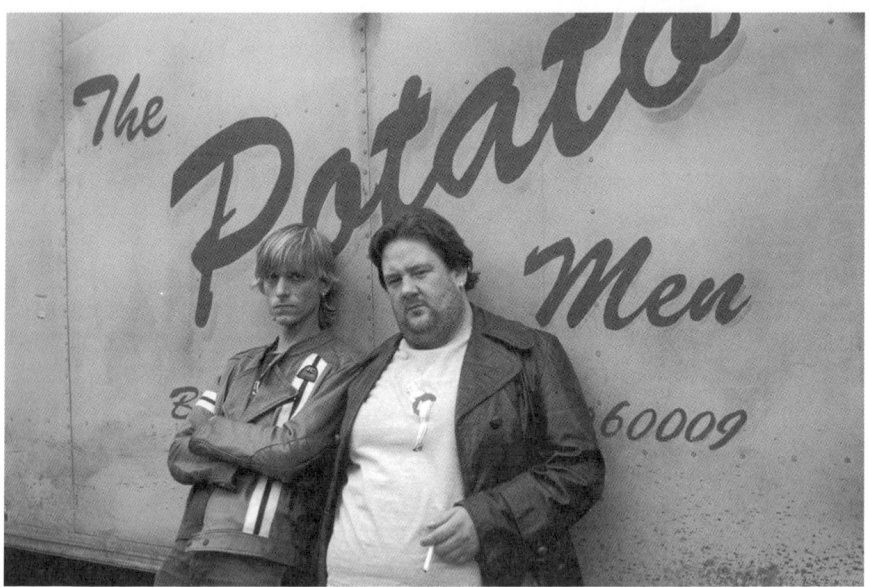

Sex Lives of the Potato Men: not a *proper* British film?

the 1970s; and in recent years the doling out of Lottery money through the late UK Film Council led to the funding of a number of barely released, low-budget comedies, horror films and thrillers, such as *Sex Lives of the Potato Men* (2004) and *Straightheads* (2007), which, given the heterogeneity of the films supported by the UKFC, earned the Council an undue amount of negative attention.[6] The *Daily Telegraph* in 2004, after the disastrous release of *Sex Lives of the Potato Men*, which concentrated critics' minds on the funding and profile of British cinema, complained that, unlike the Arts Council, whose role the UKFC took over in 2000, the Film Council tried to second-guess the market and fund 'commercially minded' films, and cited 'wan little British films that disappear quickly from cinemas'.[7] Examples included *Bodysong* (2003), *This Is Not a Love Song* (2002), *Emotional Backgammon* (2003) and *Suzy Gold* (2004), none of which recouped their budget. *Emotional Backgammon* sold 209 tickets and grossed £1,056. Needless to say, a film like *Sex Lives of the Potato Men* is somewhat at odds with a definition of British cinema that rests on *Harry Potter* (2001–11) and Oscar-bait like *The King's Speech* (2010) (also backed by the UKFC). British cinema today ranges from *Wuthering Heights* (2011) and *Skyfall* (2012) to *Stag Night of the Dead* (2011) – all of them, in one way or another, expressive of contemporary Britain, but who is to say which is more properly 'authentic'? Which represents the 'true' British cinema that projects 'our' culture to the world?

CINEMA IN THE RAW

Beyond the heritage of official British cinema, there has always been, for want of a more precise term, British trash cinema – a long tradition of cheap exploitation and *improper* entertainments that has shocked, appalled, frustrated and delighted in equal measure.

Into this makeshift category are grouped all manner of critically and often popularly despised offences against what British cinema *ought* to be, offences even more blatant than Bond, Hammer and the *Carry On*s, which by some standards are quite trashy enough.

Trash represents what Charles Barr emphasised was a key component of British cinema – a 'strong under-life – represented most powerfully by the horror film'.[8] Here are weird, obscure, haphazardly surreal and marginal films, compellingly bad and entrancingly bizarre, the sort of films that mainstream critics disdain or simply never see but which cultists seek out (or rather nowadays click to purchase on amazon.com or download as torrents). Much of this is 'psychotronic' cinema, as Michael Weldon called it, condemned by critics 'for the very reasons that millions continue to enjoy them: violence, sex, noise, and often violent escapism'.[9] They especially appeal to that category of film fan, the 'trash cinephile' who revels in films exiled from the mainstream and 'is far too cynical to sit through whimsical romantic comedy, or a big budget event movie'.[10]

This book outlines some of the key modes of British trash cinema, and their reception by their original intended audiences, but it is also, and in many ways more fundamentally, about the contemporary cult of trash cinema. Many of the films are *not* cult films – or at any rate not yet, though the field of British cinema as a whole is certainly the object of cult interest. But the reasons for getting interested in these films, and the pleasures they afford viewers today who watch them in a generous and receptive spirit, are absolutely informed by cult. There is then a dual perspective on the films – on the one hand, a neutral view which summarises the history of trash, and on the other, a cult view, not the same as that of the intended audiences, which addresses the films' particular attractions and, more important, uses for a certain kind of excessively committed viewer.

Most obviously trash cinema includes exploitation and sexploitation films – low-budget horror and science fiction, shoestring sex comedies and softcore pornography, which are typically dismissed as the lowest, most formulaic and sometimes most dangerously corrupting manifestations of film production.[11] From the 1950s to the 1980s over 400 exploitation films were made in Britain, ranging from international hits, such as Hammer's *Dracula* (1958), to eternal outcasts little seen outside specialist cinemas, such as the sex films *Come Play with Me* (1977) and *Erotic Inferno* (1975). They count as trash because they are or were regarded as worthless, disposable and ephemeral junk; in short, not so much bad but disgraceful, and consequently the target of harassment by censors and moral guardians, who in Britain have long been suspicious of cinema's delinquent energy and popular reach. Cultists have of course revived interest in the margins of cinema, especially horror and sex films, and it is cultists with a taste for low genres, bad taste and bad films, kitsch and the frankly sub-cinematic who are the main enthusiasts nowadays for British films which, however popular at the time, have since fallen by the canonical wayside.

But British trash cinema is arguably distinct from the disreputable cult cinemas of the US and continental Europe. It is less well known, for one thing. Hammer apart, British trash remains a niche cult among cults. It is true that the most celebrated of all cult films, *The Rocky Horror Picture Show* (1975), is indeed British, but how many fans of that unique prefabricated trash movie went on to explore *Devil Girl from Mars*

(1954), *Psychomania* (1973), *Toomorrow* (1970), *Vampyres* (1974), *Big Zapper* (1974), *Dirty Weekend* and the unforgettable kitsch of *Boom* and *Can Heironymus Merkin Ever Forget Mercy Humppe and Find True Happiness?* (1969)? Most *Rocky Horror* fans, I suspect, kept their virginity as regards such obscure gems. Yet each of those films can boast a select following of connoisseurs. Many times I've witnessed eyes light up in disbelieving recall at the mention of *Psychomania* – zombie bikers! Beryl Reid turning into a frog! As *Fangoria* sardonically remarked, that film 'is an artefact of post-mod British kitsch, admired with irony and worshipped by millions, perhaps thousands, even dozens of cult movie fans around the globe'.[12] For, alas, its cultists are few indeed, even in Britain, compared to those of the Italian horror maestro Lucio Fulci, the inept American auteur Ed Wood and, attracting the largest cohort of fans of British films, James Bond.

British trash also – how can I put this? – *feels* different from other trash cinemas (in ways not all cultists will respond to) thanks to the impact of restrictive censorship and the peculiar social, production and distribution contexts of British film. Although this book trolls through a cinema of transgression, not all of it is a wild ride into excess, subversion and lurid erotic defiance. British trash is also, and perhaps mostly, a cinema of routine underachievement, of stupid sub-B movies, austerity thrillers, unfunny comedies and failed grabs at naughtiness. Sometimes inspired, frequently weird, often sad and desperate – rather, in fact, like Britain itself – our trash cinema opens onto not only a world of exotic pleasures but also one of compromise and impoverishment, thwarted ambition, social embarrassment, silent erotic yearning and suburban boredom. That, being British myself, with a stereotypical fondness for unassuming mediocrity and gallant failure, is reason enough for me to love it.

BEASTS IN THE CELLAR
Trash refers in large part to what Julian Petley in 1986 famously called, borrowing the term from Hammer's 1968 fantasy, 'the Lost Continent'.[13] Petley, in a foundational article for what I'll risk capitalising as the New British Revisionism in Film Studies, highlighted the crucial counter-tradition of romance and anti-realism in British cinema, which had been overlooked for reasons of class, aesthetic snobbery and hostility to popular cinema and even, you might say, to cinema itself: 'an other, repressed side of British cinema, a dark, disdained thread weaving the length and breadth of that cinema, crossing authorial and generic boundaries, sometimes almost entirely visible, sometimes erupting explosively, always received critically with fear and disapproval'.[14] This lost continent included not only trash but the saturated romanticism of Michael Powell and Emeric Pressburger, and the Gothic tradition of Hammer and its imitators, as well as the ambitious hybrid art cinema of Ken Russell and Peter Greenaway. Emerging from deeply culturally embedded traditions of fantasy, nonsense and absurd humour, this was a heterogeneous cinema which challenged the subordination of cinema to literature and theatre. Visceral and 'visual', boldly mythic and erotic, it had been habitually overlooked by critics committed to realism and the literary. The films, from art house to horror, still challenge dominant conceptions of British cinema and expand its range and remit beyond what cultural gatekeepers allow. Kate Egan makes the crucial point that horror films, for example, and especially modern ones,

are not considered in relation to the idea that they are commercial ventures based around spectacle and fantasy, but are measured against a realist norm, where the logic and plausibility of narrative and characterisation always takes priority over the visual and spectacular.[15]

Consequently, reviewers tend to 'view any deviation from the notion that a narrative should be convincing, logical and realistic as evidence of a "bad" film'.[16]

The keynote of the films of the lost continent was fantasy, even a strain of British surrealism. Many of the films Petley highlighted were popular genre films, which critical convention had overlooked or taken for granted – the horror films in particular. But beyond them is, as well as other genres, *unpopular* popular cinema – films catering to the wrong people (devotees of sex cinemas, for example), or films barely seen at all, or flops even in otherwise successful genres. Tom Ryall, referring to British cinema in the 1930s, highlights the importance of conceiving of national cinema as being as diverse as the nation it represents. British cinema has always been torn between art and entertainment, low culture and literary ambition, imitation and rejection of Hollywood, public-service realism and genre:

> The notion of a sub-current or an alternative oppositional strand of national cinema is important in the analysis of the idea of national cinema itself. The term 'national cinema' is often locked into a form of essentialism which implies the possibility of a single unitary form of expression which can be designated as representative of a nation. A corollary of this is that there also exists a unitary national culture which can simply be mapped onto a set of cinematic signifiers to constitute the national cinema. Britain, however, as a political entity has been carved out of a variety of regions and nations, ways of life which can be differentiated from each other in terms of gender, class and race. National cinemas in their overall profile necessarily reflect such differences and, indeed, can be conceptualised as elements in the broader arena of ideology.[17]

This notion of an alternative or 'dark side' of British cinema is a provocative and attractive metaphor, and I'll exploit it ruthlessly throughout this book. But it can be criticised as an oversimplification, like the other handy binaries which bedevil mappings of British cinema, such as Michael Balcon's phrase 'realism and tinsel', and which denote two opposing strands in British cinema.[18] For a start, it depends on what is meant by realism, which is an endlessly moveable feast; and also by what's meant by alternative? The problem critics had, for example, with the horror films that sprang up in the 1950s was that they were too realistic by half in the sense of *explicit* – all that blood and cleavage – and that they left little to the imagination. Films like *Dracula* and *Horrors of the Black Museum* (1959), in which spring-loaded binoculars stab spikes into a young woman's eyes, were an advance in their unprecedented directness; like the kitchen-sink films of the same period, they updated British cinema by splashing across the screen what had hitherto been politely left off it. The scandal of Michael Powell's *Peeping Tom* (1960), that period's key *film maudit*, was not that it depicted a surreal fantasy world but that it was too close to home, its monster too human, its violence too intimate and its depiction of Soho too seedily precise. British cinema has often prided itself on undercutting the

escapist fantasies of Hollywood, and the radical, influential novelty of such groundbreaking genre films as *The Quatermass Xperiment* (1954) was that it dragged horror into the terrors of contemporary life.

The same might be said of the nudist and sex films that proliferated from the late 1950s. They were realist films rather than exercises in make-believe and often disguised as documentaries. Their motives were not so different from the British New Wave's. They revelled in sexual openness, voyeurism, changing mores and the unconsidered lives and desires of ordinary people. It is true that the emphasis of such exploitation films on spectacle and their direct address to real-life peeping Toms worked against some of the self-effacing conventions of narrative cinema; but the appeal of exploitation and its unique promise to viewers was that it would show them the world naked – as nature intended. A similar revelatory impulse is at work in the sex comedies of the 1970s and even the hardcore films of contemporary pornographers such as Lindsay Honey (Ben Dover) and Anna Span, which, concretising homely fantasies in familiar domestic landscapes, document flabby white bodies in poorly matched cheap underwear exerting themselves in motel rooms, council flats and suburban kitchen-diners. The surrealism of *Psychomania* – zombies, frogs, Beryl Reid and all – lies not so much in its resurrected biker suicides but in seeing them do the ton on the M3 and rampage around supermarkets in nondescript Walton-on-Thames.

Stylistically, too, while the films of Powell and Pressburger and Ken Russell certainly blurred the worlds of dream and the everyday, their 'excesses' were arty authorial interventions. Most of the 'dark side' films in fact conformed to the usual rules of classical cinema, and were far from the subversive tradition of any strand of modernism and the avant-garde, whether surrealist, underground or the rigorously experimental abolitions of convention attempted by Jeff Keen, Peter Gidal and Laura Mulvey in the 1970s. In fact, if one is looking for a truly hidden and 'unknown' British cinema – to use Alan Lovell's memorable phrase – well, that better describes arty oddities such as *Herostratus* (1967) and *The Riddle of the Sphinx* (1977) rather than *Fire Maidens of Outer Space* (1956) or *Psychomania*, which, curious as they were, at least reached mainstream audiences and had an afterlife on late-night television.[19]

That suggests another problem with the 'dark side' or lost-continent metaphor: the popular cinema it describes may have been critically disregarded, but it was hardly invisible. Indeed, so far as critics were concerned, it was often *too* visible, cluttering up cinemas with censor-baiting rubbish like *Virgin Witch* (1971) and *Confessions of a Sex Maniac* (1974), which audiences were far too willing to consume. The films were not genuinely undiscovered, except by critics adrift from popular taste; the films were simply ignored, taken for granted and hidden in plain sight down at the local Odeon or Jacey.

There is a final reason not to get too carried away with dramatic metaphors of dark side and lost continent. Reviewers and critics, with perhaps the exception of Raymond Durgnat, overlooked these films simply because most of them weren't very good. They were in fact *trash*, and the thankless task of writing about them could be left to the trade press and *Monthly Film Bulletin*. And it is indeed true that many trash films engage us only to the degree that they are vaguely symptomatic of trends in British cinema and society; even the most partisan cultist would struggle to say much else about *Nudist Memories* (1959) and *Paul Raymond's Erotica* (1981). In any case the lost continent was

not uniformly transgressive and disturbing. Little attention was paid to *Not Now Darling* (1973), *The Slipper and the Rose* (1976) and *Wombling Free* (1977), but it was not because critics recoiled from them in bourgeois disgust. Innocuous minor films rather than exploitation, they could tell you something about popular entertainment and public taste, but it hardly seemed worth analysing them in detail or breaking the butterfly of their trivial significance upon the wheel of film theory.

THE NEW BRITISH REVISIONISM

Since the 1980s Petley's lost continent has become increasingly familiar ground as well as a – perhaps *the* – presiding cliché of recent British film scholarship.[20] Vast tracts of the continent have been excavated in a spirit of cinephile curiosity. The 'systematic and creative process of rethinking British cinema', as Jeffrey Richards welcomed it, has been industriously pursued by film academics but crucially also by film fans and savvy video and DVD companies, such as Redemption, Jezebel, Odeon Entertainment and recently the BFI.[21] Films that, when I started getting into British trash back in the 1990s, were merely rumours, titles patiently reviewed in *Monthly Film Bulletin* or blurred fourth-generation copies of 'pre-cert' videos are suddenly available once more thanks to DVD and the internet. The BFI's Flipside series of DVD and Blu-ray reissues offers rarities like the mondo film *Primitive London* (1965), the first British sex film *Her Private Hell* (1968) and the Swinging London drama *Joanna* (1968) with elaborate notes and commentaries, and relocates them from low culture to specialist cult items. Odeon Entertainment's DVDs similarly present sex films, from *Take Off Your Clothes and Live* (1963) to *Come Play with Me*, and mislaid gems like the horror film *Mumsy, Nanny, Sonny and Girly* (1970) under the unlikely banner of 'The Best of British', which at least acknowledges that 'Britishness' may lurk in even the lowest cultural products. At the same time, maligned aspirational kitsch like *The Magus* (1968) and *Hammersmith Is Out* (1972) are newly available or can be watched in pirated snippets on YouTube. Even movies that were never released, such as *Queen Kong* (1976), or which embarrassed the inside of cinemas for merely days, as did *Toomorrow*, can be easily imported or downloaded by insatiable film fans. Moreover, new kinds of British trash continue to mushroom, such as straight-to-DVD comedy-horror films like *Kill Keith* (2012) and *Strippers vs Werewolves* (2012). Since 2000, legitimate British hardcore pornography on video and DVD has been passed by the British Board of Film Classification – a whole new category of British film production, albeit secreted away safely in sex shops. Although cultists may regret the loss in rarity value of their treasured pre-cert videos, this is plenty indeed. As I look at the piles of DVDs at home and in the office, I am dazzled by the sight of so many films I thought I'd never see, with even the most trivial of them afforded more lavish treatment on DVD than masterworks by Ozu and Bergman.

Exploitation, sex films, pornography, the work of 'sleaze artists' of all kinds – what was once the province of a handful of cultists is also the subject of an academic industry. Books by fan-scholars from small presses such as FAB Press and Headpress and academic imprints playing catch-up have provided detailed histories of not only Hammer but exploitation companies such as Tony Tenser's Tigon and once patronised genres such as the crime film, science fiction movie, 1930s 'quota quickies' and the British B movie.[22] Even the sex comedy of the 1970s, perhaps the low-point of British cinema's

creativity, has its superbly committed historians, who demonstrate that the films offer valuable insights into the tastes, values and frustrated desires of ordinary filmgoers at a period of rapid social and moral change, when sexploitation was one of the few thriving areas of indigenous cinema.[23] TV programmes on the sex film, the British SF film and the B movie have drawn on this work to explore the territory with enthusiasm and sympathy.[24] In short, a field of study once wholly beneath contempt is not only now visible but well served by both fandom and academia. The outlines of British film history have been revised and the canon of British cinema reordered.

This canon has edged, thanks partly to generational change among critics and 'acafans' (academics who also identify as fans), towards populism, genre cinema and cult favourites whose transgressive and stylised realism caught the imagination of youth audiences. This is of course not a phenomenon restricted to British cinema. Interest has shifted generally in Film Studies to complement cultists' enthusiasm for the low and exploitation cinema of many countries. Cultists have long valued the energy and combative artistry of American trash films by exploitation directors such as Roger Corman and the badfilm chaotician Doris Wishman and the gory extremism of Italian exploitation cinema from the 1960s to 1980s. Indeed, the last twenty years has seen the flourishing of Cult Film Studies as an academic field of its own, and a wealth of publications specifically devoted to trash, sleaze, exploitation and pornography.[25]

Moya Luckett, dating British canonical revisionism to the 1990s and the influence of lad-centred magazines like *Loaded* and its swaggering take on Cool Britannia, comments on 'the formation of a new British film canon that counters traditional heritage-centred ideas of British cinema … this "alternative" canon focuses on violence, style and sexuality as well as more traditionally reified traditions of British horror and comedy'.[26] British cinema is now as closely identified with its cult films, such as *Get Carter* (1971), *The Wicker Man* (1973) and *Withnail and I* (1987), as with its literary, realist and heritage traditions, though the cult films are caught up in those as well. Few of the most celebrated of these newly canonised cult films find their way into this book, but their qualities – eccentricity, dubious taste, allegorical significance – are often shared by the films that do. But other kinds of films have emerged as central to our understanding of British cinema, inspired by a renewed interest in auteurs committed to outrage, offence and tastelessness, such as, pre-eminently, Ken Russell, who infiltrated low genres with a radical style and an enthusiasm for vulgarity and excess, and who was at once inimical to British film tradition and deeply embedded in British Romanticism, low comedy and simple eccentricity. It is not petty nationalism either to reclaim our heritage of trash. The links between British cinema and American and continental European talent and money work against any easy notions of trash films representing more 'authentic' versions of national identity. As Andrew Higson remarks, 'English cinema has been hybrid from the very start' and contemporary British cinema, from Harry Potter blockbusters to straight-to-DVD trash, is more transnational than ever.[27]

The symbolic centre of that revision, and indeed of the lost continent itself, is the aforementioned *Peeping Tom*. It is now regarded as a classic, and – since this is an argument about aesthetics and critical preferences as well as definitions – one of the greatest British films ever made. Its passage from trash to classic, though a familiar tale, remains exemplary and instructive.

Peeping Tom: the greatest British *film maudit*

Peeping Tom was greeted with an appalled critical reaction in 1960, Derek Hill in *Tribune* saying, 'The only satisfactory way to dispose of *Peeping Tom* would be to shovel it up and slush it swiftly down the nearest sewer. Even then the stench would remain.'[28] The film was beyond trash; it was abject and excremental. The critical reaction to *Peeping Tom* – though it was actually a modest commercial hit[29] – ended Powell's film career in Britain. It was in France that its merits (like those of Hammer director Terence Fisher) were first recognised. As Peter Wollen notes, French critics 'concentrated on the issue of sadism, probably because the French critics who first praised the film, in *Positif* and *Midi-Minuit* were heavily influenced by Surrealism and hence by André Breton's own fascination with the Marquis de Sade'.[30] The film has since been recuperated by academics for its self-reflexive discourse on film, voyeurism and pathology – useful, twinned with *Psycho* (1960), for illustrating the male gaze in seminars – and by cultists of Powell, who also appreciate it as a film about film, a genre cultists often warm to. The film, full of the kind of in-jokes that please cinephiles, such as Powell's playing Mark Lewis's (Carl Boehm) sadistic father, is also very knowing about pornographic subcultures in Britain at the end of the 1950s, and uncomfortably links the world of cinema to that of exploitation – Lewis takes photographs, for example, for a character based on the glamour photographer Harrison Marks.[31] Though released as an exploitation film by Anglo-Amalgamated, *Peeping Tom* also works as an intense art film, transgressing boundaries between high and low culture, not least by focusing on psychoanalysis rather as Hitchcock did, and the film's cult is partly a response to this boundary crossing. It was influential especially on Martin Scorsese: the 'neon-expressionism' of *Taxi Driver* (1976) owes much to its sordid and saturated realism. If *Peeping Tom* is a new centre of gravity for understanding British cinema – if its most excremental film becomes its pivotal and

perhaps greatest one – then this revision, founded on 1960s auteurism (the same impulse that elevated *Psycho* into the ultimate film) and backed up by cultists, has implications for rethinking British cinema entirely.

REVISIONISM TRIUMPHANT?

In part this revisionism involves a drive towards completism, a desire by fans and academics to map the whole of the territory in a kind of panoptic frenzy that allows no film to go uncollected, unlabelled and unaccounted for. This utopianism will end, perhaps, only when every last film, and every last person who made it, saw it and wrote about it has been accounted for by the recording angel of British film criticism. But revisionism is also a modest shift towards taking account of the films that audiences, especially working-class ones, actually watched at cinemas – an astonished acknowledgment, for example, that *On the Buses* was the most successful British film of 1971 and grossed over £1 million in domestic rentals in the first six months of release. Revisionism investigates the persistence of the sex comedy, from *Confessions of a Window Cleaner*, the top British film of 1974, to *The Inbetweeners Movie*, similarly successful in 2011, rather than regarding it as evidence of the recidivist hopelessness of public taste. Revisionism encourages us to take seriously films few people saw and fewer still liked, or which, like sexploitation and hardcore porn, virtually no one even admits to watching.

As well as films, this revisionism pays homage to the lived experience of cinemagoing and to forgotten audiences of the past, from the proverbial 'man in a mac' to the *habitués* of rep cinema clubs like the Scala in London. Revisionism asks such questions as who went to sex cinemas in the 1960s and 1970s, with their teasing visions of continental plenty and suburban wickedness. What was it actually like to sidle furtively into the Jacey Piccadilly and enjoy time out from everyday suburban life? How did one anticipate the visit and cope afterwards with the disappointment of yet another film that promised so many thrills and delivered so few?

This new wave of revisionism, inspired equally by scholarship and cult enthusiasm, is, in the end, a defence of British cinema and its unruly multiplicity. It is a reaction against the negative definitions of the 'Britishness' of British cinema, that disappointment I mentioned at the start of the chapter – the idea that it is theatrical, staid, overliterary and generally lives down to François Truffaut's much quoted comment about the incompatibility of British and cinema and the contempt expressed thus in the 1960s by the British auteurist journal *Movie*: 'The British cinema is as dead as before. Perhaps it was never alive.'[32] Revisionism wrenches the canon away from middlebrow and middle-class critical preferences, and takes seriously the commercial aims of the industry, changing contexts of reception and the unpretentious tastes of real audiences.

Insofar as taste judgments go, revisionism may involve a critical animus against official definitions of British cinema, such as the irritated boredom that has bubbled up since the 1980s against the reactionary and nostalgic British cinema represented by Merchant–Ivory, *Chariots of Fire* (1981) and *Four Weddings and a Funeral* (1994). One catches that in David Thomson's comment (though he is appreciative of *The Remains of the Day* (1993)) that 'The loveliness of Merchant–Ivory gives me the creeps Merchant–Ivory is *Masterpiece Theatre* moviemaking: prestigious, well furnished,

accurate, prettily cast – and bland, anonymous and stealthily interchangeable. Can you tell one Ivory-ized classic author from another?'[33] And it is there too in Ken Russell's characteristically forthright complaint that

> The success of a film like *Howard's* [sic] *End* [1992] at the Oscars, BAFTA and elsewhere is depressing. Is this how the British cinema will end? Not with a bang, but a genteel whimper in full period costume?[34]

Indeed, from a revisionist perspective, 'bad' British films, the ones that really betray the possibilities of cinema, are those conventionally associated with that kind of conservative quality film-making. Rather as the New Wave scorned the tradition of quality in French cinema, so we might sympathise with Anne Billson when she despairs at the visually drab blandness of much of our official cinema:

> I once heard a British film director say in an interview that he wasn't interested in telling a story visually (why were you directing a bloody film then?), and it's clear he's not the only one. Historically, Britain has produced more world-class writers than painters, and words tend to be valued far above visual imagery, if only because reading and listening apparently require more effort than looking, and so are deemed to be worthier pursuits.
>
> A lot of British film-makers assume that screenplay equals dialogue, and because the Brits still haven't caught on to William Goldman's maxim that 'Screenplay is structure', we get endless exposition and a plodding procession of scenes unfurling like stage plays. Scene begins, there's some dialogue, scene ends, next scene begins, more dialogue and so on. Lawks-a-mercy, we might as well be watching a Restoration drama at the Old Vic.[35]

In that sense, then, contemporary revisionism is not neutral at all. It reflects a decision (political as much as aesthetic) in favour of pleasures and purposes for British cinema different from those represented by, say, Richard Curtis's films, which, as James Leggott writes, 'triggered expansive, and usually sniffy, analysis of Curtisland, deemed by many an unpalatably selective and politically suspect version of Britain, populated by characters in thrall to American culture and to a facile romance of instant attraction'.[36] (Indeed, so far has the pendulum swung that it is probably now more transgressive to admit admiration for *Love Actually* (2003) than for *Confessions of a Sex Maniac*.)[37]

As will be obvious in this book, emotional investment as well as scholarly neutrality is involved. I want passionately to impress on the reader that *Frightmare* (1974) is not only symptomatic of social upheavals in the 1970s but one of the decade's best films, and that the films of the pornographer John Lindsay and the later films of the arch-populist Michael Winner are not wholly without interest and merit. Alan Lovell summarised complaints about British cinema in the early 1970s: 'British films are generally mediocre; they have no style; they lack humour; they are snobbish and class-bound; they are too dependent on documentary modes; too literary; too unsophisticated.'[38] The point of comparison then may have been European art cinema or canonical Hollywood, but the same complaints are still made by cinephiles bored by the latest Terence Davies or *The King's Speech* (an excellent film, but …) and retching after contamination by the Thatcher biopic *The Iron Lady* (2011).

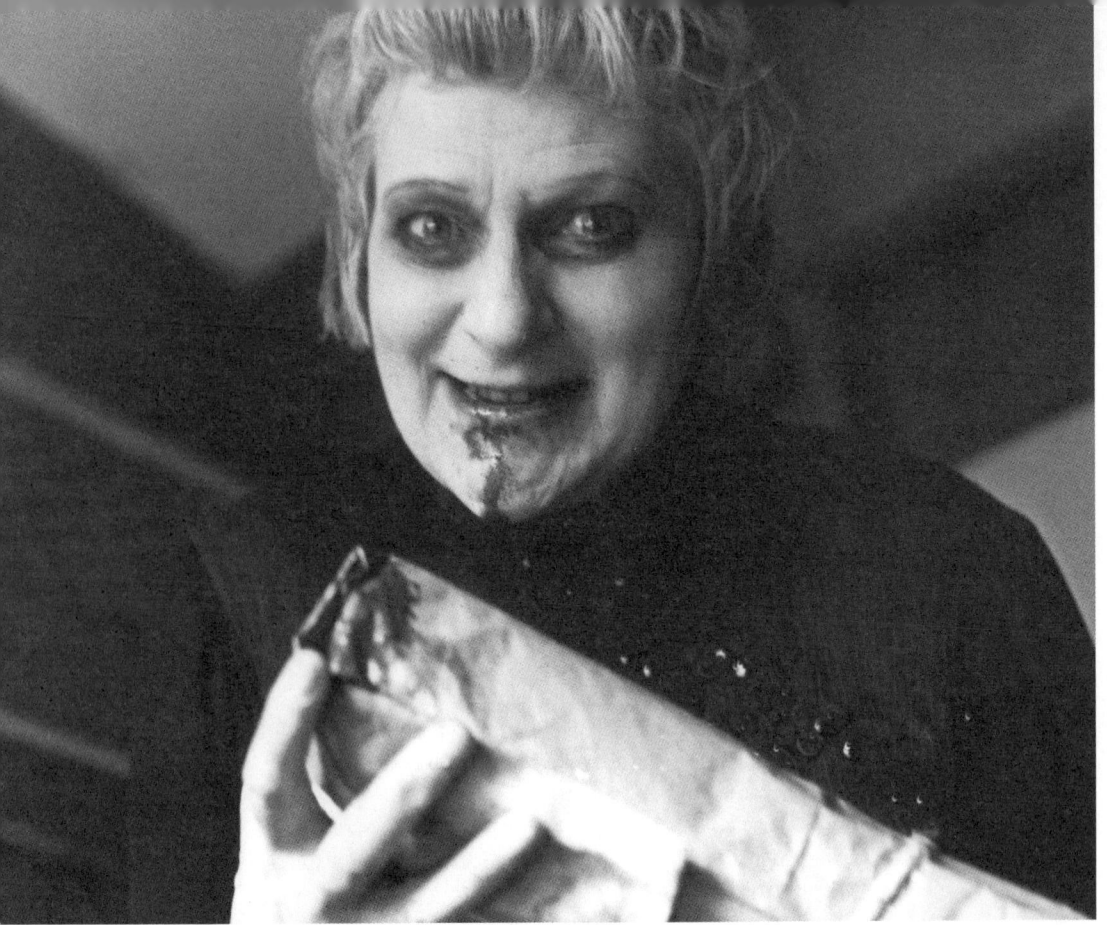

Sheila Keith and her lunch in *Frightmare*, one of the best British films of the 1970s

In fact, as I must admit, this revisionism, which was once a radical view of British cinema, is now getting pretty orthodox. There is a new openness from critics towards British genre cinema, exploitation film and the cinema of bad taste. It is important, therefore, not to set 'critics' up as a convenient and monolithic shorthand for *Daily Mail*-ish middlebrow reaction; for in many ways the argument is being won. Although an overview of changing critical tastes falls outside this book, it is notable that reviewers these days, in broadsheets as well as magazines like *Empire* and *Total Film*, are likely to reflect and even identify with cult tastes, rather as *Time Out* did in the 1970s and 1980s. One got a sense of that from the critical reception of *Kill List* in 2011. An ultra-violent hybrid of hit-man thriller and horror film, it was lauded by critics as different as Philip French, the veteran reviewer of the *Observer*, and fan websites one might expect to enthuse about such gory fare; and many compared it to *The Wicker Man*, a cult horror film that has moved to the very centre of the new canon of British cinema. Although the 1999 BFI poll mentioned earlier was more conventional in its canon formation, *Time Out*'s 2001 poll of 'the best British film of all time' was topped by another horror film, albeit an arty auteurist one, Nicolas Roeg's *giallo*-esque *Don't Look Now* (1973).[39] The canon has shifted.

There is, it must be said, echoing points made earlier, nothing *especially* subversive about this revisionism, which undoubtedly rests on an over-schematic opposition

between a straw man official British cinema and a conveniently imagined (wicker man?) counter-cinema. The lost continent and the dark side are valuable metaphors but do remain problematic for the reasons I outlined before. Thomas Elsaesser drolly remarked, echoing Ryall, that British cinema 'always functions around [a] polarization – what one might call an "official" cinema and an "unofficial" cinema, a respectable cinema and a disreputable one' and that this 'Jekyll-and-Hyde, yin-yang quality of the British cinema, first analyzed by Raymond Durgnat, has in its "realism versus romanticism" version become one of the orthodoxies of academic film studies. Both sides – romantic and realist – have their clichéd "mythemes".'[40]

SOME AIMS

In the view of the New British Revisionism there are, then, a number of different, overlapping, and at times competing as well as complementary projects.

First, *remapping* British cinema and acknowledging without necessarily elevating its low products.

Suspending conventional aesthetic standards, the aim is to understand them in relation to genre, audiences and conditions of commercial production and distribution. The films are integrated into the industrial and social history of British cinema and, regardless of cultural and aesthetic qualities, their particular economic functions are put centre stage. This is absolutely crucial. In relation to horror film, this has been achieved so comprehensively that I admit I have often struggled to say anything new or interesting about them. This (over)emphasis on horror reflects a general, international cult fascination with violent bad taste and the 'transgressiveness' of gore; it reflects too, perhaps, the enthusiasm of *male* cultists and scholars for the coolly marginal and extreme. Happily there is still much work of recovery and gap-filling to do in other, less obviously 'culty' genres. The sex comedies of the 1970s are now acknowledged as important, perhaps because their combination of bawdy and embarrassment about sex seems quintessentially British, but little has been written about low-budget thrillers, camp and kitsch films, pop musicals, fantasy and SF, hardcore pornography, and the wealth of 'bad films' across all British genres. Auteurism, still a default perspective in cultism, where much of the foundational revisionist work began, also encouraged focusing on directors, such as Terence Fisher and Michael Reeves, at the expense of writers, actors, set designers, cameramen, composers, editors and producers, whose contribution to British cinema is only starting to be explored.

Second, *re-evaluating* these films and inserting some of them on their merits into the canon of British cinema.

This is a major achievement, and again it is horror (*Dracula*, *Peeping Tom*, *Witchfinder General* (1968), *The Wicker Man*), along with that other 'male' genre, the crime film (*The Italian Job* (1969), *Performance* (1970), *Get Carter*, *The Long Good Friday* (1980)), that has seen the most enthusiastic advocacy. Even so, there is much more you can do with films than simply judge them good or bad, or indeed 'so bad they're good'. The trash films in this book, which as a cultist I often value very highly, are rarely 'good' by conventional standards, but this begs many vexed and fundamental questions. Who decides what counts as a good film? How far do judgments of value and taste reflect distinctions based on class and cultural status rather than access to universal aesthetic standards? Why do popular

and critical tastes diverge and why do they change over time? And why – if I may strike a personal note – do I positively *love* trash like *Psychomania* while 'modern classics' such as *Distant Voices Still Lives* (1988) make me lose the will to live? How can some films seemingly without value be yet so valuable to me? The issue of value and quality remains, for me, in many ways impenetrable, and I'll return to it in bafflement and confusion many times in the course of this book. This leads on to the next and most ambitious and combative project of the New British Revisionism:

Third, resisting and replacing official conceptions of British cinema, canonicity, indeed cinema itself, in accordance with what might be called *trash aesthetics*.

This is down to fans and cultists as much as film critics and scholars, though the distinction between freelance trash mavens and film academics is increasingly moot. Here we must confront the problem of what we *do* with all these disinterred trash films? Revisionism hints at new ways of writing about British cinema, drawing on fan and cinephile discourses as much as on academic ones. On the one hand, we can still pursue the usual methods of film scholarship and set the films in their generic and cultural contexts, analyse them for their ideological underpinnings, and offer tentative appraisals of their 'quality' (a different thing, of course, to recapturing the meaning and value they had for their original intended audiences). But, on the other hand, there are other less scholarly and more 'cultist' approaches that could lead us far away from level-headed normative film interpretation – towards, for example, hermetically private responses to the films' photogenic qualities, or autobiographical accounts of the life-changing significance of trash to cultists' identities and politics.

There is one final and more elusive reason to re-map British cinema. Insofar as the national imaginary is influenced by films, then rethinking the canon goes further than arguing that British cinema is as much about horror and sex, low pleasures and high camp as it is about Forster and *Brief Encounter* (1945). Trash films project, if you like, an alternative psychogeography of Britain that allows us to rethink what is meant by Britishness itself. Watched end to end, British trash cinema is an epic mondo film reporting back on Britain's imaginative edgelands, far removed from the stately homogeneity of heritage cinema.

2 BRITISH TRASH CINEPHILIA

Why should anyone care about trash?

Plucking masterpieces from dross is a wholly respectable activity; you might even say it is our chief duty as critics and film fans. Providing a comprehensive overview of film production is equally important if we're to understand how and why films get made and critical and audience tastes change. But why enthuse about and even *prefer* trash films that may be very 'bad' indeed? Why does the Blu-ray of Andrea Arnold's *Wuthering Heights*, dutifully rented from LOVEFiLM after good reviews in the *Guardian* and *Sight and Sound*, still languish unwatched next to my TV, while I leapt at the chance to see *Stag Night of the Dead* on the Horror Channel?

We need to step back and define the role of trash generally in contemporary culture, and then to ask why trash films in particular became objects of critical and cult interest.

TRASH, CLASS AND CULTURE

Trash is necessarily a loose term, as much defined by films that tickle a certain sensibility as a predictable combination of qualities already mentioned, such as kitsch, surreal, tasteless and weird. I chose it because, though 'trash' seems a derogatory word, redolent merely of contempt and dismissal, it chimes with the enthusiasm for the lower pleasures of cinema itself that have energised film critics from Parker Tyler to Pauline Kael and J. Hoberman and artists generally from the surrealists to postmodernists.[1] It also links to a wealth of scholarship by aca-fans about exploitation and bad films that has flourished since the 1980s, in which the term 'trash cinema' is a convenient synonym for exploitation without any pejorative intention.[2]

The term 'trash' obviously has wider cultural meanings than just film. In culture, trash is not a precise category, but rather, like a genre or a mode, changeable and pragmatic, in part evaluative (badness, indifference to aesthetic value, throwaway), in part descriptive (a style of reckless or hapless excess and lack of inhibition), and in part simply denoting aesthetically null aspects of popular culture – the disposable products of society, anonymous, replaceable, ephemeral and seemingly worthless – in short, the vulgar. The conception of trash in culture emerged with modernism and avant-garde high art, with trash being identified with popular culture *tout court* rather than with the 'lowest' level of it. In this book there are two main ways of defining trash in general – one refers to everyday disposable culture, which might equally be called junk; the other to *low* culture, so low as to be more or less oppositional.

Trash certainly embraces culture – commercial, not folk – aimed at and enjoyed if rarely made by the working class. This is what Leon Hunt means, in the context of

Britain in the 1970s, by 'low culture'.[3] In Britain one might think of what developed from the proletarian culture of naughty postcards, music hall and fairgrounds, pulp novels, low comedy – the aspects of British culture explored by Orwell, for instance, in his celebration of the saucy postcard artist Donald McGill, whose vulgar comedy is 'the voice of the belly protesting against the soul'.[4] But this kind of British low culture, which might be seen as in some senses authentic, has often been regarded, on left and right, as continuously threatened by the insidious encroach of Americanised popular culture, more violent, anomic and amoral; that fear, in which America represented modernity itself, has certainly underpinned fears about the horror film, from Hammer to the 'video nasties', and pornography. The notion that the 'United States is a corrupting influence in British cultural life' has, as James Kendrick reminds us, been a continuous thread in British moral panics.[5] (Conversely, the uninhibited brashness of American popular culture has been an inspiration to the British working class, eager to escape from the binding shackles of the British class system.) But the conception of trash as low culture also implies that it is the culture, both imposed and appropriated, of *people* who are considered trash and who are especially vulnerable to its influence and 'effects'. The audience for trash is an audience of Others, whether it is the working class or the aspirant middle class (whose preference is for that disturbing imitation of high culture, kitsch). In fact, we cannot understand trash at all without relating it to class and to the relations of power that police the boundaries between trash and legitimate culture, since trash, like rubbish generally, only becomes recognised as such by social conventions. As Michael Thompson argues:

> only if one remains within severe cultural and temporal confines can one sustain the commonsense belief that rubbish is defined by intrinsic physical properties. Step outside these limits and one sees that the boundary between rubbish and non-rubbish moves in response to social pressures.[6]

The key aspect of trash and low culture in general is that they work on the body and emotions in direct – often embarrassingly direct – ways. Mikita Brottman remarks that 'middle-class resistance to "low" culture is rooted in the conception of a "proper" body, distanced physically and geographically from the grotesque "improper" body associated with "bad" tastes and "bad" places'.[7] Trash induces emotional participation in ways that clash with middle-class taste, which typically valorises intellectual and ironic distance. Trash is appreciated along the nerves and in the guts and groin rather than coolly at a safe remove; in film, for example, this is especially true of what Linda Williams calls 'body genres', such as horror, melodrama, low comedy and pornography, which short-circuit the intellect and incite intimate and even convulsive bodily response.[8] As James Twitchell says, 'physical arousal is almost always involved in the experience. Generating laughter, tears, shivers, and swoons is what "junk" usually strives for'.[9] A survey of trash is thus an act of reclamation that rescues historical tastes and pleasures from (crudely) the enormous condescension of middle-class (and male) critics and gatekeepers of taste towards the fetid, soiling, toxic working class and its 'diet' of junk culture. It is a history of popular pleasures, a subversive carnival that, on the whole, official culture wished certain classes of people did not enjoy because, like its close metaphorical equivalent junk food, it is probably terribly bad for them.

The notion of trash therefore involves a complex matrix of associations closely bound up with class and power. But trash has positive connotations too, insofar as it possesses an anarchic uncivilised immediacy that is uncontaminated by the bourgeois realm of art. Trash challenges the socially imposed authority of top-down high culture, which so often feels alien to everyday experience and desires. Trash culture, from this point of view, can be revalued as the cultural Id, the Unconscious Other of repressed middle-class taste. Hence trash can be turned, by artists for example and by cultural critics, into a resource and a weapon to attack conventional value judgments – not by integrating trash into 'legitimate' art (elevating it, in other words) but by passionately embracing it, re-evaluating it and declaring its superior authenticity – an attitude often associated with camp and the subversive cultural practices of gay artists, critics and consumers. If trash is a term imposed, contemptuously, on low cultural products, it can also be appropriated as a transgressive style and an inspiration for creativity (a bit like 'outsider art'). Indeed the conversion of trash into art has become *the* key signature of postmodern culture, which, as Gillian Whiteley says, 'in its pluralist embracing of mass culture ... took on *kitsch* and trash, often conflating the two. In a curiously inverse aesthetic, trash has achieved primacy.'[10] The conflation of art and trash, high and low culture, from Schwitters and *merz* to the pop of Richard Hamilton and Andy Warhol and the emergence in the 1960s of a voraciously indiscriminate postmodernism is well beyond the remit of this book, but it is an essential framework for understanding how trash has shifted from the margins to the centre of contemporary culture, not least because, being rubbish, it falls outside conventional value systems.[11] As Jonathan Culler has said, 'Rubbish has ... become an essential resource for modern art':

> At a time when there are fewer and fewer conventions sufficiently rigorously established so that to violate them is taboo, and when it is thus more and more difficult to innovate by *breaking* rules, the possibilities of change may well lie in junk and rubbish.[12]

Indeed the key gesture of modern art, from Duchamp's urinal (*Fountain*) to Tracy Emin's unmade bed, is that it converts rubbish, often ordinary objects that have lost their original use value, into auratic and durable works of art that short-circuit hierarchies of value. 'A transient piece of plumbing', as Culler remarks of Duchamp's urinal, 'detached from its function, becomes rubbish, and thus available for sudden elevation into art.'[13] As we'll see, this conversion of trash into treasure, as Kate Egan calls it, is at work too in cultists' elevation of films regarded as so worthless that they are incomprehensible within conventional aesthetic frameworks.

TRASH AND THE MOVIES
In 1940 Orwell listed 'Hollywood films' among the characteristic and invariably unfortunate phenomena of mid-century modernity, along with 'concentration-camps, rubber truncheons, Hitler, Stalin, bombs, aeroplanes ... and political murder'.[14] And indeed most cinema can be – and has been over the years – denigrated as worthless trash. I don't just mean the way the word was casually used to describe schlocky, expensively cheap filmed equivalents of airport novels by Harold Robbins and Jacqueline Susann and the sexually

explicit epic spawn of *Peyton Place* (1957), such as *Valley of the Dolls* (1967), *The Adventurers* (1970) and *The Betsy* (1978). There is a deeper point involved here than reiteration of Sturgeon's Law that 90 per cent of everything is crap. Trashiness can be regarded as an *intrinsic* quality of film, an unavoidable consequence of its Faustian pact with commerce and its historical ties to melodrama, comic books and the sub-literary, as well as the disposability enforced by its traditional weekly exhibition cycles; indeed, as Justin Smith pointed out to me, Film Studies is 'broadly engaged in resisting the consumption patterns of popular cinema in practices of undue scrutiny and canon-formation'.[15] You get a sense of that when it comes to literary adaptations: the assumption that film – too visual, too mindlessly literal – will always drag material down to its level, debauching it with accessibility and populism. Trashiness is one of the irredeemable characteristics of the big, vulgar and moneyed 'art' of the movies, not least because the apotheosis of cinema is in America, with its resistance to cultural hierarchies and democracy of sluttish energy. You might resist brash melodramas like *The Devil's Advocate* (1996) and headache-inducing eye-candy like *Transformers* (2007), but they represent what cinema, and especially American cinema, can do better than any other art form: 'the accidental forms of commercial poetry', as Jeffrey Sconce calls it, and 'the vertiginous surrealism that brought so many to the cinema in the first place'.[16] The trashier the films, from this point of view, the truer they are to cinema's historical purpose; really trashy films, such as exploitation films, are in a sense *purer* embodiments of cinema's true essence. That is reason enough to discard literary conceptions of cinema and value it precisely for not being in thrall to good taste.

Film canons are made by overturning what is regarded as trash. If we did not spend a good deal of time with bad films, then what passes for a film canon would never change. As J. Hoberman says, 'many, if not most, of the films we admire were once dismissed as inconsequential trash'.[17] Today's masterpieces – like *Peeping Tom* – were yesterday's trash, and yesterday's masterpieces get forgotten or are reframed as middlebrow or kitsch. Cinephilia – the love of film *as* film – often advances through the making of revisionary lists hostile to conventional value judgments, from the surrealists' lists of favourite films, to Andrew Sarris's categories of American directors, to the endless lists of 'best films', 'worst films' and even 'sickest films' that populate film magazines and fan-sites, and polls such as *Sight and Sound*'s greatest films poll of critics that has been going since 1952. There is a sense of free for all in the matter of evaluating films. One of the pleasures of cinema is that high and low seem endlessly renegotiable, much more so than in literature, for example, where firewalls between genre entertainments and literary novels are surprisingly resilient. James Naremore, referring to film noir, says that:

> media critics have always defended certain types of ostensibly disreputable, formulaic thrillers by appealing to their moral ambiguity and their lack of bourgeois sentimentality or 'high-mindedness', and such a defense is valuable to the movie industry because it enhances the films' crossover potential, allowing them to play at the higher end of the market.[18]

There are always new ways of describing even the trashiest films so that they suddenly click into place as auteur works, or as subversive realism. Film, of all the arts, is the

one most deconstructive of bourgeois conceptions of value and established aesthetic hierarchies.

We can trace the re-evaluation of trash historically, at any rate in relation to Hollywood. By the early 1960s auteur theory – which Robert Ray described as 'in effect, an elaborate justification for cult films' – was revising the entire history of American cinema.[19] Disregarded and marginal films were lauded at the expense of the middlebrow films that made money and won Oscars. 'The shock value of auteurist aesthetics', Ray said, 'depended on the existence of a gap between popular and critical tastes … . The disagreement … lay not only between the auteurists and the popular audience, but also between the auteurists and the critical establishment.'[20] From American B movies and Poverty Row noirs and horror films, from Sam Fuller to Russ Meyer, what was once seen as the detritus of cinema became the object of critical approval and cult appreciation, often with a political edge. As Ernest Mathijs reminds us, in 1970s France left-wing reviewers in *'Combat, Le Monde* and *Positif* … champion aesthetically low-value films *because* they challenge taste'.[21] The result was a collapse in the consensus as to what represented a good, serious, pleasurable American movie. Notions such as 'highbrow', 'lowbrow' and 'middlebrow' turned out to be increasingly hard to entertain. Wide gaps opened up between the mass audience and the minority of cultists and art-house devotees, and, in critical circles, between auteurists and mainstream critics. New and competing reception contexts, in Europe as well as the US, destabilised the status and meaning of films.

A positive understanding of trash implies that trash has a certain authenticity absent in the highbrow and the mainstream. This lies behind the enthusiasms of critics like Ado Kyrou at the surrealist-influenced *Positif*, the cult criticism traced in detail by Greg Taylor in *Artists in the Audience*, Parker Tyler's willing immersion in the camp trashiness of Hollywood's commercial 'hallucinations', and the overturning of big serious cinema by what Manny Farber called 'termite art'.[22] By the early 1970s there was a considerable difference among critics as to whether, like Sarris, one revalued low art or, like Pauline Kael and the surrealists, one simply lapsed into vicarious enjoyment of it. As the conservative critic John Simon wrote, 'Even some of the feeblest flicks can be pronounced movie-movies, glorified trash, pure Americana, pop art, silly but harmless fun, or whatever term is thought to vindicate one's addiction best.'[23] Sarris attacked the kind of critic who is fascinated by the vulgar spectacle of popular films but cannot bring himself to admit they are art: 'He conceals his shame with such cultural mechanisms as pop, camp, and trivia, but … [his] intellectual guilt compels him to deny serious purpose and individual artistry to the mass spectacles he has been educated to despise.'[24] For Kael, trash and trashiness, as a critical category and as a general quality of cinema, was essential to the vitality of American cinema because America itself was trashy. Trash for her certainly covers exploitation movies, like *Wild in the Streets* (1968), but more typically she uses the term to mean straightforward commercially inspired entertainment films, like *The Thomas Crown Affair* (1968) ('trash undisguised') and *Morocco* (1930) ('great trash'), which were 'never meant to be anymore than frivolous and trifling and entertaining'.[25] A refined notion of art is 'what America isn't, and it's especially what American movies are not'.[26] It denoted energy, unpretentiousness, visual zip and pleasure in the undergrowth of American culture and the potency of cheap movies:

audiences who have been forced to wade through the thick middle-class padding of more expensively made movies to get to the action enjoy the nose-thumbing at 'good taste' of cheap movies that stick to the raw materials. At some basic level they *like* the pictures to be cheaply done, they enjoy the crudeness; it's a breather, a vacation from proper behaviour and good taste and required responses.[27]

This is trash imbued with positive, liberating connotations, whether you regard it as ripe for appropriation or as exciting on its own terms, though Kael was amused and irritated by the younger generation of critics treating trash as art. Gary Hentzi went so far as to argue that exploitation films embodied uniquely American virtues:

Freedom, individualism, and inventiveness in the face of financial limitations – these time-honoured Yankee values are part and parcel of the schlock moviemaker's creed, and the psychotronics pantheon offers innumerable examples of American ingenuity in action For these are above all low-budget movies, turned out by a kind of film industry underclass, who pride themselves on their ability to do without, and look on the privileges of their rich relatives with a mixture of envy and disdain. As a result, in their films we can *see* money – or rather the lack of it – and this fascinates us because of the way it exposes the conditions under which more successful Hollywood illusions are created ... big-budget spectacles, whose astonishingly convincing special effects are matched only by the unsurpassed shallowness of their conception.[28]

Here again is that sense of an *essential* trashiness in cinema itself, or rather that trash displays or releases those aspects of film – speed, immediacy, eroticism, fantasy, emotion, modernity – nurtured by American cinema and perfected by the lively commercialism of its 'lowest' products, which have no fear of what Farber called 'the potential life, rudeness and outrageousness of a film'.[29]

British cinema – and its critical reception – has of course been uncomfortable with the trashiness of cinema. It is as if, in Britain, cinema needs to be rescued from itself, by alignment with the saving graces of literature and theatre. Kael spoke approvingly of 'the generally tawdry movies [that] contributed to our national identity'.[30] That is not, generally, how one would conceive of the role of British cinema. The movies, to adapt what Katharine Hepburn says about nature in *The African Queen* (1951), are what British cinema is here to rise above.

CULT, TRASH AND PARACINEMA

Trash has accrued a more useful and specific meaning in relation to film than just popular films or an emergent quality of all cinema. It means exploitation – sleazy, cheap and blatantly vulgar films, full of sex and violence, which are now objects of fandom and nostalgia for their transgression and tastelessness. If legitimate high culture feels exclusive to some people – and that often seems the whole point of high culture – then in the low culture of exploitation films they may find equal excitement, significance, liminal experiences and instructive shocks, with the added frisson that the films' pleasures offend against the repressive conventions of middle-class taste. The French sociologist Pierre Bourdieu said that,

> A work of art has meaning and interest only for someone who possesses the cultural competence, that is, the code into which it is encoded A beholder who lacks the specific code feels lost in a chaos of sounds and rhythms, colours and lines, without rhyme or reason.[31]

That is a feeling that may be encouraged by contemporary high culture, insofar as such a thing still exists. Unlike low culture, some people may think, it is not meant for 'people like us', is meant in fact precisely to exclude them and bring home their inadequate cultural capital ('knowledge', in Sarah Thornton's words, 'that is accumulated through upbringing and education which confers social status').[32] Trash culture, *our* culture, becomes, for cinephiles, an alternative to *both* high culture and the mainstream rather than merely their degraded Other, and we relish having the cultural competence to appreciate the kind of alienating trash, such as exploitation films, that others simply cannot stand or make worthwhile sense of.

The sensibility that could embrace trash films was given impetus in the 1960s by the success of camp and pop art and the emergence of what Robert Ray called 'the ironic audience', which had morphed into the cult audience by the end of the decade.[33] This began with the dissolution of the homogeneous audience in the US in the early 1950s. The minority art-house crowd and the phenomena of the cult film and the cult star were manifestations of 'the new widespread and growing audience awareness of alternative possibilities for the movies [They] discovered something that profoundly shook the industry: the Classic Hollywood movie was not the inviolable model for the commercial cinema.'[34] According to Ray, the catalyst for irony was television, whose endless and indiscriminate recycling (Ray's words) of the traditional codes and genres of the Hollywood film ensured that the audience, soon overfamiliar with these exhausted paradigms, acquired an ironic, 'knowing' distance from them; it became an unwitting participant in camp. An audience evolved of, in Umberto Eco's phrase, instinctive semioticians, countercultural in taste as well as politics.[35]

Nirvana for the ironic audience came with cult movies. Cult films often share textual qualities but are chiefly defined by an enthusiastic following. Nowadays the term has expanded to include any low-budget movie which might appeal to a cult sensibility – a rather circular definition, in which the choices of a pre-existing taste, especially for trash, are more crucial than the qualities of any particular film. The key period of cult films was the early 1970s, the period of the midnight movie in the US, which can be dated from screenings to ironic audiences of Alejandro Jodorowsky's 'head film' *El Topo* in New York in 1970. Cult films were on the one hand films of Hollywood's Golden Age, often commercial successes like *Casablanca* (1942) as well as re-evaluated films like *Freaks* (1932) and *Touch of Evil* (1958) and on the other the products of the New Hollywood and the fusion of underground and exploitation cinema – *2001: A Space Odyssey* (1968), *Pink Flamingos* (1972), *Harold and Maude* (1971) – which found an adoring audience among a countercultural crowd looking for mind-expanding experiences. Cult films are often prized for qualities that condemn them from a conventional perspective, such as their incompleteness, the vividness of their production backstories and their transgressive style and content.

Films began to be made which were essentially programmatic cult films, deliberately aimed at audiences attuned to the pleasures and bourgeois-baiting subversions of trash. Pioneered by underground film-makers, such as George and Michael Kuchar, Andy Warhol, Kenneth Anger and Jack Smith, trash became a deliberate countercultural aesthetic. It might be a gay intervention, as with the British director and film programmer, Antony Balch; or, as with Michael Reeves, who was not gay, it might exemplify a cinephile's desire to use a trash genre for personal expression, as Reeves does in *Witchfinder General*.[36] By the 1970s 'trash film' had hardened into a recognisable category of deliberately trashy movies catering to cultists delighting in bad taste, violence, kitsch, camp and sexual explicitness. John Russell Taylor traced the forerunners of such trash films back not only to the camp side of the American underground but also to Roger Corman's absurdist and self-parodying horror films, *A Bucket of Blood* (1959) and *The Little Shop of Horrors* (1960): 'They occupy a *terrain vague*, not exactly commercial, not exactly underground, not exactly pornographic, but a bit of all. There is an element of defiance about them. Some films are trash by accident; these are trash by design.'[37] The examples he cites are Kuchar and MacDowell's *Thundercrack!* (1975), an epic hardcore underground film, and John Waters's celebration of decadence, *Female Trouble* (1974). Since then the programmatic trash movie has flourished in Britain as well as the US as a category of ultra-low-budget

Witchfinder General: countercultural exploitation

film production that pastiches and emulates exploitation in an attempt to reach a niche audience of gorehounds and other self-selecting trash fans. Most recent British examples are horror and SF comedies whose titles sum up their content and appeal, such as *Pervirella* (2002), *Evil Aliens* (2005), *Lesbian Vampire Lovers* (2009), *Kill Keith* and *Strippers vs Werewolves*.

It is important, then, that trash cinema is neither simply a genre of film nor a dismissive blanket term for low-budget movies. Trash is a discursive category – like 'video nasty' and 'torture porn' – associated with a specific *taste* associated with the popularisation of camp since the 1960s and the emergence of a culture of cultism. This taste, while consonant with the critical re-evaluation of low cinema, was finessed mostly in fan culture, and, again, as my references here betray, it has chiefly been explored in relation to the US. Liking trash films of all kinds is caught up in an aggressive and punkish anti-aesthetic, which Jeffrey Sconce, in a seminal article on trash, called paracinema –

> seemingly disparate subgenres as 'bad film', splatterpunk, 'mondo' films, sword and sandal epics, Elvis flicks, governmental hygiene films, Japanese monster movies, beach party musicals and just about every other historical manifestation of exploitation cinema from juvenile delinquency documentaries to soft core pornography.[38]

It is, according to Sconce, 'an extremely elastic textual category … less a distinct group of films than a particular reading protocol, a counter-aesthetic turned subcultural sensibility devoted to all manner of cultural detritus', in which 'the explicit manifesto of paracinematic culture is to valorise all forms of cinematic "trash", whether such films have been explicitly rejected or simply ignored by legitimate film culture.'[39] Sconce points out, crucially, that paracinema is not only a discursive construct but a taste, a strategy as much as a checklist of weird movies and an unofficial, rather than academic or critical, form of resistance to the mainstream that 'seeks to promote an alternative vision of cinematic art, aggressively attacking the established canon of quality cinema and questioning the legitimacy of reigning aesthetic discourses on movie art'.[40] Paracinema is a way of disputing the categorisation of films into high and low and even inverting such categories; it is based on ironic reading strategies that, paradoxically, by appropriating and remediating the films, create 'a hierarchy of "skilled" and "unskilled" audiences'.[41] Since the 1970s this has been a key taste formation for cultists, especially lower middle-class young white men (like me, at any rate in my younger days), culturally insecure and keen to distance themselves expertly from the 'feminised' mainstream.

Mikita Brottman came up with a complementary discursive label of 'offensive film' – an alternative taboo cinema – 'trash cinema par excellence' – that links *Blood Feast* (1963), *Cannibal Holocaust* (1980) and *Irreversible* (2002) because they share an irredeemable quality of shock and body horror, strategies valuable to high and low alike.[42] They are films not only 'genuinely shunned from mainstream cinema' but which 'can be understood as symptoms of a nervous disorder, revealing themselves to be part of the *unconscious* of mainstream cinema and thereby the locus of all its anxieties, problems, and frightening neurotic taboos'.[43] Trash is conceived as having a special, privileged relationship to cultural fears and repressions.

Joan Hawkins too has pursued this idea, noting that 'high culture trades on the same images, tropes, and themes that characterize low culture', and traced the development of a taste for such films and crossovers:

> These films promise *both* affect and 'something different': they are films that defy the traditional genre labels by which we try to make sense of cinematic history and culture, films that seem to have a stake in both high and low art.[44]

Exploitation and trash are as distinct from Hollywood as art movies – and art movies may have, as Hawkins puts it, 'high production values, European art film cachet, and enough sex and violence to thrill all but the most jaded horror fan'.[45] Borrowing from the lexicon of auteurism, cult critics re-evaluate exploitation hacks, such as the prolific Spanish director Jess Franco, as warped auteurs:

> paracinema can be and has been revalued as film art by placing it in direct cultural proximity to films already deemed aesthetically (and legitimately) valuable. Again, this should remind us that trash film culture often resembles legitimate film culture, especially in its reliance on notions of film art and authorship.[46]

Trash, because it is a product of taste choices as much as a coherent set of films, can therefore move abruptly up and down the cultural scale. Ernest Mathijs argues, with reference to the Belgian cult art-exploitation film, *Daughters of Darkness* (1971), that reception contexts are all important in determining whether a film is seen as trash, art or some confusion of the two (which often in itself makes for cult status):

> 'trash' has become a very different word in cinema studies. If it first referred to straightforward rubbish, it now carries a much more subtle and complex status It has come to signify a particular kind of film, characterized by its openness to different interpretations, much more than just a bad film.[47]

A film's cultural status and also what it means change over time and across reception contexts. As Mathijs says, 'trash films seem, like *sleepers*, to stick around. But unlike canonized cinema, whose reception trajectory also covers long periods of time, the films' reputations never seem to settle.'[48]

Indeed it is a cliché that highbrows will always prefer the lowbrow to the middlebrow, and a taste for trash is to some extent a paradoxically elite and rarefied taste for low over easy pleasures, a refusal of the *popular* popular – mainstream vanilla movies, in other words, especially those liked by, say, young girls and women (even those with significant cult fanbases such as the *Twilight* films). You might call it cultural slumming, but it is also a way, as Sontag emphasised, of being a dandy in mass culture by upturning and ironising cultural hierarchies, and promoting the credentials and knowledge of *fans* over those of official arbiters of cultural value. As Helen Merrick says, within 'the realm of popular culture, fans are the true experts; they constitute a competing cultural elite, albeit one without official recognition and social power'.[49] Susan Sontag wrote, in her classic article on camp, in which she emphasised the role of film in popularising

camp: 'The old fashioned dandy hated vulgarity. The new style dandy, the lover of Camp, appreciates vulgarity.'[50] Since the 1960s, when Sontag was writing, this style of camp irony has become mainstream, standardised, and lost most of its subcultural (and gay) attitude and cachet – and thereby much of its subversiveness. It is still political, in a sense, because it denotes a refusal of mainstream taste, but, in relation to cult film audiences, it is arguably a kind of snobbish anti-snobbism. The oppositional character of trash appreciation often reproduces the practices of high cultural criticism and much of its exclusiveness and oneupmanship. According to Mark Jancovich,

> cult movie audiences are less an internally coherent 'taste culture' than a series of frequently … contradictory reading strategies that are defined by their sense of their difference to an equally incoherently imagined 'normality', a loose conglomeration of corporate power, lower middle class conformity and prudishness, academic elitism and political conspiracy.[51]

This book, like so many others that have flourished since the mass dissemination of camp since the 1960s, is the product of this popularisation of the taste for paracinema, bad films and the sub-cinematic. The uses that people make of trash will of course be determined by many competing factors, not only the usual ones of class, race, gender and sexuality, but also age, profession and nationality. (It is crucial to remember of course that what cultists get out of older trash films is unlikely to be the same as what the films' original audiences did.) Sharp competitive distinctions exist between trash fans: between, for example, amateur enthusiasts, who often have a sense of prior ownership over the field, and aca-fans, who may be regarded as pretentious Johnny-come-latelys. For middle-class cultists like me, a taste for trash is not simply a recovery of the popular (a *fantasy* of low culture as much as the real thing), but an act of transgression and a means of creating an identity. This taste for the low at the expense of the middle-brow chimes with an international trend once described as a shift in middle-class taste 'from snob to omnivore'. Richard Peterson and Roger Kern showed that in contemporary American contexts at any rate, those with high cultural capital are often 'cultural omnivores' who embrace the texts of low as well as high culture: elitist exclusion had been replaced by elitist inclusiveness.[52] This middle-class culture, in which high and low are consumed with equal confidence, was pioneered by camp ironists such as the film-maker John Waters:

> As a Baltimore teenager, my filmgoing habits were completely schizophrenic. I'd see four films in one day – maybe start off with *Door to Door Maniac* [1961] starring Johnny Cash, and then rush to the opening day matinee of *The Exterminating Angel* [1962]. After gobbling down a sandwich, I'd catch an evening screening of *Hagbard and Signe* [1967] at the most obscurely interesting art theater in town, the now-defunct 7-East, and then top it off with a late-night showing of something like *Angel, Angel, Down We Go* [1969].[53]

Nimble-footed scampering up and down the cultural scale is now the speciality of baby boomers, who value the films they loved as children, raise ephemera to the level of art and emotionally invest in and collect what aroused, entertained and distracted them in the past. In Oedipal revolt against earlier generations, these middle-class taste tourists are

used to the shock of the new and to re-evaluating rubbish as art. Whether it is gallery art, comic books, rock music, old films or literary novels, the status-seeking middle-class omnivore is adept at negotiating the most unlikely boundaries between high and low:

> The market forces that swept through all the arts brought in their wake new aesthetic entrepreneurs who propounded avant-guardist theories that placed positive value on seeking new and ever more exotic modes of expression, but in the latter half of the twentieth century the candidates being championed for inclusion were so numerous and their aesthetic range so great that the old criteria of a single standard became stretched beyond the point of credibility.[54]

In relation to cult film, this taste for trash is often caricatured as a predominantly *male* taste, expressive of a cult identity that is contemptuous of ordinary tastes and people and which demonises an establishment of censors, feminists, taste makers, the self-righteous and snobs.[55]

BRITISH CULT CINEMA

Perhaps, then, with British trash cinema what we are really talking about is British cult movies. Well, not exactly. Not all cult films are trash, and not all trash is cult. Few 'canonical' British cult films are trash exploitation or 'so bad they're good'. And, though the *field* of British trash is very 'culty' indeed, few *individual* British trash films will ever be, or deserve to be, cult favourites.

It was in the 1990s that a canon, and specifically a *British* canon, of British cult films emerged, distinct from the films included in Danny Peary's *Cult Movies* trilogy, which summarised American cult preferences in the midnight-movie era.[56] The canon is summarised in *Your Face Here*, a popular guide to British cult films published in 2002. As well as *The Rocky Horror Picture Show*, the films to which chapters are devoted include *If....*, *Performance*, *A Clockwork Orange* (1971), *Get Carter*, *Quadrophenia* (1979), *Withnail and I* and *Trainspotting* (1996), youth-orientated films with 'tribal themes' which celebrate outlaw masculinity in charismatic central performances.[57] This is not a canon of trash films in the sense of sleazy exploitation movies (though some, such as *The Wicker Man* and *Performance*, were certainly considered trash by their own distributors), and only *Rocky Horror* is thoroughly imbued with a spirit of camp trashiness. Even those belonging to the horror and SF genres, such as *Witchfinder General*, *The Wicker Man* and *A Clockwork Orange*, tend to be auteur works celebrated as art and somewhat adrift from their generic location. Neither *Witchfinder General* nor *The Wicker Man*, for example, is a conventional horror movie; the former, a historical melodrama, has been likened to a Western, while the latter is a shaggy-dog police procedural with musical numbers. Indeed, the same is true of the British films in Peary's 1980s trilogy, which include *Zardoz* (1974), *A Clockwork Orange*, *The Man Who Fell to Earth* (1976), *The Red Shoes* (1948), *Peeping Tom* and *2001*. There is no mention of trash films, such as *Devil Girl from Mars*, *Come Play with Me* and *Psychomania*, whose cult certainly exists but remains comparatively under the radar. The key British cult films, discovered on TV and video in the 1980s and 1990s, are one-offs, auteur films and films with subcultural credentials, rather than particular trash movies.

You will have noticed – and I am painfully aware of the fact – that my discussion of paracinema and the appearance of a cult sensibility has drawn mostly from American experience, where the history of cinephilia is much more developed and self-conscious. The emergence of a trash sensibility in Britain and the development of British cinephilia in criticism and film fandom have received comparatively unsystematic study.[58] You can, however, tentatively sketch the rise of trash cinephilia in Britain – the auteurist recuperation of Fisher and Reeves by critics such as Robin Wood; Raymond Durgnat's interest in trash and the national Unconscious; the influence of the gay coded magazine, *Films and Filming* and the 'younger, queerer, countercultural aesthetic' it shared with Antony Balch (one of a significant number of gay writers and directors involved in exploitation).[59] A taste for trash flourished in the 1970s against the background of glam and punk, when, as Leon Hunt has shown, trash became a cultural dominant, and in the 1980s it was showcased by rep cinemas like the Scala in London and accelerated by resistance to the video-nasties panic and the fanzine culture it inspired.[60] The Scala, in Charlotte Street from 1979 and then King's Cross from 1981 till it closed in 1992, was an especially important crucible of cult viewing practices.[61] 'The Scala', declared the filmmaker Richard Stanley, 'became my sanctuary, my alma mater, a house of dreams redolent of an opium den, with its haze of psychoactive smoke and its delirious, half-glimpsed denizens'.[62] As so often with cult, the film itself was only the catalyst for an entire sense-deranging experience: *viz* my friend Mo Bottomley's claim that 'The Scala is the only place where I stroked a cat, was offered a joint and had someone jizz on my shoulder, all within thirty seconds.' Other independent cinemas across Britain replicated the Scala's subcultural mix of classic art-house films and transgressive midnight movies, such as the Penultimate Picture Palace in Cowley Road, Oxford, where I watched *Rocky Horror* at a raucous cult event for the first time and in 1988 attended an aborted secret screening, with Brian Aldiss in attendance, of *A Clockwork Orange*.

Justin Smith argues that cult really emerged in the UK from 1976–96 because of the 'formation of niche taste-communities as a result of the fragmentation of the exhibition industry ... and the continuing decline in cinema attendance'.[63] Discrete markets, from sex cinemas to art cinemas, outlets for workshop films and finally the growth of home video, meant that 'the circumstances were ripe ... for marginalised, neglected or critically debased films to find niche audiences in a range of locations'.[64]

The Scala in London, crucible of cult viewing practices

But, with apologies to Alex DeLarge and Dr. Frank-N-Furter, this cult subculture was not especially focused on *British* films, not least because the cult qualities of foreign films allowed us to escape from the repressions of British culture, and there was more cultural capital to be earned from investment in other cinemas. (In recent years, much British cult interest seems, on the one hand, to have shifted East, away from the independent American films that dominated cult in the 1990s and

towards Japanese and Korean horror; and, on the other, to have merged with the hegemonic international geek fandom for big-budget comic-book adaptations such as *The Dark Knight Rises* (2012).) American cultists in the 1970s were often far more enthusiastic and proactive in championing British trash and genre cinema – take for example *Little Shoppe of Horrors*, the American Hammer fanzine, which first appeared in 1972, and the cult of *The Wicker Man*, which also began in the US.

British cultists in the 1970s and 1980s hankered after foreign films hard to see in the UK, which, thanks to the BBFC, were numerous, especially in uncut versions. I certainly saw and valued many British cult films at the time – *Don't Look Now*, *Walkabout* (1971), *Peeping Tom*, *Monty Python's Life of Brian* (1979), *Withnail and I*, *Performance*. But as a budding cultist in the 1980s I was more exercised by trying to see *Salò, or the 120 Days of Sodom* (1975) (finally seen uncut at a midnight screening opposite the Pompidou Centre), *In the Realm of the Senses* (1976) (seen at the PPP under club conditions) and cult hardcore porn like *Deep Throat* (1972) and *Café Flesh* (1982) than by hunting down pre-cert video copies of *Vampyres* and *Zapper's Blade of Vengeance* (1974). Some British films did acquire cult followings for very local reasons. Kubrick's withdrawal of *A Clockwork Orange* from British distribution gave it a special significance for British fans, who could only see it abroad or, as I did, on a dubbed video. British horror wormed its way into the affections of a generation who stayed up to watch Hammer and Amicus films on the 11 pm 'Monday X Film' slot on ITV in the early 1970s, and some films, such as *Psychomania*, acquired their cult reputations entirely through repeated screenings on late-night television.[65] But my life as a cultist in the 1980s, like that of many other British fans of trash movies, was defined by exasperated attempts to outwit the BBFC via pirated videos and festival, club and rep screenings.

It wasn't till the 1990s that British *trash* films, as opposed to 'legitimate' and accessible cult films by Roeg, Losey, Russell, Kubrick and Jarman, really caught my imagination. By then British trash fans were starting to be catered for by such eminently collectable publications as Allan Bryce's the *Dark Side* magazine; Stefan Jaworzyn's *Shock Xpress* magazine and books; Tim Greaves's and Paul J. Brown's little books on *Vampyres* and horror starlets; Marcus Hearn's *Hammer* magazine; *Dark Terrors* (another Hammer fanzine, first published in 1992); FAB Press's *Flesh & Blood*, edited by Harvey Fenton; and Nigel Wingrove's Redemption and Jezebel labels, with their striking Goth covers and memorably illiterate liner notes.[66] Horrorphiles made cult figures out of Pete Walker and Norman J. Warren, and sex comedies such as the *Confessions* films were re-evaluated as precursors of the New Lad humour of *Viz* and *Men Behaving Badly* (1992–9). The main focus, though, was horror, which built on the existing large cult interest in Hammer. In fact, the British horror film was pretty much identified with Hammer and a few isolated cult add-ons such as *The Wicker Man* and *Witchfinder General*. Only recently have horror studios such as Amicus and Tigon (*Witchfinder General* apart) attracted a comparable degree of interest from fans and scholars. Other British trash genres such as low-budget thrillers, with the minor exception of Lindsay Shonteff's, are still not especially valued.[67] Till recently British trash cinema has been insufficiently exotic, even when it was hard to see, and its content too diluted by censorship to gather much following in its home country. An interest in British horror, let alone British sex films and low-budget crime movies, remains a niche even now among British film fans.

The key reason for the emergence of a vibrant cinephile culture in Britain was, of course, the arrival of domestic video in the early 1980s.[68] Video made available films that were never likely to turn up on television or get revived at rep cinemas, and for the first time allowed private collections of trash (the initial films on video tended to be trash films because the major studios were nervous about devaluing their products by selling them in the new format). The most important British context here was the 'video-nasties' debacle of 1982–4 – a moral panic over the appearance in video shops of gory horror films, which, before the Video Recordings Act (VRA) of 1985, could be released without pre-censorship by the BBFC.[69] While only one or two British films, such as *Exposé* (1975), were included on the list of 'banned films' drawn up by the Director of Public Prosecutions, the 'nasties' was *the* formative cultural moment for British horror fans and the revival of interest in British trash films generally. The video-nasties panic was as crucial to British trash fandom as midnight movies in the US. It emphasised the division between official culture and the subculture of horror films, and energised a defensive but vibrant and oppositional fan culture in Britain, focused on hostility to the BBFC, collecting and swapping illegal tapes and producing fanzines, such as *Samhain* and *Shock Xpress*. The video-nasties panic not only invented a handy canon of films to collect, courtesy of the DPP, but also galvanised a generation of fan-scholars into investigating *gialli*, Nazisploitation and cannibal and zombie films, which nurtured an underground of knowledgeable, embattled and seriously pissed-off horror buffs.

As Johnny Walker has argued, the nasties loom large enough in British cultural memory to have inspired contemporary horror production by directors such as Adam Mason (*The Devil's Chair* (2007)), while *The Evil Dead* (1981), the poster boy of the nasties, became *the* template for ultra-gory and ultra-low-budget film-making.[70] There is now considerable nostalgia for the golden age of pre-VRA video, when officially dangerous and illicit films were obtainable only on third-generation copies and when, as the actor Simon Pegg recalls,

Fiona Richmond in *Exposé*, the only British film on the DPP's 'video nasties' list

> the auditorium for the viewing of such school-holiday delights was usually the front room of a friend whose parents worked during the day and couldn't afford childcare. Their absence meant the top-loading video player was open to anything the boys at Astrovision permitted us to rent, which was usually anything. ... This was most likely due to video shops being run by nerdy guys who relished introducing youngsters to a variety of mondo video rarities for vicarious thrills.[71]

Having one's favourite films banned concentrates the mind wonderfully on the iniquities of censorship, the stupidity of official culture, and the politics of taste. It also encourages obsession with acquiring both 'uncut' copies of films and exhaustive knowledge of BBFC cuts and textual variations. For someone like me, the constant irritant of censorship also accelerated my education in cinema and promoted a fierce desire to defend trash films.

I suspect this marked a major difference from the way paracinematic taste developed in the US, where videos evaded censorship and choosing trash over the mainstream did not risk the confiscation of one's prized collection of pre-cert tapes and dubs of *The New York Ripper* (1982) and *Nekromantik* (1987) traded from the backpages of *Samhain*. Danny Peary's *Cult Movies* nonchalantly discussed a number of films, such as *The Texas Chain Saw Massacre* (1974) and *Behind the Green Door* (1974), which were actually banned in Britain or, like *Pink Flamingos*, which lost the climactic shot of Divine eating dog shit, trimmed of their most iconic cult moments. This added a certain urgency to arguing that *The Texas Chain Saw Massacre* was in fact a *great* film and that *Suspiria* (1977) and *Cannibal Holocaust* had considerably more to offer the auto-didactic cinephile than *Chariots of Fire*. Conventional value judgments about films mattered more in Britain than in Sconce's description of paracinema in the US. I pounced on books like Martin Barker's edited collection on *The Video Nasties* because they offered not only analyses of the politics of the media panic, which fed a profound hatred of the censoriousness of the Thatcher years, but also positive evaluations of films like *I Spit on Your Grave* (1978) and *Cannibal Holocaust*. The same was true of Robin Wood's *Hollywood from Vietnam to Reagan*, which mounted passionate defences of both *Chain Saw* and *Last House on the Left* (1972).[72] Finding a language, fannish but scholarly, to defend a criminalised taste for these films and a prestigious framework for understanding them was crucial because so much then seemed to depend on asserting the films' legitimacy as both art and entertainment. One learnt to attend to trash films with the passionate investment associated with enthusiasts for art movies, and discovered that the films thoroughly repaid that investment. (Not surprisingly some of us ended up cashing in that knowledge by getting jobs as critics and academics and supervising PhDs on these banned films.)[73] Indeed, trash became *our* equivalent of the art film; both were pleasingly equidistant from the mainstream. As Joan Hawkins argues, 'the sacralisation of performance culture (its division into high and low art) never completely took root among art and horror/sleaze/exploitation film fans'.[74]

The nasties panic made cult figures of Dario Argento and Lucio Fulci, but it also promoted an archaeological interest in Britain's own horror film heritage and the depredations it had suffered at the hands of the BBFC. By the early 2000s, as the most astonishingly obscure films flooded onto DVD and fan culture exploded across the internet, it had never been easier to be a British trash cultist. The films were at last available and usually uncensored (thanks to the internet, the BBFC is wholly irrelevant nowadays; revenge is so *very* sweet); trash fandom had a vast online global reach; and trash, including British trash, was even attracting growing interest as an academic topic and subject for publication.

What we paracinema fans learnt, as our remit expanded to include the exciting and truly lost continent of British trash, was that, even though trash was entirely opposed to

dominant conceptions of British film, there was in fact a long history – over fifty years' worth – of British exploitation cinema that even cultists had overlooked. And it is to exploitation that we must now turn, starting with an obscure horror film called *Cat Girl* (1957), if we are to begin truly to understand what is meant by and valuable about British trash cinema.

3 TASTE THE BLOOD OF ENGLAND

Cat Girl, as its title suggests, was a belated rip-off of Val Lewton's *Cat People* and one of the first horror films made in Britain. Horror had been more or less suppressed till the 1950s, except for a few films such as *The Ghoul* (1933) and *Dead of Night* (1945). Co-financed by Anglo-Amalgamated and American International Pictures, *Cat Girl* was directed by Alfred Shaughnessy from a script that 'was a sort of joke around Beaconsfield Studios' and which no one wanted to direct.[1] He rewrote it from a straightforward werewolf film into a surprisingly effective psychological drama in which a young woman, Leonora (Barbara Shelley), controls a leopard alter ego with her mind. Shaughnessy had no high opinion of the film and his autobiography records his astonishment at David Pirie's admiration of it in his seminal *A Heritage of Horror* as a contribution to British Gothic and 'a crucially liberating moment in British cinema'.[2]

Although *Cat Girl* is a horror film, it is equally significant as one of the first British 'exploitation movies', by far the most important reference point for the term 'trash cinema'.[3] In the 1950s film producers took advantage of the 'X 'certificate introduced in 1951 to replace the advisory 'H' certificate, which since 1932 had denoted horror. 'X' films were restricted to audiences over sixteen (it changed to over eighteen in 1970). As Shaughnessy said, 'the new X-certificate was enabling the makers of what were known as "exploitation" films to combine the ingredients of erotic sex and horror in the same picture' and with *Cat Girl* his 'brief was to achieve just this' in the wake of the success of Hammer's first Gothic horror, *The Curse of Frankenstein*.[4]

Exploitation in Britain took over from the B movie, which was dominated by crime films, and added the crucial ingredients of sex and violence. It was funded by tax breaks, which, since the 'quota quickies' of the 1930s, had been designed to attract foreign investment and support the fragile production and exhibition industries. The 1927 Cinematograph Films Act had stipulated that a quota of the films distributed in Britain should be British, which 'did unlock American finance for the uncertain business of British film production and stimulate a mushroom growth of indigenous film companies'.[5] B movies and exploitation were subsequently encouraged by the Eady Levy, a tax on the price of cinema tickets which was made available for British film production, and which brought American money and personnel into Britain. Like the rest of British cinema from the 1950s to the early 1970s, exploitation such as *Cat Girl* was very often the product of international funding and strategies of targeting foreign markets. The success of the Eady Levy enabled British exploitation movies to flourish, though the concept of tax-funded trash often jarred with critics, as it still does whenever a particularly

blatant exploitation film, such as *Mum & Dad* (2008) or *Sex Lives of the Potato Men*, transpires to have been backed by Lottery money.

Exploitation from the 1950s to 1970s included not only horror, but also sex films, thrillers, sensational documentaries and science fiction films, which typically imitated American genre successes and international trends in low-budget cinema. Although sex and violence remained the key notes, exploitation also embraced showcases for pop bands, such as *The Ghost Goes Gear* (1966) and *Slade in Flame* (1975), commercially viable art films (Polanski's *Repulsion* (1966)), and downbeat cash-ins on topics ripped from the headlines, such as Gerry O'Hara's *The Brute* (1977) ('wife-beating'), and *The Black Panther* (1977), an admirably factual account of the multiple murderer Donald Neilson.

This chapter surveys the key exploitation genre of horror up to around 1970 and highlights some of the trash films that have garnered – or deserve to garner – a cult reputation. The critical writing on horror since the 1990s is very large – alarmingly so in fact – and ranges from exhaustive surveys such as Pirie's *A New Heritage of Horror* and Jonathan Rigby's *English Gothic*, to fiendishly comprehensive accounts of every aspect of Hammer's production history, theoretically dense analyses of films in their historical context, and a slew of opinionated websites.[6] What on earth could there be left to say?

Undaunted, I'll approach this well-trodden field by emphasising two aspects of British horror – its context as exploitation cinema, and the special appeal of some of its trashier films to what might loosely be called 'cult readings'. As we'll see in Chapter 5, which brings the story of exploitation horror up to the present, the cult of British horror not only determines its contemporary reception but also its production, as most of the recent 'new wave' of British horror was made by horror fans and the films' ideal viewers are trash cultists.

First, however, the term 'exploitation' needs some unpacking.

BRITISH EXPLOITATION CINEMA

Exploitation refers, in the general sense it has accrued since the 1950s, to low-budget films on sensational subjects, tailored to be appetising to specific audiences. As well as exploiting public interest in controversial topics, edgy content and the success of other genre films, they are themselves objects to be exploited through snappy titles, lurid advertising, exhibition gimmicks and the promise of material unavailable elsewhere. Cheap conveyor-belt film-making designed to fill gaps in the market, exploitation is the most unpretentious and disposable kind of pulp cinema.

So-called 'classical exploitation films' during the studio era in the United States can be more tightly defined, being a distinctive mode of sub-B movie production of independently made and distributed films on lurid themes banned by the Production Code. 'See! See! See!' movies like *Reefer Madness* (1936), *Child Bride* (1938) and *Mom and Dad* (1947) were a tabloid mixture of voyeurism, mock-exposé and self-righteousness. Their salacious moralism was defined by the 'square up', a title crawl at the start of the film that announced the producers' educational purpose in order to appease censors and legitimate the audience's curiosity; this pretence at moral purpose would remain one of the distinctive aspects of exploitation.

Classical exploitation's crudity and emphasis on spectacle over narrative coherence distanced it from the products of classical Hollywood style. As Eric Schaefer has remarked, classical exploitation was more like an alternative mode of film production, with remarkable moments padded out by long passages of exposition, than simply the 'bad' film-making it has come to represent:

> The classical exploitation films made between 1920 and 1950 had a unique style that set them apart from movies produced by the major production companies such as MGM and Universal and even those of many of the minor companies such as Republic and Monogram …. We can chuckle at the incompetence of classical exploitation films, but it is important to understand these 'problems' as the product of a specific mode of production.[7]

Classical exploitation waned in the 1950s and 'exploitation film' became an all-purpose label for cheap sensational movies that were intensively promoted, distributed to a sectionalised market, and produced in cycles: 'the wise movie maker', as Thomas Doherty remarks, '"exploited" what he knew about an audience by catering to its desires and meeting its expectations'.[8] Crucially, exploitation also ripped off other films, both mainstream and low budget.[9] Imitation to the point of plagiarism, playing variations on not only a generic theme but a specific commercially successful film, is still crucial to exploitation's strategies of copying, passing off and churning out unofficial remakes and sequels. Given cinema's tendency to repetition, imitation, remakes and 'sequelitis', it is often difficult to disentangle exploitation, except by its substandard budget, from the usual methods of cashing in on box-office hits.

The exploitation film itself was less important than its posters, adverts and sensational publicity campaign. This approach was typified by Hammer, pre-eminent among British exploitation studios. In the TV documentary *The Studio That Dripped Blood* (1987) James Carreras, Hammer's managing director, explained how Hammer would first approach distributors with a suitably commercial title and poster – his example is *To Love a Vampire* – before deciding to write a screenplay that exploited the concept.[10] Crucially, however – and necessarily, given the restrictions enforced by budgets and censors – exploitation *never* really delivered. It was all tease, especially in censor-infested Britain. As Antony Balch, a master of exploitation, said:

> From an economic point of view, censorship is very good. As long as you never deliver the goods, you'll always get people to pay up in the hope that one day you will. Actually that's the most immoral thing about it.[11]

Exploitation made a virtue of pulling a fast one on the audience, something that more legitimate kinds of cinema might shy away from for fear of bad reviews and word of mouth. With exploitation none of this really mattered. The films were scarcely ever reviewed seriously outside the trade papers and word of mouth counted for less at a time when cinemagoing was a regular habit rather than an expensive special event. Getting the audience into the cinema was all that mattered, as Jim Hillier notes:

The term 'exploitation' differentiates a certain kind of overly exploitative product from the supposedly non-exploitative product of the majors, and implies that movies thus labelled take advantage of their audiences, for example by promising more than they deliver – in effect by cheating.[12]

Although much of the discourse around exploitation as a mode of trash cinema extols its transgressiveness, freedom from good taste and unique visual excitements, it should be remembered that disappointment as well as rapture, detumescence as well as arousal, was the real-life experience of seeing exploitation films. This is why pornography is an interesting limit case. Softcore porn clearly falls within the definitions of exploitation because it doesn't go 'all the way'; it sells 'the sizzle, not the steak'. But hardcore keeps its promise to deliver the full monty. The customer can hope to be fulfilled and satiated by the film, not left aggrieved and frustrated at being ripped off.

In the US the key market for exploitation films in the 1950s was the teenage one and double bills of cheap 'teen movies' catered to this growing suburban audience with its own culture and interests. Producers such as Roger Corman, Sam Katzman, Herman Cohen and William Castle tracked the convolutions of teenage life in gimmicky trash from *I Was a Teenage Werewolf* (1957) and the 'clean-teen' beach-party movies of the early 1960s to hard-edged reports on the counterculture such as Corman's *The Wild Angels* (1966) and *The Trip* (1967). In Britain, however, there was no equivalent to classical exploitation and 'X'-rated films, aimed more at adults than teenagers, were tightly controlled. Unlike in the United States, films could not easily be screened without the approval of what was then called the British Board of Film Censors. There was, for example, no possibility of replicating American classical exploitation's tradition of 'four walling' (renting cinemas for one-off screenings of films made outside the Production Code), though films banned by the BBFC could be shown with the consent of local councils and in the context of a cinema club. Certain aspects of exploitation were certainly carried over from the US, such as narratives imbued with censor-appeasing moralism and an emphasis on gimmicks and showmanship.[13] But the history of British exploitation only makes sense within the context of British film censorship, which till recently was the most stringent in Europe. The limits of censorship defined the form and content of British exploitation: sex films were constrained to disguise themselves as documentaries on social problems, while in horror films a comforting framework of good versus evil offset any dwelling on blood and transgression. Censors banned the spectacle of sex and violence for their own sake.

Exploitation in Britain was certainly not wholly outside the mainstream or at any rate not for long, and it is misleading to call it an outlaw cinema. The key producers, such as Carreras, Michael Klinger and Tony Tenser, and directors such as Terence Fisher and Pete Walker were commercially minded professionals rather than wild-eyed visionaries, and personal expression was mostly subordinated to turning a fast buck. In the 1970s exploitation and especially sexploitation became a lifeline for British film production when American finance dried up, and journeymen like Val Guest, who only a few years before was engaged on high-budget extravaganzas like *Casino Royale* (1967), put their names to sex comedies such as *Au Pair Girls* (1972) and *Confessions of a Window Cleaner*.

Womaneater

A perfect example of early British exploitation is the SF-horror film *Womaneater* [US title: *The Woman Eater*].

Made at Twickenham Studios in 1957, directed by Charles Saunders and produced by Guido Coen, *Womaneater* could be described as a B movie designed for the bottom half of a double bill, but the fact that it revolves around opportunities for voyeurism marks it out as exploitation. Like *Cat Girl*, it had no pretensions to art or indeed to be watched more than once: it was made cheaply for the overseas market, imitated American exploitation tropes (its plot anticipates Corman's *The Little Shop of Horrors*), and is so constructed as to multiply the possibilities for bizarre spectacle. It feels more like American exploitation than almost any other British film of the period, despite its location shooting in central London; early exploitation generally pastiched American models of horror, which were the only established contemporary ones till Hammer established its brand.

Womaneater is about a mad scientist, Dr James Moran (George Coulouris), who, with his 'family taint', is a winning compendium of mad-scientist characteristics, from his foreign accent to his laboratory with its bubbling test tubes and 'pulsometer'. Moran ventures into an Amazon jungle – constructed of ill-sorted stock footage – in search of the 'great ju-ju', a sacred tree whose sap brings about immortality and which for no explicable reason requires the sacrifice of beautiful young women. The natives, though said to be descended from the Incas, appear to be Afro-Caribbean and their rituals resemble voodoo rather than anything remotely Amazonian.

Moran returns to London with the woman-eating plant – no explanation is given for how he manages to import it – and accompanied for some reason by Tanga (Jimmy Vaughn), a native who worships the tree and calls Moran 'Master'. The plant is kept behind a locked iron door in the basement laboratory, which Tanga, Moran's 'primitive' doppelganger, appears never to leave. The laboratory is Moran's private fantasy world, a Bluebeard's castle in which he acts out sadistic desires in the guise of scientific experimentation. 'I believe you're doing something wicked behind that iron door that I mustn't go through', his housekeeper tells him; 'I dream of it. What does it lead to?' Moran brings young women to his laboratory, where they are hypnotised and, under Tanga's ecstatic gaze, led into the tree's waving furry arms, an effect produced by a man standing behind the tree and pulling on strings.

Given its barmy plot, you might think *Womaneater* scarcely worth the effort of interpretation, and in some ways you'd be right. Much fan writing about trash is closely focused on interviews, production anecdotes and comparative judgments about the films' relative interest and value; pretentious flights of interpretative fancy are strictly optional. You shouldn't discount, however, the importance and prestige that some cultists may attach to 'deep' readings of their favourite movies, readings that go 'beyond all reason' in winkling out the hidden meanings of the smallest textual detail. Interpretation and especially *over*-interpretation are crucial ways in which cultists further their loving engagement with a film, both for the private pleasure of exerting mastery over the text and – in the right agonistic context – for the public reward of displaying superior cultural capital. This is certainly true – in my experience anyway – of some aca-fans, who, keen to distinguish their own cult practices from amateurs', resort to flashy knock-down

The American one-sheet exploiting the attractions of *The Woman Eater* (GB title: *Womaneater*)

references to the theories and (naturally, cult) theorists *du jour*. This doesn't discredit 'academic' readings of the films (after all, I earn my living by them); but it does draw attention to the fact that horror, like all trash genres, is a contested field and that what people *do* with the films is determined by cultural and educational capital as much as by any objective insight into what *should* be done with them or by what the films are *really* about. That is perhaps the key theme of this book: how the uses of trash films (researching, valuing, loving, interpreting and so on) vary pragmatically according to contingencies of age, gender, class, race and above all cultural capital. In a non-trivial sense, these very real and very human contexts, which are as much about emotional investment in films — in other words, caring about them — as about the discovery of true facts and appropriate interpretations, are what drive not only cult fascination with trash but also the desire to appropriate it through powerful acts of redescription and gestures of ownership. As Jeffrey Sconce puts it with reference to evaluation,

> to champion (but not necessarily enjoy) a particular film or cinema in opposition to another has less to do with any objective criteria for cinematic worth than with the social position and cultural status of the cinephile that chooses to weigh in on this question.[14]

One of the attractions of trash cinema is that it may be read as unwittingly blurting out what more aesthetically controlled films are able to repress. *Womaneater* yields easily,

for instance, to the most rudimentary feminist analysis as a film *about* the spectacle and exploitation of women. The heroine, Sally (Vera Day), is first seen as a fake South Sea Island Belle at a fun fair, which highlights not only the Orientalist phoniness of the film's representation of the primitive but also its single-minded interest in serving up women to be looked at by male audiences. Sally's character alters from scene to scene with no regard for psychological consistency. One moment she is a sideshow dancer in a hula-hula skirt and the next a prim housekeeper in a high-necked sweater, which reflects, as Vera Day recalls, the limited roles in which women were corralled – 'either glamour girls or gangster's moll or homely wife'.[15] Moran, like the spectators at the funfair, masks voyeurism as pseudo-scientific anthropological curiosity. Men identify themselves with science and rationality. 'I hate mechanically minded women', Sally's boyfriend Jack (Peter Wayn) says, while Moran claims that 'as a scientist I am more interested in things with six legs rather than two, but doubtless I am in a minority'. But the tree's furry embrace betrays Moran's disavowed murderous rage at women's independence – 'I have never trusted you or any other woman', he tells his housekeeper – and indeed he seems much more secure locked in his basement in a homosocial conspiracy with Tanga. Throughout the film women are devoured by the male gaze (Jack, the male love interest, is fixated by Day's jutting breasts), so that 'womaneating' becomes a general figure for men's compulsion to trap and smother their objects of desire. Women are there merely to be looked at, used and discarded, as when Moran overthrows his jealous middle-aged housekeeper in favour of Sally. In a nicely self-reflexive turn, the theme of the male gaze is extended to the role of women in films too. In one sequence, filmed with snatched footage in London's theatre district, Moran stalks and pick up a girl, who, asking him if he is a talent-spotter for the movies, sighs that 'All men are talent-spotters one way or another.'

Bill Warren described *Womaneater* as 'an old-fashioned, uninteresting disaster' and 'one of the most misogynist movies I've seen ... almost everything in the film indicates if not a hatred of women, at least a totally uncaring attitude'.[16] For all its tantalising self-reflexivity, *Womaneater* can be read as a fantasy of white male control over not only women but also natives, nature, science and magic. In the end the fantasy is undone by Tanga, who tricks Moran by not fully revealing the tree's secret of eternal life: when Moran uses Tanga's magic to bring his murdered housekeeper back to life, she returns as a mindless zombie and tries to strangle Sally. Little imagination is required to read the film as an allegory – a cultish mode of interpretation I'll resort to throughout this book – of white men's waning control, post-war and post-Suez, over women and empire.

Womaneater's lecherous ambivalence about women's power and sexuality is apparent too in *Cat Girl* and another early exploitation film, *The Snakewoman* (1961), which was directed by Sidney J. Furie. Set on the Northumbrian moors in the 1890s, *The Snakewoman* anticipates Hammer's *The Gorgon* (1964) and *The Reptile* (1966) in its themes of female transformation and 'irrationality'. When a doctor injects his mentally unstable pregnant wife with cobra venom, the magical serum turns the baby into a 'serpent child'. The plot follows a detective sent from London twenty years later to investigate an outbreak of deaths in the area from snake bites. Like *Womaneater*, the film is cheap and flatly shot, with inexpressive camerawork and repetitive set-ups. The narrative consists mostly of dialogue-heavy padding around the few striking moments when

we see the young snakewoman herself. As in *Womaneater* and *Cat Girl*, men are associated with rationality and contemporary scientific logic (in modern London, where he feels much more at home, the detective says, 'things are exactly as they seem'), and women are irredeemably Other. None of the three main female characters is 'normal': one, the snakewoman's mother, is mad (and then dead), one a crazy witch and one the snakewoman herself. Women inhabit a treacherous and magical world – the 'monstrous feminine' – beyond men's powers of investigation and understanding.[17]

Easy to mock, these films epitomise low-grade exploitation horror at the end of the 1950s, in a production context of 'one take and that's it', in Vera Day's words, and actors taking it all with 'a pinch of salt'.[18] Nevertheless, *Womaneater* acquired an unexpected cult cachet for the irresistible readability of its subtexts, by cultists who found it eminently suited their emotional needs. Vera Day, who is 'totally amazed at its following' recalls that fifteen or twenty years ago she met a group of fans in Los Angeles 'who would all meet up on a monthly basis and talk about it in a cellar in a very serious way, as if it were an amazingly intellectual feast'.[19]

HAMMER AND AMICUS

Horror, the exploitation genre that has benefited most from revisionism, is no longer seen as marginal to British cinema but as an abidingly sardonic, political and unrespectable expression of the struggle between eroticism and repression in the national culture.

It is an oft told tale, how British horror cinema took off in the 1950s and achieved international prominence with Hammer's novel style of Eastmancolor period Gothic. David Pirie argued – and, forty years later, this is probably still the most quoted statement about British horror – that the Gothic was 'the only staple cinematic myth which Britain can properly claim as its own'.[20] Certainly many of the early horror films, such as Hammer's, trace their origins back to British (and Irish) texts and traditions – indeed the Universal horror films had British input, such as directors and actors – and even fit within established kinds of British film style (costume melodrama, literary adaptation). Remaking American films, such as *Frankenstein* (1931) and *Dracula* (1931), was a species of repatriation, but the films cannot simply be read as authentically tapping into some exclusively British reservoir of myth. The small-scale exploitation producers who made horror films in the 1950s and 1960s had US markets in mind and were often funded by American money: Hammer's Carreras 'made most of his profits via canny international distribution deals, which he used to foster films which redefined existing boundaries of sexuality and taste'.[21] British science fiction films, which we'll look at in the next chapter, were no less indebted to foreign influence. A number, such as *First Man into Space* (1959), not only had American stars but were what Pirie called 'pseudo-American' films, which disguised their Britishness for the sake of international marketability.[22]

Discussions of the boundaries of national cinema are often fruitless, but it is important to emphasise the international frameworks of production, distribution and trading of ideas that gave rise to British genre films. Hammer and its chief rival in horror production, Amicus, were backed by American investment, and, while Hammer Gothic is often seen as characteristically 'British', the American influence introduced some of the more interesting as well as sleazy and contemporary notes. Herman Cohen, for example,

who made *I Was a Teenage Werewolf* for American International Pictures, produced a number of distinctive films in Britain, such as the brilliantly unpleasant *The Horrors of the Black Museum*; the bizarre *King Kong* (1933) rip-off, *Konga* (1961); and the despised but arresting *Trog* (1970), in which Joan Crawford finds an apeman in a cave. In many ways Gothic was a cul-de-sac, as Hammer recognised early on when the success of *Psycho* inspired it to a series of contemporary-set psycho-thrillers that began with *Taste for Fear* [US title: *Scream of Fear*] (1961), an especially successful film-with-a-twist, *Maniac* (1963) and *Fanatic* (1965), and continued into the 1970s with the 'women-in-peril' dramas *Straight on till Morning* (1972) and *Fear in the Night* (1972).

There is nothing especially British, in the sense of closed-off and purified of foreign influence, about much of British horror, even though the films resonate with the cultural tensions of post-war transition to consumerism and 'permissiveness'. In fact, I'd argue that many of the best British horror films, in which those tensions were mostly sharply defined, were the ones that combined classic 'British' Gothic with trashy 'foreign' sex and violence and experimented with generic mixing and camp self-parody.

Any discussion of British horror must begin, I guess, with Hammer. Here, for the sake of concision and because of those staggeringly complete treatments elsewhere, I'll stick mostly with their vampire movies.[23]

Hammer was set up in 1934 by William Hinds (his stage name had been Will Hammer) and produced five films between 1935 and 1937 before going bankrupt in 1937. Hammer was reactivated in 1947 as the production arm of Exclusive Films, founded by Enrique Carreras and William Hinds in 1935, with Enrique's son, James, as managing director. Hammer began by making quota quickies, radio and TV adaptations and crime B movies; adaptations as well as remakes, sequels and cycles would always remain central to their commercial strategy. The studio moved into horror production with *The Quatermass Xperiment* [*The Creeping Unknown*], adapted from Nigel Kneale's 1953 BBC serial, and *The Curse of Frankenstein*, whose impact, according to Michael Carreras, 'stemmed from *Quatermass* – remember how the monster in that, even when it was in Westminster Abbey at the end, had a kind of humanity that you could identify with. That suggested to us the Frankenstein monster idea.'[24] It was the horror rather than the SF elements of *Quatermass* that caught the public imagination.[25]

The Curse of Frankenstein and *Dracula* are masterpieces of economical adaptation by Jimmy Sangster, Hammer's key screenwriter, which take only what they need from the original novels and are careful not to imitate the Universal films too closely. They led to the celebrated run of historically set Gothic horrors, which ended with *To the Devil – A Daughter* (1976), an adaptation of Dennis Wheatley's novel in the style of *The Exorcist* (1973). The Gothic films were essentially collaborative efforts and set design and music were equally important in establishing Hammer's reputation for lushness on a budget. Hammer horror's brash Eastmancolor, sadism, knowingness about its erotic implications and consistent stylishness made for winning combinations of unpretentious thrills and intelligent subtexts.

Critics initially reviled the films for their gore, explicit sexuality and 'unBritish' extremism, all taken to be signs of post-war social decay and insidious American influence. *Dracula* and its sequels tell a vivid and romantic story about British repression and sadistic sexuality. Emerging in a period of Cold War tension and moral panic about

youth, the films offered a decadent, pop-Freudian interpretation of the vampire as dangerous, gentlemanly and sexually voracious. With their coherence of setting, secured by repeated use of the same sets and locations, the films have a consistency of moral perspective that Pirie ascribed to Fisher's clear-cut, fairy-tale separation of good and evil.[26] Fisher's key contribution is often taken to be the contrast between the films' Manichean framework and their celebration of the seductive pleasures of sex and evil, though Sangster has equal claims to authorship given how closely Fisher adapted his screenplays. In the universe of early Hammer horror, good is firmly associated with bourgeois values and restrained sexuality and evil with flamboyant eroticism and violations of order and good taste: 'The values of the films', as Vincent Porter says, 'are those of the Victorian bourgeois.'[27] Peter Hutchings, in *Hammer and Beyond*, the first important critical book on Hammer after Pirie's, argued that Fisher articulated a conservative middle-class attempt to bolster patriarchal authority at a period of 'widespread masculine ineffectuality'.[28] The male leads are often young and easily controlled by evil patriarchs such as Christopher Lee's highly attractive Dracula and Charles Gray's pompously authoritative Mocata in *The Devil Rides Out* (1968). Van Helsing, invariably played by Peter Cushing, represents Hammer's commitment to modern professional values, which struggles against the decadence of the aristocracy as well as the superstitious cluelessness of the working class. The struggle is usually over women. One patriarch, Dracula, evil and antisocial, greedily claims all the women and unleashes their repressed sexuality; while the other, Van Helsing, a modern and professional father figure, defends the bourgeois family and the erotic status quo.

The bold simplicity of Fisher's films, with their grand metaphysical struggles and confident nostalgia for Victorian certainties, lends them enormous aesthetic appeal. But their strict demarcation of good and evil was merely the formal conceit of an ageing and conservative genre and proved inadequate to changing sexual and ideological trends. While in Stoker's novel Van Helsing embodied the spirit of the modern age, by the 1960s it was Dracula who seemed the more contemporary figure – an amoral James Bond-like rebel against sexual orthodoxy, whose seductions liberated rather than despoiled his victims. The Frankenstein and Dracula films became increasingly repetitive by the end of the 1960s, though more adventurous in playing with conventions; according to Wheeler Winston Dixon, '1965 is possibly the last year in which Hammer's strength as a gothic studio dominated both the genre and the industry'.[29] Some of Hammer's other horror films are more strikingly original and even subversive. *The Mummy* (1959) echoes, like *Womaneater*, fears of imperial decline (its theme of Egyptian revenge carries unavoidable post-Suez resonances), while the underrated *The Gorgon*, which Fisher described as a fairy-tale rather than a horror film, gives powerful expression to one of Hammer's key themes of the 1960s – a fascination with archetypal women, a theme elaborated in *She* (1965) and *One Million Years B.C.*[30] The studio's finest horror film was perhaps Fisher's *The Devil Rides Out*, adapted from Wheatley's novel by Richard Matheson. The battle of good and evil is given serious weight and has an epic feel; the villain, Mocata, is as suave as Christopher Lee's Duc De Richleau; and the seductions of satanism are sufficiently emphasised. Apart from some substandard special effects, the film is as distant from trash as possible; and it is Hammer's last truly confident expression of its reactionary ideology.

Hammer's approach was strikingly different from that of the other cult British horror studio, Amicus. The latter was best known for its so-called portmanteau or anthology films. *Dr Terror's House of Horrors* (1965), along with *Torture Garden* (1967), *The House That Dripped Blood* (1970), *Asylum* (1972), *Tales from the Crypt* (1972), *Vault of Horror* (1973) and *From beyond the Grave* (1973), all involved four or five short storylines within a framing narrative, usually presided over by a supernatural character.

Amicus was founded by the American producers, Milton Subotsky and Max Rosenberg, who had worked together in US television in the 1950s (*Dr Terror* was in fact based on US TV scripts written by Subotsky as early as 1948) and subsequently on some low-budget American films. Relocating to Britain to take advantage of the Eady Levy, they based Amicus at Shepperton Studios. Amicus's first films were youth musicals such as 1962's *It's Trad, Dad!* but the studio hit its stride with fourteen horror films from 1965–74, which included not only portmanteau films (which Subotsky favoured because 'they don't bore the audience') but single-plot narratives such as *The Skull* (1965), *The Deadly Bees* (1966), *The Psychopath* (1966) and *I, Monster* (1971).[31]

Unlike Hammer, whose films under Fisher's direction were suffused with a sense of romance and moral grandeur, Amicus offered quirkier, lightly subversive and smaller-scale pleasures. Camp and tongue-in-cheek, the stories often ended with a smart anecdotal reversal like a well-timed joke – in *The House That Dripped Blood*, for instance, Jon Pertwee plays an actor who gets a vampire cloak that turns him into a vampire – and could be taken as anecdotal leg-pulls reminiscent of TV series like *The Twilight Zone* (1959–64) and the later *Tales of the Unexpected* (1979–88) or the cautionary urban legends that would inspire the slasher film. Nothing is taken very seriously and much fun is had with the contrast between Gothic convention and the mundanity of contemporary suburban settings. In *The Vault of Horror*, for example, Terry-Thomas's wife, driven mad by his demand for domestic order, kills him and shelves his minutely dismembered and butchered corpse in neatly labelled jars, including one, 'odds and sods', that appears to contain his de-bagged testicles. Whereas Hammer stayed vaguely within a Christian framework, *The Vault of Horror*, in which five men recount dreams in which their evil acts rebound on them, strays indifferently into a remarkable variety of irrational frameworks from voodoo to vampirism (Daniel Massey ends up as a blood-dispenser for dining vampires) and Indian mysticism (Curt Jürgens is strangled by an Indian rope trick he stole from a fakir). The studio's campness, derived from horror comics rather than the Gothic tradition, would continue in the trend in the 1970s for pastiche horror films such as *The Abominable Dr Phibes* (1971) and *Theatre of Blood* (1973).

Hutchings focuses on Amicus's 'Americanness' as the source of its difference from Hammer. Although the films were usually set in Britain and featured British stars, Amicus was dependent on American material such as EC comics and stories by Robert Bloch, who had written the novel *Psycho*. As Hutchings puts it, 'Too American to be properly British and too British to pass for American, Amicus hovers uneasily between the two national cinemas.'[32] In contrast to Hammer's moralism, Amicus focuses on 'the contingency and arbitrariness of everyday life' and 'offered a different [American?] view – cynical, sardonic, cruel, modern'.[33] In films like *Dr Terror*, Amicus produced little morality tales about everyday cruelties (snobbery, rudeness, smugness) that are punished so excessively as to ridicule any sense of a rational universe. With this more

worldly tone, Amicus, more so perhaps than Hammer, was in tune with the shift from 'cosy' to 'paranoid' horror in the 1960s – from the reassuring monsters of the supernatural to the random and fundamentally meaningless terrors of modern everyday life.

PERMISSIVE HORRORS

The late 1960s saw a wave of horror films such as *Witchfinder General*, which blurred art and exploitation and engaged with the counterculture. Critics and cultists have not been slow to highlight possible allegorical interpretations of these horror films in relation to social divisions of the period, and it has become a cliché that horror and science fiction films of the 1960s and 1970s were about generational conflict.[34]

British horror films on the whole sympathised with the young and demonised the Establishment. In *The Sorcerers* (1967) – in which Boris Karloff builds a machine that enables him and his wife to experience the lives of young people – *Witchfinder General*, *Cry of the Banshee* (1970) and *Demons of the Mind* (1972), the older generation is depicted as jealous, repressive and dangerous to the young and beautiful. The theme is at its most explicit in *Incense for the Damned* (1970), which is set in an Oxford college and ends with a speech to assembled students and dons by a young man (Patrick Mower) infected by vampirism. It is clear that the true vampires are the Establishment academics:

> Let us beware of those who seek to possess our bodies and our minds. For the academic world dehumanises us and we become its dependent. 'Love me', says the academic, 'and do exactly as I tell you.' In this protection racket of the Establishment, the outsiders are labelled 'Them', the collective enemy – the Reds, the blacks, the whites, the yellow peril. We are brainwashed into the same hatreds of the same threats. Over the years we have become captive. And so in brotherhood we plunge to our own destruction. But the gods ... the gods have given us freedom, my friends. Do not be trapped by the petty schemes of academic hirelings, the thieves who come to take your souls. Sitting among you now, smooth deceivers in scarlet gowns, preparing as soon as they rise from this table to leech on to you!

Some other films, however, such as *Blood on Satan's Claw* (1971) – about a Manson-like gang of devil-worshipping children in the seventeenth century – depict the young as corrupted and irresponsible and the adults as stuck in extended childhood. *Baby Love* (1968), *Twisted Nerve* (1968), *Mumsy, Nanny, Sonny and Girly* and *Straight on till Morning* suggest that the 1960s generation has reverted to a fantasy world of infantile pseudo-innocence, rejecting not so much society as socialisation itself.[35] This generational theme, with the young represented as little monsters, continues right through British horror up to the contemporary cycle of 'chav horror' or hoodie horror films such as *Eden Lake* (2008) and *Summer Scars* (2007), and *Harry Brown* (2009), *F* (2010) and *The Children* (2008), in which kids mysteriously start killing their parents; these reactionary films articulate fears of feral youth torn from the pages of the *Daily Mail*.[36]

Mumsy, Nanny, Sonny and Girly sums up some of the themes of British horror at the turn of the 1960s and 1970s. It is a strange black comedy, based on a play by Maisie Mosco and directed by the great cameraman Freddie Francis, for whom it seems to have

been a personal project. Filmed at Oakley Court, the site of many Hammer films, it is an explicitly allegorical treatment of social collapse at the end of the 1960s, though its precise politics are actually quite difficult to pin down.

The film is set in a large house in which the titular upper middle-class characters, in the absence of a controlling patriarch, are in a state of both infantilisation (the teenage children act as if they were still of nursery age) and historical regression. Keeping up the pretence of being a 'happy family', the children bring home 'new friends', young men whom they play with and then kill. One 'New Friend' (Michael Bryant) manipulates the situation and upsets the balance of the household by sleeping with both Mumsy and Girly. A comic parody of the Oedipal tensions within a dysfunctional family, the film seems to be about the challenge to a decadent upper class, stuck in Victorianism, from a free-floating new class of opportunistic and sexually liberated chancers. (Although New Friend seems to be wealthy rather than working class, *Mumsy* can easily be seen as a variation on the class-switch scenario of *The Servant* (1963); there are echoes too of *Performance* and Pasolini's *Theorem* (1968)). Memorable for its fairy-tale atmosphere, the film is a playful microcosm of a crumbling Britain dominated by a crazy upper class: a persistent theme in British film, from *The Ruling Class* (1972) and *Blue Blood* (1973) to *Sir Henry at Rawlinson End* (1980). Fundamentally, though, *Mumsy* comes across as a conservative film about the breakdown of rules at the end of the 1960s and the chaos that ensues when patriarchy is absent or challenged and sexual boundaries are transgressed; as Mumsy says at the end of the film, 'But you must have rules. A happy family needs rules. Now the rules count for so little I don't know what will happen to any of us.'

At least that's what I *think* the film may be about. Unlike, say, *The Devil Rides Out*, which neatly expresses the Manicheism Pirie ascribes to Fisher's best films, *Mumsy* is altogether messier and unhinged. I don't mean that it is mad, though the film is certainly peculiar and the authors seem not fully in control of the material; I mean that it is 'unhinged' in the way Eco famously uses the word in his foundational piece on cult films:

> Only an unhinged movie survives as a disconnected series of images, of peaks, of visual icebergs. It should display not one central idea but many. It should not reveal a coherent philosophy of composition. It must live on, and because of, its glorious ricketiness.[37]

That is why, much as I admire *The Devil Rides Out*, I find myself returning over and over to rickety trash such as *Mumsy* and *Womaneater* and the other horror films plucked out for analysis in this chapter. One fine morning, I tell myself, if I gaze at these flimsy jerry-built constructions long enough, I'll eventually figure out what the hell they really mean, if anything at all. Hence the appeal of allegory, I suspect, which freezes an otherwise unyielding and incoherent text into an oversimplified, but at least *usable*, configuration of symbolic meaning.

By the end of the 1960s Hammer had conceded what Robin Wood called the 'obsolescence' of the traditional vampire and began to satirise it in revisionist films by younger directors like Peter Sasdy's *Taste the Blood of Dracula* (1969) or sex it up with lesbianism in *The Vampire Lovers* (1970).[38] *Taste the Blood* inverted the genre's conventional moral

Taste the Blood of England

Playing happy families with New Friend in *Mumsy, Nanny, Sonny and Girly*

BRITISH TRASH CINEMA

Ingrid Pitt and Kate O'Mara in Hammer's *The Vampire Lovers*

scheme and elicited sympathy for young vampires slaughtering their hypocritical Edwardian fathers; while in *Twins of Evil* (1971) patriarchal authority is represented, on the one hand, by insanely repressive Puritan witch hunters and, on the other, by a decadent vampire count. Despite their occasional formal experimentation, most of the other later vampire films still worked within the conservative moral framework of traditional Gothic. Lesbianism, for instance, though enthusiastically exploited in *The Vampire Lovers*, retained Hammer's usual associations of transgressive sexuality – wickedness, contagion and offensiveness to British moral standards.

Hammer transported Dracula into the dying days of Swinging London in *Dracula AD 1972* (1972) and *The Satanic Rites of Dracula* (1974), where Dracula seems well attuned to youth rebelliousness and Van Helsing an out-of-date symbol of the older generation. *The Satanic Rites of Dracula* (US title: *Count Dracula and His Vampire Bride*) is a quasi-SF film in which Lee's Dracula, who turns up late on in the film, plots to destroy the world by spreading the plague. In a curiously Marxist twist, he is a property developer, an aristocrat turned bourgeois capitalist, and the film strikes a new note of 1970s paranoia in its suspicion of bureaucracy and blood-sucking corporations. The Dracula of these films was a monosyllabic red-eyed beast, far removed from the tragic 'English aristocracy of Christopher Lee's Dracula', which, as David Thomson remarks, was Hammer's most original contribution to the vampire subgenre.[39] Weary of travestying his greatest role, Christopher Lee left the series after *The Satanic Rites*. Hammer ploughed on with vampire films and with *The Legend of the 7 Golden Vampires* (1974) came up with one of its most unlikely offerings, a fusion of Gothic horror with elements of Hong Kong cinema, newly fashionable in the West with the success of Bruce Lee's *Enter the Dragon* (1973). Casting around for new sources of finance and inspiration, Hammer had made a deal with Run Run Shaw of Hong Kong's Shaw Brothers company to make two films on location in Hong Kong: *The Legend of the 7 Golden Vampires* and *Shatter* (1974). Don Houghton's script was directed by a sceptical Roy Ward Baker ('It was a good idea, not that I had any real taste for it and I didn't really want to do it but I did it')[40] but, for the sake of authenticity, the martial-arts scenes were choreographed by Chang Cheh, one of the Shaw Brothers' Chinese directors. Commercially, *Legend* was a great success and did 'fantastic business' in Britain and the Far East.[41]

The later Hammer horror films have come in for a rough ride from critics and fans, who generally prefer the seriousness of the earlier 'classic' Dracula and Frankenstein films to the pastiche of *Legend*, the sexploitation and female vampire frolics of the 'Karnstein trilogy' and the black comedy of *The Horror of Frankenstein* (1970). For many Hammerphiles these films' tendencies towards camp and sexploitation are merely signs of exhaustion, inauthenticity and a slide into bad taste. James Rose, for instance, takes offence at the decapitation of a woman at the start of Roy Ward Baker's *The Vampire Lovers*:

> This brief but violent death draws together three potent images – the crucifix, breasts and decapitation – into one powerful sequence that is simultaneously seductive, erotic and ugly. Baker coherently encapsulates Hammer's new approach to horror and by doing so marked the beginning of the studio's steady decline into exploitation territory.[42]

In a telling use of 'perverted', Rose says that *The Vampire Lovers* 'retains much of the studio's established traditions that have been perverted by the relaxations within the censorship system'.[43] It seems odd to attack Hammer, which was after all an exploitation studio, for grasping at new opportunities for exploitation in an attempt to move pragmatically with the times. The retrospective conferral of classic status on the earlier films risks uncoupling them from Hammer's wholly commercial motives for investing in exploitation horror in the first place. It is true that, trapped within Gothic conventions, late Hammer lacks some of the energy and innovation of *Witchfinder General*, *Blood on Satan's Claw* or *Death Line* (1972), which features a sympathetic cannibal picking off commuters on the London Underground. But critical investment in serious Gothic and in Fisher's authorship have detracted from the achievements of such lively, camp and experimental films as *Legend*, a genre mash-up years ahead of its time, and the swashbuckling *Captain Kronos – Vampire Hunter* (1974). Their 'failings', notably their generic hybridity and irreverent jokiness, are precisely what make them perfect – and rickety enough – for cult reappraisal; for, as Justin Smith remarks, 'Generic instability ... marks the entry of the kitsch and the camp into cult film sensibilities.'[44]

The 'classiness' of Hammer's style of exploitation in the 1960s made it distinctive in the market, but in the end it left the studio trailing behind more aggressive and financially viable players of the same game. The 'trashiness' of the later films should not be seen as a betrayal but as the result of Hammer trying, without enough success in the end, to extend the life of its brand by imitating, adapting and outdoing its competitors. By the early 1970s, however, the studio's most successful productions were TV sitcom spin-offs such as *On the Buses* and *Love Thy Neighbour* (1973) and the British Gothic horror film would not be revived again for nearly forty years.

4 *MOON ZERO TWO* AND OTHER UNEARTHLY STRANGERS

Many of the horror films we discussed in the last chapter could just as easily be described as science fiction. In fact most British science fiction overlaps with horror, which unlike SF would prove a reliable money-spinner for cash-poor British producers. SF has never entirely found a secure place in British film production, thanks to low budgets, competition from TV and the superior production values of US films.

Although Britain has produced a major body of SF films since the 1930s, few captured the box office or the public imagination in the same way as Hammer's Gothic films, or indeed the quirky absurdism of British SF TV or nostalgic British fantasy, like *Harry Potter* and *The Lord of the Rings* (2001–3). And those that did, such as *2001: A Space Odyssey* and *Alien* (1979), often didn't seem very 'British' at all. With few exceptions, the films that are now critical and cult darlings are attached to a significant auteur, such as *Things to Come* (1936), *2001* and *A Clockwork Orange*, *The Man Who Fell to Earth*, *The Damned* (1961) and the *Quatermass* films. Cultists too have generally preferred horror, and academic writing on the genre did not take off till the late 1990s.[1]

Although there is a serious realist tone to some British SF cinema, which is derived from TV and novels rather than the pulps which inspired the boom in American SF in the 1950s, most of the films have been cheap, often luridly titled trash exploitation such as *Stranger from Venus* (1954), *Fire Maidens of Outer Space*, *They Came from beyond Space* (1967), *The Sexplorer* (1975), *Outer Touch* [US: *Spaced Out*] (1979), *Xtro* (1982), *Lifeforce* (1985) and *Inseminoid* (1981). British SF unsurprisingly includes some of the most unforgettable British trash films, such as *Devil Girl from Mars*, and also some of the most obscure, such as *Toomorrow*. Little, however, has been written about them.

In this chapter, to restore the balance a little, I'll recap the history of British SF, linger over a few characteristic films with cult appeal, and offer an extended case study of a personal cult film, the very odd *Moon Zero Two* (1969), a 'space Western' and Hammer's last SF film, in order to summarise the pleasures and limitations of Britain's wayward contribution to the genre.

A BRIEF HISTORY OF BRITISH SF CINEMA

A few British silent films played in a vaguely science fictional way on fears of invasion and war in the sky, such as *The Airship Destroyer* (1909) and *The Aerial Anarchists* (1911). But the landmark of early British SF was *Things to Come*, H. G. Wells's retort to the Germanic gloom of *Metropolis* (1927). Wells's utopian vision of rule by scientific elites makes for stiff and talky drama, but the film is memorable for the stark white futurism of its set design and for spookily prophesying the Blitz in scenes of London under aerial bombardment.

It was not till the 1950s, when the genre took off in Hollywood, that British SF production began in earnest. Hammer contributed *Spaceways* (1953), the first British spaceflight movie, and *Four Sided Triangle* (1954), but it was *Quatermass*, in which a contaminated spaceman morphs into a giant fungus in Westminster Abbey, that established the direction that British SF films would subsequently take, and most subsequent films were thrilling hybrids of SF-horror.[2]

This first wave of SF saw some outstanding films – insular, small-scale, black-and-white scare stories about post-war threats to the British way of life. The best were *Quatermass 2* (US title: *Enemy from Space*) (1957), in which aliens take over the Establishment; the documentary-like *The Day the Earth Caught Fire* (1961), about the earth plummeting towards the sun; *Village of the Damned* (1960), whose happy ending, uniquely, requires the mass murder of schoolchildren; and Joseph Losey's *The Damned*, a bleak, masterly nuclear fable made for Hammer, whose theme of gang violence anticipated *A Clockwork Orange*. Though maltreated by Hammer, who regarded it as disposable trash and cut it by ten minutes, *The Damned* is one of the masterpieces of British SF, a film of stark and evocative symbolism about children deliberately irradiated in an experiment so that they might survive an impending atomic war, and a nation in which emotions are cauterised by the bomb. These films show British SF at its best. Sober, small scale, noirish and unsensational, they crackle with subversive ideas and uneasy subtexts about the changing British social landscape and the new realities of the nuclear age.

Although there were screen versions of science fiction novels, including *1984* (1956) and *The Day of the Triffids* (1963) (the most adapted British SF author was, in fact, Charles Eric Maine), a significant clutch of these films were adaptations of radio and TV hits, including *The Strange World of Planet X* (1957), *The Abominable Snowman* (1957) and *The Trollenberg Terror* (1958) and spin-offs such as *Dr Who and the Daleks* (1963), *Daleks: Invasion Earth 2150 AD* (1966) and two *Thunderbirds* films (1966, 1968). The heroic auteur of the period was Manx writer Nigel Kneale, who wrote the TV *Quatermass* serials and *The Abominable Snowman*. His 1958 TV *Quatermass and the Pit*, adapted by Hammer in 1967 (US title: *Five Million Miles to Earth*), is a superb *2001*-like story of alien interference in human evolution, whose pessimism and irony bracingly contrasts with the gung-ho tone of most American SF.

British SF films were mostly earthbound in the style of American paranoid horror such as *Invasion of the Body Snatchers* (1956) rather than colourful expansive fantasies like *Destination Moon* (1950) and *Forbidden Planet* (1956). Like most exploitation, they were often made with an eye on the American market. Because America dominated the SF genre, British SF films often drafted in American lead actors to encourage international distribution, and even masqueraded as American productions. Brian Donleavy headlined *The Quatermass Xperiment* and Forrest Tucker, *The Trollenberg Terror*, while *Stranger from Venus* (1954) was an unofficial remake of *The Day the Earth Stood Still* (1951) with the same star, Patricia Neal.

The Trollenberg Terror [US title: *The Crawling Eye*] sums up the ambitions of low-budget science fiction of the period. Adapted from a TV play by Jimmy Sangster, the film is about a cloud of radioactive gas on the side of a Swiss mountain, which harbours telepathic and literally bug-eyed aliens which resemble giant Cyclopean octopi. The film

throws together contemporary themes – shape-shifting killer blobs, alien possession and fear of the atomic bomb, symbolised by the radioactive cloud. A woman with psychic powers picks up the aliens' presence and she is also able to shield people from their influence. This link between women and aliens, insinuating that women were themselves rather alien, would be developed in a number of other SF films. On the other hand, as Mark Jancovich has argued in relation to American SF in the 1950s, the most alien quality of women in these films is their access to a world beyond 'male' reason and science, which is often depicted as dangerously cold and inhuman. Paradoxically the alienness of women makes them seem more human than the emotionally closed-off men.[3] The film ends with the aliens being bombed in a gung-ho display of victory from the air, a military solution recalling World War II and following the logic of the Cold War. Like much British SF, this unpretentious film combines rich subtexts and weird haunting visuals (the aliens are monsters worthy of Lovecraft) that belie its low budget.

Two plotlines predominate in 1950s and 1960s SF: alien invasion (by one alien or just a small group of aliens rather than a mass invasion) and urban disaster. This followed the example of H. G. Wells and John Wyndham and the 'cosy catastrophe', as Brian Aldiss called it.[4] *The Earth Dies Screaming* (1964), directed by Terence Fisher, is a typical example of British SF of the 1960s: a handful of cheaply costumed aliens invade a village and a cross-section of social types retreat to the pub and react with various degrees of stiff upper lip to these symbols of modernity and 'Otherness'.[5] One baffling aspect of the invasion films is why any self-respecting alien colonist should bother to invade post-war Britain at all. Invading Washington or New York made sense in American films like *The Day the Earth Stood Still*, but why launch the conquest of earth from Scottish pubs and sleepy villages? In fact, British SF tended to look anxiously backwards rather than prophesy the future. The recurring theme of invasion tapped directly into memories of the Blitz and the threat of Nazi conquest. Aliens – most famously the Daleks – tended to resemble Nazis rather than Communists. The model for the films seems to be Ealing's German-invasion film *Went the Day Well?* (1942). The scenario of waiting in a pub for the end of the world still turns up occasionally, as in *Shaun of the Dead* (2004).

Communism does not seem to be an underlying fear. Classic American SF films of the 1950s like *Invasion of the Body Snatchers* were paranoid about the Communist threat and subversion from within, but British SF was nervous about Britain's loss of prestige, power and influence after the war and the humiliation of Suez in 1956. *The Day the Earth Caught Fire*, for example, looked back to the war as a time of purpose and resistance and asks whether the Blitz spirit – the pluck and resolve Londoners showed during bombing – could survive the new realities of the nuclear age.[6] The enemy was the bureaucratic Establishment of the emerging Welfare State (as in *Quatermass 2*); dangerous youth (like the super-intelligent Aryans in *Village of the Damned* and its sequel, *Children of the Damned* (1963)); and those aliens closest to home, housewives and career women.

If one had to choose one film to represent British trash cinema of the 1950s and 1960s, it would be cult favourite *Devil Girl from Mars*. An adaptation of a play, it is a deliciously camp tale of an interplanetary dominatrix on the prowl in rural Scotland. Nyah (Patricia Laffan) is sent to earth from Mars, a matriarchal planet which, despite

being an advanced civilisation, is dying out for want of men. Nyah plans to capture a breeding stock, but she lands, bathetically, in the Scottish highlands by mistake. A random assortment of guests at a pub foils her plans and she, her robot, Chani, and her flying saucer are destroyed. The film stages a comic encounter between Britain and modernity, as if modernity itself were alien, and it has a charmingly parochial quality. Like *Fire Maidens of Outer Space*, it bears comparison with erotically charged American trash science fiction films such as *Cat Women of the Moon* (1953), a style it attempted to imitate with a sensuality of costume – Nyah, whom Laffan plays with haughty seriousness, is dressed in shiny leather like some intergalactic dominatrix – and eccentricity of set design at odds with the flat dialogue. It inspired an unusually appreciative and camp review – perhaps the earliest in British film criticism? – from the *Monthly Film Bulletin*:

> Settings, dialogue, characterisation and special effects are of a low order; but even their modest unreality has its charm. There is really no fault in this film that one would like to see eliminated. Everything, in its way, is quite perfect. (June 1954)

Unlike *Womaneater*, it is about women in the ascendant. In fact ever since the comedy, *The Perfect Woman* (1949), in which a male scientist tried to make an obedient female robot, an abiding theme in British SF has been an eroticised fear of assertive, independent and uncontrollable women. In *The Strange World of Planet X* (1958), *Unearthly Stranger*

Devil Girl from Mars: a perfect British trash film

(1963), *Invasion* (1966) and *The Body Stealers* (1969) women were literally creatures from another world, alluring threats to normality and the British way of life. Their erotic threat would be even more overt in sexploitation films like *Zeta One* (1969) – a truly bizarre piece of psychedelia in which Charles Hawtrey plays a heavy – and *The Sexplorer*, where luscious alien femmes fatales seduce earthmen or whisk them off to repopulate their dying planets.[7]

Horror vied with juvenilia as the main modes of science fiction in the 1960s. The one major exception to the main trends of British SF was *2001: A Space Odyssey*, which, though thematically linked to *Quatermass and the Pit*, had a vastly larger budget. *2001* did not inspire many films to experiment with ambitious themes or fantasise about space flight. Although some British SF films of the 1950s such as *Spaceways* and *Satellite in the Sky* (1956) casually assumed that Britain would lead the space race, by the end of the decade it was clear that space would be carved out between the two great superpowers. The heroic tradition of the RAF and Britain's contribution to aerial exploration, as celebrated in *Q Planes* (1939), *The Sound Barrier* (1952) and John Wyndham's novel *The Outward Urge* (1959), fizzled out because of 'a failure of the nation's political will and economic capacity to match the ambitions and capability of her scientists'.[8] The 1960s saw Britain withdraw from the space race. Not surprisingly, as the odds lengthened against a real-life Dan Dare (the astronaut hero of the *Eagle* comic from 1950–61), British space-flight movies became increasingly uncommon and, aside from a few pseudo-American films like *Spaceflight IC–1* (1965) and *Moon Zero Two*, they tended to be either comedies mocking Britain's diminishing power or nostalgic adaptations of Victorian novels. In *First Men in the Moon* (1964), for example, based on H. G. Wells's 1901 novel, modern-day American astronauts landing on the moon discover that a British spaceman got there first in Victorian times. Crucially, this pioneering Briton was not a committed professional, but a stereotypical English eccentric propelled into space by an anti-gravity paint of his own invention. Since the 1960s British space travellers have been generally portrayed as either eccentric – *Mouse on the Moon* (1963), in which explosive wine fuels a rocket into orbit – or downright idiotic (Norman Wisdom in *The Bulldog Breed* (1960), Peter Sellers in *Heavens Above!* (1963), Griff Rhys Jones and Mel Smith in *Morons from Outer Space* (1985)). From Dr Who (an alien Time Lord, but coded as a British eccentric) to Wallace and his dog Gromit in Nick Park's *A Grand Day Out* (1992), British astronauts are never symbols of heroic colonialism, but rather harmless Mr Bean-like amateurs on an interstellar jaunt. In *Moon Zero Two*, for example, the paradox of finding Brits in space is heightened, for British audiences anyway, by the unlikely presence of actors from TV comedy and the *Carry On* films: the double act, for instance, of Warren Mitchell and Bernard Bresslaw camping it up as Hubbard and his mountainous heavy.

The 1970s began in high spirits with one of the most unusual, ridiculous and now rarest SF films from that period, *Toomorrow*, which the press book optimistically described as 'the screen's first musical space adventure, introducing filmgoers to the exciting new sound of the "Seventies" … a thrilling foretaste of what the new decade can offer'. (It was not the first British SF-musical, preceded by *Gonks Go Beat* (1965) and a short film from 1968, *Popdown*, in which aliens check out the rock scene.) The film, a vehicle for the Australian singer Olivia Newton-John, originated with Don Kirshner,

Roy Dotrice and Olivia Newton-John in Val Guest's groovy *Toomorrow*

who had manufactured The Monkees in 1965. He sold the idea to Harry Saltzman, the James Bond producer and it seems to have been devised to launch the group Toomorrow as the new Monkees. Publicity material presented Toomorrow as a futuristic 'supergroup' offering the new sound of the 1970s. It was written and directed by the veteran Val Guest, 'a very dapper Englishman who was extremely proper', who had previously made *When Dinosaurs Ruled the Earth* (1970) and *The Day the Earth Caught Fire* and would later work in sexploitation.[9]

Toomorrow, the pop group, consists of four Chelsea art students, led by Olivia, who use a 'tonaliser', a kind of groovy amplifier. John Williams (Roy Dotrice), an alien Alphoid who has lived in disguise on Earth for thousands of years, is instructed by Galactic Control to track down the sound produced by the tonaliser, whose good vibes might counteract the sterility caused by the loss of potency of the Alphoids' computerised music. The group are kidnapped into a spaceship but, unable to reproduce the sounds in the alien environment, they are returned home just in time to play in a pop festival at the Roundhouse. (As *Monthly Film Bulletin* remarked,

> if they'd really set foot on stage there, 'dressed up like canaries and singing their cute songs of love and tears, they would have been booed, quite deservedly, off it again'.)

The Alphoids beam the festival into space, where it presumably restores the sonic balance. Next morning Olivia recalls a weird dream.

Toomorrow opened at the London Pavilion but it played there for only two days because Guest, who had not been paid, enjoined it and forced its withdrawal.[10] Although the film launched Newton-John, the group Toomorrow did not last long and the drummer, Karl Chambers, quit to 'do his own thing' a month before the film's release (*Daily Mirror*, 1 August 1970). Afterwards the film pretty much disappeared, though it is now available on DVD in Japan. To judge from Wikipedia and online searches, main interest centres on Olivia Newton-John fandom and the soundtrack is an elusive collector's item. As the plot suggests, *Toomorrow* is a generation-gap film paying homage to the lifeforce of the young which the older generation are anxious to draw on. (You could read the film as commenting on the music industry, with Williams as a manager and the Alphoids as a corporation seeking to exploit the kids for their own ends.) Although there is a sense of youth rebellion – a scene of a sit-in in the London College of Arts, with students demanding a role in the college's administration – *Toomorrow* represents an especially vapid and reassuring version of the counterculture. The upbeat message is that an exhausted Britain, and indeed the universe itself, might be revived by youthful energy, even if the music is pretty appalling. It is interesting that the older generation, represented by Williams, is cast as alien. In the 1970s that role was more often allotted to the futuristic young spearheading the Age of Aquarius, as in the TV show *The Tomorrow People* (1973–9), in which the young people, though not themselves aliens, represent *homo superior* – and the film has strong links with the TV series, which, along with other children's TV shows of the early 1970s, 'mediated in their different ways', as John R. Cook says, 'the utopian hopes and dreams of a new Aquarian order of enlightenment and rationality led by the young'.[11] The film's link between SF and pop music was prescient insofar as pop turned to SF themes in the 1970s with David Bowie, for example, and Hawkwind.

The reviews were surprisingly benign if not enthusiastic. *Kine Weekly* spotted commercial possibilities – 'A happy bit of fun in the modern idiom, this should please all but stuffy audiences' (29 August 1970). Other friendly press notices highlighted the film's innocuousness ('a harmless, jolly little film', the *Sun* called it (27 August 1970)) and the striking beauty of the cast, which as well as Newton-John, included Imogen Hassell and Margaret Nolan (as a sexy alien in the style of *Zeta One*). A number of reviewers were relieved that for once a film about young people did not involve gruelling scenes of gore and sex – it is 'a refreshing change to watch a film geared to the young, which doesn't make them all out to be sex or dope maniacs', the *Daily Mirror* remarked (26 August 1970), while Dilys Powell in the *Sunday Times* described it as 'juvenile, but at least not nauseating' (30 August 1970). *Toomorrow* is a genuine oddity, striving to be hip but clueless about the music scene and the young people for whom it was supposedly made.

Most SF production still consisted of TV spin-offs like *Doomwatch* (1972) and horror films adrift in a waning exploitation market, such as *Trog* and *The Mutations* (1974). The masterpieces and cult classics were art-movie one-offs – Nicolas Roeg's *The Man Who Fell to Earth*, with a perfectly cast David Bowie as the alien brought low by earthly pleasures; John Boorman's *Zardoz*, starring Sean Connery in a nappy; and Kubrick's controversial and prescient *A Clockwork Orange*, which he withdrew from circulation after death threats to his family. Commercially the most successful British contributions to SF were the James Bond films, whose fascination with gizmos lapsed into

outright science fiction with the Roald Dahl-scripted *You Only Live Twice* (1968) and the *Star Wars*-inspired *Moonraker* (1979), in which Roger Moore swapped his safari jacket for a spacesuit. SF production pretty much dried up from the mid-1970s, which was the low point for British film production anyway. After the release of *Star Wars* (1977) (which had significant British casting), Britain's main contribution was as a base for international co-productions such as *Saturn 3* (1980), scripted by Martin Amis, and *Alien*, directed by Ridley Scott, who later made *Blade Runner* (1982) in the US.

Since the 1980s SF production has mostly consisted of occasional one-offs following the same lines as before – TV spin-offs (*Whoops Apocalypse* (1988), *The Hitchhiker's Guide to the Galaxy* (2005), *Thunderbirds* (2004)), trashy exploitation (the Roy 'Chubby Brown' vehicle *UFO* (1993), *Evil Aliens*, *Infestation* (2009), *Devil's Playground* (2010)) and literary adaptations (*1984* (1984), *Memoirs of a Survivor* (1981), *Children of Men* (2006), *Never Let Me Go* (2010)).[12] But the dominant trend in British SF continues to be the horror hybrid – *Event Horizon* (1997), *28 Days Later* ... (2002) and its cack-handed Iraq-allegory sequel, *28 Weeks Later* (2007), *Creep* (2004), *Shaun of the Dead* and *The Descent* (2005), *Attack the Block* (2011), *Storage 24* (2012) and co-productions like *Prometheus* (2012). British SF film remains less celebrated than its quirky TV shows – *Quatermass*, *The Avengers* (1961–9), *The Prisoner* (1967–8), *Survivors* (1975–7), *The Hitchhiker's Guide to the Galaxy* (1981), *Red Dwarf* (1988–), *Blake's 7* (1978–81) and *The Clangers* (1969–74) – and the major British SF success of the last decade was the rebooted *Doctor Who* (1963–). Rather than space opera and ground-breaking special effects, Britain still seems to excel in *Blue Peter* spacecraft, whimsical caperings in disused Welsh quarries and cosy catastrophes featuring the end of the world and a nice cup of tea.

MOON ZERO TWO

It is difficult to choose one film to represent British trash science fiction, but *Moon Zero Two* combines many of the key elements – it is bizarre but also somehow mundane; it awkwardly disguises its British origins by presenting itself as 'the first "moon" western' as the American one-sheet declares; and it was a failure.

It would be disingenuous to make high claims for *Moon Zero Two*, whose merit rests on its magpie aesthetic, camp insouciance of tone and unexpected echoes of Kubrick's *2001*. But on close, sympathetic analysis the film emerges as more than a rip-off of the moon shot with which it was intended to coincide. For one thing its confusions and commercial failure tell us much about both the relative poverty of British SF cinema and the continuing inability of most British genre films to match the ambition of their American equivalents. But what is most surprising about *Moon Zero Two* is its close thematic relationship with *2001: A Space Odyssey*, the greatest SF film made in Britain. Both films, at different levels of ambition and competence, explore the boredom of space travel, the end of the space age, and colonialism as an expression of restless male desire.

The essence of *Moon Zero Two*'s conceit is that the moon of 2021 is a mining colony that resembles a Western frontiertown. Bill Kemp (James Olson), an American and the first man to set foot on Mars, runs a beaten-up ferry ship, 'Moon .02', with his Russian partner Karminski (Ori Levy). Threatened with grounding by Moon Bureau investigator Liz Murphy (Adrienne Corri), who is also Kemp's girlfriend, they agree to land a sapphire asteroid for J. J. Hubbard (Warren Mitchell), 'the richest man in the Universe',

in return for a new ferry. Kemp first accompanies Clementine (Catherine von Schell) to the far side of the moon to find her brother, Wally, a prospector who has gone missing. After discovering his body, Kemp and Clementine are set upon by Hubbard's hired guns sent to secure Wally's claim as a landing site for the asteroid. They escape but back at the moonbase one of Hubbard's henchmen kills Liz, and Kemp is forced to help Hubbard attach a rocket to the asteroid that will propel it safely towards the landing site. Kemp and Karminski, helped by Clementine, manage to send the asteroid, along with Hubbard and his henchmen, on a collision course with the moon. Clementine subsequently inherits her brother's claim, including the sapphire asteroid, which, it turns out, constitutes just the right material for lining rockets for journeys into outer space.

Although *Moon Zero Two* lacks both the mythic appeal of the Western and the visionary force of *2001*, it is a modest, likeable and unexpectedly satirical film (even if the satire is in large part a happy, unintentional by-product of a mischievous lack of seriousness.) Roy Ward Baker, who directed *Moon Zero Two*, retains a low opinion of its achievements:

> Of course it was a failure, and to be honest that's really because it's a poor film. Much of that was through pure ignorance – nobody knew much about making space movies in those days, mankind had only just gone into space ... we knew there was weightlessness, but I think mostly we were just plain ignorant. It turned out to be virtually impossible to stage these things properly, simply because although we had a very high budget, it was still nothing like high enough So I think we were hobbled before we really started. I don't think the script was very good, either, it was really pedestrian ... we could never get enough imaginative stuff into it.[13]

For the committed Hammer fan, the film also has a good deal of auteurist interest. Its quirky, oddball tone is highly characteristic of Michael Carreras, who produced the film and wrote its screenplay. Camp, self-reflexive and cynical, his films, even at their worst, reflect what Robert Murphy has called a 'distinctive willingness to experiment'.[14] *Moon Zero Two* sought novelty value by staging a plot from a 1940s 'oater' on a futuristic Moon. In classic British style Hammer not only cast an American, James Olson, as the hero of *Moon Zero Two*, but obscured the film's British origins by disguising it as a Western, the genre most reassuring to American audiences. Although *Moon Zero Two* now seems an eccentric production, there was a certain logic to Hammer's reverting to a type of SF it had not attempted since *Spaceways*. Science fiction film had revived somewhat in 1968 with the popular success of *Planet of the Apes* and the cult triumph of *2001*. Combined with public interest in the moon shot, the time seemed right for the exploitation of space. Unable to match American SF's special-effects budget – the stakes had been raised by *2001* – Hammer aimed the film squarely at children weaned on Britain's tradition of cheap TV SF like *Doctor Who*. Having decided on a space film, Hammer confidently allotted *Moon Zero Two* a substantial budget of £500,000. Most of it was spent on the sets of Moon City and Les Bowie's special effects, which included a seventy by fifty-foot lunarscape and a six-foot diameter fibre-glass moon – 'the result of painstaking and constant study of the latest moon-charts and photographs supplied by the most recent US moon-flight in Apollo 9'.[15] The film still seems poverty-stricken. The art direction

is bold and eclectic, but this probably reflects stylistic indecision rather than an attempt to strike a groovy contemporary note. For the juvenile audience there were clear-cut characters – the good guys in white jumpsuits, the bad guys in black – and the pleasures of toy-like space hardware, while *2001* inspired the extended sequences of silent space travel, and *Barbarella* (1967) the psychedelic futurism of its costumes and set designs – lurid wigs, bouncy white chairs and other incriminating echoes of the late 1960s fashion. The soundtrack score is no less bizarre and wide-ranging, and encompasses calypso, free jazz, a theme song by Julie Driscoll and atmospheric passages of electronic burbling. Despite its 'Americanised' setting, the film shares the camp sensibility of British SF films of the late 1960s, like *Zeta One* and *Toomorrow*, most of which refused to take the genre very seriously. Hearn and Barnes point out that *Moon Zero Two* also anticipates the kitsch psychedelia of British TV series of the 1970s like *UFO* (1970–1) and *Space: 1999* (1975–7).[16] Carreras hoped for a good return on his considerable investment, even predicting that it would be 'Hammer's biggest box office picture ever'.[17] He wrote a sequel – *Disaster in Space* – and planned a television series, but the film's poor reception and commercial failure put an end to such ideas.[18]

Although *Outland* (1981) and *Battle beyond the Stars* (1968) directly transposed Western plots to outer space – respectively *High Noon* (1952) and *The Magnificent Seven* (1960) – *Moon Zero Two* was the first SF film consistently to refer to the Western in its structure and imagery. The allusions to the Western try to make up for the lack of SF's usual visceral and intellectual thrills – aliens, monsters, robots, the conceptual breakthrough of novel technologies. The allusions are mostly on the level of opportunist jokes. Just as the space setting inspires gags about 'Moonopoly' games and Rocket Fuel cocktails at $35 a shot, so the Western gimmick prompts such trivial delights as a barfight in zero gravity and a shootout with lasers holstered like Colt 45s. There is a Pan Am Moon Express (it's called *Spaceways* – a Hammer in-joke); a rowdy bunch of miners, the Far Side Five, who sit around playing poker; Clementine's name recalls John Ford's *My Darling Clementine* (1946); *Stagecoach* (1939) is shown as an in-flight movie. The Western is used throughout as a source of comedy rather than as a serious generic underpinning, an object of nostalgia for the audience as much as for the astronauts in the film. As H. Bruce Franklin remarks of the use in *Outland* of 'the western form of the myth of the lone hero What we have here is a broken fragment of a myth, a shard, floating around like the other fragments in a disintegrating world.'[19] Nevertheless, as the film makes clear, the Western was an appropriate form for SF to merge with. The genres have obvious structural and ideological affinities. (Indeed 'space opera', the term for heroic pulp adventures, was coined by analogy with 'horse opera'.) Each involves the subduing of alien landscapes and the progress of civilisation; each draws inspiration from the myth of the frontier; and each embodies male fantasies of escape from civilisation. As Vivian Sobchack remarks, the crucial difference between the genres is that the Western's iconography of guns, horses, railroads and so on is played out in a coherent and historically bounded landscape:

> This linkage of situation and character, objects, settings, and costumes to a specific *past* [in the Western and gangster genres] creates visual boundaries to what can be photographed and in what context. This historical awareness, which leads at least to an imaginative if not

actual authenticity, demands repetition and creates consistency throughout these genres. This is not true, however, of the SF film, a genre which is unfixed in its dependence on actual time and/or place.[20]

The iconographic elements of SF are limited neither to a landscape nor to an historical period, which ensures their smooth integration into otherwise unrelated genres – film noir in *Blade Runner*, the paranoia film in *Invasion of the Body Snatchers* (1978), softcore porn in *The Sexplorer*. As Sobchack points out, 'It is the very plasticity of objects and settings in SF films which helps define them as science fiction, and not their consistency.'[21] But like *Outland*, which is set entirely on a moon of Jupiter, *Moon Zero Two* emphasises its link to the Western by restricting itself to a static harsh landscape reminiscent of the Californian desert. The moon, like Tatooine in *Star Wars*, provides a coherent and topographically familiar background for the revival of Western motifs. The moon's simple landscape maps the Western's structural opposition of the 'garden'

Moon Zero Two: the first 'space Western'

(the colonised domes) and the 'desert' (the badlands of the far side).[22] The effect, at once parodic and demythologising, is to underline the ideological continuities between the colonisation of the West and the moon, and the 'naturalness' of finding Americans leading the way into space.

But crucially this is a 'Western' from the period of the genre's decline, when 'generic exhaustion' had terminally set in.[23] In *Moon Zero Two* the frontier of space is closed and the imperial adventure has given way to international big business. Although the theme of the excluded and forgotten frontiersman was scarcely novel, it allies *Moon Zero Two* unexpectedly with such revisionist Westerns as *The Wild Bunch* (1969), for in both films it is clear that the myth of heroic expansion is well past its sell-by date. In alluding to the Western, *Moon Zero Two* suggests how misleading aspects of that grandiose myth are (or would be) to understanding the colonisation of space. Unlike the West, for example, the moon is a desert that can never, in the end, be turned into a garden. Everyone in it remains an alien, cooped up with tourists and bureaucrats in giant domes as soulless and regimented as shopping malls back on earth. Furthermore, whereas the West was founded on a utopian impulse to create a new society, the colonisation of the moon is merely an offshoot of the macho competitiveness of the Cold War.

In fact, far from celebrating the wonderful results of the new colonialism, the film parodies and belittles them. For Kemp the moon's thrills ended with the existential pleasure of getting there in the first place, and life in the domes is clearly anathema to the outlaw ideology of the Old West. The moon (like the West of *The Wild Bunch*) is run by corporations – the film mentions the 'Corporation', a United Nations-style set-up, while the novelisation states that the 'earth was in the hands of not more than 10 specialist monopolies'.[24] According to the film's production notes, Carreras had wanted to use the words 'United Nations Airways' and 'United Nations Agent' but the UN refused:

> I was very disappointed. I thought they would be pleased with the picture we were going to paint of a multi-racial society living in harmony under the United Nations. It would have indicated that in the future they would have more success than they are having in the world at this moment.[25]

In spite of these utopian sentiments, the film's vision of the future concurs with *2001*'s. The colonies are boring and dehumanised, and space flight has become an experience of bland, claustrophobic tourism. 'After Mars ... the Corporation decided that passengers were where the money was', Kemp reflects, with the lone traveller's distaste for the package tour. Like *2001*, in which astronauts snooze all the way to Jupiter, *Moon Zero Two* fixes on the irony that space travel, the greatest human achievement, would soon degenerate into tiresome commuting.

It is tirelessly repeated that science fiction sets out to create a sense of wonder and disorientation in the audience, a frisson of encounter between the known world and the spectacle of a magically advanced science. One thinks of the great Krel machinery of *Forbidden Planet*, a landscape of Otherness that dwarfs human understanding, or the narrative incoherence of *2001*, which gestures towards undreamed-of modes of communication. But in *Moon Zero Two* – as in the early, satirical scenes of *2001* – space

neither expands the mind, sensitises one to difference nor brings about cognitive reorientation. It merely enlarges the horizons of ennui. This cynicism towards space travel is compactly expressed in the cartoon credit sequence, which depicts American and Russian astronauts energetically competing to reach the moon. As soon as the astronauts land, the corporations move in, sidelining the frontiersmen and turning the moon into something resembling an airport. The astronauts, literally tossed into a dustbin, join forces as rogue exiles, escaping what they have unwittingly brought about. This is the situation at the start of the film. Kemp and his Russian sidekick Karminski are stereotypical Westerners outlawed by the coming of civilisation, no longer heroes of the space race but menial workers on their shabby ferry. Exploring space, the film tells us, can be agonistic fun but colonisation itself is dull work. The only real excitement on the moon comes from the old-timers exploring the far side – the last outpost of frontier values – and from the exotic figure of J. J. Hubbard. As *Films and Filming* pointed out, Hubbard seems to belong to a different film from Kemp. While Kemp is 'heir to that long line of clean cut, finely conscienced space heroes exalted in *2001*', Hubbard embodies an intriguing but not altogether coherent series of references.[26] A kind of Western cattle baron, he is also a figure of Orientalist fantasy rather like Emperor Ming in *Flash Gordon*. Although the villain of the film, he stands for energies now repressed but in fact essential to the spirit of colonisation. That he adheres to a conventional policy of monopoly capitalism is offset, even made attractive, by his crazy willingness to continue space exploration.

Although colonisation has what might be thought of as the typically masculine purpose of exploiting the moon's mineral resources, its creeping progress is seen as not only banal but also, crucially, feminising. Like the West, the moon was once a male space, where men could 'light out for the territory' and evade the responsibilities of home. The novelisation describes the moon's compulsive, masculine appeal:

> Along with the roughness and the toughness went something more insidious – something that a lot of them didn't know about until they got back to Earth. And then, back home, they found themselves yearning for the cold wastelands or the burning plains, for the remoteness, for the sensation of being on an ultimate frontier. It was a disease, and there was no known cure. One of the dangers of sending men to the Moon was that after six months they didn't want to go back; or, if they wanted to go back, found when they were at home that they'd made a mistake.[27]

But regiments of women have now disconcertingly invaded the colonised moon (rather as Liz bursts in on Kemp undressing in an early scene of the film). The equivalents of the Eastern schoolmarms of the Western, symbols of home and civilisation, have moved in to lay down the law and exile the frontiersmen from the homosocial utopia of this virgin land. It is true that women also take conventionally sexist roles in homage to Western values; for instance, pretty bar-girls and the dancing Go-Jos entertain the Far Side Five. But the sheriff is a woman, a significant deviation from the rules of the West, and 'real men' like Kemp and Karminski find themselves marginalised by the moon's domestication. Although Kemp and Clem pair off at the end of the film, it is clear that he will soon escape to Mercury or Venus in a rocket facilitated by the sapphire in Clem's

asteroid. Unlike the revisionist Westerns of the late 1960s, *Moon Zero Two* holds out at least some hope that the frontier spirit might be revived – if only temporarily, for strictly commercial reasons, and bankrolled by a financially independent woman.

One of the great differences between the colonisation of the moon and that of the West is that there are no natives to encounter and kill off in the name of progress. It is just another great open wilderness to be exploited and fenced in. This lack of native Others also sets *Moon Zero Two* apart from the core of Hammer's obsessions, which is the encounter between the repressed middle class and terrifying, transforming Otherness. Earlier Hammer films about colonisation, such as *The Stranglers of Bombay* (1959) and *She*, revelled in the erotic possibilities of far-off lands, locating their fantasies of sadistic and dominating women in burning deserts and wet, suffocating jungles. But in *Moon Zero Two* women represent stasis, not fearful liberation, and there is no sign of the 'moon maidens' enticingly promised by the American poster. The moon is oddly bereft of erotic interest, a timeless romantic symbol revealed as a dull and sterile rock. Despite Clem – a very demure embodiment of 'Hammer glamour' – the final impression is that, as Karminski notes at one point, there is 'no sex in outer space'. Perhaps because *Moon Zero Two*'s target audience was juvenile, it shies away from the wish-fulfilment of previous British SF films like *Fire Maidens of Outer Space*, in which space teems with men-starved young women. The one scene with any sexual charge occurs when rising heat forces Kemp and Clem to undress in the moon buggy, but this coy striptease is played strictly for laughs and ends in embarrassment rather than consummation.

The film's chaste morality is in keeping with the main tradition of the SF genre, which like the Western tends towards caution in sexual matters, being nervous about women and preferring masculine hardware to soft female bodies. Interestingly, *Moon Zero Two* conveys some of its cynicism about space travel by means of pointed feminine satire. The women ridicule the pretentious machismo of space exploration and what Liz calls 'the tatty old moon': as Clem mock-naively remarks to Kemp: 'To women space travel is just a big way of getting out of the house on Saturday night.' So much for the new frontier. Many years later the feminist writer Susan Faludi, expressing the same scepticism about boldly launching oneself into empty space, echoes the general disappointment with the space race anticipated in *Moon Zero Two*:

> Space turned out to be a place not much worth conquering ... a sterile environment, not a place where women and children could or would want to settle. To explore space was to clear the way for no one, to be cut off from a society that had no real investment in following. Nor was space a place of initiation, of virile secrets, of masculine transformation. There was no one there to learn from or to fight. It was a void that a man moved through only passively, in a state of almost infantile regression. The astronaut was a dependent strapped to a couch in a foetal position, bundled in swaddling clothes. He made it through space only by never breaking the apron strings of mission control back on Mother Earth. An astronaut returned from space unchanged by the experience, because there was no experience. No wonder that, for all the promotional effort expended on space, by the time Neil Armstrong stepped on the moon, we were already suppressing a yawn over the adventures of the new heroes.[28]

As it turned out, *Moon Zero Two* was realistic in assuming that Britain would enter space only in the context of a pan-European or United Nations enterprise.

Moon Zero Two communicates a naive sense, as Piers Bizony remarks of 1960s space films generally, that 'The future was *fun*, and full of wonderful toys … . Spaceships of one kind or another were thought of, largely, as part of the inevitable and essentially benevolent furniture of the future.'[29] But it lends itself to a darker interpretation, which finds in it a plausible vision of future boredom. How depressing to colonise the moon only to ensure a farcical repetition of the historical past, a cheap parody of an outdated genre. The film's emphasis on the banal experience of space was prescient, for, as J. G. Ballard remarked, the space race seemed over before it had really begun. Films depicting its achievements far more vividly than the grainy monochrome of TV broadcasts had already used up public interest.[30] From this disappointed perspective, the moon landing, as *Moon Zero Two* suggests, was the end of the space age rather than its glorious beginning.

5 ZOMBIES, SLEAZE AND PSYCHOMANIA

The 1970s has been decried as 'the twilight of the monsters' but from today's perspective, the horror films of the period benefited from a combination of generic uncertainty, artistic pretension, alertness to contemporary resonances, and new blood in writing and directing.[1]

The 1970s saw a loosening of censorship – notably the 'X' certificate being raised to eighteen and the introduction of the 'AA' certificate for fourteen and over – but much of the new wave of horror was either banned, such as *The Last House on the Left* and *The Texas Chain Saw Massacre*, or heavily cut, such as the European horror films of Mario Bava and Dario Argento. British horror tried to compete within the limitations of censorship, but ran up against the BBFC's disdain for exploitation. The BBFC, as Sian Barber says, made its 'judgements based on its own definitions of quality, integrity and cultural value, and this meant it all too often failed to take seriously films from genres not deemed to be culturally worthwhile'.[2] Nevertheless, independent horror producers pushed the boundaries when they could, especially in fusing horror and sexploitation; and, at the risk of succumbing to breathless list-making, it is worth highlighting a few of the films that have attracted cult interest since the 1990s.

Virgin Witch exemplified the trend toward erotic horror. Directed by Ray Austin for Tigon and produced by Ralph Solomons (the pseudonym of Kent Walton, an ITV wrestling commentator, and Hazel Adair, who created *Crossroads* (1964–88)), *Virgin Witch* was initially banned outright by the BBFC in 1971, though for its scenes of writhing lesbians and naked satanic orgies rather than its fairly restrained violence.[3] The film was given an 'X' certificate by the Greater London Council, and a cut version went on general release in January 1972. The narrative, such as it is (two sisters are seduced by a middle-class coven in an isolated country house), strings together a series of deliciously sleazy sex scenes, which, as usual in softcore exploitation, works against the onward momentum of the story.[4] The country house is, on the one hand, as in *Mumsy*, a microcosm of bourgeois decadence and on the other, a Sadean *huis clos*, a familiar setting for pornography, in which normal rules and conventional sexuality are suspended and primal instincts unleashed.

More successful in combining sex and horror was *Vampyres*, a lesbian vampire film directed by José Larraz, a Spaniard who made two other horror films in Britain, *Scream ... and Die!* (1974) and *Symptoms* (1974). Although – or perhaps because – it was unavailable in a full version for many years, *Vampyres* certainly has achieved a genuine cult ambience.[5] It is probably the nearest British horror came to 'Eurohorror' like Harry Kumel's *Daughters of Darkness* or Jean Rollin's delirious vampire sex films. Explicitly

erotic (and therefore heavily cut by the BBFC), *Vampyres*' visual extravagance lends it a dreamlike quality quite different from *Virgin Witch*. The story is equally vestigial but, rather than simply spacing out the sex scenes, the casual narration seems intended to imitate the art movie's loosening of classical Hollywood narrative. (Exploitation and the art movie often converge in their lack of interest in 'good' storytelling). The cult of *Vampyres* arose because of its perceived *difference* from other British horror films and because Larraz could be elevated from genre hack to 'European' auteur. This, incidentally, is a key move in the cult recuperation of trash – isolating a film from its commercial context, legitimating its 'flaws' as auteurist expression and opting to approach it more as a surrealist art movie than as a genre piece. Hence this summary in the horror fanzine, *Samhain*, written in the mid-1980s:

> Like Argento and Bava, Larraz's movies are fundamentally plotless The work of Larraz reinforces one's awareness of the limitations of horror cinema; its basic restraint and inhibition, lack of vision and general myopia. For Larraz is an imagist, telling the story in images that are striking and provocative.[6]

Among British auteurs of the 1970s Pete Walker has attracted the most active cult following, largely for his films' black humour and sheer nastiness. His compact 'terror' films now seem central to 1970s British cinema, and remarkably uncompromising in their combination of anti-Establishment social comment and what Steve Chibnall, in the first and definitive book on Walker, aptly described as 'mischief'.[7] Before turning to horror, Walker was, according to David McGillivray, who wrote several of his movies, 'the best British sexploitation director' (*School for Sex* (1968), *Cool It Carol!* (1970)).[8] *House of Whipcord* (1974), Walker's and McGillivray's fiercest denunciation of the Establishment, is meticulously devised, from its outrageous title onwards, to exploit British interest in 'fladge' and corporal punishment. It is set in a private prison in the country, where a blind ex-judge and his wife (a parody of anti-porn campaigner, Mary Whitehouse, though she now seems an alarming prophecy of Mrs Thatcher) punish wayward girls for mild sexual infringements against middle-class decency. The Establishment's reactionary politics are diagnosed as hysterical repression mingled with class hatred and sexual jealousy; and the film ends provocatively with this 'square-up' on screen: 'This film is dedicated to those who are disturbed by today's lax moral codes and eagerly await the return of corporal punishment.' A wicked parody of the law-and-order discourses of the period, it was, McGillivray admits, 'a pure publicity ploy' to 'stir up controversy by suggesting that this is where we were leading and this was where society was going in trying to bring back capital punishment which the "Festival of Light" wanted to do at the time.'[9]

However, if I had to choose only one film to represent British trash horror in the 1970s, it would undoubtedly be *Psychomania*, filmed as *The Living Dead* and released later on video as *The Death Wheelers*.

Directed by Don Sharp and written by two blacklisted Americans, Arnaud d'Usseau and Julian Halevy [Zimet], *Psychomania* is teeming with strange ideas and images. It is not – thank goodness – a 'good' film but rather, as one recent fan enthused, 'unapologetically mental'.[10] ('Mad' films, and films by 'mad' directors or with 'mad'

The Living Dead terrorise Shepperton in the sublime *Psychomania*

actors, are a shoo-in for cult approval.) Like *Dracula AD 1972*, *Psychomania* was youth-orientated, cashing in on both biker movies and zombie films such as *Night of the Living Dead* (1968), and picking up contemporary resonances because, like *Blood on Satan's Claw* and *A Clockwork Orange*, it depicted a cult with a charismatic Manson-like leader. The zombies are not shuffling decayed corpses as in *Night of the Living Dead* or, another possible influence, W. W. Jacobs's story, 'The Monkey's Paw', but happy and indestructible; and, in a horror film without much actual horror, their deaths are played for laughs.

Tom Latham (Nicky Henson) heads a surprisingly well-spoken biker gang, the Living Dead, which is introduced to the secret of eternal life by Tom's mother (Beryl Reid), a medium who has made a bargain with Satan for 'special favours', and her butler, Shadwell (George Sanders in his final role). After a mind-bending experience in a locked room, where Tom finds his father's glasses and has visions of a giant frog in a mirror, he is led to believe, like his father before him, that if he kills himself he can come back through sheer willpower. Unlike his father, he succeeds, and convinces the rest of the Living Dead to commit suicide in a series of outlandish bike stunts. Returning to life, they terrorise Shepperton, near the studio where filming took place, before Tom's mother sacrifices herself to prevent any further mayhem: she transforms into a frog and the bikers turn to stone.[11]

Psychomania has earned its cult status because it is so utterly *sui generis*, with an offhand strangeness emphasised by the contrast between the bizarre premise and the mundane setting and dialogue. Abby (Mary Larkin), Tom's girlfriend, refuses to kill herself because she's promised to help her mum go shopping in the morning. Tom returns from the dead – unchanged, though a zombie – and goes straight to the pub, orders a pint and borrows some change to call his mother: 'Are you all right?' she asks. 'Well, I'm dead, mother. But apart from that I couldn't be better.' He then murders five people and insouciantly drives off to meet 'Gash', 'Chopped Meat' and the rest of his gang.

I am tempted simply to cherry-pick the most outrageous dialogue, highlight the maddest and cultiest moments (notably the funeral scene with Tom's corpse perched upright on his motorbike in an open grave), and leave interpretation to fend for itself. Still, as Chris Alexander remarks, *Psychomania* 'was written by two expatriate Communist sympathizers. And if you really dig, there *is* subtext …'.[12] There are indeed numerous groovy subtexts you could 'dig' – the Oedipal frisson between Tom and his elderly mother, for example; 'the anti-Establishment vibe – the revolution begins and the Finefare in Shepperton High Street is its Odessa Steps', as Matthew Sweet said, referring to the bikers knocking over a pram; or the satirical emphasis, worthy of Shepperton resident J. G. Ballard, on suburban banality, eroticised crashes and death-seeking extremism as a cure for middle-class ennui.[13] The most obvious subtext is boredom, the condition from which the bikers seek to escape by suicidal rebirth. (For cultists, this takes on additional significance because Sanders, who killed himself soon after making the film, cited 'boredom' as the reason for his suicide. Rumour has it that he took his life after watching a rough cut of *Psychomania*.) The film shares an 'end of the line' feeling with road movies like *Easy Rider* (1969), *Zabriskie Point* (1970), *Two Lane Blacktop* (1971) and *Vanishing Point* (1971), in which dreams of freedom end in failure and self-destruction, and with *Harold and Maude* (1971), another film about youth, suicide, motorbikes and liberation. The anti-Establishment sentiment expressed in some other horror films has turned to outright nihilism with the Living Dead (bikers were shorthand for hedonistic nihilism in numerous texts of the period, from *The Wild Angels* and Peter Cave's biker novels for NEL, to the 'senile delinquents' of Monty Python's Hell's Grannies). Asked by his mother, 'What are you going to do now?', Tom replies: 'Do you know how many policemen there are? Judges, teachers? Do-gooders?' 'You mean the whole Establishment?' exclaims Shadwell, aghast. The bikers' search for freedom extends, however, only to smashing up supermarkets and driving through walls, a pathetic index of the counterculture's drift into selfishness and infantile hedonism.[14]

However you read it – and Nicky Henson sturdily holds the line that it is a 'piece of shit'[15] – *Psychomania* is a summit of British trash cinema. A throwaway movie, quickly made but not (to the chagrin of the cast) quickly forgotten when caught on late-night TV, it is a succession of wonderfully photogenic moments that defy conventional categories of good and bad film-making. This is one of the most appealing characteristics of cult movies – that they can come across as essentially unauthored exercises in unwitting surrealism.

SLEAZE

The turmoil of the late 1970s lent itself to allegorical embellishment, and the trashier the films the more completely they seemed to engage with the nation's Political Unconscious. Although the awfulness of the 1970s has been somewhat exaggerated, even given the Jimmy Savile revelations, discourses of the period centred on Britain in decline and overwhelmed by forces beyond its control, which spilled out willy-nilly in fantasies of killer rats (James Herbert's novel *The Rats* (1974) and 'During Barty's Party' an episode of the TV series, *Beasts* (1976)); a giant sheepdog (*Digby, the Biggest Dog in the World* (1973)); a love-sick gorilla (*Queen Kong*); and an oversized cat toppling the Post Office Tower (Kitten Kong, in TV comedy show *The Goodies*).[16]

We get a sense of this in two films from 1978, just as the monstrous presence of Mrs Thatcher herself loomed over an unprepared nation. Both *Killer's Moon* and *Terror* are self-reflexive films in which the sleaziness of exploitation itself is proof and symptom of social breakdown.

Killer's Moon is one of the canniest and grubbiest of all British horror films. Directed by Alan Birkinshaw, who had previously made *Confessions of a Sex Maniac*, it is about a group of schoolgirls menaced at a Lake District hotel by escapees from a mental institution who, having been given LSD as part of their treatment, believe they are dreaming. The men are middle-aged with working-class names – Trubshaw (David Jackson), Smith (Nigel Gregory), Muldoon (Paul Rattee), Jones (Peter Spraggon) – and, rather than the counterculture tearaways of *Psychomania*, they resemble social demons of the mid-1970s such as the Black Panther (Donald Neilson) and the Cambridge Rapist (Peter Cook, who was arrested in 1975). Mayhem ensues, mostly of a sexual kind, and the result is 'Blood on the moon, one mangled dog, one missing axe, and a girl who's just found a body at the wrong end of the axe. How's that for the great British outdoors?'

With its nubile victims from 'Maidenhill School' and gratuitous scenes of rape, *Killer's Moon* bubbles over with an impressively unhealthy and very knowing appeal to its audience, who are assumed to share the lunatics' nympholepsy and reactionary attitudes to women ('All women should cook', one of the killers declares.) The dialogue, some of which was contributed by Birkinshaw's sister, the feminist writer Fay Weldon, seems deliberately self-parodying in its blithe sexism, as when one of the girls is told:

> Look, you were only raped, as long as you don't tell anyone about it you'll be all right. You pretend it never happened, I'll pretend I never saw it and if we get out of this alive, well, maybe we'll both live to be wives and mothers.[17]

The film essentially presents itself as a fairy-tale for male voyeurs, and exploitation as the collective dream of repressed and misogynistic men. 'A shared dream is rich, I tell you, rich indeed', one of the killers says, and comments made about their 'dream' apply equally to the film – 'Of course it's a dream and stuffed full of jailbait'; 'Do you dream in colour?' – 'I like the flesh tints.' The killers even refer to what's happening to them as a film: 'I didn't kill her', Mr Trubshaw says of one woman. 'She stuck out in the scenario like a sore thumb.' Both the 'dream' and the film compensate for the inadequacy of their real lives. 'For kings we are', they announce in the full pomp of their delusion: 'We have

Permissiveness runs riot in *Killer's Moon*, the sleaziest British horror film

the power of life and death.' Perhaps because they are in a *British* exploitation film, the dream/film turns out to be disappointing: 'Why can't I dream of steak and chips?' one of them complains, 'Why does it have to be bread and cheese?' The disjointed plot and cack-handed storytelling – one character vanishes partway through only to reappear as a corpse at the very end – converts very bad film-making into an effective and unsettling experience of dream logic.

The film is also surprisingly intertextual. The obvious reference point is *A Clockwork Orange*. Here too there is a gang of thugs in boiler suits, one of them, Mr Trubshaw, in a bowler hat; the gang's dialogue is similarly ritualised, with a touch of cod-Shakespearean poetry. *A Midsummer Night's Dream* is another source of inspiration, with its sexual shenanigans in the woods, intermingling of classes and confounding of dream and imagination. The dream/film is depicted as a regression – shades of *Mumsy* – to the nursery. 'Twinkle Twinkle Little Star' and 'Three Blind Mice' are alluded to on the soundtrack (a real cat's tail is also cut off with a carving knife) and at one point there is a chorus of 'Humpty Dumpty'.

Despite revelling in sexual fantasy, *Killer's Moon* betrays some highly conservative beliefs about what the Unconscious harbours and what men would do given half a chance: as a politician says, when he is told about the lunatics' dream therapy: 'My God, in *my* dreams I murder freely, pillage, loot and rape!' Echoing Pete Walker's *Frightmare*, in which a lax system releases a cannibalistic driller killer back into the community, the true villain is the liberal Establishment: the psychos, Leon Hunt remarks, 'represent an unleashed permissive unconscious'.[18] Permissiveness – and exploitation films! – foolishly encourage working-class men to entertain fantasies of sexual liberation and the result is a nation sleepwalking into chaos.

Killer's Moon was, surprisingly, not cut by the BBFC, largely because they thought it was so hopelessly bad that it posed no danger to the public: 'If it were not so inept in both direction ... and acting this could have been a film that put TEXAS CHAINSAW in the shade. As it is, it becomes ludicrous and complete [sic] lacks impact.'[19] The censors were mostly concerned with violence towards animals – the de-tailed cat and mangled dog – and whether one of the raped actresses was over sixteen.[20] The trailer caused problems, however, and Birkinshaw had to cut the voiceover line – which actually sums up the film's reactionary assumptions quite well – '*Killer's Moon* brings to the surface the instincts we all keep buried within us.'

All these films, from Walker's to *Killer's Moon*, depict Britain in garish primary colours as a chaos of violence, sexual excess and corruption. Norman J. Warren's *Terror* is less 'political' in its subtexts but also communicates a sense of Britain in decline, for which the film's own trashiness is both evidence and symbol. Warren started in the industry in the late 1960s by making the first British sex films, a genre he was never comfortable with, and achieved cult status for a handful of very cheap, independently made horror films that began with *Satan's Slave* (1976) and continued with *Prey* (1977) (about a cannibal alien), *Terror* and his best-known film *Inseminoid*, which has, to put it mildly, close similarities to *Alien*. Warren epitomised what was then a rarity in Britain – the director as outright fan. His films are packed with movie references and in-jokes and communicate a remarkable sense of exploitation film-making as improvisational play.

Terror starts with a nine-minute sequence of a burning witch cursing a house and its descendants, a hackneyed scenario familiar from Mario Bava's early films and *Curse of the Crimson Altar* (1968). 'The End' appears on screen, and there is a cut to a an audience at the house of exploitation film-maker, James Garrick (John Nolan); the opening sequence was a film within a film, Garrick's latest, a tawdry pastiche of traditional Gothic recounting the true story of a curse put upon his family. The film is greeted with 'What a load of rubbish', which can be read as a rejection of the exhausted Hammer tradition. There follow a number of set-piece killings by an unseen assailant and suspense sequences, with relatively little dialogue – including a *giallo* style stabbing in the woods, that ends with Carol (Glynis Barber) pinned to a tree; the garrotting of Phil the Greek (Chuck Julian); a sex film director crushed by a falling studio light; and a policeman being run over by his driverless car. The blame is placed on Garrick's cousin Ann (Carolyn Courage), who is staying at a Theatre Girls Hostel with two other down-at-heel actresses, Viv (Tricia Walsh) and Suzy (Sarah Keller), but the killer turns out to be the witch from the film (played by the same actress) who reappears at the house at the end in a riot of telekinesis, and, after Ann has accidentally killed Garrick with an axe, sends a sword flying into her, so that she is pinned like Carol. There is little interest in the whodunit element, however, since the events end up being clearly supernatural in origin – Ann is trapped in a levitating car, for instance, and one murder involves an attack by malevolent unspooling film stock. It is ambiguous whether Ann committed a couple of the murders while possessed by the witch, but in the end the film is not interested in plot and motivation but in pastiching and playing with horror-film conventions. The film is held together by repetitions and echoes and is not only thoroughly rickety in Eco's sense but quite deliberately so. Textual surface is all and trashiness is the catalyst for fun.

ENTERTAINMENT FILM DISTRIBUTORS LTD. present **TERROR** x

Glynis Barber and John Nolan in Norman J. Warren's *Terror*, the British *Suspiria*

Although *Terror* starts as a parody of Hammer, it segues into what is usually regarded as homage to Dario Argento's *Suspiria*, which Warren and his screenwriter McGillivray had seen and admired.[21] *Suspiria* is a surreal horror film in which style, a deafening soundtrack, explicit violence and shock are more important than a coherent plot. *Terror* carried over certain elements in its focus on gory set pieces, flaunting its lack of logic, loud electronic music, random and unsourced blocks of light and witch-inspired supernatural murders (the attack by film reworks the death by barbed wire). It just preceded the slasher film cycle kicked off by *Halloween* (1978). The influence of *The Texas Chain Saw Massacre* can be seen in the numerous chases through woods, *Psycho* in the frenzied stabbing of Viv and *The Omen* (1976) in the decapitation scene, while the freeze-frames of the opening titles refer back to the similar end titles of *Witchfinder General*. There are references as well to Warren's own *Satan's Slave* (a poster of it on a double bill in the studio). On the DVD commentary McGillivray points out that, for all the Italian influences, the film is 'intimately English, and *not* American', with an emphasis on domesticity, cups of tea and the suburban mundane. The film's irrelevancies, plot holes, lack of motivation, longueurs and the complete absence of the kind of framework of Good and Evil that Hammer gestured towards, make it a horror film about the inability of traditional Gothic to make sense of the meaninglessness of the postmodern world, in which meaning is as disconnected as the scenes in the film.

Emphasis falls on horror as fakery and SFX, as when blood dripping from a ceiling turns out to be red paint. There is throughout a complicitous delight in cliché and teasing the audience, as when a long suspense sequence in which Susie runs through the woods to a cottage, flooded in unexplained non-diegetic blue light, ends with an intruder not being a killer but merely a tall man who asks 'You want a mechanic?' The return of the witch played by the same actress as in the film at the beginning is the invasion of the diegetic into the non-diegetic and ironically announced that the Gothic cannot be repressed – *Terror* transpires to be a film itself possessed by the film within a film.

What makes *Terror* especially revealing is its subtext about the state of British cinema and exploitation (in spite of McGillivray's droll comment to me that '*Terror* is an allegory of man's eternal struggle to write something that doesn't look like *Suspiria*').[22] Rather than *Suspiria*'s art/exploitation crossover, *Terror* is an amused and rueful acknowledgment of the state of the British film industry, with a thematic focus on degradation. Garrick's name denotes the downward slide of a great theatrical name, whose country house is now the setting for ratty horror films. This point is made in the dialogue – 'It actually happened in this house,' 'At least you didn't have to spend money on locations'; 'Cheapskate, that's the reason he made it.'[23] Garrick's film studio meanwhile is given over to the making of sexploitation films, in this case a two-hander *Bathtime for Brenda* (this may be a joke: Brenda is *Private Eye*'s name for the Queen, while Phil the Greek, the garrote victim, could allude to Prince Philip.) None of the actresses has much work beyond sexploitation or commercials for Daz; otherwise, they are waitresses at a strip bar. This fact cues a pointless scene of a punky stripper with a whip, ironically highlighting the need for nudity regardless of narrative motivation. The bedsit is presided over by Dolores (Elaine Ives-Hamilton), a deluded old actress like Gloria Swanson in *Sunset Boulevard* (1950), a reference hammered home by mention of DeMille in dialogue and a shot of a *Sunset Boulevard* poster. In other words, we have numerous allusions to a film industry out of date, on its uppers and reliant on exploitation, and to actors and directors slumming it for cash (including Garrick, who looks remarkably like Warren, though Warren insists it is not a self-portrait). The DVD commentary indeed consists of numerous droll anecdotes about cutting corners and doing things on the cheap, such as using a steaming kettle to create an effect of dry ice around a witch's head, and portrays the film's production as less like work and more like a party. The film's own cheapness stands for the state of both the film industry and the nation itself – both deserve the comment, 'What a load of rubbish.' There is a similar moment in *Wombling Free*, where the Wombles stumble into an abandoned cinema, expressive of the decline of movies in Britain. It echoes *Queen Kong*, whose shabbiness is a comment on the poverty of what a film industry, metonymic of Britain, was capable of coming up with.[24] Trash *was* British culture and these exploitation films expressive of it.

In the 1970s trash was no longer marginal, or a cult taste or even an aspect of low culture – it was a central subcultural style, a description of the country itself, and by the end of the decade, as rubbish piled up in the streets, trash became a symbol of the state of the nation itself.

CONTEMPORARY EXPLOITATION HORROR

In the 1980s relatively few horror films of any kind were made in Britain. The two key ones were *The Company of Wolves* (1984), an arty adaptation of Angela Carter, and *Hellraiser* (1987), a queer celebration of the transcendent possibilities of sadomasochism. By the 1990s, according to Linnie Blake, 'the British horror film was little more than a self-reflexive exercise in pastiche; most often of earlier American texts and their attendant ideologies'.[25] Richard Stanley, lamenting in 2002 the paucity of British horror, wrote that: 'New titles have sporadically surfaced over the years but crippled by poverty row budgets and Z-grade casting they have, without exception, gone direct to video.' The 1990s, he complained, was 'a decade whose only genre entries amounted to amateurish efforts, home movies and fan boy fluff too impoverished or basically incompetent to reach a wider audience'.[26]

Since its revival in the early 2000s with *28 Days Later* ... , *Shaun of the Dead* and *The Descent*, the genre nowadays encompasses both classy Gothic adaptations such as *The Woman in Black* (2012), the most commercially successful British horror film ever made, and over 440 mostly low-budget exploitation films. 'Fan boy fluff' was taken to some kind of apotheosis in the 'zom-com', *Shaun of the Dead*, which represented the triumph of jokey, knowing, intertextually overloaded films by and for fans of trash and exploitation.

But the field for low-budget exploitation cinema had in many ways narrowed, its staples of sex and violence having long been drafted into mainstream cinema. Although films like *The Evil Dead* had pioneered a new style of fannish, jokey and outrageous horror, the most influential British horror film of the late 1970s was Ridley Scott's big-budget SF 'body horror' film *Alien*, which typified the 'upscaling' of exploitation that had happened during that decade. As Roger Corman has said:

> 'Exploitation' films were so named because you made a film about something wild with a great deal of action, a little sex, and possibly some sort of strange gimmick; they often came out of the day's headlines. It's interesting how, decades later, when the majors saw they could have enormous commercial success with *big-budget* exploitation films, they gave them loftier terms – 'genre' films or 'high concept' films.[27]

Directors such as Brian De Palma integrated exploitation and art-movie pastiche in glossy exercises in trash like the Antonioni-influenced slasher film *Dressed to Kill* (1980). For De Palma, as for Spielberg, whose *Jaws* was essentially big-budget exploitation, the key inspiration was Hitchcock, who demonstrated in *Psycho* and *The Birds* (1963) how even the lowest genres could work simultaneously on multiple aesthetic levels, convert the lowbrow into the avant-garde and yet remain extremely popular. Through the 1970s the major studios in the US drew on the same material as exploitation cinema, and exploitation, its thunder stolen by Hollywood, remained distinctive if at all because of its much lower budgets, obscure casts, and means of distribution that bypassed mainstream cinemas.[28] Exploitation in the US turned either to extremity – as with grindhouse fare – or to the hetero-intertextual camp of parody, as with *Death Race 2000* (1975), *Piranha* (1978) and deliberately bad films such as *Attack of the Killer Tomatoes* (1978).

What revived exploitation was home video, which offered a new platform for cheap film-making. While mainstream horror films, including ones that drew on trash, like *Cat*

People (1982), remade it, like *The Fly* (1986) or deliberately elevated it like *The Shining* (1980), were serious in tone, exploitation directors in the US such as Charles Band and Fred Olen Ray aimed their intentionally trashy product at the home-video market, making fan films for cult trash fans. In Britain horror similarly opted for comedy (*Bloodbath at the House of Death* (1984), *I Bought a Vampire Motorcycle* (1990)) and camp pastiche (Ken Russell's *The Lair of the White Worm* (1988), which I'll discuss in a later chapter).

The most workable definition of exploitation nowadays encompasses low-budget genre films that are very formulaic and imitate recent cycles in the form of 'knock-busters' or 'mockbusters'. Invariably their tone is one of knowing self-parody and they are often made by young fans trying to break into the film business. Although they are sometimes premiered in the cinema, their key market is home video and DVD and their intended audience is young fans of trash exploitation. This is certainly true of the British horror film since the early 2000s.[29] About 45 per cent of the 400 or so of British horror films released since then went direct to video or DVD.[30] Jonathan Sothcott, who started as a genre journalist before moving into film production with *Stalker* (2011) and *Strippers vs Werewolves*, explains at length the economic logic of this kind of material, which is funded through pre-sales to distributors:

> Funding for British exploitation films is the hardest part and there is no sure fire formula for success. Films at my end of the market are judged worthy by comparables – nothing succeeds like success in the DVD market. That said we are all struggling at the minute, as unlike in the music business, digital sales haven't replaced physical ones yet and piracy is really hurting us in our pockets. As a result, budgets are getting screwed tighter and tighter to the floor in order to ensure profit. My model works through a series of minimum guarantees from distributors so that, on paper at least, my films are in profit before they are even released. The distributors know that, from my track record, I will deliver a certain type of film in a certain type of genre on time and on budget. They know we run a tight ship and that mine is a producer-controlled business – if a director gets out of line, they get fired. As such they are happy to pre-buy my stuff at a certain level and our budgets are set accordingly.[31]

Recent exploitation horror ranges from numerous zombie films, such as *Colin* (2008), serial-killer films, such as *The Last Horror Movie* (2003) and the quietly intelligent *Tony: London Serial Killer* (2009), to any amount of dismal amateurish nonsense such as *The Hike* (2011) – a torture porn rip-off of *Hostel* (2005) – and the extraordinarily bad self-distributed oeuvre of Richard Driscoll (*Kannibal* (2001), *Evil Calls: The Raven* (2008)), whose failings inspired an epic 20,000-word online lambasting by Leicester-based genre fan M. J. Simpson.[32] As a rule, these films owe more to trends in US horror and memories of the video nasties than to the supposedly authentic British strain of historical Gothic, which had been occasionally revived by big-budget American films like *Sleepy Hollow* (1999) and *The Others* (2001) but was not a presence again in British horror till *The Woman in Black* and *The Awakening* (2011). As Johnny Walker says,

> British horror cinema since 2000 has largely veered from the Romantic Gothic horrors … and been more inclined to pastiche the modern American and European horror film that began to flourish when British horror's popularity was dwindling … in the early 1970s.[33]

A number of these films exemplify the contemporary deliberate trash film, such as Jake West's *Razor Blade Smile* (1998) and *Evil Aliens*, which combine horror with self-reflexive pastiche in the style of *The Evil Dead* and Peter Jackson's *Bad Taste* (1987), and *Kill Keith*, a self-trashing comedy in which TV personality Keith Chegwin is a 'cereal killer' bumping off rivals to a breakfast-show hosting job. *Kill Keith* has few illusions about its quality and cultural status: when the director's name appears during the opening credits, there is a close-up of dog shit squished underfoot. Arguing that 'the revival of British horror is as bound up with tax breaks and technological advances as it is with a creative renaissance', James Leggott remarks that 'these films are perhaps most distinguishable from their 1990s counterparts through their professionalism of approach' and cites the development of CGI that allowed *Evil Aliens* to look more competent than *Razor Blade Smile*.[34]

One of the most high-profile of these trash-horror comedies was *Lesbian Vampire Killers*, which got a cinema release before finding its natural home on DVD.[35] A fixture on recent polls of the worst British films ever made, it tried to reach a cult as well as mainstream audience by parodying specifically British horror tropes in the context of an updated version of 1970s low comedy; it failed. It is unusual in drawing on the moribund Gothic tradition: unlike *Carry On Screaming* (1966), it parodies a more or less defunct mode of horror, though at one point it was actually slated to be made by the revived Hammer.

Lesbian Vampire Killers is about two sad skint blokes, Fletch (James Corden) and Jimmy (Matthew Horne), both from the TV sitcom *Gavin & Stacey* (2007–), who have been dumped by women considerably tougher and brighter than they are. They decide, in a pub, to get over it not by going to Ibiza but to Cragwitch, Norwich, in East Anglia, which is the cue for references to *Witchfinder General* and jokes about inbreeding. Hiking there, as in *An American Werewolf in London* (1981), they stay at the Baron's Rest, which is 'like some medieval gay bar' – this is a journey to the past, in other words, to a hidden and repressed Albion as well as to the nation's heritage of horror. The backstory is that thanks to Carmilla (Silvia Colloca), the vampire queen and a reference back to the monster in Hammer's Karnstein trilogy, all women in the village become lesbians on their eighteenth birthday. Lesbianism, which is passed on by vampires, is also infectious like a disease. The lads meet up with a group of impossibly pretty European students of folklore on a field trip, with names like Trudi (Ashley Mulheron) ('massive tits, never speaks'), Heidi (Tiffany Mulheron), and Lotte (MyAnna Buring), who are represented in the unreconstructed lip-smacking manner of *Nuts* or *Zoo* magazine. The lesbian vampires, rather like those in Hammer, are hypersexual in their perversity, allure, danger and orality – Carmilla has an exceptionally long tongue; women 'rob you of your testicles', and Fletch is scared of becoming 'a light buffet for a bunch of hot dykes'. Homosexual panic is played for laughs. In the pub, Fletch says he's 'Just a bit worried I'm going to get raped', as in *Deliverance* (1972). Towards the end of the film Fletch fears that he 'will be bummed by a big gay werewolf', and the film ends with a silhouetted limp-wristed werewolf. Needless to say, the film's trash aesthetic is not subversive or camp in the sense of queer and coded gay; it is more informed by the comedy of *Viz*.

Lesbian Vampire Killers' themes are shared by other low comedies and comedy-horror films – namely terror of female sexuality, which is simultaneously a source of

pornographic fantasy and a threat, and male resistance to domesticity. Lesbianism and vampirism both connote women's uncanniness – the curse is cast at 'the time of the red moon' and the 'red moon bleeds' during the final battle. The film is animated by a hatred of women as well as bafflement at lesbianism, which both fascinates and alarms because all women seem susceptible to it. Curiously, though a compilation of porn-mag fantasies about lesbians, the film doesn't explore the erotic possibilities of the material. Like most recent low comedies, *Lesbian Vampire Killers* is curiously sexless and entirely avoids the kind of outright sexploitation that Hammer dived into in the 1970s; the assumption may be that the audience gets its kicks from the internet nowadays and exploitation need not muscle into the market. The only toplessness comes in a shower scene, when a vampire's breasts melt under running water and leave only silicone implants. It is also, as with numerous of these films, simply not trashy enough – the possibilities of a trash aesthetic for subversion are hardly explored. The film's laddism, like that of *Shaun of the Dead* and *Doghouse* (2009), is complemented by a self-deprecating sense of failed masculinity, so that the film's sexist attitudes are supposedly ironised and balanced by a satirical stance on male inadequacy and powerlessness. When the women dance to 'Hot Hot Hot' the boys stare at them with stunned disbelief, and much of the film's intermittent comedy comes from the eternal hopefulness and overconfidence of Fletch. He takes the lesbian vampires as a personal insult – even dead women would rather sleep with each other than with him. By the end of the film, the worms have turned and Fletch gets his mojo back when he starts decapitating lesbians. The girlfriend, who turns up only to be infected, is killed by her head being split open with an axe to cancan music, and dies in an explosion of white liquid. Possibly an allusion to the milky blood of the robot from *Alien*, this is also a massively parodic 'cumshot', representing the girlfriend's orgasmically satisfying defeat. Carmilla, whom Fletch calls 'a complete fucking bitch', can only be killed with the Sword of Daeldo, an enormous sword with a cock on top, while Durex waterbombs full of Holy Water serve as weapons in this symbolic heterosexual revenge on lesbians. Jimmy, it turns out, is magically empowered to kill vampires, though Fletch grumbles, with a nod to *Life of Brian*, that 'Jimmy's not the Messiah, he can barely wipe his own arse.'

In *Doghouse*, too, gender warfare is put centre stage. A group of lads go on a stag weekend to a village in the middle of nowhere, the familiar setting for rural horror, and are stranded when all the women turn out to be ravenous zombies infected by 'bird flu'. As in *Shaun of the Dead*, where the now conventional trope of zombies as metaphors of aimless consumerism is specifically tweaked to apply to the living-dead existence of modern men, *Doghouse* presents men as useless and frustrated. Female zombies represent their paranoia at the devouring Otherness of women and killing them allows them to regain a semblance of masculinity. Linnie Blake argued that British horror during the Blair years saw 'a new kind of "fusion hero" … emerge: one who undertakes a hybridisation of earlier models of British masculinity in his mission to conquer the monster and become a man'.[36] These 'warrior figures' are engaged in

> their struggle with their own particular demons bespeaking the trauma wrought to long-established modes of masculine selfhood by the socio-economic and cultural changes that over the past thirty years have challenged traditional hegemonies to the clear advantage of women.[37]

In *Lesbian Vampire Killers* and *Doghouse* men are certainly warriors, as in *Dog Soldiers* (2002) and *Reign of Fire* (2002), but their enemy here is women. For all the films' parody of machismo and the hopelessness of the modern male, there is also a distinct element of vengeful wish-fulfilment by men adrift in a feminised world. If anything, *Lesbian Vampire Killers* in particular is more reactionary than Hammer's fantasies of dangerously sexy women; the film's trashiness, which supposedly inoculates it against sexism by ironising masculinity, enables it to celebrate rather than subvert the stereotypes it so knowingly pastiches.

I'll end this chapter with two zombie films that sum up contemporary British exploitation, and which are made by and for trash fans and exhibit a thoroughgoing commitment to trash aesthetics.

The first is *Stag Night of the Dead*, a 'zom-com' in the *Shaun of the Dead* mould, first premiered on the Horror Channel and then released straight to DVD a fortnight later. Directed by 'Napoleon' (Neil) Jones, it is set during the usual Romero-inspired zombie pandemic, and follows a group of lads on a stag-night getaway to a military-style complex where they play Zomball, a game that involves shooting zombies (old-school, slow-moving ones) with lasers. They take with them a 'fifty-quid stripper', Candy (Sophie Anderson), who looks on with disdain at the 'boys with their toys'. The boys treat the zombies as they treat the stripper, as playthings for their amusement, and there is an echo of *Hostel* in the idea of people being reduced to objects of consumer pleasure. The game, which is overseen by a very fat Mr Big (Brian Wheeler) and his dwarf sidekick, has one basic rule, 'Never humiliate a zombie', and the other rules occasionally appear on screen in homage to *Zombieland* (2009). One of the lads, a white Ali G type, DJ Ronny (Joe Rainbow), falls for one of the zombies (credited as Hot Zombie Chick), who turns out to be his perfect woman – 'You're different', he says. 'I feel I can talk to you.' She gives him a blow job and bites his cock off. Ronny, for whom zombiedom is something of a step up, turns into the most talkative and vindictive of all the zombies and, when they get loose and overrun the compound, he becomes their leader and discovers 'the best sex of his life'. It transpires that Zomball was designed to attract subjects for a military programme to discover an antidote to the zombie virus, after the government stopped sending asylum seekers on whom to experiment. A mad zombie soldier, kept going by an antidote, wants to create a zombie army and take over the world; he is killed on revealing this plot twist and the remaining stag nighters blow up the compound with a self-destruct device, presumably a reference to the end of *Alien*. Dean (Sebastian Street), whose stag night it is, discovers that his fiancée has been having an affair all along and goes off with Candy, who turns out to be a student paying off her student loan; this was her first work as a stripper. Hints of satire abound – of male inadequacy, the mistreatment of social groups (women, asylum seekers), the military mindset and *Big Brother*-style humiliation as entertainment – though the film's one genuinely amusing moment comes when a zombie is kicked in the balls and his testicles drop down his trouser leg. Once again, unlike earlier exploitation, there is no gratuitous sex and the film even sweetly withholds the title's promise of erotic content – the stripper does not strip and there is no nudity, just a couple of listless shots of the Hot Zombie Chick's breasts. Filmed in murky handycam, cut frenetically, with poor CGI and a relentless rock soundtrack, *Stag Night of the Dead* is trash as outright amateurism, just

a notch above home movie, and as such representative of a good deal of ultra-cheap contemporary horror exploitation. By any standards it is rubbish, but compared with higher-budget trash horror like *Lesbian Vampire Killers* those little fugitive hints of satirical awareness, while hardly enough to redeem the film, at least show it using trash to comment on rather than just reproduce cultural assumptions. Blake says that some horror films like *Creep* and *The Descent* focus on the 'will to punish iconic agents of the demise of patriarchy'.[38] Here it is patriarchy, embodied by Mr Big, the entertainment arm of the military-industrial complex, that is overthrown by the insurgent zombies; and the film can be usefully read, with a little sympathy and effort, as a fantasy of revenge against an infantilised surveillance culture.

The tautologically titled *Zombie Undead* (2011), an even lower-budget independently funded production, is intriguing for a different reason. It represents a wholly contemporary mode of exploitation: a film crowd-funded via a website.[39] Directed by Leicester-based Rhys Davies, *Zombie Undead* is essentially a survival horror film, in the mode of the *Resident Evil* videogames, whose premise is a zombie outbreak seemingly caused by a dirty bomb going off in Leicester city centre. The survivors are taken to an evacuation centre on the city's edge, where a small group of characters work their way to freedom while evading zombies and infection (it was filmed at De Montfort University, where I work, which lends the film a curious and pleasurable sense of altered reality). The zombies, as in *Stag Night of the Dead*, are slow-moving classical monsters as opposed to the sprinting ones introduced in *28 Days Later* *Zombie Undead* forgoes the political subtexts now familiar in zombie films, such as consumerism, class and social passivity, but references terrorism to suggest the theme of mass panic. Developed in the wake of the 7/7 attacks in London, the film draws on the trope of 'zombies are us' to make monsters out of ordinary people; it is, according to the director, 'about numbers – blindly following a subhuman agenda, like brainwashing and religion'.[40] Like *Stag Night of the Dead*, the film is poised between amateur film-making (some reviews assumed it was developed from a student film) and a professional independent release: such distinctions are flattened out these days by the capabilities of inexpensive digital cameras and special-effects programmes. Modishly over-directed, with continuous use of handheld 'shaki-cam', wide angles, dutch tilts and CCTV point-of-view shots, this is nevertheless, for all its lapses in continuity and story logic, not a 'badfilm' in the mind-altering mode of *Birdemic: Shock and Terror* (2010). *Zombie Undead* intelligently exploits minimal resources to produce a 'calling-card movie', while doing enough to demonstrate the director's enterprise, organisational skills and facility with the technology to hand. All the required exploitation elements are in place: close imitation of a successful genre cycle; fan-friendly nods to the conventions of zombie films, such as zombies' faces pressed up against glass doors; a handful of gross-out shock moments (vomiting on people, nasty zombie children), though staying within the bounds of the commercially necessary '15' category; and lively DVD box artwork which disguises the low-budget and splashes a strapline quotation from George A. Romero. Though clearly a fan film, it mostly lacks the deliberate badness and mocking humour of *Strippers vs Werewolves* and *Stag Night of the Dead* (though one of the cannibalistic zombies wears a *Meat Is Murder* T-shirt; the director is vegetarian, so perhaps, as with *The Texas Chain Saw Massacre*, the film can be read as an anti-carnivore tract). The film, like *Colin* and *Tony:*

London Serial Killer, is a straightforward, cheap horror movie, in a semi-realist tradition equally far removed from the camp aesthetic of *Rocky Horror* and the 'badfilm' self-trashing of *Stag Night of the Dead*. With its CCTV shots and imitation of reality footage, *Zombie Undead* sticks to the international house style of horror film-making on a seriously compromised budget, such as *The Blair Witch Project* (1999) and *Paranormal Activity* (2007). Nevertheless, it is consistent with the social realism that, for M. J. Simpson, is key to the new wave of British horror films: 'Miserable characters [who] find their miserable lives interrupted by zombies and vampires and serial killers and ghosts and evil cults. This wasn't Gothic horror, it was *Urban* Gothic'.[41] For all its limitations, *Zombie Undead* is one possible future for British trash film-making, firmly in the tradition of Norman J. Warren.

Unlike Warren, who learnt on the job in the independent sector in the 1970s, Davies did a two-day course on film-making in Ealing Studios led by Chris Jones, author of *The Guerilla Film-maker's Handbook*, then, after making a short film, went straight on to *Zombie Undead*. Davies set up a website for his company Hive Films to which donations could be sent to support the film's production. This crowd-funding model via sites such as indiegogo has since become increasingly popular for independent film-makers, who raise money by selling a stake, participation or creative involvement in their film.[42] The most high-profile release is *Iron Sky* (2012), though it is not restricted to trash genre films – others include documentaries, such as a proposed one based on the political book, *The Spirit Level* (2009), and *The Canyons* (2013), directed by Paul Schrader from a script by Bret Easton Ellis. But there was a clear advantage for Davies, quite apart from his passion for horror, in making a zombie film. As we've seen, horror is one of the most sellable exploitation genres, and there is a very large community of zombie fans more than happy to chip in, especially if they can appear in make-up as zombie extras (no acting ability required). Zombie films are also remarkably easy to make, since they require little more than accessible everyday locations, plenty of make-up and Kensington Gore, and a mass of lurching and groaning volunteers. With a minimal crew of himself, a director of photography who brought his own equipment, and a sound technician, Davies filmed *Zombie Undead* over two years on a Sony prosumer video camera and edited it on a £200 secondhand laptop. The budget was around £2,000. The main cost was employing security for weekend filming, and the biggest team was, naturally, for make-up.

Making a film is one thing; getting it seen another. Davies sent out around thirty screeners to distributors; it was picked up by Metrodome, who put enough money upfront to cover the transfer to digi-beta required for DVD release. Davies then booked Phoenix Square, an art cinema in Leicester, for three sellout screenings – rather like 'four-walling' in the early days of exploitation[43] – and promoted the film at fantastic film festivals in Portugal and South America. It has since been released internationally on DVD, including in the US. As a portfolio piece, *Zombie Undead* generated enough interest and contacts to enable Davies to set up a second film, a mock-doc called *How to Make a Film for £43*. During this production he turned to EM Media, which used Lottery money to back the creative digital media sector in the East Midlands, and then Creative England, which took over regional Lottery funding from EM Media in late 2011. This provided money for two film treatments and to develop his next film, *Acid Demons*, which is budgeted at around £100,000.

Crowd-funded gore in Rhys Davies's *Zombie Undead*

Zombie Undead does not embody an especially sustainable model of film-making, since no one makes much money from it. Nor is it entirely representative of exploitation today, being simply an entry-level exercise in drumming up attention and future investment. Only a habitual outsider artist like Ed Wood could mistake crowd-funding £2,000 movies for a sane career plan; it is simply a new twist on the hand-to-mouth economics that allowed Sam Raimi and Peter Jackson a crack at the big time. But it is nevertheless indicative of several trends and possibilities in British exploitation. First, low-budget exploitation film-making is the province of fans nowadays, and their house style is a cultist trash aesthetic. Second, the future of trash exploitation rests not only with such semi-professional fan productions, but with films released to video on demand and streamed directly from fan websites. Moreover, the quality of affordable new DSLR video cameras and CGI packages (as demonstrated by the effects in Gareth Edwards's *Monsters* (2010)) will further close the gap between fan exploitation and higher-budget exploitation such as the creature features that crowd the schedules of Syfy or even mainstream trash films like *Piranha 3DD* (2012). This doesn't mean that British exploitation will be left wholly to fans knocking together horror movies in their bedroom and broadcasting them from YouTube; though, as with online pornography, the distinction between amateur and professional may blur a good deal. But it does suggest that budding Norman J. Warrens may find it a lot easier to get started in this new online economy, even if Warren himself has found it difficult to get funding since 1985's *Bloody New Year*. Although trash horror like *Zombie Undead* inhabits one of the least respectable corners of the lost continent, it is nevertheless an entirely sensible location for a commercially astute film-maker to set up shop.

Exploitation remains, over fifty years on from *Womaneater*, an essential, lively and innovative strand of British film production, as demonstrated by the hundreds of cheap horror films churned out over the last ten years. Jonathan Sothcott points out that trash

horror, albeit with a rather bigger budget than Davies had to play with, has an international market if you can get it right and tailor it for foreign audiences:

> [*Strippers vs Werewolves*] was an incredibly difficult film to make that has turned out to be a bit of a mess. But on the other hand, what it had done is sold all over the world, unlike some of my more Brit-centric stuff. The high concept (or low concept!) exploitation film is actually much more international than a lot of stuff and we'd certainly look at this type of stuff again, but I'd learn lessons – no name casts, no complex prosthetics and more boobs.[44]

Films like *Zombie Undead* may seem to have little in common with Hammer's Gothic or even Walker's seedy terror films. But they testify to the continuing importance of both exploitation and horror to the economic sustainability of British cinema, and demonstrate how trash can tap into cultural undercurrents as effectively as more respectable films. In many ways the attractions of exploitation have not changed that much from *Womaneater*, though directors nowadays are more likely to be horror fans than jobbing hacks. Cultists are the creative future of exploitation rather than just its audience. Low-budget exploitation has passed (like so much cinema nowadays) into the hands of fan-boys and -girls, for whom horror is, as it was for Norman J. Warren in the 1970s, the perfect sandpit genre – a place for outrage, homage, improvisation and fun. As Rhys Davies told me, with characteristic enthusiasm, you don't need to write a screenplay and send it out on spec any more: 'grab a camera and make a film, sell it and doors will open. No one will want to make it more than you.'

6 DINOSAURS AND FUR BIKINIS

The most iconic and widely recognised single image produced by Hammer was Pierre Luigi's shot of Raquel Welch in the prehistoric romp *One Million Years B.C.*, looking extraordinarily beautiful in her fur bikini.[1] 'I should think', claims Ray Harryhausen, who did the movie's special effects, 'that this picture created more publicity for the film than any other still picture in the history of motion pictures.'[2]

One Million Years B.C., which Hammer's publicity claimed was its hundredth film, was the studio's internationally most successful production, grossing £3.6 million by 1972 on a £400,000 investment. Its success inspired Hammer to make three other films on prehistoric lines: *Slave Girls*; a more conventional sequel, *When Dinosaurs Ruled the Earth*; and *Creatures the World Forgot* (1971), all of which combine, as Robert Murphy suggests, the pleasures of the Italian sword and sandal epic (the *peplum*), the nudist film and the African wildlife movie.[3] Prehistoric films go back to the earliest days of cinema, when films such as D. W. Griffith's *Man's Genesis* (1912) and *Brute Force* (1914) centred on thuggish cavemen, but the genre's commercial heyday was more directly inspired by the invention of the bikini in 1946. In cheaper sexploitation flicks the lure of semi-nakedness was sufficient to justify the narrative, as for example in tropically set Z movies of the 1950s such as *Prehistoric Women* (1950) and *Wild Women of Wongo* (1958). For Hammer the genre had the added benefit of special effects that appealed equally to juvenile and adult audiences, and the films were ideal for international distribution because, with the exception of *Slave Girls*, the dearth of dialogue made dubbing unnecessary.

Though generally patronised and often overlooked in histories of Hammer, these borderline SF fantasies are among the studio's most enjoyable productions, with lush visuals, superior special effects and frankly erotic pleasures. Most cult interest has been spurred by the special effects of *One Million Years B.C.* and *When Dinosaurs Ruled the Earth*, of which there are several very detailed accounts.[4] The effects in *One Million Years B.C.* were created by Ray Harryhausen, a master of stop-motion animation, and *When Dinosaur Ruled the Earth*'s by Jim Danforth, who earned Hammer's only Oscar nomination. The films' 'indulgent surrealism', as Pirie described it in 1973, also demonstrates low-budget cinema's ability to engage playfully with myth.[5] *One Million Years B.C.* and its sequels strayed from Hammer's usual nominally Christian framework into what might be described as archetypal drama, offering schematic visions of human origins that reinterpret beefcakes and pin-ups as archetypes of healthy sex and primitive vitality. As with any other historical genre, they evoke a sense of pastness rather than adhere to the complexities of historical truth. Far removed from the banal landscape of 1960s consumerism, these films improvise myths of lost worlds of magic, desire and irrationality, in which

Dinosaurs and Fur Bikinis

The iconic shot of Raquel Welch in her fur bikini in *One Million Years B.C.*

blonde centrefolds are symbols of timeless primordial beauty and stop-motion rubber dinosaurs embody fears of nature out of control. Whereas Hammer's Dracula films pathologise sex as the repressed erupting into bourgeois normality, the prehistoric films can be interpreted as nostalgic visions of virile energy in a period when Britain was emerging from the unheroic aftermath of war.

The prehistoric films are important to an understanding of Hammer because they represented an attempt at diversification in the 1960s, when the BBFC was discouraging gory horror and the studio, especially under the influence of Michael Carreras, was ambitiously reaching out to wider audiences, such as the 'A'-certificate market and the 'U'-certificate children's matinee crowd. Not only the high-point of 'Hammer glamour', the films incorporate themes such as colonialism, gender and myth that cut across Hammer's remarkably eclectic roster of productions. Many of these under-remarked films might be classed as historical fantasias, designed to showcase the studio's skill at conjuring the illusion of lavishness despite very low budgets. They include war films, such as *Camp on Blood Island* (1958); a Roman melodrama (*The Viking Queen* (1967)); Civil War dramas (*The Scarlet Blade* (1964)); a number of films set in the empire (*The Brigand of Kandahar* (1965), *The Stranglers of Bombay* (1959), *Terror of the Tongs* (1961)); swashbuckling adventures (*Captain Clegg* (1962), *Pirates of Blood River* (1962) and a couple of Robin Hood films); and adaptations of pulp novels, such as *She* and the utterly bizarre *The Lost Continent*, based on one of Dennis Wheatley's more obscure non-horror novels.

HAMMER AND EMPIRE

The immediate inspiration for *One Million Years B.C.* was *She*, a version of H. Rider Haggard's much adapted novel starring Ursula Andress as Ayesha, who is essentially a Jungian anima figure.[6] Although Hammer had already emphasised what Russ Meyer might call the buxotic attractions of its starlets, with *She* the studio began to construct films around their 'glamorous' attractions and sell them as glossy sexploitation; the female leads were iconic objects of erotic fascination rather than dramatically complex characters. The sequel to *She* was *The Vengeance of She* (1968), often considered to be one of Hammer's weakest films, in which Ayesha seems to be reincarnated as the Hungarian model Olinka Berova, whose listless performance reflects Hammer's policy of casting for looks and frissons of continental sex rather than for acting ability. *Vengeance* incorporates an important theme for Hammer: the irruption into the present of the erotically charged past, which was often associated with the fading world and excitements of the British empire. The role of women in these 'Hammer glamour' films and their interest, over the heads of children in the audience, to male viewers can be easily summed up in a still photograph or reproduced on a poster: Andress, fresh from *Dr No* (1962), the very image of untouchable blonde disdain in a long white gown; Welch, of course, in her anachronistic swimwear; Martine Beswick as Kari in *Slave Girls* slinkily reaching out from her couch of furs. These are pre-modernist visions of Beauty and the Eternal Woman, luminous femmes fatales and figures from Leighton and Alma-Tadema updated in the idiom of the *Playboy* pin-up and the 'Bond girl'.[7]

In the prehistoric films the women, except for Kari, are generally passive or even mute; their role is to look spectacular, tussle in cat-fights and be saved from menacing

dinosaurs. But in *She*, as in *The Stranglers of Bombay* and *The Gorgon*, beauty is also something to be feared. Karim (Marie Devereaux), the voluptuous disciple of Kali in Fisher's *The Stranglers of Bombay*, anticipates what would be the key theme of Hammer's representation of women: the duality of beauty and terror. *Stranglers* was enthusiastically championed by French critics, largely because of its textbook sadism. Luxuriating in the ritual torture of men like an Indian Mme Defarge, Karim is a cartoonish assemblage of erotic signifiers: a mountainous cleavage, passive and silent, overseeing, as would Ayesha, the spectacle of male death.[8] Women who transgress Hammer's conservative vision of glamorously inert femininity are invariably coded as evil monsters, whether they are lesbians, Dracula's over-aroused victims or merely old and sexless as in *The Brides of Dracula* (1960) and *She*, in which Ayesha pays the price for her terrible beauty when she steps into the cleansing eternal flame and withers into an apelike crone. Old women are monstrous and disgusting, like Bette Davis's malevolent matriarchs in *The Nanny* (1965) and *The Anniversary* (1968); and women's active desire and sexual power over men must be punished and destroyed. *Countess Dracula* (1971) combines, like *She*, the twin stereotypes of nubile youth and wizened crone in a single female character, played by Ingrid Pitt: at the end of the film the vampire countess shrinks from smooth-skinned sex goddess to desiccated granny.

One of the richest explorations of *She*'s Jungian theme of the Eternal Woman, agelessly beautiful, desirable yet frightening, was *Blood from the Mummy's Tomb* (1971). The last of Hammer's mummy films and a return to form after the slapdash *Curse of the Mummy's Tomb* (1964) and *The Mummy's Shroud* (1967), this was an updated adaptation of Bram Stoker's *Jewel of the Seven Stars* (1903). Tera, an evil Egyptian queen, is reincarnated in the imposing form of Valerie Leon, the daughter of the archaeologist who discovered Tera's tomb. Leon goes on a murder spree around contemporary London to secure artefacts taken from the tomb, which the film amusingly presents as girly consumerism: 'There is still some shopping to do', she declares, sweeping off to kill another survivor of the dig. Possessed by Tera, Leon changes from obedient daughter into a haughty embodiment of female power that men, seen in this film as generally camp or ineffectual, struggle to control.

She was also, of course, an imperialist fantasy, unashamedly Victorian and reactionary, on the theme of the white goddess, the 'natural' ruler of the Dark Continent. Another overlooked and somewhat confused treatment of imperialism was *The Viking Queen*, directed by Don Chaffey, an 'entertainment', as the screenplay is subtitled, about the colonisation of Britain by the Romans.[9] The film is a curious reimagining of *She* that grafts elements of *Norma*, Bellini's opera about druids, onto a garbled retelling of Boudicca's rebellion. For some reason, probably to justify its star Carita's Finnish accent and to cash in on the success of *The Vikings* (1958) and *The Long Ships* (1964), the Boudicca character becomes a blonde Viking, Salina, who, in a splendid defiance of historical possibility worthy of *Carry On Cleo* (1964), falls in love with a Roman general, is raped (like Boudicca) and dies leading the British in battle against the imperial enemy. As in the SF films, and even though Britain has historically been invader more often than invaded, the theme is British resistance to imperial aggression, with rape symbolising colonisation. Imagining Britain as a colonised race – in a film where a British icon, Boudicca, is transformed into a Viking, and the Romans come across as more British

than the British – seems a convoluted overcompensation for the British empire as well as an unwitting admission of Britain's increasingly post-imperial state.

Hammer made a number of films on the imperial theme, which were often surprisingly sympathetic, or at any rate, even-handed in their treatment of the colonial Other, and which intelligently used the exotic to criticise Western attitudes. In *The Abominable Snowman*, for instance, a clichéd Orientalist fantasy of Tibet is counterpointed with the grasping materialism of Western and especially American values. As Marcia Landy notes, the film

> expresses discontent with the aggressive behaviour of Western males and uses traditional stereotypes of Eastern culture to undermine Western attitudes. The 'Orientalism', the portrayal of the Eastern way of life that is usually negative in the empire films of the 1930s is ... inverted. The culture of the East is now seen as offering a corrective to that of the West.[10]

Similarly the horror films *The Reptile* (1966) and *The Plague of the Zombies* (1966), both set in Britain, mirror *The Viking Queen* in engaging otherwise racist tropes of foreign infection to depict colonialism as corrupting. *The Plague of the Zombies* constructs an explicit anti-colonial metaphor: workers in a Cornish tin mine are zombified with the aid of knowledge acquired in the West Indies – they suffer in effect the revenge of the colonial repressed. As Pirie remarks of these two films, 'Both concern small Cornish communities threatened by a kind of alien and inexplicable plague which has been imported from the East via a corrupt aristocracy: both are, by implication at least, violently anti-colonial.'[11] Similarly, *The Stranglers of Bombay* depicts the violence of Thuggee not as the brutality of a lower race but as a product of Western infection and interference. As Marcia Landy notes, 'The Indians are portrayed as seeking to reappropriate what has been expropriated from them, and the violence of their methods, when read against the grain, is a distorted mirror of the methods of the expropriator.'[12] Even so, Landy goes on to remark, the film 'dramatizes how the liberal Englishman must still regard the colonial Other from a position of rational superiority. The white man must save the Indians from themselves.'[13]

WHEN PLAYMATES RULED THE EARTH

The prehistoric films focus more abstractly on sex and violence, moving entirely away from the present and dealing in archetypes – which is to say stereotypes that seem to have been around forever. Like all prehistoric films, they also work as allegories of human nature in an original state of pure Social Darwinism. However up to date the special effects, there is always something nineteenth century about the films, which are not only unbelievably inaccurate as science but also inspired by a genre that was invented seventy-odd years before. But the prehistoric films are closer to Greek or Biblical myth than paleoanthropology, with the same larger-than-life characters, symbolically charged events and a sense that moral lessons are being communicated by the action representing man and woman rather than individualised psychological types.

One Million Years B.C. was a remake of *One Million B.C.* [*Man and His Mate*] (1940), directed by Hal Roach, and starring Victor Mature. Hammer had wanted to

follow *She* with a remake of *King Kong* but RKO were unwilling to release the rights. Kenneth Hyman, the son of Elliott Hyman of Seven Arts, with which Hammer was currently associated, suggested remaking *One Million B.C.* instead. The director was Don Chaffey, experienced with special-effects films, having recently made *Jason and the Argonauts* (1963) with Harryhausen's special effects; the director of photography, Wilkie Cooper, had made five films with Harryhausen. The script was by Michael Carreras. According to Chaffey, 'We cobbled up the story over a few weekends at his house and mine from seeing the original *Man and His Mate*, then sat down and went through Europe on paper as to where we'd shoot it.'[14]

The 1940 version is chiefly remembered for Roy Seawright's not particularly special effects, which have appeared as stock footage in numerous low-budget productions – the creatures consist of lizards with fins and mammoths played by elephants in furry garb with curved tusks. The film is essentially a benevolent fable about two tribes coming together to battle dinosaurs. Loana (Carole Landis) of the more egalitarian Shell Tribe civilises the brutish Rock Tribe of her lover Tumak (Victor Mature) rather like a bourgeois woman organising the working class, though she needs Tumak's big stick to enforce the law. Carreras's adaptation eliminated the original's modern prologue and replaced it with a portentous voiceover, not in the shooting script, describing the creation of the earth. He also dropped the comic relief of a baby bear and a child character and, while the 1940 film verges on the pastoral, his script placed emphasis firmly on the cruelty of prehistoric times. Carreras also shifted a scene of catastrophe – in the original an exploding volcano – to the end of the film. Instead of the story climaxing with two tribes uniting to kill an unconvincing lizard-cum-dinosaur, the warring tribes in the remake are interrupted by a volcanic explosion that sets off an earthquake (abruptly ending prehistoric tales with some kind of natural disaster is a cliché of the genre). Carreras's screenplay included a sequence preceding the explosion carried over from the 1940 film in which the tribespeople are attacked by a brontosaurus, but while this was storyboarded it proved too expensive to film. Moving the catastrophe to the end also binds the film more closely to 'the imagination of disaster' of so many 1950s and 1960s SF.[15] In fact the original script specifies that a 'huge mushroom cloud hangs over the scene of desolation' as the survivors walk off 'With Tumak slightly ahead ... the others follow him into the distance ... across the utter desolation ... towards the mushroom cloud.'[16] It is unclear from the screenplay whether the cloud is due to the volcano or was intended to have a more symbolic implication; the imagery of an atomic explosion, again referencing 1950s SF, hints that, as in *Teenage Caveman* (1958), the events may have actually taken place in the future.

Hammer's take on *One Million Years B.C.* mixes *Romeo and Juliet* and the story of Cain and Abel within a plot driven by the conventional motifs of prehistoric tales – tribal warfare, exile, quest, kidnapping, fighting monsters and catastrophe.[17] The set-up resembles *The Viking Queen* – a blonde heroine, a bad father figure and love across two opposing camps – and the simple there-and-back-again storyline is structured as series of standalone encounters with prehistoric beasts and ape people. As in other Hammer films of the period, fathers and the established order are repressive and sympathies lie with the young's attempts to overturn them. One million years ago Tumak (John Richardson, who had starred in *She*) is exiled by his father, Akhoba (Robert Brown)

from the very primitive Rock Tribe, which inhabits a harsh cliff, and meets with Loana (Raquel Welch) of the culturally more evolved coastal Shell Tribe, which is led by Ahot (Jean Wladon), whom he impresses by killing an allosaurus. When Tumak tries to take Ahot's weapon, he is exiled once again and is joined by Loana on an epic journey back to the Rock Tribe. They find that Akhoba has been deposed by his equally cruel son, Sakana (Percy Herbert). Tumak fights and wounds his brother, who has attacked Loana, but spares him to general astonishment; Sakana is banished. Loana is carried off by a pteranodon, but she is rescued by her tribe, whom she persuades with cries of 'Akeeta, akeeta Tumak!' to take her back to the Rock Tribe. A battle ensues when Sakana, now leading a new tribe, attacks the Shell and Rock people. Tumak spears Sakana and is about to brain him with a rock when, like a Biblical judgment, a volcano sets off an earthquake. The film ends, in black and white, as a handful of survivors are left to unite and continue human evolution. There is an element of Cold War fable (the two tribes, in the west and east of the prehistoric landscape, really should put down their weapons) in this variation on the hero's journey 'myth' with which Hollywood is currently so enamoured.

One Million Years B.C. is genuinely memorable for the erotic spectacle of Welch (if you like that sort of thing) 'grunting and bulging out of her Stone Age Maidenform', as *New Statesman* put it, and Harryhausen's special effects which, despite his lifelong interest in dinosaurs, showcased his first dinosaur animations in a dramatic movie.[18] Having been in the film industry since the 1930s he had learned his mastery of stop-motion animation on *Mighty Joe Young* (1949), working with Willis O'Brien, who had done the effects for *King Kong*. Harryhausen then had a series of individual credits for screen effects on creature features and SF films such as *The Beast from 20,000 Fathoms* (1953), *It Came from beneath the Sea* (1955), *Earth vs. the Flying Saucers* (1956) and *20 Million Miles to Earth* (1957). Harryhausen is the greatest exponent of the painstaking technique of stop-motion animation pioneered by O'Brien. His process, known as Dynamation, uses front and rear projection to combine live action with miniatures. Budgetary limitations on *One Million Years B.C.*, however, enforced certain shortcuts. The first creatures on screen are not animated but an iguana lizard kitted out with a large rubber tongue, filmed at high speed and back-projected, and a real tarantula, blown up to giant size and eating a confusingly large grasshopper. Harryhausen 'felt it might add to the realism if the first creature we saw was a living specimen', and that, as well as making the animated ones looks comparatively more convincing, it would pay homage to earlier and shoddier representations of dinosaurs – parodying the original film before trumping it, as it were.[19] He later described this as 'an irrational mistake'.[20]

The dinosaurs, of which the most memorable are the young allosaur that attacks the Shell Tribe, a tyrannosaurus (or ceratosaurus, depending on which source you consult) battling a triceratops, and the pteranodon that snatches Loana, are shown as solitary creatures in continuous warfare, not so far removed from Disney's *Fantasia* (1940). This notion of dinosaurs derived in part from the dinosaur pictures of the artist, illustrator and muralist, Charles R. Knight, whose work Harryhausen admired, and it was not overturned in films till *Jurassic Park* (1993) represented dinosaurs as social beasts related to birds rather than slow-moving symbols of primeval violence. The imagery of dinosaurs as representing nature itself at its most unheeding and catastrophic was intrinsic to the

Dynamation dinosaurs by the great Ray Harryhausen in *One Million Years B.C.*

prehistoric genre's version of Social Darwinism. Unlike Godzilla or the mutated creatures of 1950s B movies, dinosaurs in prehistoric films are everyday terrors rather than punishment for human meddling in the secrets of nature. They belong in the landscape and are not chaotic interlopers to be heroically defeated in combat like dragons or the supernatural menagerie encountered in *Jason and the Argonauts*. One of the most beautifully animated sequences in *One Million Years B.C.*, for example, is the fight, traditional in the genre, between a tyrannosaurus and a triceratops, which Loana and Tumak simply watch and try to avoid.[21] But it is nevertheless worth mentioning that the dinosaurs in *One Million Years B.C.* resemble the giant creatures smashing up London in the handful of British creature features at the turn of the 1960s – *Behemoth – the Sea Monster* [*The Giant Behemoth*] (1959), *Gorgo* (1961) and *Konga* (1961). Reworking the irresistible scenario in Conan Doyle's *The Lost World* (1912) of a brontosaurus running riot in the capital, these are richly overdetermined re-enactments of the Blitz and symbols of the revenge of empire (as in *Konga*) and nature's power unleashed by the Bomb.[22]

One Million Years B.C. depicts essentially modern humans enduring what Stuart M. Kaminsky calls the keynote scenario of Chaffey's films: 'confrontations between inadequately prepared primitives and a hostile fantasy world'.[23] There is no attempt to enter the minds of beetle-browed Neanderthals; this is not the world of Edgar Rice Burroughs's Caprona in *The Land That Time Forgot* (1924). Tribal differences are

defined by hair colour, the women especially being divided into blondes and brunettes according to the criteria of pin-up magazines. Brunettes, as a rule, are feistier and less civilised; they are epitomised by Martine Beswick, as Tumak's girlfriend Nupondi, who fights Loana for his affections. Hair colour, which ordains temperament, tribal allegiance and even location on the evolutionary scale, is obviously a displaced treatment of racial difference and interracial sex. The fair-haired Shell people are generally more advanced than the dark Rock Tribe, which exists in a state of pure Darwinian struggle. The Shell people by contrast have tools, agriculture and are somewhat more altruistic. Tumak is shown as capable of learning from them – he is not irredeemably brutish, though he has never heard laughter before – so that his encounter with the Shell people is an experience of cultural evolution and his union with Loana a utopian blending of the best of higher and lower aspects of human nature. The volcano kills off the least sympathetic characters (and possibly the dinosaurs, the snakes in this harsh Eden) and Loana and Tumak stride forth as Adam and Eve leading the human race into a brave new shared future.

Visions of prehistory are always ideological: here, they seem to say, is mankind in its incomplete yet bare, forked and somehow truest state. As with evolutionary psychology, the implication hovers that the dawn of man is when our natures were fixed, especially our proper gender roles (strong men, subservient women). Prehistoric films and novels often pivot on imaginary key moments in the progress towards full humanity and comment on the continuation into the present of prehistoric attributes, especially the violence of cavepeople and their apeman ancestors, which, like original sin, can never be entirely repressed. *Quest for Fire* (1981), based on J.-H. Rosny, *aîné*'s 1911 novel, centres on the encounter between thuggish male Neanderthals and a gentler female prehuman, who teaches them more civilised habits, notably sex in the missionary position, and so leads them a baby-step up the evolutionary ladder. *The Inheritors*, William Golding's novel about Neanderthals, depicts, like Jack London's *Before Adam*, the extermination of a gentler human species by modern humans, whose genocidal brutality towards those they regard as devilish Others has obvious contemporary resonance. The use of prehistory is never innocent or merely scientific; the prehistoric human or 'apeman' is as much a symbolic type as Caliban, Yahoos and the Noble Savage and equally caught up in skeins of Biblical, racial and colonial discourse. Prehistoric people in their simple mythic world are both what we have evolved beyond (and *must* evolve beyond) and also more authentic in their paradoxically timeless embodiment of humanity uncorrupted by civilisation.

The depiction of men and women is therefore contradictory. On the one hand, they are incomplete versions of ourselves – or rather our *white* selves – and on the other, purer versions, primitive but nobly and enviably prelapsarian. There is nostalgia too of course for sharply defined gender roles. Racial difference, though, is far trickier to negotiate, especially in *One Million Years B.C.*, where all the characters are shades of white. There is a sense of this in one curious scene, cut out of the original US prints, in which Loana and Tumak are trapped underground in the lair of some cannibalistic black-furred gorilla men. These creatures seem to be the genuinely racial Other, outside the film's symbolic division of humanity into light and dark white tribes (identifying apes or the apelike with black people has been a trope of jungle stories since *Tarzan* and *King*

Kong). The film is unable to incorporate into its dualism these chthonic creatures of the white racial Unconscious.

The assumption that cavepeople, or at any rate the cavemen who defined humanity's essential nature, were fundamentally brutal was current in the mid-1960s. *One Million Years B.C.* anticipated *2001: A Space Odyssey* in feeding off pessimistic theories of the 'killer ape' and 'man the hunter', popularised by Robert Ardrey's 1961 book, *African Genesis*. The Social Darwinism this might imply is tempered in the film, however, by emphasis on the merits of the gentler Shell Tribe, which seems rather like some Swedish collective, and the civilising influence of Loana. But like *Quatermass and the Pit*, the film nevertheless circles around the idea that our evolved nature, forged in the unyielding world of the dinosaurs, is naturally aggressive. Only catastrophe will jolt 'us' into transcending it.

SLAVE GIRLS AND SURREALISM

One Million Years B.C. is one of Hammer's most complete achievements, innocent and erotic, exciting, juvenile but perfectly crafted in its own way. As the film was such a success, Hammer followed it up quickly with another prehistoric fantasy using the same sets at Elstree, *Slave Girls*. It has been claimed that the working title was *Slave Girls of the White Rhino*, though the screenplay dated 1965 is titled *Prehistoric Women*, the name it was released under in the US.[24] (It is not a remake of the 1950 American film *Prehistoric Women*.) Filmed quickly by Michael Carreras, who wrote it under his Henry Younger pseudonym, *Slave Girls* reflects Carreras's winning enthusiasm for bizarre projects and camp humour. The extravagance of CinemaScope mocks what even I, a long-term *Slave Girls* fan and collector, must admit is a threadbare production with a ramshackle plot, poky set, unconvincing special effects and dialogue, and a complete absence of narrative logic or coherent thematic development – none of which, happily, matters in the least.

The story – which has been likened to that of *Avatar* (2009)[25] – is about a white hunter, David Marchant (Michael Latimer), who is captured by natives in the forbidden African territory of the White Rhinoceros, and taken to the temple where they worship a rhinoceros statue. A flash of lightning splits the temple wall and Marchant finds himself in a possibly prehistoric jungle where brunette white Amazons take him before their queen, Kari (Martine Beswick, exuding 'dark sexuality' in showgirl costumes and an elaborate headdress.). Kari has enslaved all the men and a local tribe of fair-haired women, whom she gives to a neighbouring tribe of men as peace offerings (the tribe is called the Devils of Darkness, which may be a curiously inapt allusion to the 1965 British vampire film of the same name). With the help of a blonde woman, Saria (Edina Ronay), Marchant aids the blondes to rebel and free the imprisoned men, while Kari is impaled on the horn of a 'real' white rhino that magically appears out of the jungle. Marchant finds himself back in the temple, where lightning destroys the rhinoceros statue, to the delight of the liberated natives. Released by his native captors, he discovers that his adventures lasted only a few moments and, when he returns to lead another hunting party, it includes a woman who is or resembles Saria. The film was held back in Britain till 1968 when it was cut by twenty-one minutes and released as the bottom half of a double bill with *The Devil Rides Out*; the cuts were mostly to scenes back at the camp.

The result, depending on your tolerance for camp trash, is either what *Monthly Film Bulletin* called 'a ludicrous farrago' or a splendid, psychoanalytically rich allegory of gender conflict overloaded with fetishism, lurid subtexts and extravagant phallic symbolism. *Slave Girls* is like *Devil Girl from Mars* made by someone with no resources except shamelessness and a sense of humour. Carreras himself said:

> I made one terrible mistake in that film – it should have had speech bubbles because it was the *perfect* comic strip film. If we went back now and re-edited it, putting in balloons and the words OUCH and ARGHHH, it would be great.[26]

Like *She* and *The Vengeance of She*, it restates Hammer's fascination with primitive passions, reincarnation, the perils of glamorous women and the persistence of ancient superstitions. For the cultist, it is a cinematic Rorschach test and an irresistible semiotic playground, whose combination of eroticism, self-reflexive exploitation techniques (such as the blatant use of stock footage), and 'unhinged' subtexts demand full-blown interpretative fantasies rather than rational accounts of its ideological operation and stylistic methods (or lack of them). The film's possibilities are wonderfully suggested by a review in the ever-camp *Films and Filming* by Michael Armstrong, later the director of *Mark of the Devil* (1970) and writer of *Eskimo Nell* (1975). Armstrong reads *Slave Girls*, tongue in cheek, as a disquisition on the elusive boundary of reality and illusion:

> Throughout the film one assumes one thing and the illusion is immediately shown to be false … all combines brilliantly to produce a total falseness about anything that happens to be in the film. In this sense, it becomes a comedy for everything which appears real is always exposed as something artificial … an illusion.[27]

His review, like that of *Devil Girl from Mars* in the *Monthly Film Bulletin*, might be regarded as a minor landmark of cult reception in Britain: 'Yes', Armstrong concludes, 'the film may be boring as a mere piece of entertainment: but it is certainly a very sincere work of art, with a lot to say.'[28] Subsequent critical acclaim, however, has been sadly lacking, though did it receive lavish praise from David Pirie as a 'superbly and intentionally comic … and outrageous extravaganza which positively dwarfs even De Mille's more baroque conceptions', though he doesn't vouchsafe whether the film is actually about anything other than its own self-consuming flamboyance.[29] The consensus is summed up, though, more in sorrow than in anger, by the entry on the film in Tom Johnson and Deborah Del Vecchio's *Hammer Films: An Exhaustive Filmography*:

> *Slave Girls* is a terrible movie, and it is embarrassing to include it in a book about one's favourite film company. Even worse, it is not endearingly bad like *Plan Nine from Outer Space* (1959). It is just plain *bad*, and the less said about it the better.[30]

Other critics have been no kinder, for *Slave Girls*, hidden deep in Hammer's own lost continent, diverges radically from the kind of Hammer film that most fans approve of. Nevertheless, it does have a modest cult following, thanks to Beswick's lively performance

and the film's unabashed outrageousness. (As with *The Wicker Man*, there is a pleasing symmetry in that it is a cult film about a cult.)

If *One Million Years B.C.* is receptive to Jungian readings, then *Slave Girls* is riotously Freudian, given the pride of place given to whips and caressed and weaponised rhino horns, and the frank come-on of its British title. Its key theme does seem to be the battle of the sexes – central to sexploitation films once they got going in the late 1960s – and especially the proper relationship of equality between them. Marchant's sojourn into this Oz before time is never really explained, but it makes vague sense as a symbolic trip into a mirroring dreamworld in which the warring natures of men and women are dramatised with elemental simplicity. The key scene that defines sex as power, which I'll quote directly from the screenplay, is a stand-off between Kari and Marchant, which ends with Kari lashing out at him with a whip:

> DAVID What makes you so cruel?
> KARI Cruelty has made me cruel ... I was once their slave. Before the Devils came we Dark Ones were in bondage to the Fair Ones.
> She crawls towards DAVID.
> KARI You would have pitied me then, a meek cringing creature ... but you would not have wanted me.
> DAVID I don't want you now.
> KARI Why not ... ? Must a woman always be subservient to the man to be wanted?
> DAVID Neither should be dominant.
> KARI (craftily) You suggest we should be equals.
> DAVID Yes.
> KARI (smiling) Then I offer you equality. Share my throne and my kingdom with me.[31]

Kari represents the dark/masculine side of woman: sexually predatory (she gets miffed when Marchant rejects her), identified with the phallus (the rhino is her totem; she impaled a girl earlier on the statue's horn; and she dies believing she has power over the rhino charging at her – or rather trundling, as it is evidently a model on wheels), and capable only of dominating men rather than befriending them. Saria, meanwhile, is blonde and submissive and altogether more appropriate wife material for Marchant; hence, I guess, her reappearance at the end of the film, presumably to become Marchant's partner. The final shot of their shaking hands with a medallion embossed with a rhino symbol clasped between them represents the uniting of man and woman in a relationship not based on force and subjugation (and merely on sexist stereotypes). The phallus and its mythic power are now associated with Marchant, who has earned them by freeing the men from female domination and ending the reign of the phallic woman, the dark equivalent of the Aryan Ayesha. The film betrays a conservative inability to think beyond the dualisms of patriarchal and colonial discourses, though it is worth noting that Kari, in the dialogue quoted above, explicitly tells Marchant that it was white men who made her as she is. Her tyranny, as in *The Stranglers of Bombay*, is a product of oppression and it is this which caused her to convert hatred of whiteness into fetishised appropriation of its phallic power.[32]

The film's other theme is freedom, not just from subservience to the other gender but racial freedom too. The black natives at the end of the film, having seen the rhino

statue, which symbolises their oppression, crack and crumble to fragments before them, break into wild celebration and set fire to the temple. A seemingly interminable sequence then ensues of tribal dancing (Pirie said that *Slave Girls* was 'choreographed like a zany musical', but this scene is outright padding in the great exploitation tradition of spinning things out to fill the allotted running-time).[33] This seems an allusion to decolonisation: the natives have broken free of their white master (the rhinoceros) and overthrown the phallic law of the colonial father. The high priest of the tribe, the Kulnaka, has previously explained to Marchant why he must die for straying into the sacred lands of the White Rhino:

> At that time [when it was the domain of the White Rhino] tribes of the primitive white races came from the far north and having no fear of, or respect for our religion they entered this area and senselessly slaughtered the sacred beasts. Instead of falling upon them and killing them for the sacrifice, we of the Kulnaka set up a false idol and entered into a hideous pact with them. In this we displeased our Gods who placed us in spiritual bondage until the White Rhinoceros itself reappears.

As in *She* and most pulp fantasies, including *Avatar* and *John Carter* (2012), it nevertheless takes a white man to be the agent of their liberation and release them from their 'primitive' superstitions.

I am tempted to describe the film as 'surreal', though I am aware that that word does perhaps too much heavy lifting in legitimating trash cinema. By surreal I really mean its ambience of general weirdness and discrete scattered moments of photogenic bizarrerie rather than any settled relationship to Freudian or Lacanian theory which the film might be said to illustrate or exemplify. Nevertheless there is reason to use the word 'surreal'. It has rhetorical force in encouraging us to hunt for occult meanings and correspondences beneath the 'ramshackle' surface of the text. It captures too something of the film's sheer *unnecessariness*, that sense of hysterical excess underlying its ridiculous clichés, rampant symbolism (horns, whips, a huge fake moon, lightning flashes, rhino medallions, rhino-shaped mountains, suggestive soft fruit) and incomprehensible narrative non sequiturs. As Sue Harper and Vincent Porter comment, in reference to Hammer's horror films, the studio's 'field of operation is clearly the audience's unconscious. There, the films both lull and excite.'[34] What surrealist films do by intention, *Slave Girls* does spontaneously. Or, to adapt Kenneth Tynan's gag about Greta Garbo: what we see drunk in other films we see in *Slave Girls* sober. This is not the forced, intensely authored effect of weirdness you find in Buñuel or Ken Russell but an unwitting closeness to otherwise repressed, hidden or too neatly packaged desires and drives. 'Surreal' pays homage to the fact that plot summary and symptomatic interpretation cannot communicate that quality, shared by *Psychomania* and some other singularly trashy films, of evading rational discursive capture. Or, to put it less pretentiously, what sends me back continually to the film is its impenetrable oddity – I am really not sure what the film thinks it is doing and how deliberately and consciously it is doing it.[35]

The surrealists themselves found wonder and solace in popular films as places where the Unconscious had free rein. They adored *Fantomas* (1913) and anarchic silent comedies, the Marx Brothers and fantasies like *King Kong*, with its violence and *l'amour fou*,

which seemed 'to correspond to all that we mean by the adjective "poetic"'.[36] Their own films, such as *The Seashell and the Clergyman* (1928) and *Un Chien andalou* (1929), included elements that would become the staples of trash cinema – horror, sexuality, crazy juxtapositions and effects deliberately offensive to official aesthetic criteria. Their practices of ludic film criticism, such as irrational enlargements, continue to offer a model of excited cult engagement with film as something new, non-literary and uniquely connected to dreams and desire. One thinks of André Breton and his friends, cultists before the fact, darting in and out of cinemas, watching films in fragments so as to unmoor images from narratives.[37] The surrealists forged the connection between trash and the Unconscious and pioneered the belief that the lowest, 'worst' and most unrespectable forms of cinema could be sublime, in the much-quoted statement of Ado Kyrou, which is frequently cited on bad film fan-sites, 'Learn to see the "worst" films; they are sometimes sublime.'[38]

One quality of cinema that lends itself to surreal interpretation is precisely badness, the category to which *Slave Girls* has sadly and unreflectively been relegated. It is conventional to make a distinction between bad films generally and 'badfilm', often one word and sometimes capitalised, which refers to ultra low-budget movies whose badness is not ontologically separable from their other qualities. They are what J. Hoberman, in the best critical piece on the topic, calls 'objectively bad films'.[39] The term is meant to cut through subjective judgments and locate the films within a sort of genre that 'casually promotes perceptual havoc'.[40] These films evince amateurism, cluelessness, cheapness and misplaced seriousness. Technical shoddiness is the key. In the manner of classical exploitation, badfilms are so distant from the conventions of mainstream cinema as to represent an alternative universe of cinematic practice:

> At their best – which is to say, at their fascinating worst – movies like *Birdemic* can be surprisingly rich experiences. They don't merely afford us a groan at their wooden acting or a laugh at their crude charms: They drop us into a murky vortex of authorial intent, sabotage some of our most basic notions about character and narrative, and remind us of film's power to disturb, disorient, and discombobulate us.[41]

At best this is a welcome deviation from conventional notions of good taste and correct style – 'anti-masterpieces' of badfilm, as Hoberman says, 'break the rules with such exhilaration as to expand our definition of what a movie can be'.[42]

The surrealists' delight in the unexpected and the Unconscious lies behind the continuing appeal of bad films, and their proto-cult enthusiasm is a model of how seeming trash can fire the imagination. Thus we return to the foundational idea that trash is to the mainstream cinema as the Id is to the Ego, or, more accurately, that trash, above all other kinds of film, is the great involuntary spillway of the Unconscious. Brottman pushes this line in relation to offensive films:

> The unprofessional production values, clumsy narratives, and hastily conceived structure of such films, as well as their wide commercial appeal, give them the same kind of value that free association has in psychoanalysis, making them important vehicles for helping us to understand the bodily nightmares of the culture that gives rise to them.[43]

Slave Girls, however bad it might seem, is not *quite* a pedigree badfilm. It is not *Robot Monster* (1953) or *Plan Nine from Outer Space*, or, to choose British examples, *Gonks Go Beat* and *The Ghost Goes Gear*, which combine bewildering irrationality with technical incompetence. Like all of Hammer's films, it is professionally put together and there is no sense, as there is in badfilms like *Plan Nine from Outer Space* or *Birdemic* that the director, cast and crew were either deluded, on hallucogenic drugs or bamboozled by the business end of a movie camera.[44] *Slave Girls* is altogether more difficult to pin down. The film came at that turning point in the mid-1960s when the unconsciously camp weirdness associated with, say, Ed Wood and *Womaneater*, turned increasingly into something more poised and self-aware. Armstrong's interest in the film's camp possibilities – significantly a couple of years *after* the film was actually made at the time of its delayed release – alerts us to the fact that, if *Slave Girls* had been made ten years or even five years later, it might have been received as a hilarious pastiche rather than an outright failure. By 1973 Pirie was confidently describing the film as '*intentionally* comic [my italics]', which, even if meant in a spirit of teasing contrarianism, nevertheless confirms that reading it as deliberate camp had become, in the age of the midnight movie, a perfectly reasonable option.[45] In fact, Armstrong's earlier review is spot on, acknowledging, as the *Monthly Film Bulletin* review of *Devil Girl from Mars* did not – and perhaps could not – that the film *was* capable of being read not simply as outsider art but as a smart discursive essay about reality and illusion. Pertly drawing attention to its own idiocies and BDSM subtexts, *Slave Girls* uses its own falsity (lazy stock footage, over-the-top acting, Amazons with cut-glass accents, phallic symbols used *as* phallic symbols) as Sirkian (or Godardian) devices to subvert its diegesis. As we've seen, deliberate camp films – custom-made trash films, in other words – were emerging by the mid-1960s, and Beswick and Carreras were certainly aware that the movie's ridiculousness soared towards self-parody.[46] Beswick recalled:

> We were laughing hysterically all the time that we were making it. I mean, I was being serious about the acting We played it seriously because otherwise it would have been ridiculous. So we did go into it seriously, but we had a lot of fun.[47]

I don't want to suggest that earlier film-makers, however wide-eyed and clueless in the Ed Wood mould, were necessarily blind to the subtexts of their films. After all Freudianism had been a cultural dominant since the 1930s and it's unlikely that the implications of *King Kong* (huge black male with no penis lusting after a blonde girl on top of the world's most supremely phallic building) entirely escaped either the film's makers or its audiences. In the US at least, camp criticism in the 1960s by the likes of Parker Tyler was already aligning itself with the kind of countercultural and pop enthusiasm for trash and its creatively useful qualities, such as boredom, flatness and anti-illusionism, that led Andy Warhol to deadpan that *Creation of the Humanoids* (1962), an amazingly dull SF film, was his favourite movie. The subversiveness of the self-trashing film would usually be associated with auteurs; but it was becoming more difficult to assume that popular culture, even in its most degraded and stupid forms, was altogether untouched by the self-pleasuring ironies of postmodernism. *Slave Girls*, like *Modesty Blaise* (1966), may in fact have been one of the first *deliberately* bad and camp British

films, or at any rate exploitation films, and led the way to the trash aesthetic finessed by Antony Balch and other camp film-makers over the next ten years.

These days, of course, when trash has thoroughly lost its bloom of innocence, the appearance of a *truly* bad film, whose director really doesn't seem to know what stylistic foolishness and subtextual chaos he is wreaking, is rare enough to occasion cult celebration – *viz* the wonder of comically humourless disasters such as *The Room* (2003), *The Happening* (2008) and *Birdemic: Shock and Terror*.

BALLARD AND THE DINOSAURS

Hammer returned to prehistory with two more films. *When Dinosaurs Ruled the Earth*, written and directed by Val Guest, reworked *One Million Years B.C.* as a curious hybrid of children's adventure and sexploitation in which the action again centres on conflict between two tribes, here the Rock Tribe, which sacrifices its fair-headed women to the sun, and the more peaceful Sand Tribe, and ends with a tidal wave caused by a newly formed moon breaking away from the sun. Nudity (at least in the British cut) was added to keep up with the times and the cruelty of the earlier film is softened. There is even a cute baby dinosaur, as in *Son of Godzilla* (1967), for the heroine, Sanna (*Playboy* model Victoria Vetri), to tame and bond with. Guest recalled that:

> The treatment was done as a story, actually it wasn't in script form at all. I can't remember how long it was, but I imagine something like 20 or 25 pages. I departed quite a lot from that treatment. I took the basic line and one or two good ideas in it but then had to build it from there. It was a very sketchy treatment.[48]

Hammer glamour in a production still from *When Dinosaurs Ruled the Earth*

Nevertheless Guest's shooting script declares that 'THIS SCREENPLAY has been written with the intention of shooting it in completely FACTUAL style' and promises that using 'a form of Cinema-Verite for some of the Tribe sequences; drawing on Newsreel techniques for the Fighting Sequences; giving a stimulating YOU-WERE-THERE feeling to the overall subject' will make it 'an extension of the film treatment we used in THE DAY THE EARTH CAUGHT FIRE – in which Science Fiction was made to look like Science–Fact'.[49] The script draws on the rudimentary language invented for *One Million Years B.C.*, and meticulously notes which twenty-seven made-up words should be used in the dialogue (a glossary is included with the script).[50] The main ones are 'Akeeta!', 'Neekro!' and 'Akhoba! – the name of the Rock Tribe's leaders in both versions of

One Million Years B.C. – used in both films to refer to more or less everything. Publicity material for the film included an 'easy-to-use reference of prehistoric words and phrases', which explained that the plaintive 'Akhoba' could mean variously 'Help', 'Mercy', 'Please' 'Forgive me', 'Greetings' and 'So be it'.

The story, once again, has mythic overtones and takes place at a key moment of invented history. Whereas in *One Million Years B.C.* this was the earthquake that mingled the two tribes, here it is the creation of the moon. Instead of Harryhausen, who was working on *Valley of the Gwangi* (1969), Jim Danforth was brought in to create the impressive special effects. Initially hired for eight months, he eventually spent seventeen months completing the animation. According to Danforth, who had less control over the film's content than Harryhausen had, he was not involved in scripting the film:

> They had so many animation scenes planned that we'd still be working on it next year. Just impossible. They wanted sea monsters fighting in the water to be picked up by a tornado and deposited on a beach. They scripted aerial shots of dinosaurs running across the plateau and scenes of pterodactyls blowing in the wind and crashing into the village. Just incredibly complicated things that couldn't have been done in time and budget for that film.[51]

Other cuts included a sequence involving giant ants, which was scrapped after the live action had been filmed. Budget restrictions led to stock footage of battling lizards being spliced in from Irwin Allen's remake of *The Lost World* (1960); unfortunately, it was filmed in anamorphic CinemaScope, which meant squeezing it into a different aspect ratio.

Perhaps the most intriguing aspect *of When Dinosaurs Ruled the Earth* is that its screen treatment (just one page long according to Hallenbeck) was written by the great New Wave science fiction novelist, J. G. Ballard, though little of his conception remained in the film.[52] According to Ballard, Aida Young, who produced the film, 'had read my first novel, *The Drowned World* [1962], and thought that I might bring something of its atmosphere to their projected sequel':

> [Young and Anthony Hinds] talked enthusiastically about giving the new film a far greater psychological depth, it didn't take me long to discover that they really thought in terms of basic action-adventure – 'And the psychological dimension?' 'Exactly, he hits her over the head with a club' – they assumed the brooding atmosphere of *The Drowned World* could be aerosolled over the film in a tasteful shade of jungle green – I suggested what I thought were original story-lines, but they weren't impressed – 'More like *The Drowned World*, Jim', they would say, but this was the last thing they wanted – then Tony Hinds announced that his secretary has suggested the idea of the birth of the Moon – everyone seized on this as a brilliant and original idea (actually one of the oldest clichés of s-f which I would never have dared to suggest) – and of course, they chorused, the new Moon would produce a huge tidal wave (another age-old cliché) – at that point I was virtually on the way out, but I did suggest that rather than concentrating on the destructive power of the wave as it ran ashore they should show the bizarre fauna and flora exposed when the wave receded – this was virtually my only contribution to the film, apart from a general contribution to the story-line, and I don't think it throws any light on my fiction – in fact, my early novels were pitched against

precisely the sort of s-f clichés that the film contains The people at Hammer had enormous flair for popular Barnum & Bailey-style extravaganzas, one reason why their Dracula & Frankenstein films could be so good – once they tried to move into what they imagined was the 'psychological' they were completely lost, since that was already their domain (something they never grasped) along with Punch & Judy showmen, comic book artists and modern s-f, of which I am a proud part –

For reasons I won't go into I disliked the film, but I've only ever cared for *King Kong* among the monster movies, one of cinema's masterpieces – why couldn't the Hammer directors have made a film equally rich and moving? Because they were experts at manipulating the safe & well-established clichés, and felt a genuine sense of panic when even briefly faced with the new & original, like American tourists in the 1950's handling their 'first' foreign currency – it still worries me that Aida Young admired *The Drowned World*.[53]

Nor was there any sign of what Pirie claimed was the inspiration for the film, which is that it illustrated 'Horbiger's theories about violent cosmic upheaval and the creation of the moon'.[54] (Ballard flatly denied this.) Adding insult, Ballard is credited as J. B. Ballard. He later declared he was proud to have been involved in the worst film ever made.[55]

Creatures the World Forgot, Hammer's last excursion into prehistory, is nominally more realistic in that it is free of dinosaurs. Directed by Don Chaffey from Michael Carreras's script and filmed on location in the Namib Desert, southwest Africa, it is the starkest of Hammer's prehistoric films. The poster, with Julie Ege (Miss Norway 1961 and *Penthouse* Pet of the Month in May 1967) posed like Raquel Welch in *One Million Years B.C.*, promised 'Pre-historic love rites!' and 'Primitive chieftains duel in naked fury!' However, 'Staked girl menaced by giant python!' betrayed the film's major difference from the earlier extravaganzas. Except for the python, an unconvincing bear and the cavepeople themselves, there are no 'creatures' to speak of. Instead the film is a study of Stone Age tribes – predictably enough the dark Rock Tribe and the Scandinavian-looking Fair Tribe – trekking through expanses of harsh savannah, forests and swamp lands. Few spectacular moments interrupt the travelogue, though a couple of scenes of volcanic devastation are lifted from *One Million Years B.C.*

The plot follows the rudimentary structure of escape and recapture that underpins the other prehistoric films, with the action turning on a battle between hostile tribes, but its reliance on time shifts makes it virtually incomprehensible on first viewing. This isn't helped by the absence of any dialogue whatsoever. The actors merely grunt at one another, so that the film seems a throwback, as it were, to the first silent films about prehistory. In line with Hammer's exploitation strategy in the early 1970s, it was the first of the series to receive an 'X' rating, and instead of expensive special effects, the main attractions it exploits were nudity and violence.

Sans dinosaurs there is little sense of an archetypal battle between man and nature, though Stuart Kaminsky claimed to spot distinctively Chaffeyan themes: Chaffey's prehistoric films

> show small groups of confused modern/ancient men rooted in antiquity and looking like movie stars stepping carefully through a vividly colored world which can, literally, come

apart at any second. Fissures, lava and sudden natural destruction pervade his films, gobbling up minor characters as if the earth itself were some kind of colourful, horrible marshmallow. Chaffey, like Busby Berkeley, has more ties to George Méliès than he does to modern genre directors.[56]

Only the most reckless cultist would claim for it, however, any of the photogenically surreal undercurrents of *Slave Girls*. Robert Murphy commented that the primitives resembled 'a tribe of hippies on their way to the Isle of Wight'.[57] In fact this image of prehistoric people as proto-flower children, which was more attuned to countercultural faith in the benevolence of human nature, was replacing that of thinly disguised killer apes engaged in relentless Darwinian struggle. The rediscovered apeman in the same year's *Trog*, for example, is certainly violent but he more resembles an alienated young student than the throwback Id monsters of *The Neanderthal Man* (1953), *Monster on the Campus* (1958) or *The Nutty Professor* (1963). Hairy outsiders had new symbolic resonance and the apeman, as in The Kinks' 1970 song, had acquired more positive associations with nostalgia for a simpler life.

Hammer announced, and commissioned posters for, some further adventures in this vein such as *Zeppelin v Pterodactyls* and *The Day the Earth Cracked Open*, both planned for a 1972 release, and *Nessie*, a co-production with Toho scheduled for 1977.[58] But it was Amicus that revived the British prehistoric film with the Burroughs adaptations, *The Land That Time Forgot* (1975), *The People That Time Forgot* (1976) and *At the Earth's Core* (1977).[59]

Hammer's prehistoric films were not only, at their best, theatrically rich but also shot through with fantasies and anxieties about sex and Otherness, from which historical concerns their alternative worlds were temporary relief. But it wasn't all about sex and gawping at beautiful women in fur bikinis. The movies evoked an older, archaic world of myth and spiritual meaning. They were sexist, certainly, but elegies too for lost enchantment as much as for the end of empire, patriarchal confidence and bourgeois hegemony. They lamented a world discarded by anomic modernity: a purer world of gods, taboos, magic and mythology.

7 NAUGHTY!

'They're coming! They're coming! Men! Horrible men!'[1]

The British sexploitation film, as David McGillivray, its first historian, authoritatively states, can be dated from 1957, when the first nudist films and *The Flesh Is Weak* were released, to 1981, when production petered out with barrel-scraping efforts such as *Emmanuelle in Soho* and *Paul Raymond's Erotica*.[2] That is not to say British cinema had ever been entirely chaste; Gainsborough's whip-cracking melodrama *The Wicked Lady* (1945) is evidence of that. But as a topic for exploitation sex began in the late 1950s, just before, as it were, the end of the Chatterley ban and The Beatles' first LP. Sexploitation, like so much else, did not long survive the onset of Thatcherism, and fell victim to the arrival of video, tighter censorship, inflation and the abolition of the Eady Levy in 1985.

Softcore sexploitation in American cinema is usually dated from Russ Meyer's 'nudie-cutie' *The Immoral Mr Teas* (1959), which improved on nudist films such as *The Garden of Eden* (1954) by adding a plot, colour and a degree of self-reflexive humour. As the title suggested, it was not pornography like the stag film, or a moral tale like classical exploitation, but an amusing tease, in which, after having an anaesthetic at the dentist, a delivery man sees naked every woman he meets. It is focused on breasts rather than on the explicit depiction of sexual acts, and has a sunny and uncomplicated disposition towards the pleasures of voyeurism. British sexploitation, similarly, began with cautious 'A'-rated nudist films, which posed as propaganda for naturism, and then diversified into subgenres that responded to social trends, changing audiences, the vagaries of censorship and the financial success of key films. British sexploitation was kept in check by censors who rigorously distinguished between 'serious films' and exploitation and cut gratuitously arousing nudity and sex scenes. Consequently, sexploitation subgenres, such as sex comedies and documentary exposés, flourished in Britain long after the legalisation of hardcore had marginalised them in the US and continental Europe, and British film-makers had to find ways to attract audiences with extremely mild fare. By the 1970s, when sex films accounted for the majority of British exploitation, they remained mildly titillating softcore romps or, in the spirit of classical exploitation, were disguised as something other than attempted pornography – as social realism, for example, or documentary reports on alleged subcultural and suburban trends. This had advantages. Sexploitation was eligible for money from the Eady Levy, got shown in mainstream cinemas in the 1970s, and could draw mixed audiences with saucy fare related to TV sitcoms, adaptations of stage farces such as *No Sex Please – We're British* (1973) and the

dire *Not Now Darling*, and the bawdy British tradition of music-hall comedy and dirty postcards.

McGillivray describes British sexploitation as a genre with no redeeming features whatsoever and, on the whole, he's right. You can make a case for *Eskimo Nell* (it is generally regarded as the brightest spot in a dark period) and Antony Balch's surreal and rather wonderful *Secrets of Sex* (1970), but conventional value judgments aren't much use or relevance vis-à-vis delinquent paracinema like *Naked – As Nature Intended* (1961), *Come Play with Me* and the remarkable *Take an Easy Ride* (1976). The horror and SF films have their masterpieces but sexploitation tends to be enjoyed by cultists for different reasons – its endearing failure to be erotic, its inadvertent documentation of the 1960s and 1970s, and nostalgia for a lost world of political incorrectness. Sex films endure as records of a hidden history of film viewing that spoke to thwarted desires. They can also be seen as tracking the convolutions of permissiveness from the 1960s and 1970s as it evolved from an elite to a populist ideology, though the films themselves are rather distant from the actual counterculture they sometimes purported to expose. None of the films attempts to reach out to as well as exploit the counterculture as Roger Corman's, for example, did in the US from *The Wild Angels* and *The Trip* to *Gas-s-s-s* (1971). That was left to art films like *Performance* and *If....* . Sexploitation is more like a series of outsiders' views, recoiling from the smelly hairiness of young people, and aimed at round-eyed punters in sex cinemas and the suburbs. These were middle-aged films for people goggling about wife-swapping, foreign au pairs, the arrival of porn and the terrors of bra-burning feminists.

The 1970s is often seen as a strange amorphous period between two sharply defined eras of differing libertarianisms – the permissive 1960s and the Thatcherite 1980s (though for most people outside London the '1960s' didn't happen till the 1970s). Sexploitation films are sometimes held up as nightmarish mementoes of a hellish decade that taste forgot; naive at best, grotesquely conservative at worst. They can indeed be pretty grim and depressing, not so much excitedly exploring the new permissiveness as drearily counting its cost, but some, and especially the sex comedies, are engagingly enthusiastic about (male) sexual freedom and individual liberation. I can't help watching them with a certain nostalgia, which I am barely old enough to experience, not so much for their politically incorrect depiction of unreconstructed masculinity as for their unwitting evocation of a period of relative social equality and working-class power in the dog-days of progress and social democracy.

In 1982 McGillivray wrote that:

> Utterly worthless and insignificant, the [British sex film] will be completely ignored [in less than twenty years' time]. Nor is it likely that middle class intellectuals will rediscover the films in order to laugh at them at late night screenings. Unlike such chic trash as *Plan 9 from Outer Space* and *Santa Claus Conquers the Martians* [1964], British sex films lack even the redeeming quality of being so bad they're good. They're simply unwatchable by any standards, and will consequently disappear without trace leaving future generations to wonder, 'What were they like?'[3]

McGillivray hadn't counted on nostalgia for the 1960s and 1970s, cinephiles' perverse pride in a genre whose failings were also a mark of its pathological Britishness, and the pleasure of catching sight of numerous future film and TV stars caught literally with their pants down.

NUDISTS AND PLEASURE GIRLS

The nudist film from 1957–63 began with the release of the American offering, *The Garden of Eden* in the UK in 1959, which local authorities passed with a 'U' certificate. This was followed by British films, such as *Nature's Paradise* (1959) and *Travelling Light* (1960), *Sunswept* (1961) and *Eves on Skis* (1963). The most celebrated was *Naked – As Nature Intended*, made for Compton by the first key auteur of British sexploitation, George Harrison Marks.[4] Marks had been in a music-hall cross-talk act in the 1940s before turning to glamour photography in 1957 with his own publication *Kamera*, which showcased his partner and most famous model Pamela Green. Marks subsequently enjoyed a long career in the sex industry, from making 8mm glamour films available over the counter in camera shops to a run of extraordinarily inept feature films, *The Naked World of Harrison Marks* (1965), *Pattern of Evil* (1967) (made for the US market and never shown in the UK), *Nine Ages of Nakedness* (1969) and *Come Play with Me*. He also made some hardcore films as well as editing *Janus* and founding *Kane*, both spanking magazines. *Naked – As Nature Intended*, which had the working title *Cornish Holiday*, was a vehicle for Green, in which a bunch of friends tootle down to the famous naturist colony, Spielplatz in St Albans. Perhaps the most boring genre ever conceived, nudist films generally combined a rudimentary plot, travelogue and mobile 'art studies' of healthy young people engaged in such sporting activities as would ensure bouncing breasts, and were sufficiently anodyne to receive 'A' certificates from the BBFC. The films emphasise the naturalness of nudity, while the actors' shaved pudenda (though never actually seen) rendered them as pristine, fresh and unsexual as Victorian nudes or *tableaux vivants* at the Windmill Theatre.

In Britain film-makers did not proceed from nudist to cheesecake films on the Russ Meyer model. A more effective way of integrating sexual material with narrative proved to be the dramatic vice-exposé film, a variation on social-problem films like *Sapphire* (1959) and *Victim* (1961). In the tradition of classical exploitation, 'X'-rated films such as *The Flesh Is Weak*, about a girl dragged into prostitution, *That Kind of Girl* (1963), about venereal disease and *Secrets of a Windmill Girl* (1966), which detailed the dangers of the vice industry, used a risqué contemporary issue 'torn from the headlines' as an excuse to speak openly and moralistically about sex, especially as it related to a threat to women and youth. As Michael Ahmed notes, *That Kind of Girl*, which its producer, Tony Tenser of Compton-Tekli, described as 'a new wave drama', 'neatly incorporates two strands of late 1950s British film genres, social realism and lurid horror'; the New Wave 'kitchen-sink' films allowed film-makers 'to embrace themes that had previously placed their films firmly within the exploitation market'.[5] *The Yellow Teddybears* (1963), an 'exposé' of teenage promiscuity supposedly based on a newspaper story and one of Compton-Tekli's biggest hits, is about girls at a London school who start wearing yellow teddybear badges to mark the loss of their virginity. Tenser claimed that

> I provided the original idea, as I do for most of our films. We wanted to call it *The Yellow Golliwogs*, but Lord Morrison [Home Secretary] objected. He said it would bring publicity to the school where the girls actually wore them.[6]

The films' worried fascination with women differentiates them from the more male-centred New Wave films, in which women were given few plotlines beyond pregnancy and abortion, and their exploitation angle makes them seem less like middle-class films reporting back to middle-class audiences. At their best they were films of considerable raw impact, made by talented young working-class directors, as the producer Ray Selfe explained to Simon Sheridan:

> Many of these films' directors were regarded as the 'boys on the other sides of the tracks' and were really not accepted by the British movie community. People coming from working class backgrounds would never have been given the opportunity to make movies in the 1940s and 1950s, because we would have been excluded from the system But this stopped with the birth of British sex films.[7]

A cinematically more vigorous style of exploitation reportage derived from the so-called 'mondo film', after an Italian documentary of 1962, *Mondo Cane* ('a dog's life'), which was a sarcastic journalistic compilation of exotic sights, startling incidents and staged curiosities from global locations – 'a hymn to death and mutilation, embellished with a shrug and a giggle' (*Monthly Film Bulletin*, January 1963). It was initially refused a certificate but widely shown by local authorities and finally passed with cuts.[8] Its worldwide success led to numerous sequels and imitations, usually mapping the emerging sexual counterculture. British efforts began, however, with Stanley Long and Arnold Louis Miller's *West End Jungle* (1961) – a 'report on undercover vice after the Street Offences Act of 1959' (*Daily Cinema*, 4 August 1961). Pre-dating *Mondo Cane* and owing something to Free Cinema's use of light cameras and location filming, *West End Jungle*, just fifty-five minutes long, ran into censor problems and was banned. It was nevertheless shown at the Cameo-Poly Film Club in London and passed by local authorities in Cardiff, Leeds and Coventry for over sixteens. *Monthly Film Bulletin* remarked that it was 'undeniably factual and well organised' (September 1961) and *Kine Weekly* gave it a good review – 'Crisp, up-to-the-minute documentary', 'First rate screen reporting' (10 August 1961) – though *Variety* complained that 'what it offers is very much the same thing as it purports to deplore' (1 November 1961). The film's high moral tone, simultaneously condescending and empathetic, feigned contempt for both its subject matter and audience. Follow-ups included *London in the Raw* (1964), *Our Incredible World* (1966) and *Primitive London* (1965), which combined footage of childbirth (a staple of exploitation), striptease, hair transplants and intimations of a hidden and 'primitive' subcultural London 'behind', as the promotional material cried, 'the facade of respectability': 'The Capital city [now] lives at a fast pace, a dizzy hangover from the wartime "easy come, easy go, spend it while you can" attitude.' (The film opened at the Windmill Theatre with Vicki Grey and her pet leopard in attendance.) *Our Incredible World* – 'Millions of us enjoy it – what strange creatures we are' – was a 'cash in on *Mondo Cane*' (*Variety*, 26 October 1966). The sights included visits to a slaughterhouse,

the removal of twelve piglets from a sow's uterus, eye operations and the extraction of a wisdom tooth – the soundtrack introduced a sequence with 'Many of you will not be able to watch the next sequence but we bring it to you because it happens and is part of this incredible world.' Recut to include new nudist sequences, it was retitled *The Mystery and the Pleasure*. Later mondo films such as *Extremes* (1971) homed in on Hell's Angels, drugs and hippies and promised that 'This film is a statement of fact. Nothing was staged. Nothing was shot for sensation.' Psychogeographies of permissiveness, the films mapped a country transformed by new subcultures, but they were spectacles of horror as much as eroticism and muddled high and low within an overarching category of the sensational. The result was a genuine trash aesthetic of recycling and recombination – an indiscriminate and influential style of raw bricolage and instructional voyeuristic shocks.

The first British sex films were made by Norman J. Warren for the producer Bachoo Sen, *Her Private Hell* (1968) and *Loving Feeling* (1968). *Her Private Hell*, as Simon Sheridan points out, was the first British film 'to show women and men in bed *having sex just because they want to*'.[9] According to Warren, 'There was no script at the start. Bachoo Sen and Richard Schulman [the co-producer] just knew they wanted the story to include sex.'[10] Its sleazy plot tracked an innocent Italian girl straying into the coils of the Soho porn industry, but Warren's style, generally more imaginative than the run of exploitation film-makers, was inspired by European art films rather than the British New Wave. *Loving Feeling*, a comparatively lavish followup to *Her Private Hell*'s considerable success, was about a male DJ grappling with groupies and its downbeat conclusion, in which the DJ finds himself alone and unloved, was in line with the 'awful warning' of the square-up – as the poster says, he 'played so much he wore out'. In contrast to the enthusiasm for recreational sex in the period's illegal hardcore films, it is remarkable how few softcore films, except the comedies, were able to take a positive view of permissiveness.

As sexploitation industries grew in the US and Europe, niche cinemas sprang up to showcase them. Cinema clubs, starting with Tony Tenser's Compton Cinema Club in Soho in 1960 (by 1965 it claimed 50,000 members), took advantage of a loophole in the law that allowed uncertificated films to be shown under club conditions – in 1968 this cost 10 shillings for membership, after which one had to wait an hour and then pay 10 shillings a time.[11] The films were softcore, but also included ones banned by the BBFC such as *The Wild One* (1953).[12] Others were 'specialist' European films distributed by Tenser and Klinger's Compton-Cameo which

Softcore thrills at the Jacey Piccadilly advertised in *Continental Film Review*

could not get onto the Rank and ABC circuits, whose dominance, according to Michael Ahmed, 'over the development of the British film industry was extremely damaging'.[13] The products of the fledgling British exploitation industry as well as cut-down versions of product from elsewhere were screened at the Compton and other cinemas owned by Tenser and Klinger, such as the Windmill Cinema Club, and by the Jacey cinema chain run by the Cohen family. These cinemas mushroomed in most provincial towns, showing double bills of softcore, often leavened with saucy art films. In the US grindhouse cinemas, such as those on 42nd Street in New York, developed a drug-fuelled homo-erotic ambience; their British equivalents were probably more sedate, especially in the 1960s. According to Warren:

> In the case of a 'sex programme' the majority of the audience would be male, between the age of 25 to 55 and from all areas of society. The men were usually on their own and the atmosphere was strangely quiet, with everyone keeping themselves to themselves. It was the age of the 'raincoat' which meant the audience tended to all look alike. I'm sure many would feel slightly guilty at being there and would keep the collar of their raincoat turned up in an attempt to hide their face.[14]

PERMISSIVE DRAMA

While in the 1960s films such as *The Yellow Teddybears* had explored sexual themes and youth misdemeanours, a new subgenre, the 'permissive drama', took off in 1970 with films such as *Permissive* (1970) and *Groupie Girl* (1970), which cashed in on the rock scene and its exploitable hangers-on such as groupies and drug addicts. Permissive drama ran from 1968–79 and twenty-nine were produced in total in the 1970s, exposing newly visible transgressions including lesbianism (the surprisingly sensitive *Monique* (1969)), and jailbait sexuality in *Twinky* (1970), *All the Right Noises* (1971), *Mumsy, Nanny, Sonny and Girly*, *I Start Counting* (1969) and *Baby Love* (1968), which starred Linda Hayden as a working-class Liverpudlian nymphet who, in a variation on Pasolini's *Theorem*, seduces and destroys a fashionable metropolitan family.[15] Permissive dramas offered snapshots of both changing mores and the pleasurably reprehensible behaviour of the liberated young.

Lindsay Shonteff's *Permissive* was one of the most striking films to exploit the counter-culture, and worth discussing in more detail to explore how British sexploitation combined eager sensationalism with disapproval. Variously known during filming as *Suzy Superscrew*, *The Now Child* and *The X Project*, *Permissive* was made for Tigon for less than £20,000 and played on a double bill with another Tigon production, the lesbian drama *Monique*. It is not quite what you might expect from a 'sexploitation' film intended to cash in on the notoriety of groupies. Groupies were certainly a timely topic for exploitation. The antics of high-profile groupies like the GTOs and the Plastercasters were widely documented in the rock press in 1969. *Groupie Girl*, one of two films on countercultural themes by Stanley Long (the other is *Bread* (1971)), achieves a certain sense of authenticity because it was co-written by Suzanne Mercer, a groupie who had gone out with a member of Juicy Lucy. Rather than a gleefully tacky celebration of free love, *Permissive* is a lugubrious cautionary tale of a girl from the country joining the London 'scene' and learning only too well its lessons of detachment

and exploitation. Arriving in London in a duffel coat and with no backstory whatsoever, Suzy (Maggie Stride) hooks up with an old schoolfriend, Fiona (Gay Singleton), who hangs around a folk-rock band, Forever More (a real band, who made a couple of albums for RCA). Faintly echoing *All about Eve* (1950) Suzy proceeds to inveigle her way into the territorial, backbiting world of the groupie and screws her way through the band, eventually notching up Fiona's lover, the gnomish lead singer Lee (Allan Gorrie). Distraught, Fiona slashes her wrists in the bath and Suzy, unmoved by her friend's suicide, takes her place as queen of the groupies.

Instead of a plot, *Permissive* strings together abrupt fly-on-the-wall vignettes of the band lounging around hotel rooms, touring in a van and performing at gigs (as well as Forever More, songs are by two other Jethro Tull-ish bands, Comus and Titus Groan), while Suzy wanders the streets with Pogo (Robert Daubigny), a folk-singing dropout, and has sex with interchangeably hairy musicians. The tone is downbeat and condemnatory and the view of the rock scene as disillusioned as *Slade in Flame*. Listless, pessimistic and poverty-stricken, *Permissive* achieves an unusual level of grubby authenticity. Location shooting eschews the usual tourist traps and red buses of Swinging London films in favour of anonymous hotels, bombsites and places to squat and beg (in this it anticipates the anti-heritage London of *Naked* (1993)). There is a melancholy sense, as *Withnail and I* retrospectively laments, that this is 'the end of the greatest decade in the history of mankind, and … we have failed to paint it black'.

A typically cheery shot of groupies from Lindsay Shonteff's *Permissive*

The British Board of Film Censors required numerous cuts to all five reels of *Permissive* for an 'X' certificate, trimming the film to seventy-five minutes. The cuts included uses of 'fuck' and 'fucking'; all references to unzipping trousers and 'plating', the film's hip preferred term for blow jobs; shots of pubic hair; and the whole of a lesbian seduction scene. The cuts were so extensive that it is a mystery what sexual material could have remained. But the film is more interested in communicating ennui than sensual excitement. Sexual content is pared down to brief shots of pale nudity and glimpses of writhing flesh, frequently intercut with snippets of other scenes, which rather defuses their erotic charge. Only the lesbian scene is conventionally pornographic in its lingering voyeurism and even then extra-diegetic flash-cuts disrupt the punter-pleasing close-ups of naked breasts.

Easy Rider perhaps inspired Shonteff's use of flash-cuts, which, as in *Performance*, confuse chronology and introduce a sense of foreboding and circularity. Images of Fiona's and Pogo's deaths burst into scenes from early on and the film begins, ominously, with a freeze-frame behind the opening credits of Suzy impassively watching Fiona die in the bath. Also reminiscent of *Easy Rider* are extended shots of the landscape as the group's van trundles from gig to gig. Whereas in *Easy Rider* these display the glorious freedom of the American wilderness, in *Permissive* they are merely repetitive and boring shots of the motorway verge and claustrophobic grey skies that get darker as the film goes on.

In its glum sleaziness, *Permissive* was in fact little different from the other permissive dramas that sought to exploit the counterculture. *Monthly Film Bulletin*, which ended its review by condemning 'the inordinate foolishness of the whole enterprise' and commented that *Permissive*'s story is 'curiously elliptical' (February 1971), misses the point of its uninspiring atmosphere and unengaging storyline. The film has no humour and very little emotion, except towards the end when Fiona fights Suzy at a party and bloodies her nose. In short this is a cold-eyed outsider's overview of a 'love generation' that has little time for love, beautiful people so intent on 'cooling off' and not being 'uptight' that they have cauterised their emotions. Suzy is a social vampire whose unflinching availability unsettles even the predatory band members. Finding Fiona in the bath she stares blankly, closes the door on her friend and walks off leaving her to die (the effect is enhanced by Stride's acting, which is inexpressive to the point of catatonia). Only Pogo, who declares that 'the world is my scene' and with whom Suzy shares a platonic night of homelessness, seems genuinely to care about the wider world. But he turns out to be a religious fanatic. After delivering a hysterical impromptu sermon about poverty and war to a near-empty church, he is arrested and then arbitrarily killed in a road accident. References to politics or even the world 'off scene' are otherwise pointedly absent. The world of the groupie is closed off, disconnected and entirely self-involved. While some British exploitation films, especially the horror films, come across as anti-Establishment critiques with a powerful sense of generational conflict, *Permissive* seems drained by a culture of exhaustion, drift and aimlessness, and the erotic content is as uninspiring as in *Groupie Girl*, which *Films and Filming* described accurately enough as 'a ninth rate skin flick with the ugliest, spottiest, dirtiest assembly of misshapen non-actors since Tod Browning's 1932 *Freaks*'.[16]

If not exactly feminist, the film echoes feminist disillusionment with the counterculture's ideology of free love. As in *Groupie Girl*, the men are arrogantly misogynistic

and possessive (even Fiona describes Jimmy (Gilbert Wynne), the road manager, as a 'creep') and the women are tolerated insofar as they are useful for sex or chores. Nothing here is as rich in misogynistic symbolism as the scene in *Groupie Girl* when a girl is bundled from one speeding van to another on a motorway, but *Permissive* is nevertheless an exploitation film implicitly about the exploitation of women. Suzy succeeds as a groupie because she understands the band's misogyny (at one point she accuses Lee of making Fiona do all his 'dirty work') and learns to beat the men at their own game of strategic promiscuity. When Lee accuses her of 'fucking around too much', her justifiable retort is that he is a 'hypocritical bastard'. What is missing, of course, is any sense of female solidarity and it is Fiona who pays the price for Suzy's own icily methodical exploitation of men's fecklessness and lust. Its success encouraged Tigon to bankroll Shonteff's next sexploitation film, *Take Some Girls*, released as *The Yes Girls* (1971), which was also about a provincial innocent corrupted by London, this time by falling in with softcore pornographers.

Permissive and *Groupie Girl*, like *The Yes Girls*, Pete Walker's *Cool It Carol!* and Kenneth Rowles's *Take an Easy Ride*, warned against the very pleasures they exploited and in particular the dangers of the sex-drenched metropolis. The hypocrisy infuriated critics. As *Today's Cinema* put it in a review of *Groupie Girl*, 'The whitewashing of an implied message purporting to discourage girls from becoming groupies is offensive in a film that sets out to titillate so blatantly.' But a moralistic tone was a standard, and necessary, strategy of exploitation films and was designed to appease censors and audiences by presenting the films as serious-minded and educational. British sexploitation's recurring theme of respectable daughters ruined by permissiveness doubtless resonated, too, with the fears of its middle-aged male suburban viewers.

Although sex films like *Loving Feeling* and *School for Sex*, *Cool It Carol!* and *Some Like It Sexy* (the last three are gritty in the social-realist tradition) were commercially successful, British sex cinema turned increasingly to comedy in the *Carry On* style not least because there was the possibility of crossing over into mainstream cinemas. They could not in any case follow continental European and American sex films into hardcore porn (the first widely released US porn film, *Mona*, was in 1970). The sexploitation films of the 1960s found their *anni mirabiles* in the 1970s. Driven by permissiveness, and allowed more leeway by the age of entry to the 'X' certificate being raised from sixteen to eighteen, low-budget sex comedies, permissive dramas, sex education films (known in the trade as 'white-coaters') and sexploitation documentaries helped sustained the British film industry in the 1970s. As McGillivray, who worked in sexploitation as well as scripting horror films for Walker and Warren, pointed out in 1976, the films made excellent business sense:

> First and foremost exploitation films are extremely easy to set up. This means regular employment in a business in which there is heavy unemployment … . Secondly, exploitation films are a sound investment in a business in which only the very rich or the very gullible generally dabble. (But bring in a sex comedy for under £50,000 – quite feasible – and you'll be very unlucky not to get your money back within eighteen months.)[17]

As one of the few games in town, they were made by a surprising number of name directors, from Val Guest to Jack Arnold, and starred familiar TV actors, who, while not exactly slumming, knew that sex comedies represented steady work. The fly-by-night productions of leading 1970s sexploitationeers like Stanley Long and Derek Ford and films like *Come Play with Me* and *Confessions of a Window Cleaner*, which was backed by Columbia, ran for months or even years at Soho sex clubs and provincial theatres. *Confessions* was held over for six months in Leicester and *Come Play with Me* ran for four years at the Classic Moulin in Great Windmill Street.

LOVE VARIATIONS

The most popular solutions by far to enforced castration by the BBFC were the sex comedy and the sex documentary. Sex comedies peaked in 1975. Six were made in 1971, seven in 1972, eight in 1973, ten in 1974, twelve in 1975, eight in 1977, five in 1978 and two in 1979. They combined simulated sex scenes with saucy humour in the tradition of the *Carry On* films and the crude bawdy of sitcoms of the period, such as *On the Buses* (1969–73) and *Mind Your Language* (1977–86) and their feature film spin-offs, which Julian Upton has described as 'the only domestic cinematic trend to see the decade through'.[18] The *Carry On*s attempted to compete with the boom in sexploitation films with two disastrously bad entries, *England* (1976) and *Emmanuelle* (1978), which earned the series its first 'AA' ratings. Titles such as *Percy* (1971), *Confessions of a Sex Maniac*, *Can You Keep It Up for a Week?* (1974), *Penelope 'Pulls It Off'* (1974), *I'm Not Feeling Myself Tonight* (1975), *Adventures of a Taxi Driver* (1975) and *Eskimo Nell* have come to define the British contribution to erotic cinema – 'ghastly British cinematic abominations', as Julian Petley dubs them, 'the majority of which were neither sexy nor comic'.[19]

Their unglamorous vulgarity is that of the ever popular British take on the 'real wives' genre of pornography, which offers a proletarian (or, more pretentiously, Bakhtinian) focus on the body's low pleasures, represented by 'Readers' Wives', an invention of David Sullivan's.[20] In the sex comedies as in softcore magazines like *Fiesta*, there was, in Feona Attwood's words,

> a particular brand of carnival in which ordinary life becomes a fiesta because of the endless opportunities that can be filched from the routine of life for physical pleasure – for sex and laughs; a utopian and vulgar practice of everyday life.[21]

The sex comedy played not so much on the audience's fascination with sex as on its embarrassment about it, and lived up to the national stereotype of the British as a sniggeringly repressed people, who, to paraphrase George Mikes, had hot water bottles instead of sex lives. As Ian Conrich has noticed, 'the British male's sexual fantasies about the provinces are of the ordinary, recognisable and available woman and her libidinous neighbour'.[22]

Key – indeed now iconic – films such as the *Confessions of a Window Cleaner* record the farcical exploits of a working-class young man taking advantage of the new 'permissive society'. Leon Hunt has traced how the discourse of 'permissiveness', which was articulated in 1970s sex comedies, embodied an attitude to sex typified and popularised to the working classes by the *Sun* newspaper under Rupert Murdoch's ownership from

1969, a 'vulgar hedonism' that testified to a 'mythology of lowbrow (male) sexual "liberation"'.[23] Unlike the *Carry On*s, which centred on the impossibility of sexual fulfilment, the sex comedies gazed yearningly at a male-centred paradisiacal world of instantly available dolly birds and carefree serial copulation. The women were willing (often alarmingly willing) sex objects, the men permanently randy if frequently inept, and the attitude to sex firmly consumerist – something you got whenever the opportunity arose. The *Confessions* comedies 'celebrated the joys of laddish abandon and zipless, post-Pill hedonism' and contrasted Robin Askwith's proletarian dynamism with his customer's pretence of bourgeois rectitude.[24] As Sian Barber says, Timmy (Askwith's character in the *Confessions* series), 'attempts to be upwardly mobile and circumnavigate class barriers, while simultaneously remaining firmly rooted in his working-class background'.[25]

By the early 1970s most sexploitation films were changing from cautionary tales of the effects of unrestrained pleasure-seeking to cautious condemnations of the effects of sexual repression. As permissiveness filtered down to the ordinary punter, they managed to reflect something of the liberated pleasures newly available to their working-class and suburban audiences, which, as Barber remarks, were nevertheless likely to be 'thoroughly conventional'.[26] The funniest was *Eskimo Nell*, written by Michael Armstrong and directed by Martin Campbell, which was something of a *film à clef* of the sex industry, with Benny U. Murdoch, played by Roy Kinnear, parodying producer Tony Tenser. Although the most high-profile success was the *Confessions* series, there is no escaping *Come Play with Me*, which is iconic in terms of British trash cinema and a film so strange and unexpected that it verges on avant-garde. It was directed by Harrison Marks, whose career in porn had stalled after he had been tried at the Old Bailey in 1971 for dealing with pornography by post, and was intended as a vehicle for the porn baron David Sullivan's girlfriend Mary Millington, who was noted for her campaigning enthusiasm for sex. Sullivan owned the chain of Private Shops, which tended to sell mild pornographic material while promising 'strong' stuff. *Come Play with Me* was promoted in his magazines such as *Whitehouse* (cheekily named after the anti-porn campaigner, Mary Whitehouse) by a similar strategy, with rumours of a non-existent hardcore version. This so upset Equity and the film's uniquely mismatched cast, which included Irene Handl and Alfie Bass, that Equity put out a press statement denying their involvement in hardcore.[27] *Come Play with Me* is a truly bizarre hybrid of music-hall comedy and sex film, highlighted by musical dance sequences and as incoherent as you might expect a film made by a long-term alcoholic to be. Millington devotees generally appreciate not only her girl-next-door looks but her seemingly genuine enthusiasm for sex. As Leon Hunt put it, she 'became pornography itself, a distillation of its self-justification, its martyrdom and its unfulfilled utopian promises'.[28] Shadowing both Marilyn Monroe and Linda Lovelace, she typified the troubled female star, and her suicide was blamed on persecution by the authorities for her proselytising for pornography. This was the burden of the posthumous *Mary Millington's True Blue Confessions* (1980), which uniquely combines tasteless obituary, self-serving exploitation and persuasive condemnation of the forces of reaction.

The other popular subgenre was the sexploitation documentary, of which the most straightforward and apparently instructional versions were the handful of British-made

sex-education films that began with *Love Variations* (1969) and *Love and Marriage* (1970). *Love Variations*, directed by David Grant under the pseudonym Terry Gould, was given an 'X' in London. The film consisted entirely of alternating scenes of a 'family doctor' showing diagrams of sex positions and illustrative tableaux of naked posed figures faking coitus in increasingly unlikely and back-breaking postures. The producers stressed their good intentions to the censors, while the press book stated, more than a little disingenuously,

> The film does not seek to entertain – only to inform. The producers wish to point out that although the film is frank, comprehensive and explicit it will almost certainly prove unrewarding to those looking for titillation or sensation and will be of interest only to those motivated by a sincere desire to be informed.

The BBFC, indecisive about how to treat sex-education films, accepted this, but nevertheless at first rejected *Love Variations* on the splendidly perverse grounds that, since the film was not entertaining it was unsuitable for cinemas, which were essentially places of entertainment. When finally released, *Love Variations* smashed house records at the Jacey Tatler Cinema in London, taking £19,309 in the first three weeks and achieving seventy-one capacity houses out of eighty-five performances (*Kine Weekly*, 8 August 1970). The censors remained opposed to sex films without even an inadvertently educational value, as the chief censor, John Trevelyan, explains:

> We used to pass the more educational ones, believing that they might be helpful to some people, even to people who went to see them for other reasons, but we used either to ban or to cut those which were clearly made for sex-exploitation.[29]

The sexploitation documentary emerged in the 1970s as a fascinatingly impure and often haphazard style of realism, which voyeuristically depicted forbidden worlds of sexual pleasure and the interpenetration of subcultural, countercultural and suburban practices. Usually presented as drama-documentary exposés, they awkwardly combined a semi-documentary look at emerging sexual trends with moralistic disapproval and a campaigning condemnation of Victorian prudishness. *Naughty!*, a report on porn made by Stanley Long, typified both the sexploitation documentary's promiscuity of style and its ideological commitments. A political, albeit self-serving film, it took the side of the younger generation and the 'average man in the street' against the oppressions of the old order and appropriated the discourse of permissiveness in the name of popular sexual liberation. Like the sex comedies, *Naughty!* was enraged by Victorian values and what its press book describes as 'structures imposed by moralising law-making sections of society', and emphasised the difference between healthy permissiveness and the supposed hypocrisy and repression of the Victorian era. Stanley Long, interviewed in *Cinema X*, thundered:

> Believe me, we have very little to teach our Victorian forefathers Under the guise of middle class respectability, Victorian men were secret monsters, living a complete double life. Some of the most extraordinary pornographic books were written and published in

Victorian times, 'Walter' being only one example. And what went on in private when Queen Victoria thought that she was ruling a church-going, God-fearing country is almost beyond belief.[30]

Like the British horror film in the 1970s, sexploitation films were addressed to audiences understood to be either sympathetic to or at least tempted by alternatives to repressive middle-class hypocrisy. *Today's Cinema* noted that *Naughty!* 'should prove very popular with the elderly raincoat and the youthful Kaftan trades alike' (1 October 1971).

While the sex comedies tracked working-class sexuality, the documentaries more often contrasted the boredom of suburban living with the promise of permissive sex. The penetration of a new sexual morality into 'the sexual desert of suburbia', as *Suburban Wives* (1971) called it, particularly agitated a remarkable series of sex documentaries made by Derek Ford and Stanley Long ('Britain's Russ Meyer', according to *Cinema X*).[31] These were vignette films showcasing a variety of documentary techniques, whose multiple storylines, held together by sardonic voiceovers, worked through the impact of permissiveness on the suburban middle class and the proliferation of tempting new alternatives to married convention. The first of the series, *The Wife Swappers*, directed by Ford in 1969, was a cautionary tale that depicted swinging as 'a game of increasing risk and diminishing returns' even as it revelled in the opportunities for nudity. Blaming women's lib and the Pill for outbreaks of wife-swapping, the makers claimed it was intended for thirty-five-year-olds.[32] According to McGillivray, it cost only £16,000 but became one of the most successful British sex films ever made.[33] It broke the daily house record at the 450-seat Cinephone moviehouse in its opening week with £3,723 (*Kine Weekly*, 5 September 1970) and was still consistently making nearly £1,500 in its twentieth week at the same cinema (*Kine Weekly*, 4 July 1970). *Suburban Wives* was followed by *Commuter Husbands* [also known as *Sex Games*] (1972), *Sex and the Other Woman* (1972) (about adultery), *On the Game* (1973) (prostitution) and *It Could Happen to You* (1975) (VD, reissued as *Intimate Teenage Secrets*). Despite their often baffling confusions of style, tone and moral address, these films coherently articulated ideological positions justifying permissiveness as reviving the natural man repressed by suburban life and taking for granted the fact that the battle of the sexes is an eternal state of affairs. 'A woman is a completely different creature from the male', *Suburban Wives*' voiceover wearily intones, while in *Commuter Husbands*, over a shot of a bowler-hatted gent, the narrator languidly declares, 'At first sight the commuting man is a peaceful law-abiding creature, placidly accepting the dullness of his nine to five routine and the burden of his thirty year mortgage' but inside 'he 'blazes into breathtaking fantasy'. *Commuter Husbands* is explicitly organised by a theory of man as a hunter, his natural self damped down by contemporary work, and consists of six stories told by a woman in order to support its pseudo-anthropological homage to *The Naked Ape:* 'MAN, when off the leash, reverting to his natural role as the HUNTER, a predator with an appetite not for food, but for a more tasty dish called WOMAN', as the press sheet puts it. According to Ford, interviewed here in *Cinema X*, it was the film's humour that set it apart:

> Ford's almost Ealing comedy approach is a breath of fresh air to the nudie market. 'In America', he reports, 'they've released [*Suburban*] *Wives* as a family picture – heavily cut,

but as a naughty family comedy.' He's more surprised with the film's success in Germany and Japan, neither market renowned for favouring comedy. 'We've always enjoyed a rude joke in Britain,' comments Ford, 'but the German sex films, for instance, never appreciate the power of a good laugh. People like to laugh and they like to look at pretty girls. Even girls like looking at pretty girls.'[34]

The sexploitation documentary's fragmented style, ideological commitment and fascination with spectacle harked back to the outmoded practices of classical exploitation. This is perfectly demonstrated in *Take an Easy Ride*, a short (forty-four minutes) programmer whose chaos of documentary styles and indifference to narrative renders it, like *Come Play with Me*, all but avant-garde in its experimental incompetence. To tell its story of the dangers of hitchhiking, the film combines found footage; dramatisations; flashback reconstructions; allusions to multiple unrelated genres, from the rock film to the *giallo*; and as many exploitable topics as could be crammed into and stretched out to forty-four minutes: drugs, rape, threesomes, runaway youth and the abiding social problem of homicidal hitch-hiking lesbians. According to a note in the BBFC archives, 'the TV programme/film was apparently initiated & financed by a Kent solicitor who had prosecuted in four rape cases. In essence (I am told) the film is non-fiction.'[35] Production strategies directly comparable to those Schaefer isolates in classic exploitation include 'padding' (interminable scenes of cars winding through country roads for no purpose other than to fill up the running time), 'recycling' (found footage that would turn up in numerous other films) and 'the square-up', in that the film is presented, with an entirely straight face, as an exercise in public information.[36] The BBFC required cuts to a rape scene and some pubic close-ups, the examiner noting that the film 'which supposedly shows the perils of hitch-hiking becomes an exercise in "tongue-licking" sex in Reel 3'. Yet Kenneth Rowles insisted that

> this film will give the opportunity for the public to see the dangers in hitchhiking and as this film will be viewed in the West End cinemas, where there will be a large proportion of young people, I expect it will be taken in a more serious light.[37]

None of these films was especially erotic (the sexiest films of the period were erotic horror films such as *Virgin Witch*, Hammer's Karnstein trilogy and Larraz's *Vampyres*). Some were made in alternative versions or had material added to spice them up for foreign markets; *The Sex Thief* (1973), for example, an entirely standard sex comedy directed by Martin Campbell, was released in the US with hardcore inserts under the title *A Handful of Diamonds*.[38] *Erotic Inferno*, a dark softcore melodrama, was, as Simon Sheridan says, unusual among British sex films in that it actually devotes a good deal of its running time to sweaty depictions of people having sex.[39] (Its screenwriter, Jon York, was paid merely £250, somewhat below the Writers' Guild minimum of £5,000 but par for the course.)[40] After the success of *Emmanuelle* (1974) a few softcore films, such as *Emily* (1976), which achieved notoriety when its star, Koo Stark, was linked to Prince Andrew, and the De Sade adaptation, *Cruel Passion* (1977), also with Stark, ignored the prevailing style of seedy realism and nursed pretensions to be glossy erotic dramas. Later *Lady Chatterley's Lover* (1981), directed by Just Jaeckin, and Gerry

The perils of hitch-hiking exposed in Kenneth Rowles's *Take an Easy Ride*

O'Hara's impressively sexy *Fanny Hill* (1983) continued a tradition of erotic literary adaptations that in British cinema went back to Tony Richardson's *Tom Jones* (1963). With sequences in country houses, brothels and other fantasy spaces isolated from the everyday world, *Emily* and *Cruel Passion*, like *Virgin Witch* and *Mistress Pamela* (1974), depicted obsessional fantasies played out in a self-enclosed pornotopia unhindered by law, social ties and middle-class restraint.[41] *Emily*, like *Cruel Passion* and *Emmanuelle*, is a version of that key porn narrative, a young woman's sexual education or awakening, in which her 'true' identity emerges only when the virgin is transformed into a sex kitten.

In retrospect, films like *Naughty!* or *Take an Easy Ride* or even the attempted softcore of *Erotic Inferno* sum up all the problems of the British sexploitation film in the 1970s, quite apart from their low budgets, impoverished acting and disorientating editing, which to fans of paracinema scarcely count as flaws at all. Although the producers, with the exception of David Sullivan and Derek Ford, appear not to have been anxious to move into hardcore production, the films were pathetic substitutes for the unavailable real thing: 'The Brit sex comedy is a celluloid prick-teaser. It says "yes", and then changes its mind and says "no".'[42] Doomed to euphemism, British sex films offered mild comic thrills and redundant instruction to punters eager for altogether juicier meat. It was not till 2000, when hardcore finally became legal, that they would get it.

HARDCORE
British hardcore porn did exist in the 1960s and 1970s, though it was illicit and not strictly 'cinema', most of it being for home consumption (as in the opening scene of *Get Carter* in which a bunch of gangsters watch homemade silent black-and-white stag reels).

British stags have been dated back to 1910, but it was only after World War II that a Soho-based industry emerged.[43] Legal 8mm films of nude models and strippers (of the sort made by Mark Lewis in *Peeping Tom*) were produced by companies such as Stag Films (run by arch-exploitationeers Stanley Long and Arnold Louis Miller) and Pete Walker's Heritage Films.[44] According to Walker, he made from 1962–3 some '470 16mm girlie films, the Heritage range, all terrible, all shot within half-an-hour. They were duped to eight and packaged in lovely coloured boxes'.[45] The kind of 'short striptease movies you could buy in Dixons – 39 shillings for 50 ft' was, as Long recalls, 'very tame. They were self-censored.'[46] But illicit hardcore loops ('rollers') were also made in the 1960s. The best-known producers were Evan 'Big Jeff' Phillips, who made films from 1965 till his suicide in 1975 after an eighteen-month prison term; Mike Freeman; and Ivor Cooke, whose stags for his Climax Films included *Pussy Galore* (1965) and *Satan's Children* (1975), which have been lauded as 'some of most exquisitely realized British stags ever made'.[47] Freeman made 8mm films in the early 1960s and, after a period in prison for obscenity offences, upgraded to a 16mm Bolex camera and Eastmancolor before returning to prison in 1969 for murder.[48] Harrison Marks dabbled in hardcore too. By the 1970s, the leading figure was John Lindsay and, thanks to police corruption and a loophole in the Obscene Publications Act, his films could be bought in Soho sex shops and seen in licensed sex cinemas, such as Lindsay's own Taboo Clubs and David Waterfield's Exxon Club in Islington.[49] Harrison Marks recalled the popularity of the Exxon Club when it opened in 1973–4: 'My God, you couldn't cram enough of them in. They were almost hanging from the ceiling. We had to send them over the road to the pub to wait for the next show. It was just incredible.'[50]

As we've seen, sexploitation films were sometimes made in stronger cuts for the export market. Derek Ford, responsible for some of those export versions, made the most striking British hardcore feature, *Diversions* (1975), whose eighty-seven minutes were cut down in Britain to a fifty-minute softcore supporting feature, *Sex Express* (1975). The main actors in *Diversions* take part in the hardcore scenes, unlike in many of the spiced-up sex comedies, in which the hardcore was added later in close-up inserts of other actors. The export version, which is unusual in combining sex and violence in the manner of an American 'roughie', stars Heather Deeley from *Erotic Inferno*.[51] Structurally it combines the portmanteau form of Ford's *Commuter Husbands* and *Suburban Wives* with the unsynched porn loop. Within the framework of a train journey, a handcuffed Imogene (Deeley) fantasises a series of sexual encounters with other passengers; at the end of the film it is revealed that she is one of the escorts and not the prisoner. A couple of the sequences are fairly anodyne (sex in a barn full of apples – 'Did you know that apples have buttocks? Oh yes, they do, beautiful buttocks' – an anecdote about a woman mistaken for a call girl, romps in front of a magic Victorian camera), but two are more interestingly transgressive. In the first, which is introduced as a revenge fantasy for 'men only wanting one thing', Imogene, having seen a passenger reading *Vampirella* magazine, imagines (or remembers in flashbacks) while she is having sex on a leather sofa, being gang-raped by soldiers; these shots are tinted orange and accompanied by non-diegetic drumming. This inspires her to stab her lover (Timothy Blackstone), ecstatically rub the knife over her bloodstained breasts, masturbate with its handle, and finally cut her victim's penis off and pop it in her mouth. She

disposes of the body with the help of a golf cart and then heads off to Piccadilly Circus, bringing home a man in a cape and evening dress (James Lister). As they have sex on the same sofa, there are intercuts to the previous sex scene and the mutilated corpse. Imogene stabs the man, but he turns out to be a vampire and sinks his teeth into her neck while ejaculating over her; the sequence ends with a freeze-frame of her screaming. Coming out of her reverie, Imogene exclaims in voiceover, 'Nightmares! I even lose in my nightmares.' A later sequence involves her in what she calls a 'frightening' story in which, mostly in wide-angle shots, she is interrogated, tied up and beaten by what seem to be Russian guards, led by a woman passenger (Jacky Rigby). This leads to a lesbian sex session watched by the two male guards, one of whom joins in and appears to sodomise Imogene. (A simulated 'golden shower' sequence in which a soldier urinates in Imogene's face was present in the German video cut of the film, also titled *Sex Express*.) *Diversions* is often taken to reflect Ford's own 'peculiar fetishes', as his business partner Stanley Long described them.[52] According to Long, Ford's 'sexual preferences off camera had eventually seeped into [his] movie-making activities. Derek ... liked living on the edge. I think danger excited him, and making hardcore versions of his "harmless" British sex comedies soon became an obsession.'[53] But the film also indicates the more generous narrative possibilities of hardcore in the 1970s, when the boundaries of hardcore and exploitation subgenres such as horror were more negotiable, as with the 'Naziploitation' film, and sex, comedy and horror were able to combine to maximise the effect. There is a degree of experimentalism too in *Diversions* (cross-cutting, genre-shifting, slow motion) that echoes American films such as *Deep Throat* and *Behind the Green Door*.

John Lindsay, who also produced the softcore sexploitation films, *The Love Pill* (1971), *The Hot Girls* (1974) and *I'm Not Feeling Myself Tonight!*, was the most notable British hardcore director in the 1970s. According to some sources, from 1966 Lindsay made about 400 hardcore shorts for various companies including his own Taboo Films under the name Karl Ordinez. As well as around twenty films with his discovery Mary Millington (notably *Miss Bohrloch* (1970), which like *Diversions* features slow motion, repeat footage and other mildly experimental elements), Lindsay made numerous films on schoolgirl themes, included *Jolly Hockey Sticks* (1974), *Juvenile Sex* (1974) and *Girl Guides Rape* (1976).[54] From 1969 to 1971 Lindsay made films for Joop Wilhemus, a Dutch publisher, including *Miss Bohrloch* with Mary Millington, and was soon producing over thirty films a year, allegedly for export only. Wilhemus was arrested in 1971 and in 1975 for producing the child-pornography magazine, *Lolita* (there is no suspicion that Lindsay dabbled in child-abuse films: his 'schoolgirls' look well over eighteen). Lindsay was prosecuted and found not guilty several times, after which in 1975 he opened the Taboo Club in Great Newport Street, 'supposedly the most luxurious and popular cinema club in London in the mid-1970s'.[55]

Lindsay was the subject of a documentary, *The Pornbrokers* (1973), given an 'X' cert. by the GLC, which was intended as a response to the Longford Committee's report on pornography in 1972. A semi-autobiographical crusading take on the fledgling porn industry, *The Pornbrokers* offers an insight into Lindsay's filming methods, with behind-the-scenes footage of his filming one of his shorts, *Wet Dream* (1973). Consisting mostly of vox pops, including an interview with Wilhemus, *The Pornbrokers* is partly a defence

of porn (it ends with the voiceover declaring 'In the final event porn is rather like television. If you don't like it you can simply turn off') and partly, and more curiously, an indictment of its own audience as sad victims of typical male weakness – 'men are such suckers when they look at pretty birdies', Lindsay remarks, adding, 'Men are nuts, they like to see this crap.' *Cinema TV Today* said it was 'For the usual sexploitation crowd' but admitted that it was 'Objectively presented, without any salacious lip-smacking or hypocritical moralising' (8 September 1975). The film shares the campaigning anti-Victorianism of other sex documentaries of the period and presents Lindsay as advancing liberation by harmlessly catering to natural male needs.

Juvenile Sex, whose title card reads 'Taboo Films present a Teenage Production', is pretty representative of the style of Lindsay's porn loops. Post-synched, as the loops usually were, with comical overdubbing and chirpy music, *Juvenile Sex* is made with considerable flair and communicates a genuine sense of fun – his films certainly, as Dave Thompson says, 'remain among the best, and certainly the most archetypal, "schoolgirl" movies ever made'.[56] Around twenty minutes long, *Juvenile Sex* is set in a school (and was in fact filmed in a real school, in Birmingham), where a young male teacher engages with aggressively confident schoolgirls in a series of encounters that starts with a blow job in a classroom and ends with group sex in a dormitory. The school is a staple of porn stories, a regimented setting ripe for power play, the transgression of generational boundaries and fantasies of educational curricular sex. The overall effect is of 1970s carnival – if only because the participants all have pubic hair, invariably shaven off in porn these days – and in keeping with a discourse of ordinary people doing what comes naturally. In *Naughty!* Lindsay claims, 'The girls I use in my films are nice girls. Because they screw and have it up here and up there and in their mouths and that, this doesn't mean to say they're not nice girls.' Today's porn seems largely about performance, but in the 1970s there remained a link to the counterculture and its promise of what Steven Marcus, in a popular term of the day, called 'pornotopia' – 'that vision which regards all of human experience as a series of exclusively sexual events or conveniences'.[57] Lindsay's films became more widely available in the brief period before the 1985 Video Recordings Act, when they were released on video and available by mail order.[58] After the VRA under-the-counter and swapped copies were the rule once more, though some of the films are of course now available randomly and gratis at free online porn sites. Lindsay himself was finally arrested for obscenity in 1983 and imprisoned for a year; on release he retired from porn and, though he has appeared in a couple of TV documentaries, has otherwise dropped out of sight.

The 1980s saw the arrival of video, which in the US and continental Europe marked the end of the 'Golden Age' of porn filmed on 35mm – and indeed 8 and 16mm – aiming to compete with mainstream cinemas. Video may, for aficionados, have meant a dwindling of quality, but it proved the perfect medium for porn consumption (unless one pined for the homo-sociability of porn cinema clubs, which in Britain were more or less suppressed in the 1980s). Uncertificated hardcore was briefly available on video, including what David Flint has rather harshly described as the 'generally horrible tapes' produced by Mike Freeman, on release from prison, for his Videx label from 1980 to 1983.[59] Filmed on Professional Umatic, such films as *The Glass Table Orgy* (1980), *Colonel Winterbottom's Ladies* (1981) and, the most popular according to Freeman, *Truth*

or Dare (1980), which starred Lindsay Honey (Ben Dover) and Paula Meadows, were, Flint says, 'devoid of editing, script or coherent production values' and 'have an almost surreal edge to them'.[60] Freeman says he had '6000 buying customers who made regular orders'.[61] Better remembered are the softcore standbys of Electric Blue and Fiona Cooper. Electric Blue was a series of sixty-minute videos, produced by Paul Raymond, which were also released in Australia and later became a Playboy channel. The videos' content, showcasing British and American glamour models within a magazine format, was mild even before the VRA and consisted, as one drolly accurate comment about the DVD rerelease on amazon.co.uk puts it, mostly of 'boobs and hairy muffs' and big hair. By contrast, Fiona Cooper edged towards hardcore in her mail-order videos, which were essentially Warholian single-shot films of girls along the lines of 'beaver loops'. Still going, the company summarises Cooper's style on its current website as 'a real girl in a real house'.[62] Fiona Cooper – the company is now run by her daughter, Chloe – has remained remarkably consistent in its realist 'readers' wives' aesthetic. There is a focus on striptease, uniforms (schoolgirls and nurses) and specific acts, including the use of sex toys and nowadays 'weeing' and some hardcore material, especially lesbian performances. This is sex as domestic naughtiness and fantasy role-playing, rather than, as with Electric Blue, privileged access to inaccessible glamour. The videos' down-to-earth settings, the next-door ordinariness of the actors, the minimalist unfussy camerawork, and the creation of fantasies for what Adam Cole, who ran Electric Blue, described as 'the amorphous mass of grey man' who is 'just as happy to live out his sexual fantasies with Beryl from Neasden as he is with a Helmut Newton-esque extravaganza' – all these would be intrinsic to the British style of hardcore porn, when it was finally legalised.[63]

SEXPLOITATION SINCE THE 1970S

British cinema, despite its tradition of bawdy, might still be regarded as where 'a stiff upper lip has tended to triumph over the stiff anything else'.[64] The style of British sexploitation documentaries of the 1970s continues, albeit in different contexts and guises. The square-up lives on, dedicated to convincing censors that sexual material is really educational, as with *The Lover's Guide* instructional video in 1991 (now in 3D) and, more recently, the TV series, *A Girl's Guide to 21st Century Sex* (Five, TX 30 October–18 December 2006), in which, as in the whitecoater, jaw-droppingly explicit renditions of real sex were legitimised by the medical context and, just as in classical exploitation, any excitement was immediately deflated by thin-lipped warnings about venereal disease. The TV genre of medical documentaries such as *Embarrassing Bodies* (2008–), while admirable in many ways, certainly gain some of their impact by showing what could not otherwise be shown – so long as the bodies (usually working-class ones) are framed as unsexual, deformed, diseased or excessive. A prolapsed vagina leaking urine can be shown in close-up, while a healthy and aroused one would, one suspects, still be controversial.[65]

Hardcore pornography was finally legalised in 2000. The 'R18' certificate had been introduced in 1982 following the recommendations of the Williams Committee report in 1979. This allowed for stronger films to be available for cinema clubs and on video, but only in licensed sex shops and not distributed by post. However the 'R18s' were scarcely more explicit than '18'-rated softcore and it wasn't until 1997 that the BBFC

experimented with allowing through unsimulated sex, albeit in medium and long shot. In September 2000 a judicial review sought by the BBFC, bizarrely enough against its own Video Appeals Committee, upheld the VAC's 1999 ruling that certificates should not have been refused to seven explicit porn films. The BBFC revised its guidelines and effectively legalised the sale of hardcore in licensed sex shops only (it is still illegal to send hardcore by post). Explicit unsimulated sex is passed at '18' by the BBFC only if 'justified by context' – in other words, serious intention – or by an educational purpose (one of the first was *The Lover's Guide*). The films passed have tended to be art-house movies, from rereleased classics such as *In the Realm of the Senses* to Lars von Trier's *The Idiots* (1998) and the 'New French Extremity' – *Romance* (1999), *Baise-moi* (2000) and *Anatomy of Hell* (2004). Most of these 'artcore' films, with the exception of the cheerful and sex-positive American independent *Shortbus* (2006), were depressingly unerotic.

The first British film to take advantage of this relaxation of censorship was *Intimacy* (2001), in which Kerry Fox gives Mark Rylance a blow job, but the most significant British 'artcore' film is Michael Winterbottom's *9 Songs* (2004). The film is structured around sex scenes in the manner of a porn film (and *In the Realm of the Senses*, another story of sexual obsession) rather than just affording occasional unsimulated glimpses of penetration and aroused genitalia.

9 Songs is the short – a spare sixty-six minutes – and seemingly improvised story of Matt (Kieran O'Brien) and Lisa (Margot Stilley), who meet at a Black Rebel Motorcycle Club gig at the Brixton Academy and embark on a year-long affair before she returns to her native America. Rough, grainy sex scenes alternate with adequately filmed concert sequences of post-Britpop guitar bands and Michael Nyman. The film succeeds in catching the mundanity of sex by extending the British realist tradition to include unfaked love-making. As Linda Williams says in her sympathetic discussion of *9 Songs*, the film is graphic and not 'intent on the maximum visibility of sexual function' of all the art-house porn films. The sex scenes tend to be under or backlit, with a handheld camera, often quite short, indeed almost subliminal in the first sequence, and fading to black or revealed only in close-ups and cut-aways, and they tend to miss out key elements of the porn sequence such as external 'cumshots', except in a blow-job scene. Nevertheless, as Williams remarks, the film

> structurally comes the closest to conventional pornography. If pornography can be defined simply as a string of sexual numbers hung onto a plot existing primarily as an excuse for the sex, then ... pornography's closest genre affiliation is the musical in which the lyrical choreography of song and dance numbers resembles the rhythms of bodies in the sex act. *Nine Songs* [sic] thus merges the lyrical structure of the musical – in this case nine songs by popular bands – with the sex acts performed by Matt and Lisa.[66]

There are some of the requisite close-ups of genitals, but as much emphasis is placed on reaction shots as on sexual description, and it is unclear whether the film is meant to be arousing. Admirably, though, this is a rare film that suggests sex might be central to the protagonists' lives and that how they have sex might reveal character no less effectively than dialogue.

The film is in flashback from Matt's point of view and starts and ends with shots of the Antarctic, where he takes samples of the ice, which holds 'memory of a time before there were people'. The implication is that women are a distant enigmatic and unexplored continent, but also that life in the Antarctic, as Matt says, is as claustrophobic and exclusive as a relationship (there is a good deal of imagery of sky, sea and wilderness, though the sex takes place exclusively in rooms): 'Exploring the Antarctic is like exploring space. You enter a void ... claustrophobic and agoraphobic in the same place. Like two people in a bed.' The sex comes to symbolise emotional distance – Lisa never invites Matt to her flat and, as her interest in him wanes, she becomes more attached to her vibrator. Over the course of the affair Lisa takes control and Matt becomes increasingly more passive; he seems to find her imagination, recklessness ('Sometimes when you kiss me I want to bite you Not in a good way') and perhaps bisexuality difficult to deal with. At one point they go to a lap-dance club, in a sequence intercut with Lisa using her vibrator, and Matt leaves because Lisa is getting too involved with the dancer (this may be an homage to a sex-club scene in *9½ Weeks* (1987)). It is as if independent female sexuality is the mark of a troubled mind, as when Matt watches Lisa masturbate with her vibrator, which has become the index of her sexual distance and the fading of their relationship, before he goes to a concert by himself. Lisa is more verbal than Matt, which combines stereotypes of the garrulous American and taciturn Englishman with those of women as linguistically adept when aroused and men as predominantly visual. She is the link between language and fantasy – whether imagining being on a beach in Thailand when she is tied up, or reading equivalent erotic passages from Michel Houellebecq's novel *Platform* (the book is a signifier of arty sex; in a sense Matt represents British realism and Lisa the complexities of foreign art-house films).[67] She gives him a book on Antarctica and reads from it a paragraph about how icebergs 'last less than two months in open sea', which seems to apply to their own drifting relationship. Lisa involves Matt in bondage (first she is tied up, then he is) rather as in *In the Realm of the Senses* – the blow-job scene plays as an homage to Oshima's masterpiece, the 'two people in a room' film that, along with *Last Tango in Paris* (1972), is Winterbottom's template. Lisa has had numerous international lovers (again there is a subtext about the laidback Englishness baffled by energetic foreignness); and she is mercurial, difficult to pin down and androgynous – at one point she asks Matt, 'Do you think I look like a boy?' (in the background there is a Modigliani postcard, which once again associates her with high art). As the film goes on Lisa, who takes antidepressants and cocaine, comes across as simply mad. At any rate that is how Matt, the more romantic of the couple, depicts her, controlling our perspective and sympathies with his voiceover as Ryan O'Neal does in *Love Story* (1970) ('She was twenty-one, beautiful, egotistical, careless, and crazy'). In the end the film makes an entirely conventional association between madness and sexually driven women, who embody the impossibility of perfect freedom – the femmes fatales of French art-house films, for instance, such as the insufferable Catherine in *Jules et Jim* (1962) or Beatrice Dalle's *Betty Blue* (1986). As Linda Ruth Williams remarks, there is 'a sense of essentially sexualised girl-womanhood: even her irritating capriciousness reinforces an impression of girl-can't-help-it eroticism'.[68] The final sex scene, which includes the most explicit penetration shots, ends in mutual orgasm but not a cumshot; which highlights one of the main narrative problems of the film – unlike *In*

the Realm of the Senses, in which mutual obsession spirals towards the ultimate *petit mort* of death, or *9½ Weeks* and *Bitter Moon* (1992), where it mounts in destructive extremity, the sex in *9 Songs* is merely repetitive and, as McFarlane and Williams say, 'Matt and Lisa struggle to maintain the sexual heights of their early encounters.'[69] Lisa returns to America after a Michael Nyman concert, telling Matt, 'Sometimes you have to have faith in people', which presumably spins off the last line of *Manhattan* (1979). Matt goes alone to another Black Motorcycle Rebel Club concert and the song comments explicitly on the situation: 'Now she's gone love burns inside me.' The BBFC passed the film uncut, though oddly the eighteen minutes of DVD extras were rated 'R18', presumably because, without the square-up of narrative, viewers might mistake the scenes for sex works and behave inappropriately in their living rooms.

The downbeat and frankly rather depressing treatment of sex in *9 Songs*, so different from the enthusiastic naughtiness in British hardcore films by Ben Dover and Anna Span, is repeated in a handful of British erotic thrillers, such as the dreadful Nicci French adaptation, *Killing Me Softly* (2002), and in saucy art films such as *Damage* (1992), in which Jeremy Irons communicates his passion to Juliette Binoche by banging her head on the floor during sex. Two religious-themed films stand out, however, as genuine efforts to make softcore erotica, Nigel Wingrove's nunsploitation film, *Sacred Flesh* (2000), which as in an earlier era looks to the continent for inspiration, and his short about St Teresa's erotic fantasies of Christ, *Visions of Ecstasy* (1989), which the BBFC banned for blasphemy till 2012 when, after the repeal of blasphemy laws, it invited Wingrove to resubmit it and passed it at '18'.[70]

Livelier and more frequent are sex comedies, which have revived since the 1980s, and still get mileage out of British repression and hypocrisy – *Preaching to the Perverted* (1997), for example, about a naive's introduction to the BDSM scene, and *I Want Candy* (2007), more or less a retread of *Eskimo Nell*, in which a group of young men make a porn film. Most recent sex comedies are invigorated by the examples of *Viz* magazine's reclamation of working-class bawdy, the continuing popularity of unreconstructed northern comics like Roy 'Chubby' Brown, and American gross-out comedies such as *American Pie* (1999). Though critically despised, low comedies and TV spin-offs such as *UFO* (1993), the underrated and revealing *Sex Lives of the Potato Men*, *Fat Slags* (2004), *Gladiatress* (2004), *Kevin and Perry Go Large* (2000), *Ali G Indahouse* (2002) and *Swinging with the Finkels* (2011) demonstrate that, whatever the aesthetic disaster of British sexploitation, it embodied a distinctively British take on sex still relevant and commercial today.[71]

8 EROS EXPLODING

The film-maker, distributor and film programmer Antony Balch (1937–80) offers a revealing case study of someone involved with all aspects of the exploitation industry, albeit with a highly individual and indeed eccentric twist. As the director of the sex comedy *Secrets of Sex* and the horror film *Horror Hospital* (1973), two of the best films in their respective genres and among the high-points of British trash cinema, he is, in a sense, the hero of this book. His sensibility defines and his films, as works of cult trash art, embody precisely what I value in trash cinema. Balch was an important contributor to British avant-garde cinema as well, whose collaborations with the Beat writer William S. Burroughs – *Towers Open Fire* (1963), *The Cut-Ups* (1966) and *Witchcraft through the Ages* (1967) – were at the intersection of the underground and trash. In what seems a prophetic manner, Balch promoted a cinephile sensibility in Britain, and, as Tony Rayns has said, 'straddled the intellectual/exploitation divide like no other Brit in the 1970s', combining 'a commitment to exploitation values with ideas that came up in conversations with Burroughs – the whole, of course, given a squeaky sheen of camp'.[1]

By all accounts, and in the memory of those I've spoken to, such as Norman J. Warren, Balch was an immensely liked figure on the film scene in the 1960s and 1970s. Warren remembers him as

> very colourful and charismatic. He was tall, slim and good looking, with a well-educated and commanding voice. His appearance was very like that of the French actor Jean-Paul Belmondo. Antony was also a very warm and generous person, and he was certainly popular with people in all areas of the film industry.[2]

Balch was privately educated and gay; 'his manner', according to Barry Miles, 'was somewhat stereotypically camp; he had full wet lips and a rather arch way of speaking with a public school accent. He was always beautifully dressed.'[3] Jeff Nuttall, recounting a meeting with Balch and Burroughs in *Bomb Culture* (1968) describes their 'Senior Quad drawls'.[4] Balch's mother, Delta, worked in the film industry and he grew up fascinated with the business, creating home-made films that he'd screen in the family living room, charging his relatives admission. Balch started out making commercials, which is how Warren first came across him:

> I first met Antony Balch in 1959, when at the age of 17 I started work as a runner for the producer Dimitri De Grunwald. In addition to feature films, Dimitri also ran a company called Screenspace. This company produced cinema commercials. The studios were located

Antony Balch, 'The Abominable Showman'

in Paris and the post-production, editing etc. was located in the building where Dimitri had his office. Antony had worked for Screenspace and had only recently left to become an independent distributor and film maker when I started working there. I'm not sure just how much involvement Antony had with shooting the commercials. He spoke fluent French and I did learn he spent a considerable amount of time at the Paris studios, but his main occupation was in the London cutting room.[5]

Balch subtitled foreign films for British release such as Bresson's *Pickpocket* (1959) and Renoir's *Le Déjeuner sur L'Herbe* (1959) for a company called Mondial before, in 1963, moving into film distribution to handle Tod Browning's horror film *Freaks* (1932), which had never been granted a BBFC certificate.[6] It opened on a characteristically innovative programme with Godard's *Vivre Sa Vie* (1962) and *Towers Open Fire*.[7] From then on Balch's company specialised in cut-down foreign sexploitation films, often opportunistically retitling to accentuate their outrageousness. *Juliette De Sade* (1969) was retitled *Heterosexual* to suggest some new category of perversion, and the French SF film *Traitement de Choc* (1973) as *Doctor in the Nude*. Legend has it that he considered releasing Bresson's austere *Au Hasard Balthazar* (1963) as *The Beast Is Not for Beating*.[8] But as well as long-forgotten sex films, Balch distributed Buñuel, Russ Meyer and Kenneth Anger and art films such as *Thoughts of Chairman Mao*. His flair earned him the sobriquet 'The Abominable Showman'.

TOWERS OPEN FIRE AND *THE CUT-UPS*

In 1960, while working in Paris, Balch met the painter Brion Gysin, who introduced him to William Burroughs, with whom Gysin was living at Madame Raschoo's Beat Hotel. Burroughs was the author of *Naked Lunch* (1959) (*The Naked Lunch* in the UK, where it came out in 1964), now a classic but then a scandalous homoerotic SF fantasia in which drug addiction was an all-encompassing metaphor for paranoia and social entrapment.

Balch's two key collaborations with Burroughs, the short films *Towers Open Fire* and *The Cut-Ups*, were innovative links between Beat films such as *Pull My Daisy* (1959), which were semi-observational records of the nascent underground, and the rigour of structural and materialist films, in which formal procedures were more important than content.[9] These were not straightforward adaptations (if such a thing is possible of Burroughs), but rather stylistic experiments inspired by Burroughs's most notable compositional procedure, the aleatory cut-up method. Devised by Gysin in 1959 but anticipated by the Dadists and surrealists and influenced by the I Ching, cut-ups involved literally cutting up prose and rearranging it to make new juxtapositions. It was later augmented by the 'fold-in' technique, which produced equally non-linear results. *Towers Open Fire*, shot between 1961 and 1962 in Paris, London, Tangier and Gibraltar, was, according to Balch, 'an 11-minute collage of all the themes and situations in the book [*Naked Lunch*], accompanied by a Burroughs soundtrack narration'.[10] It is based on a routine, according to Burroughs, in *The Ticket That Exploded* (1962), 'pages 14–15', that later appeared in his *Nova Express* in 1964:[11]

> But that film is more or less narrative really, in a way based on a text that William had written in Gibralter [sic] where the towers were, and 'towers open fire' were those towers

between Gibralter and Spain on that part where the artificial frontier is. Antony had gone to Gibralter ... and saw William and was very impressed by this piece of text, so that's where the title comes from.[12]

Documentary footage of Burroughs and Gysin around the Beat Hotel is intercut with stock Pathé News footage of the stock exchange, shots of novelist Alexander Trocchi and sequences filmed in the British Film Institute boardroom. Norman J. Warren was brought in to assist with filming:

> I was to help with the camera and setting of lights, in addition to arranging props and making tea. I was a general assistant. The crew was just Antony and me. We shot in various locations around London and with an assortment of 'non-professional' actors. I must confess that all during my time on the film, I could never work out what the hell it was all about. I've seen the film recently and I still can't work it out. William Burroughs was around some of the time and I remember thinking he was a bit weird. Of course I was still quite young and didn't realise he was obviously drugged up to the eyes. He never seemed to be really with us.[13]

The film is, as Warren concedes, surpassingly obscure but it possibly, one critic bravely suggests, 'depicts society as crumbling in the form of a stock exchange crash'.[14] The BBFC asked for 'fuck' and 'shit' to be removed but passed a shot of Balch masturbating apparently because they didn't realise that was what he was doing. As well as a general sense of social collapse, the film conveys a fascinated interest in Burroughs himself and might be read as a Warholian study of his distinctively poised persona and emerging celebrity. As Nick Zurbrugg says,

> Here, in black and white, Burroughs demonstrates the considerable impact of maximal 'talk' set against almost wholly motionless imagery, writing for – and reading and acting in – a cinematic adaptation built both around and upon the auratic energy of his cinematic presence.[15]

Equally important, the disorientating clash of footage, exasperating repetitions and aloof voiceover make the film a jarring and unsettling experience, a kind of assault on the audience rather like a mondo film. This would become one of Balch's signature strategies in his later films and in his film programming. Burroughs, in a letter to Alexander Trocchi in 1964, extolled the virtues of Balch's editing as well as his parsimonious, exploitation-minded approach to film-making:

> He has made a number of interesting developments since *Towers Open Fire* which will I think revolutionize the film industry The most revolutionary aspect is economic. We have a method of making films of more entertainment value than the films now being shown and produced at great expense for no more outlay than that necessary to cover the price of film stock and lab work.[16]

After *Towers Open Fire*, Balch filmed *Guerrilla Conditions*, a documentary following Burroughs and Gysin from 1961 to 1964, a project that was later abandoned. As well as

sequences at the Beat Hotel, in Tangier and the Chelsea Hotel in New York, its twenty-three silent minutes reportedly included scenes from *Naked Lunch*.[17] Some of the footage from the ultimately unrealised film ended up in *The Cut-Ups*, which was a much more brutally alienating experience but more formally precise in its minimalist experimentation. Gysin was very critical of *Towers Open Fire*, which was not strictly a cut-up film, and urged that *The Cut-Ups* should more accurately represent the technique. As Gysin recalls,

> Antony was applying ... the 'cut-up' technique where he simply took all the footage he had and handed it over to an editor, just telling her to set up four reels, and put so many feet on each one in order – one, two, three, four, and start again, the same number.[18]

'There was', Gysin goes on, 'no editing done at all on the movies, none'.[19] The editor was simply given instructions for assembly and left to get on with it.

The voices in *The Cut-Ups* are those of Burroughs and Gysin, reading texts based on ones Burroughs had encountered in the Scientology classes he went to in London.[20] The soundtrack was put together by Ian Somerville (Burroughs's boyfriend), Burroughs and Gysin, and consists of just four repeated phrases: 'Yes, hello?', 'Look at that picture', 'Does it seem to be persisting?' and 'Good. Thank you' – 'They asked Balch how long the film was, and they produced permutated phrases to the exact length of twenty minutes and four seconds.'[21] The result is frankly unbearable, an exercise in driving the audience to the limits of tolerance. Balch showed it at various lengths, including a version at the Cinephone in Oxford Street, where it ran for a fortnight, that had to be edited down to twelve minutes because 'the staff had to put up with this five times a day'.[22] He also ran it at various speeds: 'I don't know that it was necessarily the right length. I've shown the film at 16 fps instead of 24, and it's also very interesting.'[23] The cut-up technique was used in *Performance* after its co-director Nicolas Roeg 'asked Balch to show him how he made arbitrary cuts'.[24]

The next collaboration was *Bill and Tony* (1972), though it was strictly an experiment to show to friends rather than the public:

> [I]t was a very expensive one, 70mm, at my insistence. I was very swept away by the first 70 I'd seen, and I thought we should do that. But I wasn't actually there and didn't have anything to do with the way it took. But the soundtracks are reversed. They are synched to the lips, but it's Bill who says 'I am Tony', and it's Tony who says 'I am Bill.' It's Tony's image with Bill's voice It had a different purpose, as a matter of fact, than the others.[25]

Bill and Tony, which was shot in a studio in the West End, is not a cut-up film but a 'face projection' (some scenes with face projections were in fact included in *Towers Open Fire*). The footage was intended to be projected onto the faces of its cast, as Burroughs explains:

> Antony Balch and I did an experiment with his face projected on to mine and mine on to his. Now if your face is projected on to someone else's in colour, it looks like the other person. You can't tell the difference; it's a real mask of light. Brion was the first to do this at [the

American Center at] the rue Dragon in Paris, and no one would believe how it was done. They thought it was all a film.

Another experiment that Antony and I did was to take the two faces and alternate them 24 frames per second, but it's such a hassle to cut those and replace them, even to put one minute of alternations of 24 frames per second on a screen, but it is quite extraordinary.[26]

The first half of the film shows Burroughs and Balch side by side introducing themselves as each other and then reading short texts; in the second half they dub each other's voices.

Towers Open Fire and *The Cut-Ups* made a notable debut as underground films in a role reminiscent of Warhol's at his Exploding Plastic Inevitable multimedia events of 1966 and 1967. Accompanied by performances from Pink Floyd and Soft Machine, the films were shown in 1966 projected onto sheets hung on a clothes line over a stage; this was at the first official screening of the London Film-Makers' Co-operative, held during the International Times launch party at the Roundhouse in Chalk Farm.[27] The films were also shown at the Academy in Oxford Street and, according to Gysin, had sufficiently deranging impact that 'this moviehouse finally asked if we could please take them off the screen because they'd had such a high incidence of people forgetting really strange things in the theatre'.[28] The ability of *The Cut-Ups* especially to disorientate audiences chimed with Burroughs's interest in Scientology's techniques of brainwashing and deprogramming. In 1965 he wrote to Balch suggesting they produce a 'new type of science fiction film' about the story of Scientology that would use cut-ups to produce 'a unique audience impact'.[29] He was mindful of the 'publicity angle':

> We warn [the audience] that it is dangerous to watch this film and only those with strong nerves and self reliant character should apply for this ordeal and so forth we have purposely made the price of admission high in order to discourage the casual and unprepared viewer.[30]

Although Balch's later films were exploitation rather than avant-garde, they shared many images, themes and the assaultive form of the Burroughs adaptations. Above all, they revelled in the shock of unlikely juxtapositions to convey just such a unique audience impact and the magical capacity for images to unlock the irrational. Balch later tried to make a film of Burroughs's *Naked Lunch*, and was 'in an advanced planning stage' for it in 1972.[31]

BALCH AT THE JACEY AND THE TIMES

In 1964 Balch was hired to programme the Cohens' Jacey Piccadilly, which, like the Classic, Continentale and Compton (later Cinecenta) chains, showed 'X'-rated sex films. Balch also did front of house, designed characteristically witty posters and distributed many of the films that were shown: 'So he managed both of those houses, doing everything: front of house, seeing that the cleaning ladies cleaned up, and sharpening up the lady at the cash box, and above all being up in the projection booth.'[32] He was involved in programming other Jacey cinemas too, such as the Jacey Charing Cross.

In the 1950s, especially in the US, art films became synonymous with erotic content and it was not unusual for art and exploitation movies to be programmed

together, offering similar titillating pleasures in different cultural registers. Art and exploitation were unstable categories, and art films were just as likely to include sensational material worth exploiting. Balch delighted in programming double bills that blurred categories of art, filth and the avant-garde in a distinctly cultish style. One can only imagine what the habitués of sex cinemas made of them. A glance at the listings in *Continental Film Review* gives a taste of the varied fare on offer at the Jacey Piccadilly, and a sense of the more general overlap between art and exploitation in the 1960s.[33] In 1964 the Jacey, showcasing British mondo films, ran *London in the Raw* (1965) from July to September and *This Shocking World* (1964) from October 1964 to January 1965. Then settling down into runs of sex films, the Jacey played Westerns in February and March 1965 and Clouzot's *Wages of Fear* (1953) in April. Starting with *Beauty by Night* in July 1965, it headlined sexploitation films with increasingly splendid titles – *Secret Paris* (distributed by Balch) from August 1965 to January 1966; *Damaged Goods* (1937), a classical exploitation film about VD, and *Go Go World* (1964) in April; *The Kinky Darlings* (1964) and *Image of Love* in September, and, in 1968, *Aqua Sex* and *Skin Skin*, with occasional breaks to showcase some of Balch's favourites, such as Jacques Tati's comedy *M. Hulot's Holiday* (1953) in July 1968. In October 1967 Balch twinned a sex film, *The Pussycats*, with Louise Malle's *Zazie dans le metro* (1960). Balch preferred 'X' films, of course, because 'An "X" on a good film means £1,000 a week' (*Guardian*, 21 July 1966). Balch's typically tongue-in-cheek advertisement in *Continental Film Review* for the 'X'-rated *Secret Paris* promised 'unbelievable scenes' such as 'Suicide brigade', 'The homosexuals', Navel worshippers' and 'The girl with the removable behind'. Occasionally Balch offered especially

Antony Balch advertises the attractions of *Secret Paris* in *Continental Film Review*

CINEPHONE and **JACEY**
OXFORD STREET (opp. Selfridges) MAY 4721 PICCADILLY REG 1449

UNBELIEVABLE SCENES:

THE GIRL WITH THE REMOVABLE BEHIND
SUICIDE BRIGADE
SECRET STRIPTEASE
THE HOMOSEXUALS
SECRET WRESTLING
THE BEE MANIAC
SCHOOL OF SEDUCTION
FORBIDDEN FOOD •
FORBIDDEN VOODOO RITES
NAVEL WORSHIPPERS
CORPSES ON ICE
HOT STREETS
CALL GIRLS ON WHEELS
HOW TO RESURRECT YOUR HUSBAND
THE STRANGE HOTEL
MEDICAL PARTY

ANTONY BALCH presents

SECRET PARIS

'X'

AN ARTHUR COHN • PIERRE ROUSTANG PRODUCTION
DIRECTED By EDOUARD LOGEREAU IN EASTMANCOLOR

bracing collisions of art and trash, such as a triple bill in December 1968 of *Witchcraft through the Ages* (his cut, with a commentary by Burroughs, of *Häxan* (1922), a silent Danish film about witchcraft), Buñuel's *Un Chien andalou* and a sex film, *Young Aphrodites* [also known as *Shepherds in Love*] (1963). This does not give a full picture of what was shown, since programmes would also include shorts (such as the Burroughs films) and cartoons. Balch's own *Secrets of Sex*, for example, opened to great success at the Jacey Piccadilly on a bill with another sex film, *Sweet Wounded Bird* (1970), and a Bugs Bunny cartoon.

The programmes were more eclectic than most sex cinemas' but Balch was certainly not alone in scheduling such double bills. As Matthew Sweet has pointed out, from the late 1950s, when the growing market for exploitation defied falling cinema attendance and cinema closures, 'as far as producers and exhibitors were concerned, no market boundaries existed between productions that would now be considered the preserves of totally different audiences'.[34] The Edinburgh Jacey, for example (which Balch may have had a hand in programming) played the Japanese ghost story *Onibaba* (1964) with the self-explanatory British film *Nudist Paradise* in October 1967. In December 1969 the Glasgow Tatler followed a week of Godard's *Weekend* (1967) with one of *Erotic Touch* – both attractions were edgy continental adult fare – and at the Manchester Tatler, after a run of the exploitation film *The Acid Eaters* (1968), came Alain Robbe-Grillet's *Trans-Europ-Express* (1967) paired with John Cassavetes's *Shadows* (1959), and then a double bill of softcore sex films, *Piece of the Action* and *Pretty but Wicked* (1965). Independent producers such as Compton, as Michael Ahmed says, 'blurred the line between art cinema and popular cinema, between prestige or worthy cinema and low budget exploitation cinema'.[35] In 1968, Balch also took on the Times Baker Street, an interesting cinema built into an underground station. The Baker Street stuck to a declared 'policy of new and important repertory films' and showed fare such as *Zazie dans le métro*, a Polanski season and, in June 1969, Buñuel's *Adventures of Robinson Crusoe* (1954) (distributed by Balch).[36] It opened in November 1968 with *Witchcraft through the Ages*, Balch's first cinematic venture since the Burroughs films, billed with *Un Chien andalou*.[37]

This was a period when programmers had the freedom to impose their taste; nowadays distributors tend to have the upper hand. For Balch a sexploitation cinema was a mondo sensorium, an opportunity to offer different kinds of sensational enticements and incorporate a Burroughsian aesthetic of montage and bricolage into his programming. All films were to him, in one way or another, exploitation and, under a roving erotic gaze adventurously indifferent to cultural distinctions, everything is potentially exploitable. There is an interesting anticipation of this sensibility in a discussion in which Balch participated in 1960:

> Franju's *Les Yeux sans Visage* [1960] is incredible, the most ugly elements are at the same time the most beautiful. The operation scene (in full) is a rare jewel amongst the precious stones of the cinema. Most people will tell you this is impossible – horrible ... [in the original] here is this girl having her face cut off. This happens to be a form of beauty to which I react. Those who don't like it are sick, but as the subject matter isn't you or I, it is an accessible creation to which we react.[38]

The context in which a film appears often determines whether it is art or exploitation, and this, as Joan Hawkins remarks, is certainly true of a film like Franju's:

> In both the French popular press and the film journals ... *Les Yeux* always occupied a double niche. Horror but not Hammer horror, not low horror, not *horror* horror, Franju's film became a sort of cultural lightning rod, a property around which contradictory discourses about horror and art cinema could take place.[39]

Balch was forward-looking in distributing art-house as well as sex films, which Roger Corman's New World did too in the 1970s, and in recognising the shared appeal of such specialist alternatives to mainstream taste. This would be the typical feature of cult programming in the 1970s, which catered to new culturally omnivorous audiences, and it was towards these audiences that Balch aimed his own films.

WITCHCRAFT THROUGH THE AGES

One sees this in his version of *Witchcraft through the Ages*, which treats Benjamin Christensen's silent *Häxan* essentially as found footage, and revivifies it with a jazz soundtrack and Burroughs's sardonic narrative to appeal to a trendy underground fascination with satanism and paganism. *Häxan* is difficult to categorise since it is both a serious documentary and a sensational collection of staged scenes of torture and witchcraft. Balch cannily repackaged the film as an 'ironic entertainment' so that it became a proto-midnight movie.[40] He cut it to seventy-six minutes and added music by, among others, the jazz violinist Jean-Luc Ponty, and a monotone commentary by Burroughs that mostly translates the original film's intertitle cards. It starts, however, with an incantation Burroughs also recited in *Towers Open Fire*: 'Lock them out and bar the door, lock them out for ever more. Nook and cranny, window, door, seal them out for ever more.' The movie fits in with Burroughs's own fascination with subterranean conspiracies and occult influences, and his own status as a Crowleyan magus whose cut-up technique conjured secret affinities and encouraged sympathetic magic. Balch's cut

> distances and ironises the silent film, but also complements Benjamin's pedagogic goals rather than poking fun at them ... Burroughs's gravelly voice and Christensen's didactic direction give the film a hyper-authorial and thus factual focus, reinforcing Christensen's original aim for the film and adding another level of authority in the form of the Burroughs voice-over.[41]

Having played in Baker Street since 1968, *Witchcraft through the Ages* was shown at the Elgin, New York in February 1970 on a double bill with Sergei Parajanov's *Wild Horses* (1965). Jonas Mekas, the doyen of American avant-garde cinema, attacked it as 'bastardized' and 'a barbaric act'.[42] A recent account by Jack Stevenson is more sympathetic: 'Some torture scenes are shortened, it is less unrelenting, less "brutal", but Burroughs's spoken dialogue gives it a more unified (if still disjointed) narrative flow, or at least the feeling of such.'[43] He also notes this of a film tailored for a ready audience in the counterculture:

> The Balch/Burroughs version is more political, more anti-authoritarian, more 'beat', as one might expect. In one scene where Maria the weaver is interrogated by two witch hunters, Burroughs laconically observes: 'here we see an example of "good cop / bad cop," which is still being practiced in police stations all over world'.[44]

Indeed Balch was tapping into a vein of interest in witchcraft and paganism that was spreading from the counterculture (the Rolling Stones' 'Sympathy for the Devil') to films such as Polanski's *Rosemary's Baby* (1968); *Witchfinder General*; *Mark of the Devil* (1970); *Simon, King of the Witches* (1971); *The Wicker Man*, and exploitation documentaries like Derek Ford's *Secret Rites*. As well as suggesting, to an increasingly paranoid and embattled subculture, why bad vibes were transforming the Age of Aquarius to that of Saturn, the films drew comparisons between the hysterical persecution of the witches and the Establishment's persecution of political and sexual non-conformity. But even though Balch made films that exploited the underground, just as he released films for the straight mainstream, he was, as a gay man and an entrepreneur, equally detached from both:

> Not that Balch wanted to be a part of an underground film-making scene; he saw them all as scruffy hippies who, instead of just getting on with it, were always bleating about getting grants. He preferred his independence and his own smart high-flying gay friends. They were two different worlds.[45]

Warren concurs: 'I don't remember Anthony being part of the so called underground scene, or any other scenes come to that. He was too strong minded and independent to be a part of any group.'[46]

SECRETS OF SEX

Balch left the Jacey in the early 1970s (the building, currently vacant, closed as a cinema in 2001 and reopened as the Pigalle Club from 2007 to 2011; the Times has become a tourist shop, the Baker Street Emporium). It was during this period that Balch, who lived in the same block of flats as Burroughs at 8 Duke Street in London, tried to get his film of *Naked Lunch* off the ground, buying the rights from Burroughs, setting up a company, Friendly Films, to back the film, and signing a contract with Gysin, who would get 5 per cent of the net proceeds.[47] It seems to have been planned as a sexually explicit musical adaptation, scripted and with songs by Brion Gysin and a score by the jazz musician Steve Lacy.[48] Gysin's screenplay outline 'is the story of a writer named William Lee who finds that what he writes can become his reality'.[49] The picaresque plot centres on Lee's flight to Neverzone, where 'perhaps he can learn to rewrite the fate of a whole world full of addicts hung on power and money, sex and drugs', and incorporates a number of Burroughs's most celebrated 'routines', including scenes with Doc Benway and his baboon assistant, Violet, 'which are the funniest ever written and should be played by Groucho'.[50] Although Groucho seems never to have been involved, Mick Jagger was interested, but 'did not want Balch as director. He didn't like him. He thought Balch was coming on to him sexually, and in any case he didn't have a reputation as a director in the industry. He wasn't bankable.'[51] Dennis Hopper was also

approached but, by 1972, despite having a shooting script, the film had stalled for lack of finance.[52]

In the meantime and to raise funds for the film of *Naked Lunch*, Balch put together the sexploitation film, *Secrets of Sex*. This was the first of two films he made with the producer Richard Gordon, whom he had first met at Cannes in 1964 and some of whose films he had distributed. According to Gysin, he had originally wanted the Cohens, who owned the Jacey chain, to fund it.[53] In 1968, Balch brought Gordon a proposal for a sixty-five-minute picture called *Multiplication*, which he budgeted at £15,000. Rewritten under various titles such as *Bizarre* and *Eros Exploding*, *Secrets of Sex* would eventually cost £32,000 and run for ninety minutes.[54] It was cut by nine minutes ('fucked up', according to Balch) by John Trevelyan at the BBFC.[55] Although sharing many themes with other British sexploitation films, *Secrets of Sex* is the strangest, campest and most avant-garde of them all.

Secrets of Sex is a portmanteau film rather in the Amicus style, consisting of vignettes about sex and horror that document the battle of the sexes – a common enough theme, as we've seen, of British sexploitation documentaries from mondo films to *On the Game* and *Suburban Wives*. It is, the narrator intones, about 'the endless struggle of the sexes' and 'the extremities to which mankind, and particularly womankind, will go in pursuit of satisfaction' – and concludes that women have won ever since Eden. Its alternative US title, *Bizarre*, adequately sums up its effect on the audience. The deadpan, indeed Burroughsian, narrator is an ancient mummy (Valentine Dyall), who observes the battle of the sexes through history:

> For a thousand years these eyes have been hidden in the blackness of time. That is to say, a thousand of your years. But on certain occasions I have been able to observe the uncertain struggle of the battle of the sexes. The fruits of victory do not go to the strongest or the cleverest, as I myself have good cause to know.

The film's episodes include a female photographer torturing and castrating her male model by suspending him over the blade of a 'Spanish Horse'; a young woman scientist giving birth to a monster; a female cat burglar blackmailing a man into not calling the police by offering herself to him; a spy film pastiche (based on a comic strip in *Mayfair*) with a silent movie sequence; a 'strange young man' talking a prostitute into a threesome with him and a pangolin; and an elderly woman, whose new butler, having been told that the plants in her greenhouse contain the souls of her seventeen previous lovers, exclaims 'Misappropriation of souls is a very serious offence' and strangles her. None of these sequences is remotely sexy; most edge towards horror with a cautionary twist, and evince disgust at sex, or at any rate heterosexual sex. It parodies sexual perversions, Freudianism, the occult and Scientology (in which Balch was also interested) and Burroughs's own ideas (one of the 'wild boys' lolls about reading the Grove Press edition of *Nova Express*), such as desire as a form of addiction and control and that 'man and woman is one of the most basic splits … . What does such a split mean? It means that you have groups of people on one planet living together with basically opposed interests.'[56] (In fact, in a letter to Balch in 1968, Burroughs had recommended making avant-garde gay porn films. Hardcore was on the fringes of underground film-making at the time, as with Warhol's *Blow Job* (1964) and *Blue Movie* (1969)).[57]

Valentine Dyall as the ancient mummified narrator in Antony Balch's *Secrets of Sex*

The sheer oddity of the film rather inhibits textual analysis and seems intended to bewilder rather than to arouse its audience. Like other British sexploitation films, it pragmatically unsettles classical style with spectacle, silent-cinema elements, found footage and a mock-serious anthropological format. Few other sex films take stylistic dislocation to such an extreme or are so determinedly anti-erotic. The keynote is rampant misogyny – men are victims, while women, who are literally castrating or soul-sucking seductresses (even more so than in *Zeta One*), are shown drenched with water and pelted, for some unexplained reason, with tomatoes. Most interesting is that the film is highly self-reflexive (not as unusual in sexploitation films as one might imagine) – at the start a woman is shown stripping and the voiceover says 'Imagine making love to this girl … imagine making love to this boy' – taunting the audience with the unattainability of the beautiful people on screen, the young generation rumoured to be endlessly available but presumably not to the types viewing them in sex cinemas – 'Desirable and unattainable … the tortures of the damned'. The desire to punish women for their dangerous power links it to the homosocial panic of *Witchcraft through the Ages*, as does the implication that the audience itself is the damned, trapped in the circle of its own frustrations. This sequence ends in violence as the men approach women with machine guns, so that it plays out an allegory of frustration by the film itself, by sexploitation.

One way of looking at the film is therefore as a homoerotic sabotage of the sex-film formula, an extended joke at the expense of its audience and perhaps aimed at jolting them out of their brainwashing by (or addiction to) heteronormativity. (The subversive use of the kinetic impact of a sex film is demonstrated in the culminating scene of Gysin's screenplay outline of *Naked Lunch* – a screening of *Gallows Gal*, 'The Last Blue Movie' which 'is such a powerful piece of porno that sensitive people in the audience get

up and hang themselves out of sheer excitement'.)[58] This fear of women is wholly in the William Burroughs mode – the section in which a woman traps men's souls in plants iterates, as Jack Sargeant notes, 'a proposal suggested by Burroughs that women were all in fact alien agents for an "insect trust"'[59] – but it also parodies the misogyny and yearning of the sex film while slyly normalising 'deviant' homosexuality. In the midst of such bizarre perversions as three-way sex with a pangolin, homosexuality seems perfectly normal. The film starts with two men embracing with a woman, and throughout young men are erotically fetishised and coded as gay (as well as reading Burroughs, one of them is seen reading Genet), shown in bed together, and brought together in the final orgy sequence. Parodying heterosexuality as perverse and warlike, the film quietly validates images of gay sexuality. After all, sexually at least, men are not at war with other men.

Although it has been called a British *Glen or Glenda* (1953), *Secrets of Sex* is not really evidence of an aesthetic of incompetence.[60] There are, it has to be said, similarities to *Glen or Glenda* in the use of montage and the covert defence of queerness; and both films can be relocated to a debatable zone between art and exploitation. But Balch is not a bad film-maker – 'an unwitting enabler of a signifying catastrophe'[61] – he is rather a pasticheur like Anger, Warhol, Kuchar and Smith, who is documenting (with cues for insiders) the camp sensibility of a particular sexual and cinephile subculture. More so even than *Slave Girls*, *Secrets of Sex* is one of the very first, perhaps *the* first, deliberate cult trash movie in British cinema. What John Russell Taylor says of *Female Trouble* and *Thundercrack!* could also apply to *Secrets of Sex*:

> Both these seem to pass beyond the taste barrier, to get to the point where trash, in common with Susan Sontag's definition of Camp taste, 'turns its back on the good-bad axis of ordinary aesthetic judgment … to offer for art (and life) a different – a supplementary – set of standards'.[62]

Secrets of Sex played for six months at the Jacey, though unfortunately it is not known how the audience responded to its provocations and visual bromide. The film got remarkably good reviews, partly no doubt because Balch was by then well known to many of London's film critics, but they also responded to its quirkily innovative strangeness. Jan Dawson in *Monthly Film Bulletin* said it was 'an exploitation sex film informed throughout by the refreshing view that sex is less often fun than funny' and complained that 'the bowdlerised film moves closer to pornography than the version from which its audience is being protected' – 'while the liberalised British censorship now seems prepared to tolerate nudity and references to orgasm in solemn or pseudo-intellectual contexts, it does not yet seem prepared to let us laugh at them' (March 1970). *Kine Weekly*, a trade paper less attuned to the joke, said, delightfully, that 'This film is quite blatantly directed at a certain type of audience which, unfortunately, does exist' (28 February 1970). It was released in the US by Bob Shaye and New Line, a company getting a reputation then for films that crossed over between art and exploitation; but, as Richard Gordon explained:

> I brought the film to the United States in its original version and the first sign of trouble was when US customs held it up for several weeks before deciding to allow the importation,

followed by the refusal of the MPAA [Motion Picture Association of America] to give it a rating. New Line Cinema, which was then a pioneer in the specialised distribution of controversial films from overseas, finally agreed to release it under the title *Bizarre*, as part of a series entitled *Art of Pornography*. It enjoyed only modest success.[63]

The first issue of *Cinefantastique* welcomed it as 'a product superior to the run-of-the-mill sex cheapie and worthy of attention'.[64] According to *The Times*, it was even 'taken up as an intellectual cult film in the US' (22 October 1970).

HORROR HOSPITAL

In 1973, Balch and Gordon went on to make another cult film, *Horror Hospital*, which exploited the wave of gorier horror films that would include *House of Whipcord* and *Death Line*. Following good exploitation practice, they came up with a title first and only then devised a story outline, bringing in Alan Watson, a young writer Balch knew in Paris, to work on the screenplay. The film was shot in less than a month in 1972 on a budget of just £100,000 and released on a double bill with *The Corpse Grinders* (1971). It received favourable reviews – the *Financial Times* called it a 'piece of brilliant surrealist film making ... a film of genuine individuality and style'.[65] Dawson in *Monthly Film Bulletin* was again sympathetic, accurately suggesting that Balch was 'the closest thing this country has to a product of the Corman stable' by 'stressing his films' defects rather than attempting to camouflage them, and inviting us to laugh where we might otherwise be tempted to wince' (June 1973).

Michael Gough plays Christian Storm, a figure straight out of *Naked Lunch*, who, like Burroughs's Drs Benway and Schafer, employs Pavlovian mad science as a means of control. Storm attracts young people to his country house, Brittlehurst Manor, under the guise of offering 'Hairy Holidays', a rest cure for hippies. In fact, aided by Harris (Ellen Pollock) (an ex-brothel keeper from Hamburg), a dwarf called Frederick (Skip Martin), and a team of leather-clad zombie bikers (his 'Stormtroopers'), he lobotomises his guests, possibly with the aim of creating a personal army. Jason, a disenchanted songwriter (Robin Askwith, who had appeared in Gordon's previous production, *Tower of Evil* (1972)), pitches up there with Harris's niece, Judy Peters (Vanessa Shaw), and discovers that under his mask and black gloves Storm is a fire-disfigured monster who enjoys flagellating his catatonic victims. Jason and Judy set Storm's laboratory on fire and escape but at the end of the film, though decapitated and drowned in quicksand, Storm appears to have survived to continue his fiendish schemes.

A masterpiece of camp trash, *Horror Hospital* bubbles with Burroughsian paranoia and homoeroticism under its exploitation surface. In many ways it is the missing link between the social critique of *A Clockwork Orange* and the louche, intertextual pastiche of *The Rocky Horror Picture Show*, even if the obvious comparison is with *The Abominable Dr Phibes* and other comic-horror films about mad scientists in what Harry Benshoff calls that early 1970s 'period of campy baroque period horror', which culminated in *Flesh for Frankenstein* (1973) and the overtly queer subtext-busting *Rocky Horror*.[66] There are numerous textual allusions – Dr Storm's burns pay homage to Lionel Atwill in *Mystery of the Wax Museum* (1933), while a handheld sequence in which Jason is dragged through a wood and beaten up by thugs recalls Alex's (Malcolm McDowell) assault by

the police in *A Clockwork Orange*. Jason's treatment at the hotel is not far off Alex's at the Ludovico Centre, and indeed Harris seems intended as an allusion to Dr Branom (Madge Ryan), the female doctor who administers drugs to him. The bikers come from Cocteau's *Orpheus* (1950) and Anger's *Scorpio Rising* (1963), though of course this is not the only horror film of the period with evil motorcyclists. As well as the living dead in *Psychomania* there are Dracula's biker minions in *The Satanic Rites of Dracula* and the rampaging cycle gang in *No Blade of Grass* (1970), where, as in David Gladwell's *Requiem for a Village* (1975), helmeted bikers symbolise anonymous modernity. Like *Rocky Horror*, the film is a loving compilation of horror clichés at the very moment of the genre's deliquescence.

The obvious context for *Horror Hospital* is the theme of 'generational horror' discussed earlier – the revenge on the young by an older generation that is 'insane and oppressed, cut off from a world they no longer understand and control'.[67] Storm is identified with emblems of pre-war privilege such as a country house, servants and Rolls Royce, and his country-house laboratory is a self-created utopia in which he attempts to restore the authority of the displaced Establishment over the rebellious young, of whom he is contemptuous: 'As for these young people, they come and go like flies these days – dirty ones at that. Their disappearance will hardly be noticed.' As with *Incense for the Damned* and *House of Whipcord*, the film constructs a forthright allegory of the old hysterically trying to control youthful sexuality (inspired here, it is implied, by Storm's own homosexual desires); Storm's name, for instance, not very subtly alludes to the 'Christian Storm' of protest and reaction of Mary Whitehouse's Festival of Light.

Michael Gough as Christian Storm in Balch's camp masterpiece *Horror Hospital*

But there are wider and more original contexts. In its focus on institutional social engineering this film is the nearest British equivalent to *One Flew over the Cuckoo's Nest* (1975). Taken with some of the other trash films highlighted in this book, the film incorporates (or rather, since Balch was nothing if not knowing in his use of exploitation tropes, deliberately parodies) *the* archetypal scenario of British horror – an innocuous rural location where, in an underground laboratory, a mad scientist (usually, in fact, Gough) hides monsters created to follow his orders. This variation on *Frankenstein* and *The Island of Dr Moreau* (1977) was an enormously effective outline within which to sketch themes of patriarchal and homoerotic oppression. The hospital as microcosmic Britain also appears in

Lindsay Anderson's *O Lucky Man!* (1973), which features an isolated facility where men are spliced with pigs, and his later *Britannia Hospital* (1982) (also with Robin Askwith), in which another power-crazed boffin (who could easily have been played by Michael Gough) messes about with brains.

Balch has a deal of fun playing up the camp elements of the story. Dennis Price, seemingly inebriated, is a predatory and ever hopeful old queen. Abraham (Kurt Christian), who turns up at the hotel supposedly in search of his girlfriend, is introduced with swishy music that, as his performance confirms, immediately codes him as stereotypically gay. Storm's male zombies disport themselves semi-naked like pin-ups in a beefcake magazine. And Jason is involved with a band led by a transvestite singer (reminding us that 1973 was the hey-day of glam rock), from which he is alienated. The straight counterculture is giving way to a new mainstreaming of queer subcultures. No wonder Jason needs a rest at Hairy Holidays. His brand of unreconstructed masculinity, perfectly embodied in Askwith, is going out of style and his hairiness now denotes gender-bending rather than hippie non-conformity (in fact, Askwith's persona and looks combine, appropriately enough, Alex in *A Clockwork Orange* with a down-market Mick Jagger, whom he imitated quite effectively when fronting 'Kipper' in *Confessions of a Pop Performer* (1975)). The homoerotic implications – always there in the Frankenstein story, with its subtext about men creating men without the involvement of women – are drawn out even more overtly in *The Rocky Horror Picture Show*, where the mad scientist, Frank-N-Furter (Tim Curry), is explicitly gay and Rocky (Peter Hinwood), his creation, is designed as a sexual plaything.

David Pirie sets Michael Reeves, the director of *Witchfinder General*, in the context of a new wave of young directors who started using the horror genre as a vehicle for personal expression:

> The English commercial directors, like Terence Fisher, who had emerged in the 1950s, cared about cinema, but would have considered it highly eccentric to become passionately involved in the contemporary popular film scene as avid spectator-critics. To them, the craft of films was learned, not in cinemas, but in the cutting rooms and the studios. Reeves, however, was only the first of a number of young directors/writers who now entered British horror movies with a long apprenticeship of voracious *cinéastes*.[68]

Balch was, like Reeves, Chris Wicking and Norman J. Warren, one of that new wave, who brought to the genre a cinephile commitment to supposedly trash genres along with a wide and various knowledge of both art-house and exploitation cinema. But Balch's trash sensibility sets him apart, and *Horror Hospital* epitomises the subversiveness of camp films, which, as Benshoff says, tend to

> share a coolly ironic, distanciated, or blank style that draws attention to issues of performance and theatricality, so central to the camp aesthetic. In doing so, the films tend to make unstable commonly held notions of authenticity, identity, reality, and even cinema itself. Their highly theatricalised visions and their insistence on blurring boundaries (between art and exploitation, the serious and the comic) confounded those critics and filmgoers who demanded generic purity, moral seriousness, and absolute meaning.[69]

Balch, who died of stomach cancer in 1980, spent some of the 1970s attempting to make a film called *The Sex Life of Adolf Hitler*, written by the American critic Elliot Stein, who had played the strange young man in *Secrets of Sex*. Balch remains a cult figure whose importance is starting to be recognised. Miles describes Balch as the 'first of the British sixties experimental film-makers', but he has been underrated because he exhibited in regular cinemas, was connected to exploitation and wasn't part of the underground.[70] He was too detached and too dangerously radical.

9 THE ART OF TRASH

The director Douglas Sirk once said that, 'There is a very short distance between high art and trash, and trash that contains an element of craziness is by this very quality nearer to art.'[1] Trash may be a mark of 'badness' or of films in which aesthetics are subordinated to generic imperatives, but it has also proved an invaluable artistic resource for film-makers (not to mention brain-fodder for cinephiles).

As we've seen, trash was a creative option for Antony Balch, flitting through the interzone between exploitation and the avant-garde in the wake of underground film-makers who took advantage of the blurring of lines between art and exploitation that started in the 1950s.[2] This was institutionalised in the 1970s, when trash and art combined in films with a distinct cult sensibility and exploitation was upscaled into blockbusters. The aesthetic use of trash in the mainstream was a feature of the New Hollywood, with its overlapping roots in exploitation, the art and underground film and American genre film-making. We've seen too how contemporary exploitation directors channel their horror fandom into programmatic trash films for the home-video market such as *Evil Aliens* and *Stag Night of the Dead*. Their films are not trash merely out of commercial necessity as exploitation was in the 1950s and 1960s. They deploy trash and its traditions to aesthetic and strategic purpose, whether to reach out to cult connoisseurs of camp, to indulge in fan-boy homage, or to integrate the transgressive content and style of exploitation into assaults on the middlebrow.

The five case studies in this more wide-ranging chapter focus on different uses of trash as film style in Britain since the late 1960s. All of these films have cultish qualities such as transgression, campness, *film maudit* status, dubious critical reputations and lashings of sex and violence. More important, they represent intriguing and sometimes troubling mergers – or stand-offs – between trash/exploitation and the art house, which alienated critics and made audiences uncomfortable.

The first case study is Joseph Losey's *Boom*, a kitsch showcase for Elizabeth Taylor at her most extravagant, and an example of what has been called the 'loathsome movie'. The second is Anthony Newley's astonishingly egotistical *Can Heironymus Merkin Ever Forget Mercy Humppe and Find True Happiness?*, which aspires to combine the auteur cinema of Fellini's *8½* (1963) and the Broadway musical. Derek Jarman's *Jubilee* (1978), the third case study, was one of a handful of punk films that included the Sex Pistols semi-documentary *The Great Rock 'n' Roll Swindle* (1980). Its mondo-esque bricolage involves a collision of exploitation, post-glam subculture and underground gay style and the British art film. By contrast, Ken Russell's trash horror movie, *The Lair of the White Worm*, shows the eminent auteur adrift from his natural home in the 1970s and

experimenting with genre pastiche and self-parody to explore themes of surrealism and political allegory. The final case study compares Peter Greenaway's art-house flop *The Baby of Mâcon* (1993) with *The Great Ecstasy of Robert Carmichael*, a low-budget 'offensive film' whose imitation of art-house stylistic tropes works to distance it from its roots in exploitation. Both films are 'sick' allegories that employ similar styles of detachment to complicate their audiences' intellectual and visceral relationship with grotesque material such as scenes of rape-murder.[3]

My aim is not to argue that 'low' films are capable of as much complexity as art films, or that art films can be just as gross and trashy as exploitation. That point has been made endlessly in the history of film criticism and indeed throughout this book. The art film, with all its various stylistic conventions, is, after all, a genre and framework of reception as opposed to a qualitatively different or superior mode of textual operation. Rather I argue that these films' assaultive (and, in most cases, commercially disastrous) combination of high and low is central to their aesthetic purpose, even as it ensures their commercial and critical trouncing by leading them into the kind of pretentiousness, kitsch and self-parody that only a cultist could love. All of the films could be – and have been – dismissed as simply *bad* and they are still hard to evaluate, though I'll certainly have a stab at doing so. What makes them so valuable as case studies is that each in its different way undercuts systems of evaluation, even the supposedly alternative ones in which cultists so passionately invest.

BOOM AND THE GOLDEN AGE OF CULT *FILMS MAUDITS*

In the late 1960s and 1970s the relationship shifted between kitsch, trash and the art movie. As well as exploitation films that benefit from the raised eyebrow of camp viewing, oddball psychedelic films such as *Wonderwall* (1968), and successful exercises in high camp such as Ken Russell's *The Music Lovers* (1970) and *The Devils*, the period saw such arty and overreaching flops as *The Magus* (1968), Peter Medak's *Negatives* (1968), John Boorman's *Zardoz* and the late films of Elizabeth Taylor, such as *Boom*.

John Waters's term 'failed art film' is as good a definition as any for these films, which now often seem bold and postmodern.[4] Another term works too – Harry Benshoff's coinage 'the loathsome film'. The term is inspired by a 1970 *New York Times* review by John Simon that excoriated 'indescribably sleazy, self-indulgent, and meretricious films', which were generically unstable, overran the boundaries of art, exploitation and the mainstream and foregrounded parodic, camp and queer elements.[5] These films sprang from the coincidence of counterculture permissiveness, relaxed censorship, funding from studios unsure how to address changing audiences and directors being given more control than before, all of which encouraged genre-bending pretentiousness and ambitious imitations of European cinema. In the US experiments in search of an audience included Otto Preminger's LSD film *Skidoo* (1968), in which Groucho plays a gangster called God, the hard-edged radicalism of Antonioni's *Zabriskie Point* and Dennis Hopper's Jodorowsky-influenced follow-up to *Easy Rider*, *The Last Movie* (1971). Loathsome films were to some extent evidence of the popularisation of camp in cinema, which Benshoff dates from 1966 when a 'rift between traditional Hollywood film-making and the era's newer countercultural sensibilities opened up a space for camp

reception practices'.[6] That uncertainty was also felt in Britain, where producers struggled to know what might work for changing audiences.

Although loathsome films included a number of British films, most came from Hollywood, and many of them would become cult midnight movies. Key ones included *Performance*, *Beyond the Valley of the Dolls* (1970), *Boom* and *Myra Breckinridge* (1970), which John Russell Taylor called 'an epoch-making essay in the big-budget trash movie'.[7] Some, like *Boom*, were flamboyantly over the top, and combined the art film with a harmless pop camp style that threaded through *Modesty Blaise* (1966), *Slave Girls* (perhaps), *Danger: Diabolik* (1968), the TV series *The Avengers* and the Bond film, *Diamonds Are Forever* (1971). Others, like *Myra Breckinridge*, were much less 'pop-y' and, inspired by the experiments of underground cinema, comprehensively trashed the codes of art and Hollywood in a spirit of subcultural camp. Crucially, to 'get' *Myra* required a complete overhaul of one's frames of aesthetic reference. Anticipating the full-blown postmodern tricksiness of David Lynch and Paul Verhoeven, the films left insufficiently hip and ironic audiences at a loss whether to take them seriously or not. Was the 'badness' of the films a sign of incompetence or a sophisticated put-on? Something queer is happening here, the films insinuated, but *you* don't know what it is. These were Hollywood films in drag, performing the clichés of cinema within quotation marks, rather as Douglas Sirk had deconstructed melodrama in the 1950s. While *Valley of the Dolls* seemed merely hapless, *Beyond the Valley of the Dolls* was knowingly and unnervingly hip as it guyed and parodied Hollywood – if, that is, you were in on the joke and approached it with the right cultist attitude.

Boom is a prime example of a British loathsome film, though it is much less confrontational than *Performance* and *Myra Breckinridge*. William Johnson makes the case for the prosecution. Films like *Boom*, he writes,

> contain all of the most fashionable elements to be found in films today – sex, perversions, nakedness, obscenities, and violence. It seems as if Losey ... [is] deliberately using these elements to make their serious content more palatable.
>
> Meanwhile, as Hollywood becomes more 'emancipated', frankly entertainment films are doing the reverse: introducing social and philosophical significance in order to justify their sex and violence They suggest that both heavy- and lightweight films are converging on a common ground where they will no longer have any true individuality of style or feeling.[8]

Adapted by Tennessee Williams from his 1963 play *The Milk Train Doesn't Stop Here Anymore*, *Boom* was inspired by the abstract action of a kabuki play.[9] Elizabeth Taylor, in a series of outrageous frocks and headdresses, plays a dying rich woman on a Mediterranean island who is visited by Chris (Richard Burton), a poet known as the Angel of Death, who every now and then exclaims 'Boom!' because it is the sound of 'the shock of each moment of still being alive'. Noel Coward appears as the Witch of Capri, a role originally intended for a woman, and shares with Taylor a meal of 'sea monster'. Legend insists that the actors were drunk most of the time. This offers cultists another route to enjoying the film: watching for signs of on-set havoc breaking the diegesis, the actors signalling frantically through the fourth wall that something is hopelessly out of whack. Cult films are very often valued for such accidental documentary

pleasures, either as visible traces of a troubled production history, or as sublime moments when the real personalities of the actors break through and merge with their roles – moments that only cultists with detailed knowledge will fully appreciate.

Boom has become a cult film largely because of John Waters, who for a while toured what he said was the only print around and celebrated it as 'the best failed art film ever'. Kimberly Lindberg, on her *Cinebeats* website, describes it accurately enough as 'an uneven European art film masquerading as a mainstream Hollywood movie'.[10] But it can also be seen as one of an unfolding series of projects – vanity or otherwise – by Burton/Taylor that played off their relationship and the image of themselves in *Who's Afraid of Virginia Woolf?* Benshoff cites that film as one of the key camp films of 1966, along with *Batman*, and quotes Stanley Kauffman describing Burton/Taylor in 1968 as 'a movie star vaudeville team [that] has become one of the greatest camps of our time'.[11] This is the moment, he suggests, that camp entered the mainstream.

Taylor's late films, such as *Hammersmith Is Out* (1972), *The Driver's Seat* (1974), *Dr Faustus* (1967), *Ash Wednesday* (1973) and *Zee and Co* (1972), can be read as Warholian portraits of the artist as icon of excess. These 'Lizploitation' movies revolve in awe around her and snatch meaning from Taylor's own troubled and spectacular life. As Lindberg says of *Boom*:

> The role ... struck a little too close to home for Elizabeth Taylor and she saw a lot of herself in the character ... [and her] numerous dead husbands, who were abusive and suffered from impotence (two things Taylor had experienced herself) as well as her 'one true love' who had been an adventurous mountain climber that fell to his death ... Richard Burton later told Joseph Losey that Elizabeth had been haunted on the set of *Boom* by the spectre of Mike Todd, which could possibly explain the uncomfortable distance between Burton and Taylor that seems somewhat apparent in the film at times.[12]

The same is true of *The Driver's Seat* and *Ash Wednesday*, which is about a woman undergoing plastic surgery to try to win back her husband. These are films about ageing and misogyny at a period when older women were often depicted as gargoyles, as in horror films after *Whatever Happened to Baby Jane?* The films have a hypnotic vulgarity that is embodied in Taylor herself, who symbolises Hollywood in all its wild overblown sexiness. It is as if the films' grossness, excess and aspiration – too big, too flashy, too self-obsessed, gaudy and blowsy – were transferred to Taylor's own magnificent and compelling body, which had the same oversexed out-of-control fabulousness that Divine would celebrate in John Waters's films.

Boom is an especially cunning version of kitsch, that most nerve-wracking of all modern cultural modes. Kitsch is 'art' that repackages high and especially avant-garde art into accessible, fashionable imitations for mass consumption by the culturally insecure lower middle class. Kitsch is arguably inextricable from popular cinema itself, with its populism, reliance on the pre-packaged emotional content of genre, and melodramatic realism. Trash films and art-house films are, in a sense, safe choices – they are secure in the cultural hierarchy, and appropriate attitudes towards them are easily learnt. True, one may regard the art film, as Manny Farber did, as insufferably airless and its pretensions merely chic, but admiring Antonioni and Godard is, even now, a reasonable

Noel Coward and Elizabeth Taylor in the 'loathsome' *Boom*

marker of correct taste. The same goes for trash. As we saw in Chapter 2, trash films can certainly slip the surly bonds of low culture and get redescribed as art. But mostly they stay trash and are valued ironically if at all or are adored according to the passionately contrarian aesthetic criteria of cult viewing practices. Kitsch is altogether more difficult to negotiate, unless one is confident in one's irony towards it (self-reflexive *knowingness* is an essential accessory and defence mechanism). Admiring without sufficient irony art which aspires to high art but appeals directly to middlebrow taste is a fatal slip, not least for middle-class cinephiles and what Greg Taylor calls 'vanguard criticism'. Unless one has plenty of cultural capital to spare, admiring kitsch, unless you admire it *as* kitsch, marks one out as irredeemably middlebrow and lower middle class. I am obviously simplifying things somewhat in this Bourdieu-inspired summary, but my point is to emphasise, once again, that taste judgments and evaluation are deeply implicated in class and cultural/educational capital. That is no less true of cultists, who are as competitively obsessed by correct value judgment and status as any other audience.

In fact, as a rule, it is easier to elevate trash into art than it is to elevate the kitsch and middlebrow, unless it is done by radical recontextualisation. The art critic Clement Greenberg said that the 'pre-condition for kitsch, a condition without which kitsch would be impossible, is the availability close at hand of a fully formed cultural tradition, whose discoveries, acquisitions and perfected self-consciousness kitsch can take advantage of for its own ends'.[13] For modernists like Greenberg, writing in the 1940s, kitsch

was the most dangerous and toxic kind of trash culture, and more dangerous even than outright lowbrow trash, because it passes as culture to those naive enough to mistake it for high art. It also undercut the status of critics, whose job is to explain art to the masses (critics have precious little status otherwise). Kitsch is uniquely worrying because it blurs class boundaries and counts as art to the wrong people. As Greg Taylor says, 'Middlebrow culture has been so intensely feared by the avant-garde precisely because it raises the spectre of inherent aesthetic value successfully marketed to the masses and therefore threatens the critic's prized authority and creativity.'[14]

This brings us back to the loathsome films of the late 1960s. What alienated critics and audiences, aside from the films' delving into underground material, their rejection of realism – or rather standard methods of non-realism – and their refusal of good/bad taste distinctions, was precisely their striving to make art out of the popular, to turn melodramas into statements, musicals into autobiographies and erotic dramas into state-of-the-nation pieces. They got above their station, in other words, by drawing on the stylistic devices of art cinema and heightening them into self-conscious camp devices for twitting the bourgeois mainstream. Crucially, these uppity films were not standard kitsch, but rather evidence that cultural hierarchies were changing and cultural authority was up for grabs. Niche audiences and niche value judgments based on subcultural identities (countercultural, gay) fragmented any sense of a stable pyramid of high, middle and low, and trash was heading for the mainstream and becoming not only avant-garde but popular. Insistently tasteless, irreverent and knowing, unlike 'true' kitsch, these art-trash-kitsch crossover films were genuinely *Zeitgeist*y.

CAN HEIRONYMUS MERKIN EVER FORGET MERCY HUMPPE AND FIND TRUE HAPPINESS?

These confusions can be fruitfully explored in relation to another failed art film, *Can Heironymus Merkin Ever Forget Mercy Humppe and Find True Happiness?*, which demonstrates the aesthetic uses of staggering pretentiousness. This is a notoriously bad and extremely rare film, too embarrassing even to have been released on DVD.[15] A Sondheim-like musical about the life of its director, filmed in the style of Fellini, it is kitsch not so much for being queerly camp (though there are elements of that), but because it is so ambitious and jaw-droppingly self-involved. Nevertheless, it is an extraordinary film, of interest perhaps mostly to Anthony Newley fans, but worth re-evaluating for its recklessness and idiosyncratic attempt at career-risking self-analysis.

Can Heironymus is usually described as an ego trip by Anthony Newley, an important figure in 1960s theatre, who had begun as a child actor in *Vice Versa* (1948) and *Oliver Twist* (1948), gone on to a successful career as a pop singer and songwriter (his songs included 'Goldfinger'), starred in a bizarre self-reflexive television comedy, *The Strange World of Gurney Slade* (1960), in which he was trapped inside a TV show, and achieved his greatest success writing and performing in stage musicals such as *Stop the World – I Want to Get Off* (1961). Written in collaboration with Herbert Kretzmer, *Can Heironymus* is an original film musical, centred on Newley essentially playing himself, in which he looks back over his life from the perspective of thirty-six years. The intention was openly autobiographical: 'I felt it was the sum total of my life to date.'[16] Newley's earlier stage musicals were in similar autobiographical vein: *Stop the World – I Want to Get Off* was an

Everyman story about Littlechap's search for love in the arms of numerous women, and *The Roar of the Greasepaint, the Smell of the Crowd* (1964), was an allegory about class in which another Everyman figure, Cocky, is kept in his place by Sir, his social superior. *Can Heironymus* was therefore, as his then wife Joan Collins says, 'an erotic musical-comedy-fantasy, based on his life story – *one more time!*'.[17]

Can Heironymus is constructed of surreal set pieces influenced by wildly different styles – the Hollywood musical, of course, but also Bergman, the free form fantasy of Fellini's *8½*, and the unassuming old-fashioned authenticity of the music hall, represented by a number from Bruce Forsyth (the point is also being made that art-cinema techniques such as anti-illusionism, sudden shifts in tone and breaking the fourth wall were always features of low culture like music hall and indeed pantomime). The action is framed as a beach party in which Merkin (Newley), a Hollywood actor, surrounded by the detritus of his life which is about to go into a museum, screens a film about himself. As well as Merkin, Newley plays several characters who represent different facets of his own life; he also comments on the action as it goes along, with a combination of self-love and self-loathing. *Playboy* centrefold Connie Kreski is Mercy Humppe, the very young object of his fascination, while Joan Collins plays his wife Polyester Poontang (she was cast partly to keep the budget down because she took only $5000)[18] and Newley's own two children appear as Thumbelina and Thaxted Merkin. George Jessel is the Presence (Death) and Milton Berle, Good Time Eddie Filth, the Devil, who pop up in the action to provide sardonic asides. There is little in the way of conventional drama, but rather a series of vignettes, interspersed with symbolically dense musical numbers, whose 'reality' is confusingly ambiguous. Newley's uncertainty about how far he succeeds in fusing the conventional musical with the experimentalism of the art film is flagged up in the film by the comments of two critics, Penelope and Sharpnose, which pointedly include 'I don't mind his vulgarity, it's the pretension that irks me' and 'The whole thing is self-glorification on a masturbatory level.' Unlike other musical disasters of the period, such as *Doctor Dolittle* (1967) (in which Newley also appeared) and *Star!* (1968), which had attempted to repeat the success of *The Sound of Music* (1965), *Can Heironymus* was not an especially expensive folly at £500,000.[19] Indeed, in some ways, for all its ambition, it comes across as an oversized amateur film, which makes the story's presentation as a sort of home movie all the more appropriate.

Like the earlier musicals and *Gurney Slade*, the film is about an ordinary man dreaming of escaping Britain's class boundaries, but here, like Newley himself, he has achieved fame only to finds himself torn between Britain and the US, family life and promiscuity, commercialism and art, with sexual conquests as the only index of his success. Like many other 1960s British films about upwardly mobile working-class men, *Heironymus* ambivalently comments on how traditional class and family structures and versions of masculinity are giving way to new ones based on sex, the cult of celebrity, and individualist consumption. The film emerges as a very thinly disguised version of Newley's life story and obsessions, reworked as a Faustian allegory of the pitfalls of stardom in which self-pity alternates with startling honesty. There are direct references to his marriage, the death of his child, his interest in astrology and his atheism ('I need no gods, I believe no dreams, I'm all I need', he sings), and his musical successes, as well as self-lacerating comments on his egotism, misogyny and sexual selfishness – 'I have

Joan Collins and Anthony Newley in *Can Heironymus Merkin Ever Forget Mercy Humppe and Find True Happiness?*

really been committing a kind of sexual murder. The ritual homicide of the female sex, forever reopening and stabbing the divine wound.'[20]

Sex is the key theme, with allusions to Newley's struggle with his sexuality (a coy mention of toying with 'exotic fruit'); the attractions of the *Playboy* lifestyle (*Playboy* in fact devoted a major spread to the film); and especially what Collins calls an 'eye for the ladies. Especially those between the ages of fourteen and seventeen.'[21] 'Although I was still very attracted to women my own age', Merkin says, 'I found that – in my late twenties – I was increasingly drawn towards young girls. By young girls, I mean *young* girls.' Mercy Humppe, his 'perfect child-lover', is clearly meant to represent the innocence lost in selling out to fame and conveyor-belt fucking, but the film's openness about Newley's preference for Lolitas – Merkin describes himself as 'The Casanova of the Lollipop Set' – makes for uncomfortable viewing forty years later. Collins said the film, however cathartic it was for Newley, contributed to the end of their marriage (they divorced in 1970):

> I had a sick horrible feeling when I first read the script of *H.M.* He seemed to have spelt out the death of our marriage with this totally revealing picture of his life, and how little he cared for me [] and when I saw the film in a private screening room in London a few months later I knew there was no hope for us ever to live normally together again.[22]

Whereas most previous musicals were aimed at family audiences – a lost cause in the late 1960s, as the studios were slowly finding out – *Can Heironymus* was released with the new 'X' certificate in the US. Unusually for a musical, the BBFC demanded a number of cuts mostly to 'reduce' sexual detail, close shots of naked bodies and pubic hair, and indications of perversion; for example: 'Reel 3 – Reduce the scenes of love-making on a bed, and remove the shots of the masked figure caressing the woman's breasts', 'Reel 7 – Reduce the shots in which there is love-making with Mercy, in particular shots of the stroking of her nipples', 'Reel 11 – Reduce the underwater sequence so as to remove shots in which pubic hair is visible, and also the last embrace in which the woman is seen with her legs apart' and 'Reel 12 – Reduce the "Princess and the Donkey" scene in such a way as to remove any clear suggestion of bestiality. Remove shots of "Icicle Ike" stroking the little girl.' Adult, sex-themed musicals were not entirely unknown (*Hair* opened off-Broadway in 1967), but *Can Heironymus* was still an extremely challenging proposition – a self-reflexive autobiographical art-house sex musical. Not surprisingly, it flopped. Collins fairly sums up the critical response:

> [H]ad it been made by a Fellini or Antonioni [it] would have been lavished with praise. It was avant-garde, witty and gorgeous to look at, but because it was so autobiographical the critics dipped their quills in venom and the film was universally panned. This always seemed to happen to Tony, who was never a critics' darling.[23]

Like *The Magus*, the film marked a limit point of British cinema's engagement with art cinema and the 'director as superstar'.[24] Even its detractors admitted that the songs, some of which Newley later used in his repertoire, are often excellent, and the film can be seen as anticipating Bob Fosse's similarly self-indulgent *All That Jazz* (1980), which had the good fortune to appear after the New Hollywood had normalised combining traditional genres with the cinema of personal expression. In some ways, *Can Heironymus* also anticipated such elegies to the alienated working-class rock star as the David Essex vehicle *Stardust* (1974) and especially *Pink Floyd – The Wall* (1982).

Here is a perfect candidate for a cult film in waiting, if anyone could actually get to see it. A box-office failure too experimental and generically hybrid for mainstream audiences, with a charismatic lead performance that is also a documentary portrait of the actor, and numerous coded allusions and subtexts for cultists to investigate and share, *Can Heironymus* is certainly 'bad' by conventional standards and absolutely kitsch in trying so hard to restyle the middlebrow form of the musical as art-movie pastiche. But that 'badness' is also a measure of the risks Newley was willing to take. There was nothing safe about his version of kitsch; it wasn't an attempt to make the 'difficult' stylistic achievements of his cultural superiors more accessible and easily consumed. On the contrary: rather than 'elevating' his material by imitating Fellini and Bergman, Newley, suddenly liberated from conventional style and good taste, also threw in music-hall routines, bad jokes, 'X'-rated nudity, lurid confessions and sick allusions to underage sex and bestiality. In short, Newley deliberately trashed the musical, his reputation and even, as it turned out, his own marriage by letting rip with his all but pathological pretentiousness and inappropriate 'oversharing'. And that is precisely why the film is so fascinating and unique.

JUBILEE

The intersection of high and low, accelerated in the 1960s by the pop-art aesthetic of camp, kitsch and postmodern irony, found new expression in the 1970s in punk. As a trash style, punk drew on influences as various as glam and the situationists. There were a handful of punk films in the late 1970s, though they came rather later than the music. As Kevin Donnelly points out, punk films, 'in no way form a solid movement or coherent genre in the sense of having distinctive stylistic traits'.[25] They mostly documented punk or appropriated its eclectic style after the event. *Jubilee*, the first dramatic film about punk, is widely regarded as definitive, though it contains no complete punk songs and won the ire of Vivienne Westwood who saw it as a 'betrayal of punk'.[26] Purists might cite as more authentic Don Letts's *The Punk Rock Movie* (1978), filmed on Super 8 at The Roxy; the German *Punk in London* (1977); or *Rude Boy* (1980), a drama documentary about The Clash. *Breaking Glass* (1980) was a more conventional commercial film about the rise and fall of a New Wave star; and *Radio On* (1980), a British-German co-production, is an art movie centred on New Wave music. The most audacious was Julien Temple's *The Great Rock 'n' Roll Swindle*, which is the story of the Sex Pistols from the jaundiced and self-serving perspective of their manager, Malcolm McLaren, which Temple's later self-revising documentary *The Filth and the Fury* (2000) thoroughly debunked. Its release was delayed by two years by legal action brought by Johnny Rotten, and by the time it came out both Sid Vicious and Mary Millington were dead.[27]

Jubilee and *The Great Rock 'n' Roll Swindle* share what might be considered the essential punk style – an aesthetic of collage and appropriation that was 'radically hybrid, iconoclastic'.[28] It was a cut-up technique derived not only from artists such as Jamie Reid and the situationists (Reid had connections with them and McLaren was mixed up with the English situationist group King Mob), but also, especially in the case of Jarman, from the experiments of Balch and Burroughs and the radical juxtapositions of underground film-makers like Kenneth Anger.[29] As well as exhibiting a trash style in a sense of recycling the abject and ephemeral, the films were also, like *Trash* and *Flesh*, about people considered trash – the marginal and socially discarded. Both Kevin Donnelly and Claire Monk note 'the sheer Britishness' of British punk films.[30] As with much punk, Britishness defines itself partly against America, for as Mad (Toyah Wilcox), a character in *Jubilee*, says, 'America's dead, it's never been alive.'

The punk films were erratic amalgams of the rock film (*Slade in Flame*, with its cynicism about the rock business, was an obvious precursor), documentary, art film and the amateur DIY of Super 8 underground films, and exploitation, which had already covered the rock scene in *Groupie Girl*, *Permissive* and *Bread*. Exploitation was so dominant in 1970s British cinema that, as Claire Monk points out, it shaped the form of the punk films. Except for *Breaking Glass*, the punk films were 'X'-rated, 'typically commercial/art cinema/exploitation hybrids and rarely untouched by financial imperatives'.[31] The 'pornification' of Britain seeped into the films and, as Monk notes, this rather undermines the centrality of women to punk.[32] The lead character of *Rude Boy* works in a sex shop and the film, which was released by exploitation company Tigon, contains some explicit sexual material, while Mary Millington appears – she was paid £1,000 for one day's filming[33] – in *The Great Rock 'n' Roll Swindle* and fellates Steve Jones in a cinema. More generally, exploitation and selling out are central themes of all the films, and positively

celebrated in *The Great Rock 'n' Roll Swindle*. Indeed, *The Great Rock 'n' Roll Swindle* was originally to have been directed by either Russ Meyer or Pete Walker, two masters of exploitation.[34] While *Jubilee* plays its underground and art-film elements off against popular culture, *The Great Rock 'n' Roll Swindle* celebrates its own grasping nihilism with an exhilarating swagger and irreverence that puts it in the exploitation tradition of the mondo documentary. It is a compilation of reportage, autobiography, art-film allusions – a woman with ants on her face references *Un Chien andalou* – instructional film, dramatised restaging and even cartoon. Like *Jubilee*, it contrasts past and present, and presents the Pistols' anarchy in the great British tradition of the Gordon Riots, from which derived the term 'King Mob' for the unruly working class.

Jubilee, like Alex Cox's US-set punk film *Repo Man* (1984), can also be categorised as dystopian science fiction. It imagines a completely mediatised but recognisable future of gangs, fascism (Dorset has become a self-contained fascist state) and violent police that recalls not only *A Clockwork Orange* but William Burroughs's novel, *The Wild Boys* (1971) (which cropped up in *Secrets of Sex*). The original intention seems to have been to document the punk scene around Jordan, who inspired the film and plays the nominally lead character, Amyl Nitrate.[35] The producers suggested turning it into a drama to exploit interest in punk and Jarman worked in elements of another project, *The Angelic Conversation of John Dee*, so that it became what he described as 'a fantasy documentary fabricated so that documentary and fictional forms are confused and coalesce'.[36] In the film's framing story, Elizabeth I (Jenny Runacre) and John Dee (Richard O'Brien) are transported to the punk future, so that the film is 'recalling a lost period of authentic national identity which can be contrasted to the sleazy and fake forms of patriotism circulating in the year of the Queen's Jubilee'.[37] The main characters are women, Bod (short for Boadicea, also played by Runacre), Mad and Crabs (Little Nell), and the film focuses on their violence, which is self-destructive, masochistic and nihilistic.

The film has a remarkably overloaded and intertextual visual style. There are numerous images within images, and texts to read as well as look at – newspaper headlines, posters, film quotations ('He wouldn't even harm a fly', Norman Bates's final line in *Psycho*, is displayed on the back of a biker jacket) and graffiti ('THIS IS POST-MODERNISM' and 'Brave New World' are seen written on walls). This eclecticism suggests that perhaps the film's key precursor, at the tipping point of glam into punk, was *The Rocky Horror Picture Show*. Richard O'Brien and Little Nell appear in both films, of course, and Amyl Nitrate quotes *Rocky Horror*'s key theme, 'Don't dream it, be it':

> Make your desires reality ... I myself prefer the song, 'Don't Dream It, Be It' ... desires weren't allowed to become reality, so fantasy was substituted for them – films, books, pictures. They called it 'art'. But when your desires become reality, you don't need fantasy any longer, or art ... on my fifteenth birthday law and order were abolished.

The artist Viv (Linda Spurrier) says, 'Our only hope is to recreate ourselves as artists or anarchists, if you like, and release the energy for all.' The theme of authenticity is highlighted by the various styles of acting, from RSC seriousness to camped-up and straightforwardly parodic. Whether the postmodern abolition of the distinction between life and art, as advocated by surrealism, situationism and punk, is a good thing or a recipe for

megalomania, solipsism and violent anarchy are at the heart of the film. Although *Jubilee* can be read as a radical statement, a state-of-the-nation film that combined private imagery with political lament like Jarman's later intense and baffling *The Last of England* (1987), it is also conservative in a very English way. As O'Pray writes of Jarman:

> In the films there is a an acute, even nostalgic sense of a centre having been lost, but, paradoxically, there is also an urgent desire to innovate and shock ... Jarman is part of a long line of English radicals whose work has embraced a form of Romantic conservatism – William Blake, William Morris and, much closer to his own aspirations and times, the filmmaker Michael Powell.[38]

One might add Ken Russell, too, whose *The Devils* and *Savage Messiah* (1972) Jarman set-designed and with whom he shared both camp humour and a flair for anachronistic deconstructions of historical realism. Jarman, however, was himself detached from punk and cynical about its radicalism (though this in itself is a punkish attitude, given punk's contempt for the political pretensions of the counterculture). *Jubilee*, like *The Great Rock 'n' Roll Swindle*, centres on the inevitability of the sellout and the usual conversion of revolt into style. Punk was a sensibility whose 'nihilistic outburst was in the end simply transformed into mere "innovations" of existing cultural forms'.[39] As Borgia Ginz, the McLaren-like media mogul who becomes the film's most vivid presence, declares, 'They all sign up in the end one way or another':

> This is the generation that grew up and forgot to lead their lives. They were so busy watching my endless movie. It's power, babe, power. I don't create it. I own it. I sucked and sucked and I sucked. The media became their only reality and I own their world of flickering shadows.

In his memoir, *Dancing Ledge*, Jarman echoed Ginz:

> Afterwards the film turned prophetic. Dr Dee's vision came true – the streets burned in Brixton and Toxteth, Adam was on *Top of the Pops* and signed up with Margaret Thatcher to sing at the Falklands Ball. They all sign up in one way or another.[40]

Jubilee and *The Great Rock 'n' Roll Swindle*, for all their similarities, do not represent a coherent genre of punk films; they are more like art-school films (which was Julien Temple's background). As Monk says, this reflects the fact that

> film was *not* the productive medium of choice for most of those inspired by punk's DIY ethos and its (Situationist-inflected) emphasis on self-expression rather than being a mere consumer ... the non-spontaneity and protracted timescale of conventional film-making were fundamentally antithetical to punk's ethic of instantaneous creativity.[41]

In fact an 'authentic' punk film may have been impossible, insofar as notions of authentic are relevant to a style grounded in appropriation, defacement and collage. A more

distinctive punk trash aesthetic was developed in New York in the early 1980s by what Nick Zedd called 'Cinema of Transgression', which grew out of No Wave music. This radical and nihilistic underground cinema, typified by the cheap bad taste films of Zedd, Richard Kern and David Wojnarowicz, was much more amateurish and DIY than the art-house exploitation of British punk film. In Britain punk was perhaps better represented by media interventions, such as the Pistols' 1976 gleefully foul-mouthed disruption of Bill Grundy's interview with them on the *Today* show (1968–77), which was in the spirit of détourning a Pink Floyd T-shirt.

THE LAIR OF THE WHITE WORM

The camp horror film flourished as a style of generic revision in the 1970s, with *Horror Hospital*, the *Phibes* films, *Theatre of Blood* and *The Rocky Horror Picture Show*, but programmatic trash really came into its own with the 'fan fluff' of the 1980s and 1990s when young cinephiles combined auteur ambitions with delight in the expressive possibilities of exploitation. The film that experimented most impressively with trash pastiche, however, was not a fan film by a tyro cineaste. It was Ken Russell's *The Lair of the White Worm*, in which the deliberate trash film is a vehicle for wild speculations about surrealism, cod-psychoanalysis and national mythology.

In its own delightfully bonkers way *The Lair of the White Worm* is a near-perfect trash movie. Sharply self-parodic but locked into key themes of British cinema (and indeed culture), knowing and surreal, ridiculous but tightly controlled, it is a fine example of 'heterosexual camp', a compromise solution by a director exiled from the art house who is using a low genre as a vehicle for 'mad' imagery in the absence of any other commercial outlet. *The Lair of the White Worm* is both a self-parodying experiment with comic adaptation (a deliberately ridiculous version of a very bad novel) and a pastiche of the allegories of England we encountered in 1970s horror. It is also and not surprisingly a cult film. According to Russell, the cult flourished in Australia, but not in Britain:

> It did well in other countries, but not in Merrie England, where our dour-faced critics insisted on taking it seriously. How on earth can you take seriously the vision of Catherine Oxenberg, dressed in Marks & Spencer underwear, being sacrificed to a fake, phallic worm two hundred feet long?[42]

Russell retrofits the programmatic trash film to a very English style of baroque high camp, as he also did in the follow-up, the Wilde adaptation, *Salome's Last Dance* (1988). Russell's *Fall of the Louse of Usher* (2002) continues this signature style of puckish camp in what is essentially a home movie. Rather like Nigel Wingrove's underground sexploitation films, *Visions of Ecstasy* and *Sacred Flesh* (2000), the film is an often hermetic vehicle for idiosyncratic fantasies and private references, as well as being as self-consciously 'mad' as Russell's auteur persona requires.

A high Romantic for whom the term *enfant terrible* may have been coined, Russell abolished the line between art and exploitation, modernism and kitsch, and high and low throughout his career. Like Antony Balch, but coming from a different direction, he is something of a missing link in this book, its high priest, drawing together many threads of trash and art. His films, once extremely popular, combine genre cinema (especially

horror), the mainstream (the biopic and heritage film), modernism, avant-garde, TV documentary, erotica and the pop video, which he can claim to have comprehensively pioneered. They were held together by a cartoonish surrealism underpinned by belief in the surging erotic passions driving all motivation and artistic expression. With Russell trash came to be a stylistic choice as, with dazzling excess, he cut through factitious distinctions between official and popular culture in order to be true to the chaos and tastelessness of the Unconscious, from which creativity – his chief concern – springs forth. At the end of his career low-budget film-making was the only option available to him. But even then, a trash Prospero weaving low magic in an English garden, he forged a distinctive style of lurid amateurism.

Russell's reputation was perhaps at its height in the 1960s with BBC television documentaries for Monitor such as *Elgar* (1962). He achieved considerable commercial success with adaptations such as *Women in Love* (1969) and *The Devils* and raucous Dionysian biopics of musical artists, such as *The Music Lovers*, his version of The Who's rock opera, *Tommy* (1975), and the crazily phallocentric *Lisztomania* (1975). *The Devils*, perhaps his masterpiece, condenses his key themes – the force of repression, the imperturbability of sex, ceaseless change and transformation, politics as eroticism, and Catholic-inspired kitsch. Russell's over-the-top set pieces present cinema as a tumultuous visual and musical experience of ecstatic fantasy akin to a religious vision or Coleridgean drug trip. His style of 'mannerism' set him in opposition to the more polite traditions of British film-making, and O'Pray notes Russell's similarities with Jarman:

> Both directors use music centrally, both have a liking for forms of popular entertainment such as music hall, fairgrounds and circus, and both use dance. Their films are reminiscent of Eisenstein's earlier work, which was heavily influenced by revolutionary Soviet theatre with its emphasis on montage methods, high spirits and strong visual imagery as opposed to psychological, naturalist or realist narrative.[43]

In the 1980s Russell became associated, logically enough, with the horror genre, first with two films made in the US, *Altered States* (1980) and *Crimes of Passion* (1984), and then, returning to Britain, two lower-budget films, *Gothic* (1986) and *The Lair of the White Worm*, which pastiche literary adaptation and the heritage film. The horror genre was an ideal vehicle for Russell's interest in decadence, madness, monstrous outsiders and sexual violence. It suits his relentless evocation of the role of sexuality and counter-cultural emphasis on the dangers of repression. An auteur exploitation film, *The Lair of the White Worm* might be seen as a remake of *Snakewoman*. According to Russell,

> I entered a three picture deal with Vestron because, in exchange for creative control, they gave me $1,000,000 for each. It was a case of 'Don't ask too many questions, don't make too many demands for 600 on-set colour slides or three translations of the script, and I'll deliver the goods.' Only a company like Vestron would agree to that, although *Lair* did eventually end up costing $1,300,000.[44]

The Lair of the White Worm updates to the present the last novel by Bram Stoker, the author of *Dracula* (1897). Written in 1911, it is, as Russell said, 'Stoker's worst book'.[45]

The product of a period when Stoker was ill, the novel is shot through by the patriarchal, class, imperialist and misogynistic themes kept under control in *Dracula*. Adapting the book posed an unusual problem. There was little point in fidelity because the original material was so poor that nothing would be lost in deviating from or even traducing it. In fact the badness of the novel, as well as its obscurity, was a liberation and an opportunity; the trashier the film, the more faithful it would, in a sense, be to the comically lurid subtexts of its source. As Russell commented, 'One of my favourite pastimes is keeping audiences guessing whether I'm being serious or not, and this film fits the bill perfectly.'[46] The central idea is kept of a beautiful woman who transforms into a giant snake (the white worm of the title), but the novel's hopelessly confused plot is mostly disregarded. Instead the film plays up the novel's psychoanalytically overdetermined terror of female sexuality. In the book the snakewoman, Lady Arabella, 200 feet long and 2,000 years old, lives beneath her house in the Yorkshire countryside a slimy 'round fissure seemingly leading down into the very bowels of the earth' and stinking of 'the draining of war hospitals, of slaughter-houses, the refuse of dissecting rooms … the sourness of chemical waste and the poisonous effluvium of the bilge of a water-logged ship whereon a multitude of rats had been drowned'.[47] The hero dries out the hole with sand and blows it up with dynamite. The film's delirium, however, unlike Stoker's, is a deliberate stylistic choice, intended for a post-Freudian audience which can be expected to get the raunchy asides and in-jokes.

The film is about an archaeological dig in the Peak District, near the real landmark of Thor's Cave, which is the worm's lair. Hugh Grant is Lord James D'Ampton, who returns from the RAF to claim his land. He confronts Lady Sylvia Marsh (Amanda Donohoe), the priestess of an ancient pre-Christian giant snake cult, who is also a vampire capable of transforming into a giant snake. D'Ampton, helped by a Scottish archaeologist and a couple of local girls, eventually defeats the white worm, which, when it appears at the end, seems to have been constructed from a Volkswagen Beetle. The film's theme is the struggle of patriarchal control over the land of England, and its imagery is drawn from St George and the dragon. In a dream D'Ampton becomes St George in a painting, though it is significant that, while he smokes out the snake, the 'dragon' is actually killed by a Scot and two working-class girls. As Russell's biographer, Joseph Lanza, notes:

> Lord James reflects the last remnants of a dead empire, with allusions to a class war raging during the Thatcher days. D'Ampton and Lady Sylvia are ghosts of the old aristocracy, while Flint and the Trents are the commoners who have to take matters into their own hands when James sometimes seems to flounder.[48]

D'Ampton is actually rather 'damp'. Sylvia Marsh's name associates her with the rural, as well as with D'Ampton's dampness and suggests, in a nod to Stoker's sexual panic, vaginal wetness.

The use of dream sequences links the film to surrealism, which Spicer argues Russell channelled through his Catholicism:

> Russell's neo-romanticism is informed by his Catholicism, which fuels his interest in violent imagery, sexual repression, the grotesque and mysticism. In his more successful films,

> Russell creates a Surrealist dialectic between the fantasies of the central characters that are prey to irrational forces and an objective presentation of their situation.[49]

Spicer claims that Russell's weakness for 'banality and vulgarity' weakens his later films because 'the films' fantasies are not located in a particular character's perception, and therefore it is unclear what they represent, and the dialectic that is essential to Surrealism is lost'.[50] But the vulgarity of the fantasies, the sheer trashiness of the film's approach, are absolutely crucial, and it is obvious too that the character in whose 'perception' the fantasies are located is Russell himself. For Russell the wilder, the more tasteless and grubby the fantasy, the more faithful it is likely to be to the gross reality of the Unconscious. The horror film, like softcore porn and exploitation cinema, embodies the degraded inheritance of the Romantics' belief in the imagination; it is also, like the madness and drug orgies that, as *Gothic* suggested, gave birth to the genre itself, a means of accessing the Unconscious. The trashier the fantasies and the style, the more effectively the mythic content is communicated to the audience; in *The Lair of the White Worm* Russell is, in a sense, trying to do intentionally what *Slave Girls* did with offhand inadvertence.

Like much horror in the 1980s, British horror films focused on 'body horror' and camp comedy. John Kenneth Muir takes *The Lair of the White Worm* to be a parody of a subgenre of 1980s horror that Wes Craven called 'rubber reality', for which *Altered States* had been the template:

> In films of this genre subtype, the *dramatis personae* easily ... glide between alternate realities, often quite indiscernibly to audiences. There is often no traditional scene transition between these parallel 'modes' of reality and fantasy. The phantasms of the unconscious and subconscious mind are often physically externalised as tangible and tactile.[51]

The Lair of the White Worm is also aligned with that style of horror, such as H. P. Lovecraft's mythos, that imagines alternatives worlds of meaning, an erotic counter-history, and not simply the religious realm of Good and Evil. The most intriguing aspect of the film, however, is that it uses the horror film to suggest how the genre can offer a psychogeographic mapping of Britain. The film – 'his most intensely English film', according to John McCarty – is structured according to the traditions of the British rural-horror film: it is set in a country house, the monster is associated with ancestral evil and the central dynamic is class.[52] As in Hammer and Dennis Wheatley, there is a strict Manichean division of Good and Evil, with Evil represented as a compelling and, in the form of Donohoe, highly attractive and sexualised conqueror worm. D'Ampton and Sylvia are symbolic of two Englands in ancient rivalry as well as two kinds of sexuality – upper middle-class masculinity, patriarchal and repressive, and predatory and exotic female sexuality, which combines phallicism and the Dionysian. Underlying it all is a fantasy of the continuity of pagan England into the present, represented by the house being built on a temple. This fantasy flourished in Britain in the late nineteenth and early twentieth century as part of a reaction against industrialisation. In fact, as Ronald Hutton has shown, there has been no continuous pagan presence in Britain; it is a strictly modern invention.[53] But the idea of an alternative and more authentic lost pagan Britain

(and especially England), associated with nature, sexuality and often matriarchal power or resistance to the mainstream, was especially popular in the counterculture of the 1960s and 1970s. A secret Albion of magical continuity, capable of rediscovery and awakening, can be traced in horror films such as *Blood on Satan's Claw* and *The Wicker Man*, which Russell discusses directly after *The Lair of the White Worm* in *Fire over England*, though by the 1980s there was no longer a counterculture to act as an allegorical reference point.[54] This notion of what the graphic novelist Alan Moore called 'England's mythic dreamtime' embodies both radical criticism of the present and conservative nostalgia for a romanticised rural and hierarchical past.[55]

The Lair of the White Worm is a camp pastiche of these fantasies, a 'cognitive mapping', to use Fredric Jameson's term, of Britain along class and gender lines.[56] *The Lair of the White Worm* seems to set out a conventional variation on the horror film's standard scenario of the monstrous and erotic being repressed for the sake of civilisation. There is a more or less ahistorical vision of Britain, going back to the Romans, as an unending battle between, on the one hand, authentic but dangerous paganism (sexuality, the female principle, the past) and, on the other, rationalism (masculinity, science, repression, modernity), which the former haunts in dreams and erotic fantasies. But the film has a more local allegorical applicability, which is tied to the 1980s. As Barry Keith Grant notes, Russell's 1980s films 'attempt to resolve the cultural anxieties of which Thatcherism itself is in part a symptom'.[57]

We can build on Grant's insights that the film is 'about the struggle of patriarchy and British tradition to retain power' and expresses 'both the values of British tradition and a disdain for them that mirrors the tensions inherent in Thatcherism, itself a bundle of "contradictory values"'.[58] Sylvia is ancient but also an attractive and sexy modern figure associated with conspicuous consumption (her Jaguar car, for example; McCarty suggests she is a typically 1960s figure, 'a voracious (sexually and otherwise) version of Diana Rigg in *The Avengers*').[59] Sylvia can also be read as an AIDS metaphor, stalking the screen as in Cronenberg's remake of *The Fly* or Glenn Close's 'bunny boiler' in *Fatal Attraction* (1987). In her the sexual revolution – amoral, commodified and individualistic – has been appropriated by consumer capitalism. A yuppie, an urban dweller colonising and defiling the rural, she embodies the link made between postmodern capitalist consumerism and serial killing in texts like *American Psycho* (novel 1991, film 2000), and between capitalism and vampirism in *The Satanic Rites of Dracula*. Most important, her monstrous femininity is phallicised; she is a queer monster (Mrs Thatcher was camp too, which is about the only thing the inept biopic *The Iron Lady* got right about her). She is a challenge to traditional patriarchy, embodied in D'Ampton (a Tory 'Wet'), who returns, a nostalgic symbol of traditional Englishness in the uniform of official military power and hierarchy, to claim a true 'organic' relation to the land and rescue it from Sylvia's modern and exotic consumerism, which is destructive of tradition, the family (she seduces a boy scout) and masculine power (she infects the local bobby). At the same time, Sylvia is paradoxically ancient, an abiding and repressed feature of Britain. A phallic feminine monster, both modernising and reactionary, Sylvia is a figure for the contradictions of Margaret Thatcher, who also usurped, transformed and controlled traditional patriarchy. The film can be read as a hysterical attempt to make sense of the novelty of Thatcherism, both its slippery sexiness and its destructive

Lady Sylvia Marsh (Amanda Donohoe) confronts patriarchy in Ken Russell's *The Lair of the White Worm*

individualism, its atavistic appeal to the Unconscious, and its combination of Englishness and Otherness.

After *The Lair of the White Worm* Russell continued his wayward engagement with moments of extremity and decadence in British culture. *Salome's Last Dance*, a chamber piece about a performance of Wilde's play, is cheap and claustrophobic. Rather as *Gothic* legitimated Russell's lurid melodrama by tracing it back to the Romantics, *Salome's Last Dance* finds a precedent for his heterosexual camp in the *fin de siècle*. Russell's imagination circled even more feverishly on sexual matters in his last few films, which were shot on video, and he became ever more conscious of himself as a mad, Gothic presence in British cinema's attic. Indeed the hilarious commentary he produced for the US DVD release of *The Lair of the White Worm* ends with him describing himself as 'completely mad'. He embodied on the one hand a lost sense of ambition and even public service in British film and television, and on the other the spirit (as with Nicolas Roeg) of an age of British cinema that was both deeply English in its eccentricity and also a lifeline to modernist experimentalism.

This continues even in his final amateur productions such as *Fall of the Louse of Usher*, which are erotic, comic and unhinged in their freeform blend of avant-garde experimentalism and ultra-low-budget exploitation in the style of *Pervirella*, Alex Chandon's exploitation parody starring horror icon Emily Booth. *Fall of the Louse of Usher*, which is uncompromisingly dreadful, stars Russell as Dr Calahari.[60] Romping about his estate, an English eccentric making art to amuse himself, Russell reminds one of the Marquis of Bath covering the walls of Longleat with erotic murals or indeed Newley committing gleeful career suicide in *Can Heironymus*.[61] The film is nonetheless a fascinating attempt to create a personal trash style with no commercial ambitions whatsoever and, while it shares much with the DIY output of video-on-demand horror

directors, it shares something too with the films of Nick Zedd and perhaps Peter Whitehead. Lanza is encouraging about the film, which is 'disjointed and mercilessly vulgar, but it also has stunning moments':

> Russell still proves his gift for composition and his instinct for vibrant colours. An English flower garden never looks more surreal, old gravestones never exude more sinister grandeur, and even one of his trademark slow-zooms onto James Johnstone's rotting teeth exposes the undiscovered beauty behind what the consensus finds hideous.[62]

Russell seemed, in his final movies, to be happy to identify himself as the mad endpoint of the Romantic notion of genius and the cult of the amateur outsider artist that had dwindled to playful solipsism and self-indulgence.

CRIMES OF ART

While Russell was scampering around Derbyshire, the 1980s saw a revival of the British art-house film, associated with directors such as Mike Leigh, Ken Loach, Terence Davies, James Ivory and Peter Greenaway, and backed by the Arts Council, Channel 4, and the BFI Production Board, which had moved 'towards the targeting of an educated bourgeoisie minority audience within mainstream feature-film culture'.[63] A comparative analysis of two challenging films, one a bona fide subsidised art film and the other a low-budget exploitation movie filmed in the style of a 'legitimate' art film throws light on the complexities of art/exploitation crossovers. Both films might be considered kitsch, in the sense that they aspire to art but fall badly short, but they are more usefully thought of as unsettling examples of hybrid films that, equally distant from the multiplex mainstream, elevate extreme content by self-reflexively aestheticising it.

Though he is far less visible now than in the 1980s, no director is more securely located in the realm of art than Peter Greenaway. Emerging from the subsidised avant-garde and moving with *The Draughtsman's Contract* (1982) into the art-house mainstream, Greenaway kept up a steady production of stylised, intricate, painterly and politically charged dramas till *The Baby of Mâcon*, 'an arty snuff movie', which alienated audiences and critics with its coldly theatrical play-within-a-play treatment of a story about the exploitation of a child (it is, in fact, anticipated by Russell's *Salome's Last Dance*, which also ends with an onstage death that turns out to be all too real).[64] *The Baby of Mâcon* is set in the seventeenth century like all Greenaway's period films: 'For me, historic films are like science fiction – they offer a freedom to the imagination that one cannot find to the same extent in films that take place in the present.'[65] It has a Chinese-box structure, presenting its story of a child being passed off as miraculous as a stage production in which the distinction between the play and real life is gradually confused. It culminates with a woman being raped 208 times as a punishment, before the child is dismembered and the pieces taken as holy relics. As with all of Greenaway's films it is entirely anti-realist: 'My dialogue is intentionally declamatory, artificial – it has nothing to do with conversation.'[66] And in fact the film was originally intended to be an opera.[67] The action is overseen by a theatre director who is Prospero as well as Greenaway himself.[68] The result is emphatically not a conventional historical film, and resembles Jarman's *Edward II* (1991), Russell's *The Devils* or Peter Brook's film of

Marat/Sade (1967) rather than *Elizabeth: The Golden Age* (2007). While the film includes elegant tracking shots and sumptuous costumes, its claustrophobic staging in a closed space deliberately subverts many standard pleasures of the historical genre, such as lingering views of the British landscape. As in *Prospero's Books* (1991) and *The Pillow Book* (1996), with which it makes an informal trilogy, Greenaway moves film away from cinema and into new spaces, literary, digital and here the world of theatrical ritual. This denaturalises events, strips them of psychological realism and emphasises the frequently confusing interplay between audience, onstage events and backstage action. In short, this is neither a Merchant–Ivory version of history nor a comforting entertainment for the educated middle class.

The events appear to have an allegorical significance, but one planted by Greenaway rather than dreamt up by enthusiastic interpretation. On the one hand, they are a commentary on the abuse and exploitation of children, and 'this mass hysteria surrounding the ill treatment of children'.[69] On the other, to judge from an interview that Greenaway gave on *The Late Show* (BBC2 TX 22 September 1993), the film is more generally about power and the abuse of women by the Church, Greenaway citing violence and 'institutional rape' in the then Yugoslavia as one of the film's key contemporary reference points.[70] If *The Baby of Mâcon* were an exploitation film, you might call this its 'square-up' – a disingenuous justification for screening otherwise gratuitous material. Greenaway had already foregrounded violent material and cannibalism in the tightly controlled anti-Thatcherite melodrama, *The Cook, the Thief, His Wife and Her Lover* (1989). But *The Baby of Mâcon* is a deliberate theatre of boredom, frustration and cruelty that would prove accessible only to cultists of either Greenaway or 'extreme cinema' like Pasolini's *Salò, or the 120 Days of Sodom*, *Cannibal Holocaust* and Noé's *Irreversible* (2002). Indeed, Hawkins mentions that *The Baby of Mâcon* crops up in paracinema catalogues alongside Jess Franco's horror films, Godard movies and other hard-to-find curiosities.[71] Unreleased in the US and rejected by art-house audiences, the film belongs now in a new cultural position or what Hawkins calls an 'unsacralized cultural space' as a *film maudit*.[72]

Readings of the film in books on Greenaway, which tend to be astonishingly uncritical, generally unpack the film as a postmodern exercise in baroque self-reflexivity and defend it more or less entirely in terms provided by the auteur, who is assumed to have a controlling presence in the film and strict ownership over its meaning and significance. David Bordwell suggested that art cinema, which emerged as an institution in the 1950s: 'foregrounds the *author* as a structure in the film's system ... the author becomes a formal component, the overriding intelligence organizing the film for our comprehension'.[73] Thus the film, as David Pascoe puts it, 'exhibits the tyrannies of representation, and, in doing so, breaks apart the illusions that are experienced in the dark'.[74] Or, as Greenaway says, making further interpretation otiose:

> the film distorts this theatrical event and introduces 'reality' into the much-rehearsed piece of theatrical exhibitionism. The baby that is born on stage is not the expected fake wooden doll but a real child ... the priest's son is not an actor who feigns a bloody death but becomes a real fatality ... the actress who plays the virgin daughter is not just obliged to act the victim of multiple rape but is a true virgin who is raped till she perishes ... and the child

saint is not a substituted doll but a real child who is murdered and then dismembered. The 'realities' of the theatrical propositions are deliberately mocked, suggesting various reactions – first, the dividing lines between reality, artifice and theatricality, fact and fiction, are perilously thin.[75]

While popular and genre films tend to be read symptomatically, art films are still interpreted according to the intentions of the director.[76] In the case of this film, positive interpretations of it closely resemble cult recuperations of despised exploitation films, in that they similarly valorise boredom, displeasure, offensiveness and 'difficulty' as self-reflexive authorial strategies or bracing deconstructions of the conventions of mainstream narrative.

David Pascoe writes that the film 'took to a horrifically logical conclusion many of the illusionistic considerations he had been developing since his earliest work, and that were now beginning to emerge in his extra-cinematic activities', such as the exhibitions and installations that were taking up much of his time.[77] What this misses is the punishing experience of actually sitting through the wretched film. Despite Greenaway's droll claim that it is 'one of the most accessible films I have ever made', and despite too the enthusiastic (and thoroughly auteurist) comments on IMDb, the film approaches, with a certain experimental purity of spirit, the *intentionally* unwatchable.[78] It begins with a disabled stuttering figure representing Famine, suspended in space against a black background, whose dialogue is virtually impossible to comprehend. From then on the film elaborately constructs thematic richness and painterly effects while rigorously eliminating most of the pleasures of commercial cinema. Again this combination of thesis and stylised visceral impact, of self-reflexivity and psychological flatness, is familiar from exploitation films. As Hawkins says, 'high culture – even when it engages the body in the same way that low genres do – supposedly evokes a different kind of spectatorial pleasure and response than the one evoked by low genres'.[79] Ironically, while the film may be aimed at an art-house audience able to appreciate its references, while, in conventional modernist style, attacking that same audience, which expects to be shocked – the audience most capable of enjoying its displeasures is a cult one of paracinema fans educated in exploitation.

A decade or so later, treating exploitation material with Greenaway-influenced art-house style, Thomas Clay's *The Great Ecstasy of Robert Carmichael* is an even more disturbing film and a comparable exercise in the aggressively unwatchable. It is about Robert (Dan Spencer), a bright teenager, and friends Joe (Ryan Winsley) and Ben (Charles Mnene), and Joe's cousin Larry (Danny Dyer) in the coastal town of Newhaven. Robert ends up breaking into the house of a TV celebrity chef and his pregnant American wife, whose bourgeois domesticity contrasts with the teenagers' thwarted lives. Robert and the others rape the wife and Robert kills her by violating her with a bottle and the sword of a stuffed swordfish. Like *The Baby of Mâcon*, it offers itself as an allegory, this time of Iraq – a possibly Muslim child is called 'Osama' when he is mugged and his bag searched for 'weapons of mass destruction'; we see news headlines of the build-up to the war, and in a key scene a girl is raped off screen while Bush and Blair talk about war on television. Dyer, who says he did not read the script closely and did just four days work on the film out of a six-week shoot, wrote that he first saw the

film at the Edinburgh Film Festival. He had heard that it had been controversial at Cannes, but watching the culminating rape made him feel ill – 'I was embarrassed to be associated with it, to be honest.'[80]

The film inhibits involvement and communicates boredom, bleakness and anomie with a coldness of style denoted by long takes, static symmetrical set-ups in deep focus and lengthy lateral tracking shots, stretches of silence, cameras withdrawn from the action and the use of distressing sound in an off-screen space. Camera movements tend to be diegetically motivated, but not always – for example, the camera follows the chef from the kitchen to the living room but drifts back to his wife at the kitchen table before the chef returns, so that it is not anchored, as camera movements tend to be in mainstream cinema, to on-screen movement. Shot/reverse shot combinations are more or less avoided and scenes tend to end in slow fades to black. In short, the film adheres to, or attempts to replicate, what might be called the contemporary house style of art films. The staginess of the scenes, with characters distributed standing side on across the widescreen rather than blocked for movement within it, only emphasises the flatness of the dialogue, which is presumably functional rather than expressive. The shocking violence at the end plays out in brutal tableaux with few close-ups. The expected naturalism – this is basically an 'underclass' film, and the casting of Lesley Manville in a small role as Robert's mother links it to Mike Leigh's films – is counterpointed with music by Elgar and Purcell, an obviously Kubrickian device, though Clay rarely uses a wide-angle lens, as Kubrick does to cartoonish effect. Visually, Clay is much closer to Greenaway and Michael Haneke, while the tracking shots of working-class youth also recall Alan Clarke. This disconnection between style and content produces, as in *The Baby of Mâcon*, an aloof Brechtian formalism that enables the misogynistic abstraction of a sexual crime into allegory. The extended rape scene focuses themes of class revenge and turning the home into a war zone, as in *A Clockwork Orange*, *Straw Dogs* (1971), *Death Wish* (1974), *The House on the Edge of the Park* (1980) and *Dirty Weekend* and *Straightheads*. The film also refuses adequately to account for the violence in terms of conventional psychological realism or strictly as a product of social breakdown. As Dyer complained, 'I've lived on an estate all my fucking life and I've never been bored enough to do some bird with a swordfish.'[81] Robert remains a blank – a withdrawn artistically gifted observer primed to explode. There is possibly an Oedipal explanation – his father has left and he lives with his attractive mother – but while characters in exploitation films tend to lack interiority and act from cartoonishly accessible motives such as revenge, desire and hate, Robert more closely resembles Bordwell's description of the standard enigmatic protagonist of an art movie:

> The characters of the art cinema lack defined desires and goals. Characters may act for inconsistent reasons or may question themselves about their goals. Choices are vague or non-existent. Hence a certain drifting episodic quality to the art film's narrative.[82]

But explanations are generalised across the film rather than lodged in individual psychology and a quotation from *The Mahabarata* on screen at the very end, as the gang is walking towards the rising sun, suggests an even wider interpretation as well as elevating the film's pretentiousness to a new level:

Voice from the lake: What for each of us is inevitable?
Yudhishthira: Happiness.

Contexts of reception and the cultural capital required to decode these two films, *The Baby* and *The Great Ecstasy*, might seem widely different, even though both are in the modernist tradition of problematising the audience's relation to the material and chastising any enjoyment it might take in watching the film. Both films use extremity – of style as much as content – to force viewers out of their comfort zone, which is after all the function of art cinema: 'Art cinema or art-house cinema is the aestheticised sector of commercial cinema. It is a specialist cinema which valorizes art, auteurism, experiment, elitism and internationalism, but this specialism functions within the limits of both commercial cinema and bourgeois culture.'[83] Haneke's *Funny Games* (1997) is an example, though *A Clockwork Orange* is more obviously influential on *The Great Ecstasy of Robert Carmichael*.

The film flags up its own context of interpretation during a Media Studies lesson when the students discuss war films, including *Come and See* (1985), which they complain is horrible – 'War is horrible', the teacher replies. Other films cited, written on a blackboard in the lesson, include *Saving Private Ryan* (1998) and *Triumph of the Will* (1935), which take different routes to impacting on their audiences and delivering 'media effects'. *Come and See*'s influence is most obvious at the end of the film, when the murder is intercut with black-and-white images of World War II and Churchill; this mimics the devastating effect of the final sequence of *Come and See* when the young protagonist shoots a photograph of Hitler, which begins a series of montages in reverse time back to an image of an infant *Führer*. The teacher emphasises the mediation of reality and incites his students to question the image.

How to present material so that it affects an audience seems to be the film's key theme, against the background of a culture disconnected from reality by the media. The students make a short film set in World War II – it seems to be about an execution, as in *Saving Private Ryan*, during which Robert is suddenly violent. Robert reads De Sade on the toilet and masturbates, so that, in a commentary on the film, high art intersects with pornography – the film's problem, in a sense, is how to render its material ineffective and unarousing by distancing the audience from it, and how to make a film about the working class that the working class won't be able to sit through. Distanciation might be seen as a bourgeois technique, setting the art film apart from emotionally involving genres that might inflame their audiences. Indeed, similar self-reflexive tropes are used in many horror films and thrillers, not only *Peeping Tom* and *Henry: Portrait of a Serial Killer* (1986), but *The Last House on the Left*, *Videodrome* (1983), *The Last Horror Movie* and even *The Human Centipede 2: Full Sequence* (2011). There is often a class-based assumption that 'low' genres cannot do self-reflexivity and that the audience stands in need of correction. As Mark Kermode noted of *Funny Games*, 'being lectured on why you are such a bad person for wanting to watch any of this stuff in the first place gets a bit wearing' and that 'any sleazeball horror fan familiar with [*Henry: Portrait of a Serial Killer*] ... will have seen Haneke's themes – the voyeuristic power of video, the collusion of viewer and killer – rehearsed several years earlier in altogether more radical fashion'.[84]

Briefly, it is worth comparing *Great Ecstasy* with another film that combines exploitation and arty self-reflexivity. Like *Great Ecstasy*, Ben Wheatley's *Kill List* straddles art and exploitation and plays games with genre expectations. A stylised hitman thriller, it centres on veteran Jay (Neil Maskell), who is married to Shel (MyAnna Buring) with a seven-year-old son Sam (Harry Simpson). Jay works as a hitman with his friend from Northern Ireland, Gal (Michael Smiley), whose girlfriend is Fiona (Emma Fryer). The film has curious textual lacunae. The victims thank the killers before being despatched (the hitmen may be working for a sort of suicide gang); and Fiona writes a *Blair Witch Project*-style satanic or pagan emblem on the back of a mirror in Jay's bathroom. Though it is never clear whether Jay is involved in a fantasy or a conspiracy, the film transforms into some kind of allegory of, as Wheatley put it, 'the country being fucked' by the recession and debt and by being controlled by upper-class manipulators like the nameless Client (Struan Rodger) – 'What these people do is really morally reprehensible but they're still a family unit trying to support themselves.'[85] There is a shift at the end into rural horror, so that, in what appears to be a reference to *The Wicker Man*, the hunter becomes the hunted and Jay finds himself the victim of a pagan cult. Nia Edwards-Behi likened *Kill List* to *A Serbian Film* (2010), another appallingly violent film, part-gangster film and part-horror film, which uses self-reflexive allegory in the service of social comment.[86] Art in these films, or rather the stylistic markers of the art film, are used as a weapon to undercut genre, deny pleasure and ensure difficulty. It puts the films at odds with their audiences, directs attention to auteurist intentions, perhaps unexpected in the context of thrillers, and legitimates the construction of allegories.

As I said at the start of this chapter, all the films here could be regarded simply as very bad, whether deliberately so, like *The Lair of the White Worm*, or by transgressing their cultural and generic boundaries by sorties into camp, kitsch, pretentiousness (not, on the whole, a quality admired in Britain) and other styles of excess and poor taste that alienated or confused audiences and critics. Only *Jubilee*, which came armoured with Jarman's art-film credentials, has really found much critical favour.

In the final chapter, I'll pursue this theme of 'badness' and ask, 'What is the worst British film ever made?'

10 WHAT FRESH HELL IS THIS?

So far I've been careful not to define trash as simply bad films. But clearly 'badness' has sometimes been a criterion for inclusion. It is worth, in concluding this book, considering briefly what might be the worst British films. What films really *are* trash and beyond all hope even of cult recuperation?

THE WORST OF BRITISH

Any self-respecting cinephile can trot out a canon of the supposedly worst Hollywood films ever made, from amateurish exploitation such as *Plan Nine from Outer Space*, *Troll 2* (1990), *The Room* and *Ben and Arthur* (2002), which are known mostly to cultists, to big-budget follies and vanity projects such as *Battlefield Earth* (2000), *Gigli* (2003) and *Catwoman* (2004), which were high-profile financial and critical disaster zones. But there doesn't seem to be – if you can entertain such an idea – an agreed *canon* of bad British films.

To remedy this unfortunate situation and because no cultist can resist the appeal of making a list, I carried out what might very loosely be described as research. I began by googling combinations of terms such as 'worst', 'British' and 'film'; went on to examine critical and reader surveys of the worst films of all time; pored through the lowest-ranked films on IMDb, metacritic and Rotten Tomatoes; cross-checked against the winners and nominations for the Razzie Awards, which have been handed since 1981 to the Worst Film of the Year; and finally crowd-sourced opinions among film academics on Facebook. This was not, I admit, an entirely rigorous methodology, but the result was a tolerably representative list of what are popularly regarded as the absolute worst of British. More important, I gained some insight into the various and often contradictory discourses of 'badness' underpinning the naming and shaming of these movies. I did my best to discover what the choices were of specifically British audiences and critics, but I daresay my findings fell short of definitive. Nevertheless, I now have my list and it is at least a start.

Most rollcalls of bad movies, including those found in British magazines, are dominated by big-budget Hollywood films. This is not surprising, given that even good British films struggle to get noticed and bad British films rarely attract the scandalised publicity afforded to expensive Hollywood flops, embarrassing star vehicles and misjudged franchise killers. On IMDb only one film in the bottom hundred is British: *Fat Slags* (2004), an adaptation of the *Viz* comic strip, which last time I looked was at number 26. I suspect Britain's poor showing is less a tribute to the consistently high quality of our film-making and more because our bad films are too obscure to have attracted many votes.

A handful of British films nevertheless stood proud in *Empire*'s 2010 readers' poll of the fifty worst films of all time. As you might expect, the British films, with one curious outlier, were all drawn from the last twenty years. Few films, let alone British ones, burn bright enough in infamy to have caught the eye of *Empire*'s young readership. This was true of all the surveys I came across, and I quickly realised that my final list would be comprised almost entirely of contemporary duds. The cult of bad American films is sufficiently well advanced and publicised that 'Golden Turkeys' such as *Plan Nine from Outer Space* and even *Robot Monster* might spark recognition in the average British film fan. Bad British films of a similar vintage, such as *Fire Maidens of Outer Space*, remain the private passion of only the most certifiably committed British film geek. Even so, the *Empire* list included five British films in its countdown to the readership's number 1 choice, Joel Schumacher's *Batman & Robin* (1997).[1] The others were *Parting Shots* (1999) (at number 42), *Eragon* (2006) (a co-production, 36), *Highlander II: The Quickening* (1991) (9), *Sex Lives of the Potato Men* (7) and *Raise the Titanic* (1980) (4, the outlier, and one of the oldest films on the whole list). *Raise the Titanic*, incidentally, was nominated for a Razzie at the inaugural awards, along with another film from Lew Grade's ITC, *Saturn 3* (1980). Subsequent British nominees at the Razzies were *Revolution* in 1985 and *Spice World* (1997) in 1998, while British co-productions, albeit with internationally recognised stars, carried off the top award with *Swept Away* in 2002 and with *Basic Instinct 2* in 2006.[2]

Extrapolating from this hodge-podge of surveys, polls, lists and invited opinions, I found that a rough, though not wholly surprising, canon does in fact emerge of British turkeys. Equally interesting, I got a sense of what *kinds* of films had stuck in the British craw over the last ten years or so, from cheap gangster films aimed at working-class lads, to bad-taste TV spin-offs and sentimental over-Americanised musicals and comedies. They add up to a symptomatic description of what is wrong with British cinema in the 2000s. Rather than elusive films, which represented nothing but their own inadequacy, these were generally well-known films that were *worth* tagging as bad films because they symbolised something gone awry in British cinema and perhaps in British culture itself.

A few categories and a handful of their defining films I can deal with very briefly, in part because I have written about them elsewhere.[3] As you might expect, they are mostly the kinds of low-budget popular genre movies that made up Petley's 'lost continent' back in the 1980s. But not all are. Some are exploitation in the sense of cash-ins on the momentary fame of pop groups, a genre that goes back to the 1950s. The key ones here are *Spice World* and the S Club film *S Club Seeing Double* (2003). Paul McCartney's *Give My Regards to Broad Street* (1984), and Guy Ritchie's remake of *Swept Away*, starring Madonna, come into a different category, though – the star vanity project. Another musical was also singled out (especially, it must be said, by film academics), but this was not a teen pop film but one of the highest-grossing British films of all time: *Mamma Mia!* As with *Love Actually*, the other very popular film mentioned numerous times, it seemed to be the combination of sentimentality, direct emotionalism and appeal to female audiences that was so alienating. I suggested in Chapter 1, while discussing the New British Revisionism, that films such as *Mamma Mia!*, *Love Actually* and Richard Curtis's other comedies, Merchant–Ivory and 'heritage films' are often rejected as a mark of cultural distinction by certain social groups (liberal left, mostly; perhaps above

all men) who are keen to set their own tastes apart from the mainstream. But only audience research can really determine why these films are so divisive and why cultural capital accrues to disliking popular successes aimed at middle-aged women and young girls.

Here are the remaining offending categories of film and their most frequently cited exemplars.

BIG-BUDGET FLOPS
Raise the Titanic

Britain produces few big-budget flops, so this film and *Eragon* stood out in *Empire*'s survey. *Raise the Titanic* achieved iconic status for its peculiarly British combination – though, strictly, it was a UK/US co-production – of failed over-ambitious imitation of Hollywood (enough to damn it in some eyes) and bland mediocrity. Otherwise, it is notorious for contributing to the fall of Lew Grade's media empire and for Grade's comment that it would have been cheaper to lower the Atlantic. The film is irresistibly symbolic given that a film about the *Titanic* scuppered Grade's overreaching ambitions. However, the collapse of Grade's film company, ACC (Associated Communications Corporation) probably had less to do with one film than 'with the cumulative effect of mediocrity, a philosophy that seemed to legitimize it and a structure that compounded it'.[4]

British cinema offers few examples nowadays of the kind of bad-blockbuster cinema produced by Hollywood, largely because the budgets are too low (though many prominent blockbusters are co-productions with British money and personnel). The badness that critics cite in *Transformers* or the later *Pirates of the Caribbean* films such as *At World's End* (2007) lies in their post-classical drift towards spectacle and CGI at the expense of coherent narratives. This not a complaint made about British films on the whole.

LOW COMEDIES
Carry on Columbus (1992), *Fat Slags, Sex Lives of the Potato Men, Ali G Indahouse* (2002), *Lesbian Vampire Killers, Keith Lemon: The Film* (2012)

These films compound their crimes of bad taste, debauching well-liked material such as the *Carry On* series, and not being very funny by reviving the despised formats of the sex comedy and the 'opened out' TV sitcom film of the 1970s, which have become a byword for homegrown crud (*Keith Lemon: The Film*, with a rare 0 per cent on Rotten Tomatoes, epitomises the disaster of the TV spin-off film). *Lesbian Vampire Killers* also represents another frequently mentioned genre – the low-budget exploitation horror film, though it was the genre itself, mushrooming on DVD shelves, rather than any particular example which drew critical and public ire.

What is so annoying about low comedies and horror films? It seems to be their cheapness, their cashing-in on the success of better films, and the fact that some were funded by the UKFC and Lottery money. This is history repeating, of course, for the same complaints were made about sexploitation and horror in the 1960s and 1970s. That is why the key recent 'bad' film is *Sex Lives of the Potato Men*, which became a scandal.[5] I actually think it is rather good and very funny, but the sheer grossness of its depiction of the inane and sex-obsessed lives of a handful of working-class losers made it the

lightning conductor for press attacks on the UKFC. Some of the unease felt about the film, however, was that it was not only designed to appeal to the 'wrong' kind of subsidy beneficiaries – young working-class men – but that it was unquestionably 'British' in its subject matter. The film directed an unfortunate searchlight on the grubby and degraded realities of British life at the margins but, unlike the usual 'miserabilist' films intended for middle-class audiences, it worked within the tradition of bawdy comedy rather than social realism.

ANYTHING BY MICHAEL WINNER
Bullseye! (1990), Dirty Weekend, Parting Shots

Winner was a unique personality in British cinema. His late-period films, made for Cannon after a long period in Hollywood, veer from theatrical adaptations (*A Chorus of Disapproval* (1989)) and outright exploitation (*Dirty Weekend*) to slapstick comedy (*Bullseye!*, 'a sorta geriatric carry on film with class').[6] They are intriguing mixtures of middlebrow entertainment, stuffed with familiar stars such as Roger Moore and Joanna Lumley, and crass bad taste, all filmed in an immediately recognisable style, part-Kubrick and part-Doris Wishman, typified by wide-angle interiors with the camera lodged behind furniture or a pot plant.

Winner's vivid and divisive persona, unapologetic commercialism and right-wing politics had long alienated critics before he acquired fame as a restaurant critic for *The Times*, actor in advertisements and delightfully irascible exponent of randomly spelled tweets. His early films, *The Jokers* (1967) and *I'll Never Forget What's'isname* (1967) are quite well regarded, unlike the nudist film *Some Like It Cool* (1962), the Frankie Howerd vehicle, *The Cool Mikado* (1963) and his subsequent journeyman work such as *Hannibal Brooks* (1969) (with Oliver Reed, a frequent collaborator), *The Games* (1970) and *The Nightcomers* (1971) (starring Marlon Brando, one of his many good friends in the business). Winner's greatest success was the series of vigilante films kicked off by the American hit *Death Wish* (1974), which starred Charles Bronson, and its two sequels, one of which, *Death Wish 3* (1985), has a solid cult following for its crazy over-the-top violence and cheeky recreation of New York near the Elephant and Castle. By the early 1980s, when he had returned to Britain to remake *The Wicked Lady* (1983), his reputation was secure and he earned a chapter, 'The Worst of Michael Winner', in *The World's Worst Movies* for his singular contribution to bad British cinema.[7]

He was a kind of foil to Ken Russell. Both were directors with a distinctive profile but both essayed a very different style of trash. Unlike Russell, Winner was not a mad auteur with one foot in the art house. He was a clubby, mischievous and name-dropping professional in the mould of the Jewish exploitation pioneers and flamboyant impresarios of the 1960s and 1970s, such as Michael Klinger and Lew Grade, who worked his way up to joining what remains of the Establishment.

The best of his later films, because it ambitiously retools the vigilante film to feminist ends, is *Dirty Weekend*, which experiments with some self-parodying camp humour. It was based on a stark allegorical novel (1991) by 'a strange, possessed Jewish writer named Helen Zahavi', with whom Winner co-wrote the screenplay.[8] The novel is a satirical fantasy, written in a curt, repetitive and rhythmic pulp style, about a young woman embarking on a weekend of revenge killings in Brighton, which from *Brighton Rock*

(1947) to *London to Brighton* (2006) has often been depicted as a refuge-cum-fantasy space to escape to at the end of the line. The film closely adapts the book, and recreates the novel's third-person ventriloquising of Bella's (Lia Williams) voice in a conventional first-person voiceover.

Both novel and film begin, 'The story of Bella who woke up one morning and realised she had had enough.' Bella is, like the protagonists in *Death Wish* and *Taxi Driver* (1976), someone who simply refuses to take any more. A mild-mannered and put-upon secretary (in the novel she seems to have been a prostitute), after being sexually assaulted, she retaliates by waging a campaign of slaughter, targeting misogynistic men. She changes, as she says, from a lamb to a butcher. 'I thought you could be gentle in the jungle', she tells another outsider, Nimrod (played in blackface by Ian Richardson), an Iranian clairvoyant whom she abuses as 'a shitty refugee'. The turning point comes when Nimrod tells her that 'All women are sluts because of how men treat them' and gives her a flickknife. She later buys a gun from 'Mr Brown' (Mark Burns), an upper middle-class man, who seems to be gay and who, as another outsider, sympathises with her. Bella's victims include a porn-reading voyeur who calls women 'manholes'; two academics – a Lenin-quoting hypocrite who betrays Bella with a student, and Norman (Michael Cule), a massively obese criminal psychology lecturer; a dentist, Reginald Mud (David McCallum), whose murder allows Bella to say that they are 'driller and killer', referring to the notorious video nasty; and finally, in a *coup de grâce* that finishes off the purest product of patriarchal violence, a serial killer who has made his way down from Edinburgh. She kills him on the appropriately iconic and phallic setting of Brighton Pier. Along the way she also defends an old tramp, Liverpool Mary (Ruby Milton), against 'three city slickers' who are about to burn her as a 'witch'.

Bella says she is 'in sanitation', drawing on the same imagery of the excremental city used in both *Death Wish*, in which New York is described as a toilet, and *Taxi Driver*. The victims she flushes out of the system tend to be associated with dirt and the abject – Norman is physically repulsive while the dentist's name is literally Mud. More intriguing, she calls her vengeance a 'holy war', as if she were on a crusade. Bella also refers to herself as 'Hizbella', which is curious as (in the book especially) she is implicitly Jewish like Zahavi and in a tradition of strong militarised Jewish women. Presumably, by identifying herself with Hezbollah, the Islamic militant group, she signifies, first, that she is a fundamentalist on a terrorist campaign against an occupying force; and, second, that she is appropriating and parodying the violence of her (in this case, patriarchal) Other.

The film is not in any sense realistic but deliberately broad, cartoonish and satirical. Dialogue and performances are heightened and unreal, as in a fairy-tale: 'Fate came to me in the moonlight', Bella recalls in voiceover, 'and when I woke up I'd had enough.' Snatches of 'Beautiful Dreamer' on the soundtrack when she gets the gun and at the end of the film frame the events as wish-fulfilment. It is filmed in Winner's usual flat and functional manner, with wide-angle shots alternating with close-ups, but the artless style and formulaic characterisations lend *Dirty Weekend* a schematic quality typical of exploitation, almost as if it were intentionally stripped down to being a film of ideas.

In reviews, perhaps because the film came out around the same time as *The Silence of the Lambs* (1991) and *Basic Instinct* (1992), Bella was often described as a 'serial killer', but she is really a vigilante. The film belongs to a distinct subset of vigilante film,

David McCallum, Lia Williams and Michael Winner on location in Brighton for *Dirty Weekend*

the rape-revenge genre, which ranges from blaxploitation such as *Foxy Brown* (1974) and exploitation such as *I Spit on Your Grave* (1978), *Ms. 45* (1981) and *Avenging Angel* (1985) to feminist appropriations such as *Thelma & Louise* (1991), *Baise-moi* and *Red Road* (2006). As in most exploitation treatments of the theme, erotic detail is combined with violent horror and the killings are sexualised. Bella prepares for them by dressing in sexy clothes (as when she gets the gun), pretending to be a prostitute or treating the murders as erotic fantasy staged for self-amusement. 'You're not the first', she tells Norman, whom she entices into sex and suffocates, 'you won't be the last. You've heard of foreplay, this is afterplay.'

Dirty Weekend is a much more closed-off film than *Death Wish*, a private psychodrama rather than a disquisition on street crime. There is no element of police procedural (when she looks to a policeman for help, he attempts to rape her) and no mention of media coverage of the killings, which in *Death Wish* turns the vigilante into a hero. In *Death Wish* Bronson doesn't hunt down his wife's rapists (he does in *Death Wish II* (1982)), but goes out in search of any street criminals – his revenge, like Bella's, is against a class rather than specific guilty individuals. But *Death Wish* is essentially a home-invasion film, in which the bourgeois domestic space is occupied by 'freaks', working-class social demons from off 'the street'. In *Dirty Weekend*, however, danger threatens wherever men exist, and in fact only the voyeur and the serial killer are not obviously respectable and middle class. All the men are white, too, which sets the film apart from the racism of many other vigilante films, and emphasises the starkly gendered motivation for the killings. On the other hand, a number of the victims, such as

the yuppies and the leering left-wing academics, seem chosen to represent social types anathematised by the lower middle class, with whose politics Winner, I suspect, closely identified.

Dirty Weekend appropriates feminism to a worldview shared by many exploitation thrillers, which trade in harsh basic emotions energised by class resentment and fantasies of social revenge. This brand of feminism, taken directly from the novel, echoes Andrea Dworkin's purist vision of gender relations as fundamentally defined by rape – a vision which, translated to film, turns out to be entirely compatible with both the simplistic typologies of exploitation and right-wing vigilantism. With its paranoid and comically extreme vision of a world entirely populated by misogynists, *Dirty Weekend* is a darkly cynical and reductionist worm's eye view of human nature, at once bracing, exciting and deeply reactionary.[9] While in comedies, such as the appalling *A Chorus of Disapproval*, Winner's crassness of style sandblasts the material to destruction, here it is wholly appropriate; the film's 'badness' gives it a Sam Fuller-like directness and punch.

THE BAD BRITISH GANGSTER MOVIE
Honest (2000), *Rancid Aluminium* (2000), *Revolver* (2005), *Outlaw*, *Straightheads*, *RocknRolla* (2008), *Pimp* (2010)

The final and largest grouping of named bad films constitute what Anne Billson calls the 'Bad British Gangster Movie. God, they were hell.'[10] These crime films, a return to the dominant genre of the B movie in the 1950s, became an intrusive presence in British cinema after the box-office success of *Lock, Stock and Two Smoking Barrels* (1998), which coincided with the rise of 'New Lad' culture, and the cult of *Get Carter* and Tarantino. Julian Upton, calling them 'the "cool Britannia" gangster film', noted that 'Like the films of the 70s, they are imitative projects, begging for exposure and for attention in the shadow of mainstream hits.'[11] Exploitation producers quickly discovered their commercial potential, as Jonathan Sothcott says:

> Gangster and hooligan movies are the new British sex and horror pictures – the internet has made saucy films redundant and we just can't compete with the Yanks for sheer volume in the horror genre. But there is a seemingly unending appetite for football hooligan stories and examinations of the Rettendon Range Rover murders. These titles make a fortune on DVD regularly enough to have producers churning them out by the dozen.[12]

A loosely related subgenre is the 'hooligan film', which works variations on *The Firm* (1993, remade in 2009) and *The Football Factory* (2004); titles include *Green Street* (2005) and *The Rise and Fall of a White Collar Hooligan* (2012).[13] Danny Dyer, who starred in many of these crime films, rapidly became the poster boy of low-budget contemporary exploitation, as Sothcott again recalls:

> Between 2006 and 2010 the golden goose was, of course, Danny Dyer. If he was on board producers were guaranteed a strong UK distribution deal as his films were generally selling in excess of 100,000 units on DVD. Sadly for Danny and his producers, the market bottomed out because he made too many appalling films that were marketed with overly glossy, even misleading sleeves. One or two of these were mine (*Just for the Record* [2010], *Dead Cert*

[2010]) but there were many – *All in the Game* [2006], *Jack Said* [2009], *The Last Seven* [2010] and worst of all *City Rats* [2009], which was marketed as though it was a sequel to *The Business* [2005] when in fact it was a dreary urban drama.[14]

These films, while on the whole adequately made, seem to offend because of their ubiquity, repetitiveness, glamorisation of violence and status as exploitation. As Nicola Rehling remarks, even though the hooligan film reflects a sense of contemporary working-class masculinity as fractured and anomic, 'There is obviously something disturbing about the cultish popularity of an entire body of British films that feature unapologetically laddish male characters and suggest communal ties and successful masculinity to be dependent on macho displays of aggression'.[15] On the other hand, the most refreshing qualities of these films are what might roughly be described as their working-class (albeit Londoncentric) perspective and their appeal to a working-class audience of young men whose tastes are at worst demonised and at best not taken very seriously. Dyer has acquired a fan following, straight and gay, with his films and those of Nick Love gaining some cult interest among working-class audiences, otherwise somewhat underrepresented in film cultdom. The films boast a certain authenticity through their unaffected knowledge of the underworld, working-class life and male rituals, and, more importantly, show a desire to connect with the audience by reflecting its values. In that sense they update the blunt style of the eight Manchester-based, straight-to-video gangster films, spy thrillers and horror films of Cliff Twemlow from 1983 to 1995, including *GBH* (1983), *The Ibiza Connection* (1984) and *Lethal Impact* (1991).[16] Politically ambiguous, the revenge films have what might be called a tabloid view of the world, whose populism – for like all exploitation, they aim essentially to mirror their viewers' politics and prejudices – offends liberal middle-class commentators, who recoil in contempt from the films' serious interest in revenge, rough justice and male aggression. This is why it is important to look at these 'yobbish films' and politics, and to consider whether the middle-class tastes of cultists offer too narrow a sense of film fandom.

The least respectable, but in some ways most interesting, of these crime films focused on the classic exploitation standby of revenge. On the edge of art cinema, or at any rate social realism, were Shane Meadows's *Dead Man's Shoes* (2004) and Andrea Arnold's *Red Road*. More problematic to critics were *Straightheads* and *Outlaw*, exploitation films aimed at the same audience of young working-class 'lads' as *Sex Lives of the Potato Men*. These two films, which suffered exceptionally poisonous critical receptions, offer strikingly harsh, reactionary and depressing portraits of contemporary Britain. One might add to them, though it wasn't mentioned in any surveys, *Killer Bitch* (2010), an astonishingly violent and inept thriller directed by Liam Galvin, with a cast of gangsters, porn stars and cage fighters, about a woman forced to kill five people or see her family murdered.

Straightheads riffs on *Straw Dogs*, tapping into discourses about white masculinity and nostalgia and communicating a pervasive sense of social breakdown. A short, seventy-seven-minute exercise in brutal wish-fulfilment, written and directed by Dan Reed, *Straightheads* stars Danny Dyer as Adam, in his usual persona as an Essex lad, who fits a security system for Alice, a well-off woman played by Gillian Anderson.

After a party they run into a bunch of ex-military men who beat Adam up and rape Alice, setting in motion a revenge plot that ends with one of the rapists having a shotgun shoved up his arse in a scene of deliberately offensive and off-putting violence. As in *Straw Dogs*, the violence becomes ever more addictive and exciting, with Adam even finding that it reinforces his fragile sense of masculinity. There is an attempt, as with *Dirty Weekend*, to draw out the politics of exploitation. If *Dirty Weekend* co-opts feminism to populist ends, then *Straightheads* attempts to be self-reflexive – there are lots of references to eyes, voyeurism and damaged sight – and to complicate the audience's cathartic enjoyment of revenge. Unlike *The Great Ecstasy of Robert Carmichael*, it does this by manipulating and undercutting the audience's emotional reactions rather than by aloof camerawork and dry formalism. The rape is not easily shrugged off (rather different from its aftermath in *Killer's Moon*); Adam, who becomes impotent after the rape, is 'infected' by violence; and one of the rapists is made unexpectedly sympathetic when we learn that he encouraged his friends to rape Alice to prevent them from raping his young daughter instead. Ultimately withdrawing sympathy from all the characters, the film elects to punish the audience for revelling in the violence, and in the final shot Adam looks out of the screen at us with a complicitous smirk. The critic Mark Kermode was not impressed: 'It's rubbish, it's really rubbish ... I can't believe the funding or the will to make this film existed.'[17] But while unsophisticated and clichéd, *Straightheads* is schematic enough to come across as an unlikely film of ideas rather like *Dirty Weekend*, and not just an excuse to brutalise the audience.

Outlaw, directed by Nick Love, also uses exploitation and revenge to deliberately provocative effect. A more complex film than *Straightheads*, *Outlaw* sets out to be

Danny Dyer traumatised and vengeful in *Straightheads*

politically relevant, incendiary and, as Danny Dyer, who inevitably starred, put it, 'to twist the bollocks of the whole middle-class liberal establishment'.[18] Noting that 'the press hated it, calling it "revenge porn"', he admits that its politics were actually toned down:

> I think maybe we held back with the political side of things, so the film didn't make enough noise. It focused on us hunting down one man, rather than running around bashing up nonces and people who've got off lightly for crimes they've committed. Nick cut all of that sort of stuff out, which was a shame.[19]

The film, all raw green-tinged digital video with nervy editing, is about a soldier returning from duty, Bryant (Sean Bean), who puts together, with the help of ex-policeman Walter Lewis (Bob Hoskins) a group of vigilantes (including Dyer) after Cedric (Lennie James), a barrister, is threatened and his pregnant wife assaulted on the orders of a big-time gangster called Manning (Rob Fry). The film both celebrates and criticises their campaign of revenge. The 'outlaws' are motivated by their own inadequacy, frustration and prejudice as much as by a pure sense of justice. They also come to enjoy their new celebrity – 'We're famous', they exclaim as the public watches their exploits on TV in shop windows around London. Dyer's character, plagued by a nightmare about being beaten up on his wedding day in a road-rage incident, regains a sense of his masculinity when Bryant teaches him and the others to fight back. Bryant, in an echo of *Taxi Driver*, acts out of a desire to find purpose in life after the crusade of foreign duty: 'I don't want to be another face in the crowd, or what was I doing here.' At one point he is posed in front of a poster of *Munich* (2005), Spielberg's film about Israeli revenge for the Black September massacre, which elevates, perhaps with ironic intent, the outlaws' murders into a principled political act of war. As in *The Great Ecstasy of Robert Carmichael*, the Iraq and Afghanistan wars are key reference points. Vigilantism extends the methods of war to home soil but, once the war begins, it proves impossible to restrain violence and avoid 'collateral damage', especially when revenge is an excuse to restore masculine pride. The homosocial group is central to Love's films, as he is fully aware:

> I think all of the four films I've made have been about, on one level or another, attitudes towards crime and violence, and they are all homoerotic in their subtext. They are all about male bonding. They are all about men that are married to each other.[20]

One of the outlaws, a security guard called Simon (Sean Hillier), is a 'nutter', whose personal list of what Bryant calls 'legitimate targets' includes not only 'nonces' but Muslims, Ian Huntley, Gary Glitter and other populist social demons. Although the focus of humour, the fact that he is so obviously racist and unhinged undermines the outlaws' cause. Things come to a head when they put one of the gang on mock trial – 'The geezer is a fucking nonce, put him down!' Walter says – and Simon short-circuits 'justice' by stabbing him in a frenzy. Appalled, Bryant releases the man, who subsequently kills Walter, and it is left open whether Simon's deranged vengeance or Bryant's mercy is the better solution in dealing with gangsters.

The film's climax is when the outlaws converge on Manning's house. This turns out to be a police set-up culminating in a shootout in the woods. Interestingly, the revenge films are not entirely about urban violence; both *Outlaw* and *Straightheads* resemble contemporary rural horror films such as *The Hike* and *Eden Lake* in locating the ultimate source of violence in the countryside and the mansions of the new rich. The scene is partly reminiscent of a Western – the final blaze of glory of *The Wild Bunch* or *Butch Cassidy and the Sundance Kid* (1969) – but the woodland setting also recalls Robin Hood, the British equivalent of the Western myth that inspired the vigilante in *Death Wish*. The shootout itself recalls *Heat* (1995), one of Love's favourite films. Bryant is killed in a slow-motion execution while Dyer nonsensically manages to escape showers of bullets. Back in London, the film ends much like *Straightheads*. Dyer confronts Manning, who says 'You ain't got the bollocks, son', when Dyer pulls a gun on him. Dyer shoots him, smiles, and there is a cut to black. The killing plays as a queasy reassertion of masculinity.

In a documentary extra on the DVD Nick Love states that *Outlaw* is about the rise of 'chav culture'; in fact, scenes of a riot, intended to give a sense of wider chaos, were cut because they were too reminiscent of *The Football Factory*. Like *Straightheads* and *Killer Bitch*, *Outlaw* is both the depiction and product of a thuggish yob culture. Allusions to road rage, the Stephen Lawrence case and the unending corruption and uselessness of the police contribute to a *Daily Mail*-ish vision of Britain as a lawless dystopia overrun with gangsters and hoodies. As the weasely security guard, whose paranoid racism makes the other outlaws appear comparatively sane, remarks, 'It's a dirty fucking world.'

Nick Love directing the shootout on location for *Outlaw*

It is easy to see why critics hated the film, not least for its relentlessly grim politics. On the DVD commentary Love and Dyer insist that it is 'a film about something' and 'the most important film we've made ... a film about a culture, a film about a generation ... about a fucking country that is slowly in decline'. (Video footage of their expletive-strewn 'Derek and Clive'-style commentary became a minor hit on YouTube.)[21] Unlike in contemporary film noirs, there is no corporate conspiracy to explain the film's paranoia (in *Dirty Weekend* the role played by patriarchy). Everything is just shit. Social change is impossible except at the end of a gun, and the only solution is to pick off the bad guys one at a time. Such vigilantism is more usually associated with American cinema's lionisation of the outlaw hero from the Western to superhero films, though it is equally compatible with fascism. Nevertheless, as in *Dirty Weekend*, *Straightheads* and *Taxi Driver*, though not in *Death Wish*, where the vigilante is depicted without irony, the politics are complicated by the vigilantes being either mad, driven by personal demons or over-enamoured of violence and the new bollocks it has enabled them to grow.

For all its confusions, *Outlaw* makes a fascinating trilogy with the other two Dyer films, *Great Ecstasy* and *Straightheads*, which overlap considerably in their themes of chav culture, rape, violation, home invasion and war. Unsettling and alienating audiences by playing to their worst prejudices, they represent distinct uses of exploitation for social commentary.

These films, like the low comedies, are disturbing for another reason. The appeal of trash to cultists is that it is in some sense oppositional to the mainstream, and indeed these films depart drastically from the common perception of how British films should be. But the revenge films are not subversive dreamworlds like the horror films, which have attracted such cult interest; they are films in tune with the kind of hardcore right-wing attitudes promoted by tabloid newspapers. That lends them fascination because they not only energetically push fantasies of revenge, lamenting the collapse of law and order and traditional masculinity, but test those fantasies to destruction. But they also offer a vision of Britain, again one both promulgated and attacked by the tabloid press, as, precisely, *trashed*. If trash culture implies the mass produced, disposable, formulaic, degraded and degrading, then it seems to be co-extensive with modern culture itself, which is one of disposability, shallowness, grotesque commercialism and manipulation. In films like *Sex Lives of the Potato Men* and *Killer Bitch*, the nation is in ruins and trash has become a cultural dominant – 'It's a dirty fucking world' indeed.

BAD IS GOOD, GOOD IS BAD

None of the film discussed in this chapter is *loved* for its badness; these films are not 'so bad they're good'. I've highlighted a number of 'bad' films in this book which afford enormous pleasure because of their 'failure' to meet conventional aesthetic standards, and whose fascination is inextricable from those unhinged, surreal and inadvertent qualities that capture the imagination of cultists. *Devil Girl from Mars*, *Slave Girls*, *Psychomania*, *The Lair of the White Worm* – these are films to watch over and over in bewitched delight. The films in this chapter, however, are considered bad because they are hated, and that is a different thing. On the one hand, watching them is not regarded as pleasurable; instead it can be an intolerable encounter with the abject. On the other,

the films are hated for what they represent – the wrong kind of British cinema, a taste associated with a particular audience, or perhaps something bad about Britain itself. These films are a new lost continent, insufficiently distant to be recuperated ironically or with nostalgia.

It is crucial, though very difficult, to separate out the reasons why some films are simply regarded as bad and some are hated. It is a large topic which I struggle to make sense of, but I suspect the answer has to do (as always) with taste and its relation to class and cultural capital, and that this is as much about our emotional response to a film as about our aesthetic judgment of it. For example, leaving aside bad films for a moment, genuine physical unease – embarrassment, a state of fluster or disorientation, a vertiginous sense of the uncanny – can accompany the experience of 'not getting' a classic or critically lauded film. We are all familiar with the phrase and idea that 'There is no accounting for taste', and a certain relativism is positively encouraged in matters of cultural judgment – up to a point. One glance at the Rotten Tomatoes site is enough to remind us that even the 'Freshest' film has its 'Rotten' reviews. Cultists are more than happy to be in the 2 per cent minority who either love or hate a film, and to take pride in their contrariness. Yet it can still be an uneasy *experience* to hate or be indifferent to a film that others love and admire, in case this indicates that one lacks the cultural capital to appreciate the film; it may even shake one's sense of identity, which, after all, depends to some extent on possessing a coherent, socially valid and emotionally satisfying set of implicit aesthetic criteria by which to negotiate the cultural choices that define who we are. On the other hand, depending upon how much one cares about films, it may simply leave you wondering how so many people could be so stupid and wrong. I had just such an experience when I saw *The Red Shoes* (1948), which I hated, for reasons I am still at a loss comprehensively to explain. My point is the simple one that, for all of us and not just fan-boy trolls issuing death threats for bad reviews of *The Dark Knight Rises*, aesthetic judgments are closely and complexly bound up with our emotions and grasp of identity.

In fact, my personal 'worst of British' list would not include many 'bad' films at all. In fact, as you may have gathered, I rather like and certainly enjoy many of the films that cropped up in my haphazard survey of the worst British films, and not always for different reasons from their intended audiences. The British films I *hate*, in which I have invested considerable negative emotion, tend to be critically approved films whose merits jibe with my cultish liking for a certain kind of British cinema. While loathing *The Red Shoes* unsettled me – I really ought to have enjoyed that Powell and Pressburger cult classic – my identity as a trash cultist, in which I have invested so much time and emotional energy, makes it an absolute treat to hate pretentious critic-bait such as *Distant Voices, Still Lives* and *We Need to Talk about Kevin* (2011). But I am fully aware that my hatred of those films, which is enough to make me a committed 'anti-fan',[22] and my love for *Slave Girls* and *Psychomania*, are *both* voluntary political choices for a certain kind of cinema, which I nevertheless find myself helpless to avoid making, *and* culturally determined by (and therefore largely predictable) my education, gender, age – in short, my entire identity as a cultist and 'trash aesthete'. I come back to the key point, made here by Jeffrey Sconce, that 'The trash aesthetic serves as a reminder that all forms of poetics and aesthetic criticism are ultimately linked to issues of taste; and taste, in turn, is a social construct with profoundly political implications.'[23]

ENVOI

As a cultist, I tend to read books on trash films with first, an arrogant assumption that I know it all already and expect only to see my knowledge and opinions confirmed; and second, a compulsion to spot everything that is missed out, which in the case of this book, looking back over sixty years of British trash, is rather a lot. There are still, alas, so many more films to see and write about. I am haunted by the films I barely mentioned – *Zeta One*, for example – and by genres and cycles for which there was no room, such as the exploitation thriller and spy film, whose high points were Lindsay Shonteff's Bond rip-offs, *Licensed to Kill* (1965) and *Licensed to Love and Kill* (1979), and his flamboyant private-eye films, *Big Zapper* (1973), *Zapper's Blade of Vengeance* (1974). I regret too not finding more space for mainstream trash, such as Phyllida Lloyd's twin assaults on the kidneys, *Mamma Mia!* and *The Iron Lady*, which would allow for a wider discussion of cultural value beyond exploitation as well as what constitutes trash in mainstream films, which are so much more offensive to the cinephile than the worst low-budget trash. And large unanswered questions still trouble me? How far does it matter that an interpretation is true, or is it merely a way of shaping a film – especially as an allegory – to meet one's own preconceptions and emotional needs? How, really, can we make sense of quality and value if aesthetic judgments are merely distinctions reflecting class and cultural capital?

What I have learned in the twenty-odd years that led up to writing this book is that loving trash film is about much more than a trivial preference for cheap films. Certainly, trash cultism has a politics, which is slippery and ambiguous – on the one hand, subverting conventional ideas of British culture; on the other, an excuse for snobbery and nostalgic escapism. But above all, it is about emotion and identity, almost as if these cult films were not only magical places where zombie motorcyclists cavort around Walton-on-Thames and slinky Amazons caress white rhino horns, but resources for remaking the self – and even perhaps guides to life.

NOTES

1 BRITISH TRASH CINEMA

1. *Kine Weekly* on '*Secrets of Sex*', 28 February 1970.
2. Anne Billson, 'Can British Films Get Any Worse?', *Guardian*, 3 April 2009, available at <http://www.guardian.co.uk/film/2009/apr/03/the-boat-that-rocked-british-films>.
3. Ian Christie, 'Will Lottery Money Assure the British Film Industry?', *New Statesman*, 20 June 1997, p. 38.
4. *A Future for British Film: It Begins with the Audience* ... , Report to Government by the Film Policy Review Panel, p. 4., available at <http://www.culture.gov.uk/images/publications/DCMS_film_policy_review_report-2012.pdf>.
5. Available at <http://www.bfi.org.uk/features/bfi100/> and summarised on Wikipedia here: <http://en.wikipedia.org/wiki/BFI_Top_100_British_films>.
6. See I. Q. Hunter, 'From Window Cleaner to Potato Man: Confessions of a Working Class Stereotype', in I. Q. Hunter and Laraine Porter (eds), *British Comedy Cinema* (London and New York: Routledge, 2012), pp. 154–70.
7. David Gritten, 'The Ugly Truth about British Films', *Telegraph*, 28 May 2004, available at <http://www.telegraph.co.uk/culture/film/3617847/The-ugly-truth-about-British-films.html>.
8. Charles Barr, 'A Conundrum for England', *Monthly Film Bulletin*, August 1984, p. 235.
9. Michael Weldon, *The Psychotronic Encyclopedia of Film* (New York: Ballantine, 1985).
10. Blake Ryan, *Trash Cinephile* (Danville, CA: Stonegarden.net Publishing, 2008), p. 7.
11. This book starts in the late 1950s and mostly tracks the history of the exploitation film. On 'trash' precursors to exploitation, such as Tod Slaughter's barn-storming melodramas, the horror films of the 1930s, and controversial thrillers such as *No Orchids for Miss Blandish* (1949), see Steve Chibnall's '*Quota Quickies': The Birth of the British 'B' Film* (London: BFI, 2007) and Chibnall and Brian McFarlane's *The British 'B' Film* (London: BFI, 2009).
12. Chris Alexander, '*Psychomania*: Born to Be Undead', *Fangoria* vol. 297 (October 2010) p. 16.
13. Julian Petley, 'The Lost Continent', in Charles Barr (ed.), *All Our Yesterdays: 90 Years of British Cinema* (London: BFI, 1986), pp. 98–119.
14. Petley, 'The Lost Continent', p. 98.
15. Kate Egan, *Trash or Treasure? Censorship and the Changing Meanings of Video Nasties* (Manchester and New York: Manchester University Press, 2007), pp. 26–7.
16. Egan, *Trash or Treasure?*, p. 27.
17. Tom Ryall, *Alfred Hitchcock and the British Cinema* (1986; London and Atlantic Highlands, NJ: Athlone, 1996), p. 78–9.

18. For a critique of 'the dark side' metaphor, see Peter Hutchings, *Hammer and Beyond: The British Horror Film* (Manchester and New York: Manchester University Press, 1993), pp. 13–14.
19. Alan Lovell, 'The Unknown Cinema of Britain', *Cinema Journal* vol. 11 no. 2 (Spring 1972), pp. 1–8.
20. The idea of 'the lost continent' has certainly passed into the discourse of film fans. As Julian Petley pointed out to me, it is even cited in an amazon.co.uk review of *Take an Easy Ride*: <http://www.amazon.co.uk/Take-An-Easy-Ride-Special/dp/B003DV2YOS/ref=sr_1_1?ie=UTF8&qid=1342782419&sr=8-1>.
21. Jeffrey Richards, 'Rethinking British Cinema', in Justine Ashby and Andrew Higson (eds), *British Cinema, Past and Present* (London and New York: Routledge, 2000), p. 21.
22. On Tigon, see John Hamilton, *Beasts in the Cellar: The Exploitation Career of Tony Tenser* (Guildford: FAB Press, 2005), and for revisionist takes on British genre films, see Routledge's British Popular Cinema series, including Steve Chibnall and Julian Petley (eds), *British Crime Cinema* (1999) and I. Q. Hunter (ed.), *British Science Fiction Cinema* (1999). Matthew Sweet, *Shepperton Babylon: The Lost Worlds of British Cinema* (London: Faber and Faber, 2005), pp. 249–317, is a witty exploration of the rise and fall of British exploitation and 'its hotly intimate relationship with popular mores and anxieties' (p. 269). See also Julian Upton (ed.), *Offbeat: British Cinema's Curiosities, Obscurities, and Forgotten Gems* (Manchester: Headpress, 2012).
23. On British sex films, see David McGillivray, *Doing Rude Things: A History of the British Sex Film* (London: Sun Tavern Fields, 1992) and Simon Sheridan, *Keeping the British End Up: Four Decades of Saucy Cinema*, 4th rev. edn. (London: Titan Books, 2011).
24. The programmes were respectively *Doing Rude Things* (TX BBC2 5 May 1995), *The Cinema Show: The Strange World of Planet UK* (TX BBC4 2 December 2006) and *Truly Madly Cheaply: British B Movies* (TX BBC4 21 June 2008).
25. For the state of play in Cult Film Studies, see Ernest Mathijs and Xavier Mendik (eds), *The Cult Film Reader* (Maidenhead and New York: Open University Press, 2007) and Ernest Mathijs and Jamie Sexton, *Cult Cinema* (Chichester: Wiley-Blackwell, 2011).
26. Moya Luckett, 'Image and Nation in 1990s British Cinema', in Robert Murphy (ed.), *British Cinema of the 90s* (London: BFI, 2000), p. 88.
27. Andrew Higson, *Film England: Culturally English Filmmaking since the 1990s* (London and New York: I. B. Tauris, 2011), p. 4. Higson's use of 'English' here is important, and I do recognise that, while I tend to conflate 'British' and 'English' in this book, the book is essentially about *English* trash cinema in its international context.
28. Quoted in Ian Christie (ed.), *Powell, Pressburger and Others* (London: BFI, 1978), p. 54. Christie points out that, unlike the press reviews, those in trade papers such as *Kinematograph Weekly* were generally positive (pp. 53–4).
29. Kevin Heffernan, *Ghouls, Gimmicks, and Gold: Horror Films and the American Movie Business, 1953–1968* (Durham, NC and London: Duke University Press, 2004), p. 130.
30. Peter Wollen, 'Dying for Art', *Sight and Sound*, December 1994, p. 20.
31. See Ian Christie, *Arrows of Desire: The Films of Michael Powell and Emeric Pressburger* (London and Boston: Faber and Faber, 1994), pp. 86–7.
32. V. F. Perkins, quoted in Ian Cameron (ed.), *The Movie Reader* (New York: Praeger, 1972), p. 6.

33. David Thomson, *A Biographical Dictionary of Film*, 3rd rev. edn (London: André Deutsch, 1995), p. 368.
34. Ken Russell, *Fire over England: British Cinema Comes under Friendly Fire* (London: Hutchinson, 1993), p. 174.
35. Billson, 'Can British Films Get Any Worse?'.
36. James Leggott, 'Travels in Curtisland: Richard Curtis and British Comedy Cinema', in Hunter and Porter, *British Comedy Cinema*, p. 186.
37. But see Claire Monk, *Heritage Film Audiences: Period Films and Contemporary Film Audiences in the UK* (Edinburgh: Edinburgh University Press, 2011). Monk, in another turn of the critical screw, sets out to rescue 'heritage films' (and their audiences) from the reductionist charges that have been made against them since the 1980s. As Monk remarks, '"Heritage films" were established from the outset as a "genre" designed by those who expressly sought to distance themselves from the films and their audiences – both of which were viewed with political and cultural disapprobation at best' (p. 4). This work of recuperation – post-revisionism, if you like – represents an important kind of critical resistance to certain dominant notions of British cinema and indeed of Britishness itself, especially to what might be regarded as the arrogant condescension of the New British Revisionism and its cultist wing towards insufficiently transgressive movies and their audiences. Elsewhere, striking another cautionary note, Monk analyses the unexpectedly vibrant online fandom around Merchant–Ivory's *Maurice* (1987) and 'the gendered, socially critical, comic, emotional, and even sexual and queer potential appeals of some of these films for audiences' (p. 433). She argues that, instead of writing off the film as a 'genteel whimper',

> A fandom-led, 2.0-era reformulation might more accurately classify *Maurice* as all at once a classic romance, a paradigm-shifting and lifechanging queer cultural object, and a slash text; for some fans, as porn (in terms of the responses the film permits, particularly with the assistance of DVD and screencapping technologies, as distinct from its advertised intentions); and as a cult film. (p. 451)

See Claire Monk, 'Heritage Film Audiences 2.0: Period Film Audiences and Online Fan Cultures', *Participations* vol. 8 no. 2 (November 2011), pp. 431–77, available at <http://www.participations.org/Volume%208/Issue%202/3h%20Monk.pdf>.
38. Lovell, 'The Unknown Cinema of Britain', p. 1.
39. The poll is available at <http://www.timeout.com/london/bestbritishfilms/>.
40. Thomas Elsaesser, 'Images for Sale: The "New" British Cinema', in Lester Friedman (ed.), *British Cinema and Thatcherism: Fires Were Started* (London: UCL Press, 1993), p. 64.

2 BRITISH TRASH CINEPHILIA

1. For historical surveys of the intersection of trash, camp and American film criticism, see Andrew Ross, 'Uses of Camp', in Ross (ed.), *No Respect: Intellectuals and Popular Culture* (New York: Routledge, 1989), pp. 135–70 and Greg Taylor, *Artists in the Audience: Cults, Camp and American Film Criticism* (Princeton, NJ: Princeton University Press, 1999).
2. See Jeffrey Sconce, 'Introduction', in Sconce (ed.), *Sleaze Artists: Cinema at the Margins of Taste, Style, and Politics* (Durham, NC and London: Duke University Press, 2007),

pp. 1–16. Sconce's term 'sleaze' overlaps with 'trash' in that it is 'less a definable historical genre than an ineffable quality' and that sleaziness 'is a presence that must be inscribed into a text by some manner of evaluation and critical labor' (p. 4).
3. Leon Hunt, *British Low Culture: From Safari Suits to Sexploitation* (London and New York: Routledge, 1998). I cannot overemphasise, incidentally, the importance of this book to the cultural work of re-evaluating British trash of the 1970s.
4. George Orwell, *The Penguin Essays of George Orwell* (London: Penguin, 1984), p. 207.
5. James Kendrick, 'A Nasty Situation: Social Panics, Transnationalism, and the Video Nasty', in Steffen Hantke (ed.), *Horror Film: Creating and Marketing Fear* (Jackson: University of Mississippi Press, 2004), p. 171.
6. Michael Thompson, *Rubbish Theory* (Oxford: Oxford University Press, 1979), p. 11.
7. Mikita Brottman, *Offensive Films* (Nashville, TN: Vanderbilt University Press, 2005), p. 4.
8. Linda Williams, 'Film Bodies: Gender, Genre and Excess', *Film Quarterly* vol. 44 no. 4 (1991), pp. 2–13.
9. James B. Twitchell, *Carnival Culture: The Trashing of Taste in America* (New York: Columbia University Press, 1992), p. 54.
10. Gillian Whiteley, *Junk: Art and the Politics of Trash* (London and New York: I. B. Tauris, 2011), p. 28.
11. Whiteley, *Junk*, pp. 31–53.
12. Jonathan Culler, *Framing the Sign: Criticism and Its Institutions* (Oxford: Basil Blackwell, 1988), p. 179.
13. Culler, *Framing the Sign*, p. 179.
14. Orwell, *The Penguin Essays of George Orwell*, p. 113.
15. Justin Smith, personal communication.
16. Sconce, 'Introduction', p. 7.
17. J. Hoberman, 'Bad Movies', in Gilbert Adair (ed.), *Movies* (London: Penguin, 1999), p. 146.
18. James Naremore, *More than Night: Film Noir in Its Contexts* (Berkeley: University of California Press), p. 163.
19. Robert B. Ray, *A Certain Tendency of the Hollywood Cinema: 1930–1980* (Princeton, NJ: Princeton University Press, 1985), p. 141.
20. Ray, *A Certain Tendency of the Hollywood Cinema*, p. 141.
21. Ernest Mathijs, 'Bad Reputations: The Reception of "Trash" Cinema', *Screen* vol. 46 no. 4 (Winter 2005), p. 463.
22. The emergence of American cult and camp 'vanguard' criticism is covered in Taylor, *Artists in the Audience*. For Farber's distinction – seminal for valuing trash over 'masterpieces' – between 'termite art', in which 'the craftsman can be ornery, wasteful, stubbornly self-involved, doing go-for-broke art and not caring what comes of it', and 'white elephant art', typified by the mannerisms of European art movies, see his wonderful 1962 essay 'White Elephant Art vs. Termite Art', in Manny Farber, *Movies* [originally published as *Negative Space*] (New York: Hillstone, 1971), pp. 134–44. See also Sconce, 'Introduction'.
23. John Simon, *Reverse Angle* (New York: Potter, 1982), p. 434.
24. Andrew Sarris, *The American Cinema: Directors and Directions 1929–68* (New York: Dutton, 1968), p. 24.

25. Pauline Kael, 'Trash, Art and the Movies', in *Going Steady: Film Writings, 1968–1969*, available at <http://www.paulrossen.com/paulinekael/trashartandthemovies.html>.
26. Kael, 'Trash, Art and the Movies'.
27. Kael, 'Trash, Art and the Movies'.
28. Gary Hentzi, 'Little Cinema of Horrors', *Film Quarterly* vol. 46 no. 3 (Spring 1993), p. 25.
29. Farber, *Movies*, p. 142.
30. Simon, *Reverse Angle*, p. 435.
31. Pierre Bourdieu, *Distinction: A Social Critique of the Judgement of Taste*, trans. Richard Nice (Cambridge, MA: Harvard University Press, 1984), p. 2.
32. Sarah Thornton, *Club Cultures: Music, Media, and Subcultural Capital* (Middletown, CT: Wesleyan University Press, 1996), p. 10.
33. Ray, *A Certain Tendency of the Hollywood Cinema*, pp. 138–9.
34. Ray, *A Certain Tendency of the Hollywood Cinema*, pp. 140–3.
35. Umberto Eco, *Travels in Hyperreality*, trans. William Weaver (1986; London: Picador, 1987), p. 210.
36. Ian Cooper, in his useful little book on *Witchfinder General* (Leighton Buzzard: Auteur, 2012), notes Don Siegel as an inspiration (pp. 63–6); the other obvious model for an auteur anxious to instil commercial genres with personal expression was Hitchcock, whose seeming ability to square art with the circle of commerce inspired both the French New Wave and the 'Movie Brats' of the New Hollywood in the 1970s. See also Hutchings, *Hammer and Beyond: The British Horror Film* (Manchester and New York: Manchester University Press, 1993), on Reeves's location 'within a growing cosmopolitan and counter-cultural fascination with Hollywood and genre cinema' (p. 136) and the novelty of his self-conscious attempt to offer *Witchfinder General* as art (p. 137).
37. John Russell Taylor, 'Beyond the Taste Barrier', *Sight and Sound* vol. 46 no. 1 (Winter 1976/7), p. 37.
38. Jeffrey Sconce, 'Trashing the Academy: Taste, Excess and an Emerging Politics of Cinematic Style', *Screen* vol. 36 no. 4 (1995), p. 372.
39. Sconce, 'Trashing the Academy', p. 372.
40. Sconce, 'Trashing the Academy', p. 374.
41. Sconce, 'Trashing the Academy', p. 392.
42. Brottman, *Offensive Films*, p. 14
43. Brottman, *Offensive Films*, pp. 2–3.
44. Joan Hawkins, *Cutting Edge: Art Horror and the Horrific Avant-Garde* (Minneapolis: University of Minnesota Press, 2000), pp. 3, 23
45. Hawkins, *Cutting Edge*, pp. 22–3.
46. Matt Hills, 'Para-Paracinema: The *Friday the 13th* Film Series as Other to Trash and Legitimate Film Cultures', in Sconce, *Sleaze Artists*, pp. 219–39.
47. Mathijs, 'Bad Reputations', p. 471.
48. Mathijs, 'Bad Reputations', p. 453.
49. Helen Merrick, 'The Readers Feminism Doesn't See: Feminist Fans, Critics and Science Fiction', in Deborah Cartmell, I. Q. Hunter, Heidi Kaye and Imelda Whelehan (eds), *Trash Aesthetics: Popular Culture and Its Audience* (London: Pluto, 1997), p. 56.
50. Susan Sontag, 'Notes on Camp', in Sontag, *Against Interpretation and Other Essays* (1966; London: Vintage, 1994), p. 289.

51. Mark Jancovich, 'Cult Fictions: Cult Movies, Subcultural Capital and the Production of Cultural Distinctions', *Cultural Studies* vol. 16 no. 2 (2002), p. 315. See also Taylor, *Artists in the Audience*, pp. 150–7: 'Cultism and camp are fundamentally aesthetic procedures steeped in highbrow taste, and directed toward the assertion of highbrow distinctions – by highbrows themselves, or by those who wish to appropriate such distinction within the middlebrow arena' (p. 154).
52. Richard Peterson and Roger Kern, 'Changing Highbrow Taste: From Snob to Omnivore', *American Sociological Review* vol. 61 (1996), pp. 900–7.
53. John Waters, *Crackpot: The Obsessions of John Waters* (London: Fourth Estate, 1988), p. 109.
54. Peterson and Kern, 'Changing Highbrow Taste', p. 905.
55. On the association – highly problematic, in the author's view – between cult tastes and masculinity, see Joanne Hollows, 'The Masculinity of Cult' (pp. 35–53) and Jacinda Read, 'The Cult of Masculinity: From Fan-boys to Academic Bad-boys' (pp. 54–70) in Mark Jancovich, Antonio Lazaro Reboll, Julian Stringer and Andy Willis (eds), *Defining Cult Movies: The Cultural Politics of Oppositional Taste* (Manchester and New York: Manchester University Press, 2003).
56. Danny Peary, *Cult Movies* (London: Vermilion, 1982); *Cult Movies 2* (London: Vermilion, 1983); *Cult Movies 3* (London: Sidgwick & Jackson, 1989).
57. Ali Catterall and Simon Wells, *Your Face Here: British Cult Movies since the Sixties* (London: Fourth Estate, 2002), p. xii.
58. Justin Smith, *Withnail and Us: Cult Films and Film Cults in British Cinema* (London and New York: I. B. Tauris, 2010). See also Smith's 'Reading Male Anxiety in *A Clockwork Orange*, *Tommy* and *The Man Who Fell to Earth*', in Paul Newland (ed.), *Don't Look Now: British Cinema in the 1970s* (Bristol: Intellect, 2010), pp. 143–60, for a psychoanalytic summary of how these cult films 'parade camp experimentation with self-identity and image, and flaunt ambiguous sexual excess' and 'refuse to anchor masculinity according to psycho-sexual and social convention' in reaction to the social upheavals of the 1960s (p. 157). He argues that cult texts of the period are at once radical and conservative and offer nostalgia for 'a lost order and perhaps a failed revolution' (p. 158). Camp itself can be seen as a compromise solution to living within a social order that one no longer believes in and cannot fundamentally change; one is left only with burlesquing its conventions and celebrating what it has discarded as trash.
59. Harry Benshoff, 'Beyond the Valley of the Classical Hollywood Cinema: Rethinking the "Loathsome Film" of 1970', in Lincoln Geraghty and Mark Jancovich (eds), *The Shifting Definitions of Genre: Essays on Labeling Films, Television Shows and Media* (Jefferson, NC and London: McFarland, 2008), p. 103.
60. Hunt, *British Low Culture*, pp. 24–5.
61. Jane Giles, 'Scala!!!!', in Stefan Jaworzyn (ed.), *Shock Xpress 2* (London: Titan Books, 1994), pp. 30–5.
62. Richard Stanley, 'Dying Light: An Obituary for the Great British Horror Movie', in Steve Chibnall and Julian Petley (eds), *British Horror Cinema* (London and New York: Routledge, 2002), p. 185.
63. Smith, *Withnail and Us*, p. 87.
64. Smith, *Withnail and Us*, p. 175.

65. John W. Hamilton, 'Psychomaniac!', *Dark Side* vol. 81 (October/November 1999), pp. 54–5. A younger generation would have encountered British horrors such as *Curse of the Crimson Altar* (1968) on 'Dr Terror's Vault of Horrors', a late-night series of horror screenings on BBC1 in the early 1990s with a sardonic host in a latex devil mask.

66. The first survey of British trash cinema, embracing horror, sex films and sleazy thrillers, was undertaken by *Flesh & Blood* magazine. 'The British Trash Files' are collected in *Flesh & Blood Compendium*, ed. Harvey Fenton (Guildford: FAB Press, 2003), pp. 68–107. See also Tim Greaves, *Vampyres* (Eastleigh: 1 Shot Publications, 1994) and *Linda Hayden: Dracula and Beyond* (Eastleigh: 1 Shot Publications, 1995); and Paul J. Brown, *Everything but the Nipple: Valerie Leon: A Pictorial Celebration* (Upton: Midnight Media, 1995) and *All You Need Is Blood: The Films of Norman J. Warren* (Upton: Midnight Media, 1995). For an account of the education of a horror cultist, see Mark Kermode, 'I Was a Teenage Horror Fan: Or, "How I Learned to Stop Worrying and Love Linda Blair"', in Martin Barker and Julian Petley (eds), *Ill Effects: The Media/Violence Debate* (London and New York: Routledge, 1997), pp. 57–66. The frequent media appearances of Kermode and another cult critic, Kim Newman, have probably done much to normalise enthusiasm in Britain for horror films and other trash genres.

67. See Allan Bryce, 'Nickels and Dimes and No Time: The Ups and Downs of Lindsay Shonteff', in Stefan Jaworzyn (ed.), *Shock Xpress: The Essential Guide to Exploitation Cinema* (London: Titan Books, 1994), pp. 21–9. Bryce, writing just as British trash was starting to attract serious attention in print, comments that 'If the name of Lindsay Shonteff is familiar to you, then the chances are that you're either a close friend of the family or a train-spotting genre buff', adding that 'it may come as a surprise to even the most goggle-eyed, anorak-wearing cineaste that this man has a list of twenty-four movies to his credit, most of which are harder to find than Lord Lucan's forwarding address' (p. 21).

68. On the video nasties, see David Kerekes and David Slater, *See No Evil: Banned Films and Video Controversy* (Manchester: Critical Vision, 2000) and Julian Petley, *Film and Video Censorship in Britain* (Edinburgh: Edinburgh University Press, 2011).

69. See Martin Barker (ed.), *The Video Nasties: Freedom and Censorship in the Media* (London: Pluto Press, 1984); Kate Egan, *Trash or Treasure? Censorship and the Changing Meanings of Video Nasties* (Manchester and New York: Manchester University Press); and Kendrick, 'A Nasty Situation', pp. 153–72.

70. Johnny Walker, 'Nasty Visions: Violent Spectacle in Contemporary Horror Cinema', *Horror Studies* vol. 2 no. 1 (2001), pp. 115–30.

71. Simon Pegg, *Nerd Do Well* (London: Century, 2010), pp. 225–6. See also, for memories (mostly of boredom) of the video nasties, Kim Newman, 'Journal of Plague Years', in Karl French (ed.), *Screen Violence* (London: Bloomsbury, 1996), pp. 132–43.

72. Robin Wood, *Hollywood from Vietnam to Reagan* (New York: Columbia University Press, 1986).

73. Steve Chibnall and I organised the first academic conference on British exploitation cinema, *A Naughty Business!* at De Montfort University in 1995, which, though rather sparsely attended, did help kick off academic interest in the field. Over the next few years work really started to flourish with publications such as Hunt's *British Low Culture* and Routledge's British Popular Cinema series, and the foundation in 1998 of the *Journal of*

Popular British Cinema (Flicks Books; it is now Edinburgh University Press's *Journal of British Cinema and Television*).
74. Hawkins, *Cutting Edge*, p. 12.

3 TASTE THE BLOOD OF ENGLAND

1. Alfred Shaughnessy, *Both Ends of the Candle* (Milton Keynes: Robin Clark, 1978), p. 125.
2. Shaughnessy, *Both Ends*, p. 127. Pirie's discussion of *Cat Girl* was in the original edition of *A Heritage of Horror: The English Gothic Cinema 1946–1972* (London: Gordon Fraser, 1973), p. 44–7.
3. *Variety* described *Cat Girl* as 'A very minor entry for the exploitation market, where it is being packaged with *Amazing Colossal Man* [1957]', quoted in Jonathan Rigby, '*Cat Girl*', *Hammer Horror* vol. 2 (April 1995) p. 39.
4. Shaughnessy, *Both Ends*, p. 126.
5. Steve Chibnall, *Quota Quickies: The Birth of the British 'B' Film* (London: BFI, 2007), p. 2.
6. See David Pirie's *A New Heritage of Horror: The English Gothic Cinema* (London and New York: I. B. Tauris, 2008); Jonathan Rigby, *English Gothic: A Century of Horror Cinema* (London: Reynolds & Hearn, 2000) and britishhorrorfilms.co.uk.
7. Eric Schaefer, *'Bold! Daring! Shocking! True!': A History of Exploitation Films, 1919–1959* (Durham, NC and London: Duke University Press, 1999), pp. 42–3.
8. Thomas Doherty, *Teenagers and Teenpics: The Juvenilization of American Movies in the 1950s* (London: Unwin Hyman, 1988), p. 3.
9. I. Q. Hunter, 'Exploitation as Adaptation', *Scope: An Online Journal of Film & TV Studies* vol. 15 (November 2009) and eBook *Cultural Borrowings: Appropriation, Reworking, Transformation*, ed. Iain Robert Smith, pp. 8–33.
10. *To Love a Vampire* was released as *Lust for a Vampire* (1971). See also Vincent Porter, 'The Context of Creativity: Ealing Studios and Hammer Films', in James Curran and Vincent Porter (eds), *British Cinema History* (London: Weidenfeld and Nicolson), p. 198.
11. Antony Balch, 'Interview', *Cinema Rising* vol. 1 (April 1972), p. 13.
12. Jim Hillier, *The New Hollywood* (London: Studio Vista, 1992), p. 40.
13. On the often elaborate promotion of British films, see Alan Burton and Steve Chibnall, 'Promotional Activities and Showmanship in British Film Exhibition', *Journal of Popular British Cinema* vol. 2 (1999), pp. 82–99.
14. Jeffrey Sconce, 'Introduction', in Sconce (ed.), *Sleaze Artists: Cinema at the Margins of Taste, Style, and Politics* (Durham, NC and London: Duke University Press, 2007), p. 6.
15. Author interview with Vera Day, 23 April 2012.
16. Bill Warren, *Keep Watching the Skies! American Science Fiction Movies of the Fifties, Volume II: 1958–1962* (Jefferson, NC and London: McFarland, 1986), p. 371.
17. Barbara Creed, *The Monstrous-Feminine: Film, Feminism, Psychoanalysis* (London and New York: Routledge, 1993).
18. Author interview with Vera Day, 23 April 2012.
19. Author interview with Vera Day, 23 April 2012.
20. David Pirie, *A Heritage of Horror*, p. 9.
21. Sue Harper and Vincent Porter, *British Cinema of the 1950s: The Decline of Deference* (Oxford and New York: Oxford University Press, 2003), p. 151.
22. Pirie, *A Heritage of Horror*, p. 133.

23. Tom Johnson and Deborah Del Vecchio, *Hammer Films: An Exhaustive Filmography* (Jefferson, NC and London: McFarland, 1996); Denis Meikle with Christopher T. Koetting, *A History of Horrors: The Rise and Fall of the House of Hammer* (Lanham, MD and London: Scarecrow Press, 1996); Wayne Kinsey, *Hammer Films: The Bray Studio Years* (London: Reynolds & Hearn, 2003); Wayne Kinsey, *Hammer Films: The Elstree Studio Years* (Sheffield: Tomahawk Press, 2007). For an invaluable concise summary of the story of Hammer, see Denis Meikle, 'Hammer: The Rise and Fall of the House of Horror', *Dark Side* vol. 148 (July/August 2012), pp. 12–22.
24. John Brosnan, 'The Quatermass Story', *House of Hammer* vol. 9 (June 1977), p. 29.
25. Porter, 'The Context of Creativity', p. 196.
26. Pirie, *A Heritage of Horror*, p. 51.
27. Porter, 'The Context of Creativity', p. 202.
28. See Hutchings, *Hammer and Beyond: The British Horror Film* (Manchester and New York: Manchester University Press, 1993), pp. 60–70.
29. Wheeler Winston Dixon, 'The End of Hammer', in Robert Shail (ed.), *Seventies British Cinema* (London: BFI, 2008), p. 18.
30. I. Q. Hunter, '*The Gorgon*: Adapting Classical Myth as Gothic Romance', in Richard J. Hand and Jay McRoy (eds), *Monstrous Adaptations: Generic and Thematic Mutations in Horror Film* (Manchester: Manchester University Press, 2007), pp. 127–39.
31. For a summary of Amicus's output, see Denis Meikle, 'Two's Company: The Story of Amicus Productions', *Dark Side* vol. 150 (November/December 2012), pp. 5–25.
32. Hutchings, *Hammer and Beyond*, p. 133.
33. Hutchings, *Hammer and Beyond*, p. 141–2.
34. Steve Chibnall, 'A Heritage of Evil: Pete Walker and the Politics of Gothic Revisionism', in Steve Chibnall and Julian Petley (eds), *British Horror Cinema* (London and New York: Routledge, 2002), pp. 156–71.
35. I. Q. Hunter, '*Twisted Nerve*: "A Good Dose of S and V"', in Alan Burton, Tim O'Sullivan and Paul Wells (eds), *The Family Way: The Boulting Brothers and Postwar British Film Culture* (Trowbridge: Flicks Books, 2000), pp. 227–37.
36. See Jane Graham, 'Hoodies Strike Fear in British Cinema', *Guardian.co.uk*, 5 November 2009, available at <http://www.guardian.co.uk/film/2009/nov/05/british-hoodie-films> and Johnny Walker, '*F* for "Frightening"? Johannes Roberts Takes on Hoodie Horrors', *Diabolique* vol. 3 (2011), pp. 24–32.
37. Umberto Eco, *Travels in Hyperreality*, trans. William Weaver (London: Picador, 1987), p. 198.
38. See Robin Wood, 'Burying the Undead: The Use and Obsolescence of Count Dracula', *Mosaic* vol. 16 (1979), pp. 175–87.
39. David Thomson, *A Biographical Dictionary of Film*, rev. edn (London: André Deutsch, 1995), p. 244.
40. [Wayne Kinsey] 'Roy Ward Baker', *The House That Hammer Built* no. 10 (November 1998), p. 108.
41. I. Q. Hunter, '*The Legend of the 7 Golden Vampires*', *Postcolonial Studies* vol. 3 no. 1 (April 2000), pp. 81–7.
42. James Rose, *Beyond Hammer: British Horror Cinema since 1970* (Leighton Buzzard: Auteur, 2009), p. 12.

43. Rose, *Beyond Hammer*, p. 22.
44. Justin Smith, *Withnail and Us: Cult Films and Film Cults in British Cinema* (London and New York: I. B. Tauris, 2010), p. 89.

4 MOON ZERO TWO AND OTHER UNEARTHLY STRANGERS

1. See I. Q. Hunter (ed.), *British Science Fiction Cinema* (London and New York: Routledge, 1999) and Daniel O'Brien, *SF:UK: How British Science Fiction Changed the World* (London: Reynolds & Hearn, 2000).
2. David Simmons, 'Hammer Horror and Science Fiction', in Tobias Hochscherf and James Leggott (eds), *British Science Fiction Film and Television: Critical Essays* (Jefferson, NC and London: McFarland, 2011), pp. 50–9.
3. Mark Jancovich, *Rational Fears: American Horror in the 1950s* (Manchester and New York: Manchester University Press, 1996).
4. Andy Sawyer, '"A Stiff Upper Lip and a Trembling Lower One": John Wyndham on Screen', in Hunter, *British Science Fiction Cinema*, pp. 75–87.
5. See James Leggott, 'Terence Fisher and British Science Fiction Cinema', *Science Fiction Film and Television* vol. 2. no. 1 (Spring 2009), pp. 77–90.
6. I. Q. Hunter, '*The Day the Earth Caught Fire*' in Hunter, *British Science Fiction Cinema*, pp. 99–112.
7. Steve Chibnall, 'Alien Women: The Politics of Sexual Difference in British SF Pulp Cinema', in Hunter, *British Science Fiction Cinema*, pp. 57–74. See also *A Naughty Business* programme.
8. Dave Wright and Nicholas Hill, 'What Went Wrong with Dan Dare?', *History Today*, July 1999, p. 43.
9. Olivia Newton-John, personal communication, 27 July 2009.
10. Tom Weaver, *Attack of the Monster Movie Makers: Interviews with 20 Genre Greats* (Jefferson, NC and London: McFarland, 1994), p. 123. See also Val Guest, *So You Want to Be in Pictures: From Will Hay to Hammer Horror and James Bond* (London: Reynolds & Hearn, 2001), pp. 163–4.
11. John R. Cook, 'The Age of Aquarius: Utopian and Anti-utopia in late 1960s' and early 1970s' British Science Fiction Television', in John R. Cook and Peter Wright (eds), *British Science Fiction Television: A Hitchhiker's Guide* (London and New York: I. B. Tauris, 2006), p. 110.
12. On British SF since the 1980s, see Kim Newman, '1985 e oltra' in I. Q. Hunter and Chiaro Barbo (eds), *Brit-Invaders!: Il cinema di fantascienza britannico* (Turin: Lindau, 2005), pp. 177–89.
13. John Martin, 'Butcher, Baker – Nightmare Maker!', *Dark Side*, October 1995, p. 43.
14. Robert Murphy, *Sixties British Cinema* (London: BFI, 1992) p. 184.
15. *Moon Zero Two* production notes p. 8, BFI collection.
16. Marcus Hearn and Alan Barnes, *The Hammer Story* (London: Titan Books, 1997), p. 129.
17. Tom Johnson and Deborah Del Vecchio, *Hammer Films: An Exhaustive Filmography* (Jefferson, NC and London: McFarland, 1996), p. 313.
18. Hearn and Barnes, *The Hammer Story*, p. 129.
19. H. Bruce Franklin, 'Don't Look Where We're Going: Visions of the Future in Science Fiction Films 1970–1982', in George Slusser and Eric S. Rabkin (eds), *Shadows of the*

Magic Lamp: Fantasy and Science Fiction in Film (Carbondale and Edwardsville: Southern Illinois University Press, 1985), p. 81.
20. Vivian Sobchack, *Screening Space: The American Science Fiction Film* (New York: Ungar, 1991), p. 66.
21. Sobchack, *Screening Space*, p. 87.
22. The classic account of the Western's structural oppositions is Jim Kitses, *Horizons West* (London: Secker and Warburg/BFI, 1969).
23. John G. Cawelti, '*Chinatown* and Generic Transformation in Recent American Films', in Gerald Mast and Marshall Cohen (eds), *Film Theory and Criticism: Introductory Readings*, 2nd edn (Oxford: Oxford University Press, 1979), p. 579.
24. John Burke, *Moon Zero Two* (London: Pan, 1969), p. 72.
25. *Moon Zero Two* production notes, p. 9.
26. Christopher Cook, review of *Moon Zero Two*, *Films and Filming*, December 1969, p. 55.
27. Burke, *Moon Zero Two*, p. 95.
28. Susan Faludi, *Stiffed: The Betrayal of the Modern Man* (London: Chatto & Windus, 1999), p. 28.
29. Piers Bizony, *2001: Filming the Future* (London: Aurum Press, 1994), p. 153.
30. J. G. Ballard, *A User's Guide to the Millennium: Essays and Reviews* (London: HarperCollins, 1996), p. 193.

5 ZOMBIES, SLEAZE AND PSYCHOMANIA

1. David Sanjek, 'Twilight of the Monsters: The English Horror Film 1968–1975', in Winston Wheeler Dixon (ed.), *Re-Viewing British Cinema 1900–1992* (Albany: University of New York Press, 1994), pp. 195–209.
2. Sian Barber, '"Blue Is the Pervading Shade": Re-examining British Film Censorship in the 1970s', *Journal of British Cinema and Television* vol. 6 no. 3 (December 2009), p. 367.
3. Adair also wrote the screenplay, though it is often attributed to the producer Beryl Vertue. *Virgin Witch* has achieved some small notoriety because the sisters were later in the TV sitcom '*Allo 'Allo* (1982–92). See Simon Sheridan, sleevenotes to *Virgin Witch*, Odeon Entertainment DVD ODNF 188 (2010).
4. Appropriately enough the porn mag *Mayfair* vol. 5 no. 11 (1970)) devoted a spread to the film – 'Gentlemen, Would You Believe a Virgin Witch'. See Martin Jones, *Psychedelic Decadence: Sex, Drugs, Low-Art in Sixties & Seventies Britain* (Manchester: Headpress, 2001), p. 89.
5. Tim Greaves, *Vampyres* (Eastleigh: 1 Shot Publications, 1994). See also Ian Conrich, 'The Divergence and Mutation of British Horror Cinema', in Robert Shail (ed.), *Seventies British Cinema* (Basingstoke: BFI, 2008) p. 31.
6. David Alexander, 'Britannia Rules the Graves', *Samhain* vol. 6 (1987), p. 24.
7. Steve Chibnall, *Making Mischief: The Cult Films of Pete Walker* (Guildford: FAB Press, 1998).
8. David McGillivray, '"We Shall See, What We Shall See …"', *Fantasynopsis* no. 4 (November 1991), p. 17.
9. McGillivray, '"We Shall See"', p. 17.
10. Chris Alexander, '*Psychomania*: Born to Be Undead', *Fangoria* vol. 297 (October 2010) p. 16.

11. See the website *Psychomania Locations* <http://psychomania.bondle.co.uk/>.
12. Alexander, '*Psychomania*', p. 17.
13. *Truly Madly Cheaply: British B Movies* (TX BBC4 21 June 2008).
14. See Jones, *Psychedelic Decadence*, pp. 103–8.
15. Henson describes the film as such in both *Truly Madly Cheaply* (and himself as 'ashamed' at having been in it) and in *Return of the Living Dead*, a documentary extra on the 2010 Severin DVD release of *Psychomania* (SEV1164).
16. On disaster in British cinema of the period, see Peter Hutchings, 'The Power to Create Catastrophe: The Idea of Apocalypse in 1970s British Cinema', in Paul Newland (ed.), *Don't Look Now: British Cinema in the 1970s* (Bristol: Intellect, 2010), pp. 107–10.
17. David Kerekes, 'Hungry in a Dream ... *Killer's Moon*', in Kerekes (ed.), *Creeping Flesh: The Horror Fantasy Film Book Vol. 1* (Manchester: Headpress, 2003), p. 89.
18. Leon Hunt, *British Low Culture* (London and New York: Routledge, 1988), p. 147.
19. Examiner's Report by Ken Penry on a cutting-copy of *Killer's Moon* dated 20 July 1978 (BBFC file on *Killer's Moon*). Both Penry and another examiner, Tony Kerpel, were concerned about 'the first rape by the lunatic on a schoolgirl. If she is screaming and he is burbling we will probably want cuts' (Kerpel's report, also dated 20 July 1978). A note in the BBFC file dated 16 August 1978 confirms that 'Sound effects [in the final dubbed version] do not put the scenes over the top for X.'
20. In a letter of 11 August 1978 to the BBFC confirming that no animals were abused, Birkinshaw comments that 'In fact far from hurting animals (or human beings) our presence in the Lake District saved the life of a drowning girl who was rescued by our sound recordist, Doug Smith' (BBFC file on *Killer's Moon*).
21. McGillivray, '"We Shall See"', p. 23.
22. David McGillivray, personal communication 25 April 2012. McGillivray asked me not to use this.
23. Country houses were frequently locations for British horror films for logistical reasons as well to symbolise the dark repressed past. See I. Q. Hunter, 'Deadly Manors: The Country House in British Exploitation Films', in Paul Cooke, David Sadler and Nicholas Zurbrugg (eds), *Locating Identity: Essays on Nation, Community and the Self* (Leicester: De Montfort University, 1996), pp. 45–55.
24. I. Q. Hunter, 'Deep inside *Queen Kong*: Anatomy of an Extremely Bad Film', in Ernest Mathijs and Xavier Mendik (eds), *Alternative Europe: Eurotrash and Exploitation Cinema since 1945* (London and New York: Wallflower Press, 2004), pp. 32–8.
25. Linnie Blake, *The Wounds of Nations: Horror Cinema, Historical Trauma and National Identity* (Manchester: Manchester University Press, 2008), p. 162.
26. Richard Stanley, 'Dying Light: An Obituary for the Great British Horror Movie', in Steve Chibnall and Julian Petley (eds), *British Horror Cinema* (London and New York: Routledge, 2002), p. 193.
27. Roger Corman, with Jim Jerome, *How I Made a Hundred Movies in Hollywood and Never Lost a Dime* (London: Muller, 1990), p. 34.
28. For an account of New Hollywood's roots in exploitation and the legacy of the B movie in contemporary low-budget production, see Blair Davis, *The Battle for the Bs: 1950s Hollywood and the Rebirth of Low-budget Cinema* (New Brunswick, NJ and London: Rutgers University Press, 2012), pp. 208–15.

29. For an overview of recent British horror production, see Johnny Walker, 'A Wilderness of Horrors? British Horror Cinema in the New Millennium', *Journal of British Cinema and Television* vol. 9 no. 3 (2012), pp. 436–56.
30. Johnny Walker, personal communication.
31. Jonathan Sothcott, personal communication, 1 May 2012.
32. See <http://mjsnewsblog.blogspot.co.uk/2012/01/evil-calls-worlds-longest-film-review.html>. See also the entries on Driscoll in Simpson's *Urban Terrors: New British Horror Cinema 1997–2008* (Bristol: Hemlock Books, 2012).
33. Johnny Walker, 'Nasty Visions: Violent Spectacle in Contemporary British Horror Cinema', *Horror Studies* vol. 2 no. 1 (2011), p. 116.
34. James Leggott, *Contemporary British Cinema: From Heritage to Horror* (London and New York: Wallflower Press, 2008), p. 58.
35. The film's title is pretty generic, but it may have been borrowed from an article on Australian satanic killings in *Bizarre* magazine, Frank Moorhouse, 'The Lesbian Vampire Killers', *Bizarre* vol. 109 (April 2006), pp. 94–8.
36. Blake, *The Wounds*, p. 159.
37. Blake, *The Wounds*, p. 159.
38. Blake, *The Wounds*, p. 180
39. Author interview with Rhys Davies, 9 May 2012.
40. Interview with Davies.
41. Simpson, *Urban Terrors*, p. 13.
42. See <http://www.guardian.co.uk/film/filmblog/2012/may/22/iron-sky-crowd-sourcing-funding>. A glance at one prominent crowd-funding site, indiegogo, suggests that the film projects among the campaigns looking for sponsorship tend rather to worthy boutique documentaries than to exploitation films.
43. *Zombie Undead* was reported as having grossed only £10 on its opening weekend from 29 April–1 May 2011, which prompted Ryan Gilbey in the *New Statesman* to remark that it was the probably the lowest-grossing film on record: <http://www.newstatesman.com/blogs/cultural-capital/2011/05/zombie-undead-bobbi-film-box>. For the record, this is untrue. The three Phoenix Square screenings were sold out and the film has not been shown elsewhere.
44. Jonathan Sothcott, personal communication, 1 May 2012.

6 DINOSAURS AND FUR BIKINIS

1. There has been little work on Hammer's prehistoric films, except in the context of Ray Harryhausen's special effects, for which see Ray Harryhausen and Tony Dalton, *Ray Harryhausen: An Illustrated Life* (London: Aurum, 2003), pp. 194–202. For summaries and production histories of the films, see Bruce G. Hallenbeck, *British Cult Cinema: Hammer Fantasy & Sci-Fi* (Bristol: Hemlock Books, 2011) and John Parnum, 'Surviving the Lost Worlds of Hammer', *Midnight Marquee* vol. 47 (Summer 1994), pp. 49–56.
2. Harryhausen and Dalton, *Ray Harryhausen*, p. 196. See also Hallenbeck, *British Cult Cinema*, p. 187. A poster of this image plays a pivotal role in *The Shawshank Redemption* (1994), in which it represents both the 1960s and a fantasy of escape.
3. Robert Murphy, *Sixties British Cinema* (London: BFI, 1992), p. 184.

4. Mark A. Miller, '*When Dinosaurs Ruled the Earth*,' in Gary J. Svehla and Susan Svehla (eds), *Guilty Pleasures of the Horror Film* (Baltimore, MD: Midnight Marquee Press, 1996), pp. 174–205.
5. David Pirie, *A Heritage of Horror: The English Gothic Cinema 1946–1972* (London: Gordon Fraser, 1973), p. 138.
6. Ursula Andress was the original choice for the starring role of Loana in *One Million Years B.C.* but she was unavailable and Raquel Welch got the role in a deal with Twentieth Century-Fox for whom she had just made her fourth film, *Fantastic Voyage* (1966).
7. Beswick was in fact the first actress to appear in two Bond films, *From Russia with Love* (1963) and *Thunderball* (1965).
8. See that wonderful critic Raymond Durgnat's typically stylish and insightful comments on Devereaux in his *Eros in the Cinema* (London: Calder and Boyars, 1966): 'in evident erotic convulsion [she] clutches the knee and thigh of a male co-religionary, while her sumptuously displayed bosom is well qualified to arouse a simultaneous erotic pleasure in the average male spectator' (p. 162).
9. *The Viking Queen* (An Entertainment). Screenplay, 24 March 1966. Author's collection.
10. Marcia Landy, *British Genres: Cinema and Society 1930–1960* (Princeton, NJ: Princeton University Press, 1991), p. 418.
11. Pirie, *A Heritage of Horror*, p. 124.
12. Landy, *British Genres*, p. 420.
13. Landy, *British Genres*, p. 421.
14. *Imagi-Movies*, Spring 1995, p. 24.
15. Susan Sontag, 'The Imagination of Disaster,' in Sontag, *Against Interpretation* (1966; London: Vintage, 1994), pp. 209–25.
16. *One Million Years B.C.* Final Shooting Script, BFI Script Collection no. 51224, pp. 117 ff. Ray Harryhausen confirmed the ambiguous implications of the mushroom cloud in an interview with the author, 25 July 1996.
17. As Peter Wright pointed out to me (personal communication), the film repeats the 'fundamental constituents of popular fiction – combat, capture, escape, pursuit and exploration', formulae that can certainly be traced back to Edgar Rice Burroughs's Barsoom books such as *A Princess of Mars*.
18. John Coleman, review of *One Million Years B.C.*, *New Statesman*, 30 November 1966.
19. Ray Harryhausen, *Film Fantasy Scrapbook* (London: Titan Books, 1989), p. 95.
20. Harryhausen and Dalton, *Ray Harryhausen*, p. 198.
21. The battle between these two dinosaurs has been archetypal since Charles Knight's 1926 mural depicting it in Chicago's Field Museum of Natural History. The tyrannosaurus suit in *One Million B.C.* was also based on a Knight painting.
22. See Ian Conrich, 'Trashing London: The British Colossal Creature Film and Fantasies of Destuction', in I. Q. Hunter (ed.), *British Science Fiction Cinema* (London and New York: Routledge, 1999), pp. 88–98.
23. Stuart M. Kaminsky, 'New Hollywood Cinema', *Film Reader* vol. 1 (1975), p. 78.
24. Bob Sheridan,'History of Hammer Part 8: *The Viking Queen* to *Dracula Has Risen from the Grave* 1967–1968', *Halls of Horror* vol. 28 (1984), p. 42.
25. Hallenbeck, *British Cult Cinema*, p. 168.

26. Anon, 'Hammerhead – An Interview with Michael Carreras', *House of Hammer* vol. 16 no. 2.4 (January 1978), p. 32.
27. Michael Armstrong, review of *Slave Girls*, *Films and Filming*, August 1968.
28. Armstrong, review of *Slave Girls*.
29. Pirie, *A Heritage of Horror*, p. 139.
30. Tom Johnson and Deborah Del Vecchio, *Hammer Films: An Exhaustive Filmography* (Jefferson, NC and London: McFarland, 1996), p. 275.
31. *Prehistoric Women* Shooting Script 15 December 1965, p. 48. Author's collection.
32. In an interview with me Beswick described herself as 'angry' during the making of the film, not because its production especially annoyed her but because of awareness of the restrictions society placed on her as a woman. Aggression was intrinsic to her screen persona; according to Hallenbeck, her cat-fights in *From Russia with Love* and *One Million Years B.C.* had earned her the sobriquet 'Battling' Beswick (*British Cult Cinema*, p. 163). That anger can be seen, if you choose to see it, in her performance in *Slave Girls*: cultists love seeing evidence of the real world cracking the glass of a film's diegesis. The thought of Beswick channelling her anger into her performance and thereby taking ownership of and ironising her typecasting as a fiery dark Other adds not only meaning and pleasure to the film but also adds new possibilities for feminist counter-readings.
33. Pirie, *A Heritage of Horror*, p. 139.
34. Sue Harper and Vincent Porter, *British Cinema of the 1950s: The Decline of Deference* (Oxford and New York: Oxford University Press, 2003), p. 152.
35. There is one other Hammer film that might accurately be called surreal and that is *The Lost Continent*, which manages unforgettably to combine the Ship of Fools, the Spanish Inquisition, Lovecraftian monsters in the Sargasso Sea, breast fetishism and tennis racquets used to walk on seaweed.
36. Jean Ferry, 'Concerning *King Kong*', in Paul Hammond (ed.), *The Shadow and Its Shadow: Surrealist Writings on the Cinema*, 3rd edn (San Francisco, CA: City Lights Books), p. 164.
37. On surrealist film-watching, see Joan Hawkins, *Cutting Edge: Art Horror and the Horrific Avant-Garde* (Minneapolis: University of Minnesota Press, 2000), pp. 37–8, and J. Hoberman, 'Bad Movies', in Gilbert Adair (ed.), *Movies* (London: Penguin, 1999), pp. 146–7.
38. Ado Kyrou, 'The Marvelous Is Popular', in Hammond, *The Shadow and Its Shadow*, p. 71.
39. Hoberman, 'Bad Movies', p. 147.
40. Hoberman, 'Bad Movies', p. 148.
41. Jonah Weiner, 'The Worst Movies Ever Made: *The Room*, *Birdemic* and What Makes a Horrible Movie Great', *Slate*, 6 April 2010, available at: <http://www.slate.com/articles/arts/culturebox/2010/04/the_worst_movies_ever_made.html>.
42. Hoberman, 'Bad Movies', p. 150.
43. Mikita Brottman, *Offensive Films* (Nashville, TN: Vanderbilt University Press, 2005), p. 13.
44. I asked Martine Beswick whether cast and crew were on drugs; she assured me they weren't.
45. Pirie, *A Heritage of Horror*, p. 139.
46. See Chapter 8 for a discussion of the emergence of camp in film in 1966.
47. Hallenbeck, *British Cult Cinema*, p. 165.

48. Alan Frank, 'A Hammer History', *Little Shoppe of Horrors* vol. 4 (1978), p. 51. On the making of *When Dinosaurs Ruled the Earth*, see Guest's account in his *So You Want to Be in Pictures: From Will Hay to Hammer Horror and James Bond* (London: Reynolds & Hearn, 2001), pp. 158–61, in which he describes how the film, in classic exploitation style, began as a poster commissioned by James Carreras 'showing a rampant dinosaur with a writhing blonde in its mouth' (p. 159).
49. Preface to *When Dinosaurs Ruled the Earth* Shooting Script, 31 August 1968. Val Guest special collection. BFI Library. Script number S11763.
50. *When Dinosaurs Ruled the Earth* Shooting Script.
51. John Brosnan, *Movie Magic: The Story of Special Effects in the Cinema* (London: Abacus, 1977), p. 126. The sea monsters are not in the shooting script.
52. Hallenbeck, *British Cult Cinema*, p. 195. The only other formal contacts between New Wave SF writers and British genre cinema were Michael Moorcock's co-authoring the screenplay of *The Land That Time Forgot* and Robert Fuest's adaptation of his novel, *The Final Programme* (1969). See Michael du Plessis, 'Robert Fuest and *The Final Programme*: Science Fiction and the Question of Style', in Tobias Hochscherf and James Leggott (eds), *British Science Fiction Film and Television: Critical Essays* (Jefferson, NC and London: McFarland, 2011), pp. 60–72.
53. J. G. Ballard, letter to the author, 25 April 1996. Ballard recalls his meeting with Young and Hinds in similar terms in *Miracles of Life: Shanghai to Shepperton: An Autobiography* (London: Harper Perennial, 2008), pp. 252–5.
54. Pirie, *A Heritage of Horror*, p. 140.
55. Miller, '*When Dinosaurs Ruled the Earth*', p. 200.
56. Kaminsky, 'New Hollywood Cinema', p. 78.
57. Murphy, *Sixties British Cinema*, p. 184.
58. See David Flint, 'Hammer: The Ones That Got Away', *Dark Side* vol. 51 (November 1995), pp. 24–8. On *Nessie*, see also Wes Walker, '*Nessie: The Loch Ness Monster*', *Dark Terrors* vol. 15 (February 1998), pp. 26–7, and '*Nessie: The Loch Ness Monster* Part Two', *Dark Terrors* vol. 16 (December 1998), pp. 47–8.
59. See James Chapman, 'From Amicus to Atlantic: The Lost Worlds of 1970s British Cinema', in Robert Shail (ed.), *Seventies British Cinema* (London: BFI, 2008), pp. 56–64.

7 NAUGHTY!

1. *Killer's Moon*.
2. David McGillivray, *Doing Rude Things: A History of the British Sex Film* (London: Sun Tavern Fields, 1992), p. 19.
3. David McGillivray, 'History of British Sex Films 1957–1981 [Part One]', *Cinema* vol. 1 (1982), p. 50.
4. For a biography of Marks, see 'The Naked World of Harrison Marks', available at <http://gavcrimson.blogspot.co.uk/2008/08/naked-world-of-harrison-marks.html?zx=46acbd0eabeafeca>. See also the interview with Marks in Jonathon Green, *It: Sex since the Sixties* (London: Secker & Warburg, 1993), pp. 162–6, and Matthew Sweet, *Shepperton Babylon: The Lost Worlds of British Cinema* (London: Faber and Faber, 2005), pp. 289–317.
5. Michael Ahmed, 'Independent Cinema Exhibition in 1960s Britain: Compton Cinema', *Post Script: Essays in Film and the Humanities* vol. 30 no. 3 (Summer 2011), p. 58.

6. Philip Oakes, 'The Next Tycoons', *Sunday Times Magazine*, 12 December 1965, p. 36.
7. Simon Sheridan, *Keeping the British End Up: Four Decades of Saucy Cinema*, 4th rev. edn (London: Titan Books, 2011), p. 15.
8. John Trevelyan, *What the Censor Saw* (London: Michael Joseph, 1973), p. 173.
9. Sheridan, *Keeping the British End Up*, p. 54.
10. Allan Bryce, 'Warren Piece', *Dark Side* vol. 147 (June/July 2012), p. 57.
11. 'Something for Everyman', *Sunday Times Magazine*, 21 January 1968, p. 6.
12. Oakes, 'The Next Tycoons', p. 39.
13. Ahmed, 'Independent Cinema Exhibition in 1960s Britain', p. 55.
14. Norman J. Warren, personal communication, 12 June 2012.
15. On *Baby Love*, see Kevin McKenna, 'Independent Production and Industrial Tactics in Britain: Michael Klinger and *Baby Love*', *Historical Journal of Film and Television* vol. 32 no. 4 (2012), pp. 611–31.
16. Peter Buckley, review of *Groupie Girl*, *Films and Filming*, December 1970, p. 59.
17. David McGillivray, 'Keeping It All Up for a Joke: The Secrets of an X-ploitation Screenwriter', *Screen International*, 14 August 1976, p. 8.
18. Julian Upton, 'Carry On Sitcom: The British Sitcom Spin-off Film 1968–80', *Bright Lights Film Journal* vol. 35 (January 2002), available at <http://www.brightlightsfilm.com/35/britishsitcoms1.html>. See also Richard Dacre, '"From Belly Laughs to Telly Laughs": The Rise and Fall of the Sitcom Spin-off', in I. Q. Hunter and Laraine Porter (eds), *British Comedy Cinema* (London and New York: Routledge, 2012), pp. 141–53.
19. Julian Petley, '"There's Something about Mary …"', in Bruce Babington (ed.), *British Stars and Stardom: From Alma Taylor to Sean Connery* (Manchester and New York: Manchester University Press, 2001), p. 210.
20. Leon Hunt, *British Low Culture: From Safari Suits to Sexploitation* (London: Routledge, 1998), p. 130.
21. Feona Attwood, 'A Very British Carnival: Women, Sex and Transgression in *Fiesta* Magazine', *European Journal of Cultural Studies* vol. 5 no. 1 (2002), pp. 91–105.
22. Ian Conrich, 'Forbidden Cinema: The British Style of Sexploitation', *Journal of Popular British Cinema* vol.1 (1998), p. 97.
23. Hunt, *British Low Culture*, p. 19.
24. Steve Chibnall and I. Q. Hunter, *A Naughty Business! The British Cinema of Exploitation* (Festival Programme, Leicester, 1995), p. 4.
25. Sian Barber, 'The Pinnacle of Popular Taste?: The Importance of *Confessions of a Window Cleaner*', *Scope: An Online Journal of Film and Television Studies* vol. 18 (October 2010), available at <http://www.scope.nottingham.ac.uk/article.php?issue=18&id=1246>.
26. Barber, 'The Pinnacle of Popular Taste?'.
27. Mark Killick, *The Sultan of Sleaze: The Story of David Sullivan's Sex and Media Empire* (London: Penguin, 1994), p. 27.
28. Hunt, *British Low Culture*, p. 138.
29. Trevelyan, *What the Censor Saw*, p. 120. On the BBFC's and Trevelyan's 'arguably capricious value-judgements regarding art and exploitation', see also McKenna, 'Independent Production and Industrial Tactics in Britain', pp. 617–19.
30. 'Stanley Long: Britain's Russ Meyer', *Cinema X* vol. 4 no. 2 (1970), p. 82.

31. 'Stanley Long', p. 82.
32. 'The Guys behind the Groupies', *Premiere* vol. 3 (n.d.), pp. 28, 26.
33. McGillivray, *Doing Rude Things*, p. 56. He puts the film's success down to its appeal to couples.
34. 'The British X File 3: Derek Ford', *Cinema X* vol. 5 no. 1 (1971), p. 48.
35. Note by Stephen Murphy, dated 22 November 1973, of meeting with Ken Rolls [sic] at 10 a.m. on 21 November. BBFC file on *Take an Easy Ride*.
36. Eric Schaefer, *'Bold! Daring! Shocking! True!': A History of Exploitation Films, 1919–1959* (Durham, NC and London: Duke University Press, 1999), pp. 56–75.
37. Letter from Kenneth Rowles to Stephen Murphy, dated 3 December 1973 in BBFC file on *Take an Easy Ride*. Sheridan, in *Keeping the British End Up*, suggests the film was made in 1974, but the BBFC received a 16mm version of it for certification in November 1973 (BBFC file on *Take an Easy Ride*). The film subsequently took two years to get passed, which might explain why it seems so out of date for 1976.
38. On hardcore versions, see Sheridan, *Keeping the British End Up*, pp. 25–6; McGillivray, *Doing Rude Things*, p. 19; and the summary on British Girls Adult Film Database [BGAFD], available at <http://bgafd.co.uk/miscellany/british-sc70s.php>.
39. Sheridan, *Keeping the British End Up*, p. 138.
40. McGillivray, 'Keeping It All Up for a Joke', p. 8.
41. I. Q. Hunter, 'Deadly Manors: The Country House in British Exploitation Films', in Paul Cooke, David Sadler and Nicholas Zurbrugg (eds), *Locating Identity: Essays on Nation, Community and the Self* (Leicester: De Montfort University, 1996), pp. 45–55.
42. Martin Jones, *Psychedelic Decadence: Sex, Drugs, Low-Art in Sixties & Seventies Britain* (Manchester: Headpress, 2001), p. 62.
43. Dave Thompson, *Black and White and Blue: Adult Cinema from the Victorian Age to the VCR* (Toronto: ECW Press, 2007), pp. 217–18. On the background to the growth of the Soho sex industry, its links to the criminal underworld from the Messina brothers (on which *The Flesh Is Weak* is based) to Bernie Silver and Gerald Citron, and the corruption of the Obscene Publication Squad ('The Dirty Squad') of the Metropolitan Police, see Martin Tomkinson, *The Pornbrokers: The Rise of the Sex Barons* (London: Virgin Books, 1982) and Barry Cox, John Shirley and Martin Short, *The Fall of Scotland Yard* (Harmondsworth: Penguin, 1977), pp. 140–211.
44. Thompson, *Black and White and Blue*, p. 220.
45. David McGillivray 'Horrible Things', *Films and Filming*, December 1974, p. 45.
46. Allan Bryce, 'Adventures of a Mucky Movie Mogul', *DVD World* vol. 62 (2008), p. 51.
47. Thompson, *Black and White and Blue*, p. 24.
48. Laurence O'Toole, *Pornocopia: Porn, Sex, Technology and Desire*, 2nd rev. edn (London: Serpent's Tail, 1999), p. 99. On Freeman, see David Flint, *Babylon Blue: An Illustrated History of Adult Cinema* (London: Creation Books, 1999), pp. 97–8. For an account of Freeman up to his imprisonment, see Michael J. Freeman, *I Pornographer: The Life & Times of Britain's Veteran Pornographer* (no publisher, 2010).
49. A unique survey of Soho sex cinemas in the early 1980s is Nick Roddick, 'Soho: Two Weeks in Another Town', *Sight and Sound*, Winter 1982–3, pp. 18–22.
50. Tomkinson, *The Pornbrokers*, p. 61.

51. See 'Deeley-licious: The Brief, Tragic but Memorable Career of Heather Deeley', available at <http://gavcrimson.blogspot.co.uk/2008/08/deeley-licious-brief-tragic-but.html?zx=b2e19202c17938b1>.
52. Stanley Long, with Simon Sheridan, *X-Rated: Adventures of an Exploitation Filmmaker* (London: Reynolds & Hearn, 2008), p. 165.
53. Stanley Long, *X-Rated*, p. 164.
54. David Kerekes, 'Jolly Hockey Sticks! The Career of John Lindsay, Britain's "Taboo" Filmmaker of the Seventies', in Jack Stevenson (ed.), *Fleshpot: Cinema's Sexual Myth Makers & Taboo Breakers* (Manchester: Headpress, 2000), pp. 190–6.
55. Sheridan, *Keeping the British End Up*, p. 29.
56. Thompson, *Black and White and Blue*, p. 229.
57. Steven Marcus, *The Other Victorians: A Study of Sexuality and Pornography in Mid-Nineteenth Century England* (1966; London: Corgi, 1969), p. 219.
58. A full list is available at the *Pre-Cert Video* website <http://www.pre-cert.co.uk/>.
59. Flint, *Babylon Blue*, p. 98.
60. Flint, *Babylon Blue*, p. 98
61. Mike Freeman, personal communication, May 2012.
62. On the Fiona Cooper website <https://www.fiona-cooper.com/about-fiona-cooper/>. Bewilderingly, it has also been claimed that 'Halifax based video producer Fiona Cooper … was in fact a man, and the cousin of "Yorkshire Ripper" Peter Sutcliffe!', Ric Porter, *Welcome to Pornoland* (Woodford Green: Portway Books, 2010), p. 74.
63. Green, *It*, p. 182.
64. Melanie Williams, review of *9 Songs*, *Film Quarterly* vol. 59 no. 3 (2006), p. 59.
65. *Embarrassing Bodies* (Channel 4 TX 13 June 2011).
66. Linda Williams, *Screening Sex* (Durham, NC and London: Duke University Press, 2008), p. 266.
67. Winterbottom had wanted to make a film of Michel Houellebecq's novel, *Platform* but, when this proved impossible, he decided to make a film about 'two people making love' instead, with *In the Realm of the Senses* as his main point of reference. See Brian McFarlane and Deane Williams, *Michael Winterbottom* (Manchester and New York: Manchester University Press, 2009), pp. 22–3.
68. Linda Ruth Williams, review of *9 Songs*, *Sight and Sound* vol. 15 no. 4 (April 2005), p. 42.
69. McFarlane and Williams, *Michael Winterbottom*, p. 27.
70. James C. Robertson, '*Visions of Ecstasy*: A Study in Blasphemy', *Journal of British Cinema and Television* vol. 6 (May 2009), pp. 73–82.
71. See I. Q. Hunter, 'From Window Cleaner to Potato Man: Confessions of a Working Class Stereotype', in Hunter and Porter, *British Comedy Cinema*, pp. 154–70.

8 EROS EXPLODING

1. Tony Rayns, 'Grindhouse Nights', *Sight and Sound*, June 2007, pp. 22–3.
2. Norman J. Warren, personal communication, 12 June 2012.
3. Barry Miles, *London Calling: A Countercultural History of London since 1945* (London: Atlantic Books, 2010), p. 132.
4. Jeff Nuttall, *Bomb Culture* (1968; London: Paladin, 1970), p. 147.

5. Warren, personal communication, 12 June 2012.
6. Antony Balch, 'Interview', *Cinema Rising* vol. 1 (April 1972), p. 11.
7. Colin Davis, 'Eros Exploding: The Films of Antony Balch', *Shock Xpress* vol. 2 no. 4 (Summer 1988), p. 10.
8. Rayns, 'Grindhouse Nights', p. 23.
9. A lot more Balch and Burroughs footage was saved after Balch's death by Genesis P-Orridge and is discussed at length in '"Thee Films" An Account by Genesis P-Orridge', in Jack Sargeant, *Naked Lens: Beat Cinema* (London: Creation, 1997), pp. 184–96.
10. Balch, 'Interview', p. 10.
11. Bill Morgan, ed., *Rub Out the Words: The Letters of William S. Burroughs 1959–1974* (London: Penguin, 2012), p. 119.
12. Brion Gysin, 'An Interview with Brion Gysin on the Films TOWERS OPEN FIRE and CUT UPS (Paris, October, 1983)', *Cantrill's Filmnotes* vols 43/4 (February 1984), p. 38.
13. Warren, personal communication, 12 June 2012.
14. Rob Bridgett, 'An Appraisal of the Films of William Burroughs, Brion Gysin, and Antony Balch in Terms of Recent Avant Garde Theory', *Bright Lights Film Journal* vol. 39 (February 2003), available at <www.brightlightsfilm.com/39/cutups1.php>.
15. Nicholas Zurbrugg, 'Will Hollywood Never Learn? David Cronenberg's *Naked Lunch*', in Deborah Cartmell and Imelda Whelehan (eds), *Adaptations: From Text to Screen, Screen to Text* (London and New York: Routledge, 1999), p. 110.
16. Morgan, *Rub Out the Words*, p. 166.
17. Bridgett, 'An Appraisal of the Films of William Burroughs'.
18. Gysin, 'An Interview with Brion Gysin', p. 40.
19. Gysin, 'An Interview with Brion Gysin', p. 40.
20. John Geiger, *Nothing Is True, Everything Is Permitted: The Life of Brion Gysin* (New York: Disinformation, 2005), p. 159.
21. Bridgett, 'An Appraisal of the Films of William Burroughs'.
22. Balch, 'Interview', p. 12.
23. Balch, 'Interview', p. 12.
24. Barry Miles, *William Burroughs: El Hombre Invisible* (London: Virgin Books, 2002), p. 160.
25. Gysin, 'An Interview with Brion Gysin', p. 41. *Contra* Gysin, there is no evidence that *Bill and Tony* was in 70mm, which seems unlikely given the expense of that format. Balch, in the *Cinema Rising* interview, says he shot it in 35mm and took a 16mm print.
26. Miles, *William Burroughs*, p. 161.
27. Duncan Reekie, *Subversion: The Definitive History of Underground Cinema* (London and New York: Wallflower Press, 2007), p. 149.
28. Gysin, 'An Interview with Brion Gysin', p. 41.
29. Morgan, *Rub Out the Words*, p. 204.
30. Morgan, *Rub Out the Words*, p. 204.
31. Balch, 'Interview', p. 12.
32. Gysin, 'An Interview with Brion Gysin', p. 39.
33. These are taken from the BFI Library's holdings; for the sake of concision I haven't provided full references to the issues that printed the listings.
34. Matthew Sweet, *Shepperton Babylon: The Lost Worlds of British Cinema* (London: Faber and Faber, 2005), p. 260.

35. Michael Ahmed, 'Independent Cinema Exhibition in 1960s Britain: Compton Cinema', *Post Script: Essays in Film and the Humanities* vol. 30 no. 3 (Summer 2011), p. 53.
36. *Continental Film Review*, November 1968, p. 24.
37. Allen Eyles and Keith Skone, *London's West End Cinemas* (Sutton: Keytone Publications, 1991), p. 90.
38. 'The French Film: A Discussion with Jacques Brunius, Richard Roud, Antony Balsh [sic] on Carné, Renoir, Vigo, Truffaut, Bresson, Tati, Chabrol, *Film* vol. 26 (November–December 1960), p. 14.
39. Joan Hawkins, *Cutting Edge: Art Horror and the Horrific Avant-garde* (Minneapolis: University of Minnesota Press, 2000), p. 74.
40. Alison Tara Walker, 'The Sound of Silents: Aurality and Medievalism in Benjamin Christensen's *Häxan*', in David W. Marshall (ed.), *Mass Market Medieval: Essays on the Middle Ages in Popular Culture* (Jefferson, NC: McFarland, 2007), p. 52.
41. Walker, 'The Sound of Silents', p. 54.
42. Jack Stevenson, *Witchcraft through the Ages: The Story of Häxan, the World's Strangest Film, and the Man Who Made It* (Godalming: FAB Press, 2006), p. 114.
43. Stevenson, *Witchcraft through the Ages*, p. 115.
44. Stevenson, *Witchcraft through the Ages*, p. 117.
45. Miles, *London Calling*, p. 134.
46. Warren, personal communication, 12 June 2012.
47. Geiger, *Nothing Is True, Everything Is Permitted*, p. 241.
48. Gysin, 'An Interview with Brion Gysin', p. 40. See also Sargeant, *Naked Lens*, p. 173.
49. '*Naked Lunch*: Brion Gysin Screenplay', in *The Final Academy: Statements of a Kind* (London: Tarn Print, 1982), p. 17.
50. '*Naked Lunch*', p. 17.
51. Ted Morgan, *Literary Outlaw: The Life and Times of William S. Burroughs* (1988; London: Pimlico, 1991), p. 453.
52. Geiger, *Nothing Is True*, p. 241.
53. Gysin, 'An Interview with Brion Gysin', p. 41.
54. Simon Sheridan, *Keeping the British End Up: Four Decades of Saucy Cinema*, 4th rev. edn (London: Titan Books, 2011), p. 68.
55. Balch, 'Interview', p. 12.
56. '*Penthouse* Interview: William Burroughs – Mind Engineer', in Peter Haining (ed.), *The Unexpurgated* Penthouse (London: New English Library, 1972), pp. 174–5.
57. Burroughs letter to Balch, 10 September 1968, available at <http://cdn.realitystudio.org/images/correspondence/antony_balch/1968-09-10.burroughs-to-balch.jpg>.
58. '*Naked Lunch*', p. 17.
59. Sargeant, *Naked Lens*, p. 174.
60. Tom Weaver suggests the comparison on the commentary track to Odeon Entertainment's DVD release of *Secrets of Sex*.
61. Jeffrey Sconce, 'Esper the Renunciator: Teaching "Bad" Movies to Good Students', in Mark Jancovich, Antonio Lazaro Reboll, Julian Stringer and Andy Willis (eds), *Defining Cult Movies: The Cultural Politics of Oppositional Taste* (Manchester and New York: Manchester University Press, 2003), pp. 14–34.

62. John Russell Taylor, 'Beyond the Taste Barrier', *Sight and Sound* vol. 46 no. 1 (Winter 1976/77), p. 39.
63. Jonathan Sothcott, 'The Doctor Will See You Now!', *Dark Side* vol. 84 (April/May 2000), p. 7.
64. Jon R. Duvoli, review of *Bizarre*, *Cinefantastique* vol. 1 no. 1 (October 1970), p. 36.
65. Sothcott, 'The Doctor Will See You Now!', p. 8.
66. Harry M. Benshoff, *Monsters in the Closet: Homosexuality and the Horror Film* (Manchester and New York: Manchester University Press, 1997), p. 220.
67. Steve Chibnall and I. Q. Hunter, *A Naughty Business! The British Cinema of Exploitation*, Festival Programme, Leicester, 1995, p. 17.
68. David Pirie, *A New Heritage of Horror: The English Gothic Cinema* (London and New York: I. B. Tauris, 2008), p. 168.
69. Harry M. Benshoff, '1966 Movies and Camp', in Barry Keith Grant (ed.), *American Cinema of the 1960s: Themes and Variations* (New Brunswick, NJ and London: Rutgers University Press, 2008), p. 154.
70. Miles, *London Calling*, p. 134.

9 THE ART OF TRASH

1. Quoted by Laura Mulvey in the booklet notes for the Criterion edition of *All That Heaven Allows*, available at <http://www.criterion.com/current/posts/96-all-that-heaven-allows>.
2. Matthew Sweet, *Shepperton Babylon: The Lost Worlds of British Cinema* (London: Faber and Faber, 2005), pp. 259–60. See also I. Q Hunter, '*A Clockwork Orange*, Exploitation and the Art Film', in Tobias Hochscherf and James Leggott (eds), *British Science Fiction Film and Television: Critical Essays* (Jefferson, NC and London: McFarland, 2011), pp. 96–103.
3. David Church, 'Of Manias, Shit and Blood: The Reception of *Salò* as a "Sick Film"', *Participations: Journal of Audience and Reception Studies* vol. 6 no. 2 (November 2009), available at <http://www.participations.org/Volume%206/Issue%202/church.htm#_ednref77>.
4. See the interview with Waters at <http://www.egs.edu/faculty/john-waters/articles/filth-101/>.
5. Harry Benshoff, 'Beyond the Valley of the Classical Hollywood Cinema: Rethinking the "Loathsome Film" of 1970', in Lincoln Geraghty and Mark Jancovich (eds), *The Shifting Definitions of Genre: Essays on Labeling Films, Television Shows and Media* (Jefferson, NC and London: McFarland, 2008), p. 93.
6. Harry M. Benshoff, '1966 Movies and Camp', in Barry Keith Grant (ed.), *American Cinema of the 1960s: Themes and Variations* (New Brunswick, NJ and London: Rutgers University Press, 2008), p. 153.
7. John Russell Taylor, 'Beyond the Taste Barrier', *Sight and Sound* vol. 46 no. 1 (Winter 1976/7), p. 38.
8. William Johnson, 'Auteur! Auteur!' (review of *Boom* and *Birds of Prey*), *Film Quarterly* vol. 21 no. 2 (Winter 1968–Winter 1969), pp. 54–5.
9. *Boom*, not *Boom!*. The title credits leave out the exclamation mark.
10. See <http://cinebeats.blogsome.com/2008/03/04/joseph-loseys-boom-1968>.
11. Benshoff, '1966 Movies and Camp', p. 164.
12. See <http://cinebeats.blogsome.com/2008/03/04/joseph-loseys-boom-1968>.

13. Clement Greenberg, 'Avant-garde and Kitsch', *Partisan Review* vol. 6 (1939), p. 40.
14. Greg Taylor, *Artists in the Audience: Cults, Camp and American Film Criticism* (Princeton, NJ: Princeton University Press, 1999), p. 155.
15. The film is included, for example, in Tim Healey, *The World's Worst Movies* (London: Octopus Books, 1986), p. 83.
16. Garth Bardsley, *Stop the World: The Biography of Anthony Newley* (London: Oberon Books, 2003), p. 136.
17. Joan Collins, *Past Imperfect: An Autobiography* (London: Coronet, 1979), p. 267.
18. Jeff Rovin, *Joan Collins: The Unauthorized Biography* (New York: Bantam, 1985), p. 136.
19. Robert Murphy, *Sixties British Cinema* (London: BFI, 1992), p. 278.
20. Bardsley, *Stop the World*, pp. 136–7.
21. Collins, *Past Imperfect*, p. 216.
22. Collins, *Past Imperfect*, pp. 270–1.
23. Joan Collins, *Second Act* (London: Boxtree, 1996), pp. 179–80.
24. For a revisionist reading of *The Magus*, whose attempted artiness is worth comparing with both *Boom* and *Can Heironymus*, see I. Q. Hunter, 'Liking *The Magus*', in Alexia Kannas, Claire Perkins and Constantine Verevis (eds), *B for Bad Cinema: Aesthetics, Politics and Cultural Value* (Detroit, MI: Wayne State University Press, 2013 in press).
25. Kevin J. Donnelly, 'British Punk Films: Rebellion into Money, Nihilism into Innovation', *Journal of Popular British Cinema* vol. 1 (1998), p. 101.
26. Rowland Wymer, *Derek Jarman* (Manchester and New York: Manchester University Press, 2005), p. 56.
27. It was novelised (London: Virgin, 1980) by the science fiction writer, Michael Moorcock, who apparently wrote it in two weeks to coincide with the film's release rather than as an adaptation of the film. His main reason

 > was to stand up a bit for Glen Matlock, tone down Malcolm's self-serving rhetoric and have Irene Handl play Mrs Cornelius! Pistols had become more posture than punk by then, I think, though I have to say they pulled themselves together later.[27]

 (See http://www.multiverse.org/fora/showthread.php?t=8832.) In fact, Moorcock appropriated the material for his own purposes and introduced Jerry Cornelius to the plot. He subsequently revised it more substantially so that, as 'Gold Diggers of 1977', it became fully part of the Jerry Cornelius cycle.
28. Claire Monk, '"Now, What Are We Going to Call You?" Scum! … Scum! That's Commercial! It's All They Deserve! *Jubilee*, Punk and British Film in the Late 1970s', in Robert Shail (ed.), *Seventies British Cinema* (BFI/Palgrave Macmillan, 2008), p. 82.
29. Michael O'Pray, *Derek Jarman: Dreams of England* (London: BFI, 1996), p. 61.
30. Donnelly, 'British Punk Cinema', p. 101.
31. Monk, '"Now, What Are We Going to Call You?"', p. 87.
32. Claire Monk, '"The Hollywood Formula Has Been Infected": The Post-punk Female Meets the Woman's Film – *Breaking Glass*', in Melanie Bell and Melanie Williams (eds), *British Women's Cinema* (London and New York: Routledge, 2010), pp. 141–2.
33. Joel McIver, *The Making of Sex Pistols*, The Great Rock 'n' Roll Swindle (London: Unanimous, 2006), p. 66.

34. Sweet, *Shepperton Babylon*, pp. 280–4.
35. O'Pray, *Derek Jarman*, p. 95.
36. Derek Jarman, *Dancing Ledge* (London: Quartet, 1984), p. 177.
37. Wymer, *Derek Jarman*, p. 60.
38. O'Pray, *Derek Jarman*, p. 8.
39. Donnelly, 'British Punk Cinema', p. 112.
40. Jarman, *Dancing Ledge*, p. 172.
41. Monk, '"Now, What Are We Going to Call You?"', p. 87.
42. Ken Russell, *Fire over England: British Cinema Comes under Friendly Fire* (London: Hutchinson, 1993), p. 145.
43. O'Pray, *Derek Jarman*, p. 104.
44. Alan Jones, 'The Worm Turns: Ken Russell Interviewed', *Shock Xpress*, Winter 1988/1989, p. 7.
45. Jones, 'The Worm Turns', p. 7.
46. Jones, 'The Worm Turns', p. 7.
47. Bram Stoker, *The Lair of the White Worm*, 1911.
48. Joseph Lanza, *Phallic Frenzy: Ken Russell and His Films* (London: Aurum Press, 2008), p. 281.
49. Andrew Spicer, 'An Occasional Eccentricity: The Strange Course of Surrealism in British Cinema', in Graeme Harper and Rob Stone (eds), *The Unsilvered Screen: Surrealism on Film* (London and New York: Wallflower Press, 2007), pp. 110–11.
50. Spicer, 'An Occasional Eccentricity', pp. 111–12.
51. John Kenneth Muir, 'As the (White) Worm Turns: Ken Russell as God and Devil of Rubber-Reality Horror Cinema', in Kevin M. Flanagan (ed.), *Ken Russell: Re-viewing England's Last Mannerist* (Lanham, MD, Toronto and Plymouth: Scarecrow Press, 2009), p. 181.
52. John McCarty, *The Modern Horror Film: 50 Contemporary Classics from* The Curse of Frankenstein *to* The Lair of the White Worm (New York: Citadel Press, 1990), p. 239.
53. See Ronald Hutton, *The Triumph of the Moon: A History of Modern Pagan Witchcraft* (Oxford and New York: Oxford University Press, 1999).
54. Russell, *Fire over England*, pp. 145–8.
55. Alan Moore and Kevin O'Neill, *The League of Extraordinary Gentlemen Century #3 2009* (Marrieta, GA: Top Shelf Publications and London: Knockabout Comics, 2012), n.p.
56. See Fredric Jameson, *The Political Unconscious: Narrative as a Socially Symbolic Act* (London: Methuen, 1981).
57. Barry Keith Grant, 'The Body Politic: Ken Russell in the 1980s', in Flanagan, *Ken Russell*, p. 28.
58. Grant, 'The Body Politic', pp. 34–6.
59. McCarty, *The Modern Horror Film*, p. 239.
60. According to M. J. Simpson, Russell originally intended the film to be a musical horror comedy starring Roger Daltrey and the Mediaeval Baebes (who do appear in it). See Simpson's *Urban Terrors: New British Horror Cinema 1997–2008* (Bristol: Hemlock Books, 2012), p. 57.
61. Russell also published a number of equally eccentric and sexually explicit novels, such as the futuristic SF romp, *Violation* (Bloomington, IN: AuthorHouse, 2005), which begins 'An arc of golden piss splashed off the shithouse wall … ' (p. 1).

62. Lanza, *Phallic Frenzy*, p. 318.
63. Duncan Reekie, *Subversion: The Definitive History of Underground Cinema* (London: Wallflower Press, 2007), p. 170.
64. Angie Errigo, *Today*, quoted on *The Late Show* (BBC2 TX 22 September 1993).
65. Michel Ciment, 'Interview with Peter Greenaway: *The Baby of Macon* [sic]', in Vernon Gras and Marguerite Gras (eds), *Peter Greenaway: Interviews* (Jackson: University Press of Mississippi, 2000), p. 154.
66. Ciment, 'Interview with Peter Greenaway', p. 154
67. Ciment, 'Interview with Peter Greenaway', p. 157.
68. Ciment, 'Interview with Peter Greenaway', p. 162.
69. Ciment, 'Interview with Peter Greenaway ', p. 158.
70. *The Late Show* (BBC2 TX 22 September 1993).
71. Joan Hawkins, *Cutting Edge: Art Horror and the Horrific Avant-garde* (Minneapolis: University of Minnesota Press, 2000), p. 8.
72. Hawkins, *Cutting Edge*, p. 11.
73. David Bordwell, 'The Art Cinema as a Mode of Practice', *Film Criticism* vol. 4 (1979), p. 59.
74. David Pascoe, *Peter Greenaway: Museums and Moving Images* (London: Reaktion Books, 1997), p. 199.
75. Peter Greenaway, *The Baby of Mâcon* (Paris: Editions Dis Voir, 1994), p. 3.
76. David Bordwell, *Making Meaning: Inference and Rhetoric in the Interpretation of Cinema* (Cambridge, MA and London: Harvard University Press, 1989), pp. 102–3.
77. Pascoe, *Peter Greenaway*, p. 198.
78. *The Late Show*.
79. Hawkins, *Cutting Edge*, p. 6.
80. Danny Dyer, *Straight Up* (London: Arrow, 2011), p. 170.
81. Dyer, *Straight Up*, p. 170.
82. Bordwell, 'The Art Cinema as a Mode of Practice', p. 58.
83. Reekie, *Subversion* , p. 170.
84. Mark Kermode, 'Scare Us, Repulse Us, Just Don't Ever Lecture Us', *Observer*, 30 March 2008, available at <www.guardian.co.uk/film/2008/marc/30/features.horror>.
85. Catherine Shoard, ' "I Know It's Brilliant": Ben Wheatley and Michael Smiley on SXSW hit *Kill List*', *Guardian*, available at <http://www.guardian.co.uk/film/2011/mar/22/kill-list-sxsw-ben-wheatley>.
86. Edwards-Behi's review is available at <http://www.brutalashell.com/2011/12/dvd-review-kill-list/>.

10 WHAT FRESH HELL IS THIS?

1. The poll is available at and commented on at <http://www.empireonline.com/features/50-worst-movies-ever/> and <http://www.guardian.co.uk/film/2010/feb/03/batman-robin-worst-film-ever>. The choice of *Batman & Robin*, which I remember quite liking, strikes me as somewhat homophobic, but then I dislike comic-book movies and am not a Batman fan scandalised by the nipples on George Clooney's batsuit. Incidentally, the obscurity of many British trash films does sometimes make passionate defences of them less satisfyingly contrarian and outrageous than standing up for high-profile Hollywood

disasters such as *Batman & Robin* and what I hesitate to call the underrated *Sucker Punch* (2011).
2. A director's cut of *Revolution* was re-released in 2012 by the BFI on its exceptionally varied 'lost continent' Flipside label; its passage from disaster to underrated gem may be underway.
3. See, for example, I. Q. Hunter, 'My My How Did I Resist You?', in Louise Fitzgerald and Melanie Williams (eds), *Mamma Mia! The Movie: Exploring a Cultural Phenomenon* (London and New York: I. B. Tauris, 2013) pp. 145–62, and I. Q. Hunter, 'From Window Cleaner to Potato Man: Confessions of a Working Class Stereotype', in I. Q. Hunter and Laraine Porter (eds), *British Comedy Cinema* (London and New York: Routledge, 2013), pp. 154–70.
4. Quentin Falk and Dominic Prince, *Last of a Kind: The Sinking of Lew Grade* (London and New York: Quartet Books, 1987), p. 10.
5. See Hunter, 'From Window Cleaner to Potato Man'.
6. Michael Winner (MrMichaelWinner), '@iqhunter odd mvie not without quality a sorta geriatric\carry on film with class' [sic passim], 17 March 2012, 10.32 am, Tweet.
7. Tim Healey, *The World's Worst Movies* (London: Octopus Books, 1986), pp. 100–4.
8. Michael Winner, *Winner Takes All: A Life of Sorts* (London: Robson Books, 2004), p. 268.
9. The cinema version was uncut but the video and later DVD versions were trimmed by the BBFC after being held up by two years after the murder of James Bulger and in the light of amendments to the VRA that tightened up what was allowed on video. The cuts of 1.22s, which the BBFC described as 'cautious', were to violent detail in four scenes – when Bella kills the sleeping man with a hammer, the asphyxiation of Norman, the oral rape of Bella and the final attack, which was 'reduced to establishment only'.
10. Anne Billson, '@iqhunter During my stint as Sunday Telegraph film critic, barely a week went by without a Bad British Gangster Movie. God, they were hell', 12 April 2012, 10.22 pm, Tweet.
11. Julian Upton, 'Poverty Row, Wardour Street: The Last Years of British Exploitation Cinema', *Bright Lights Film Journal* vol. 33 (July 2001), available at <http://www.brightlightsfilm.com/33/britishexploitation1.php>.
12. Jonathan Sothcott, personal communication, 1 May 2012.
13. See Nicola Rehling, '"It's about Belonging": Masculinity, Collectivity, and Community in British Hooligan Films', *Journal of Popular Film and Television* vol. 39 no. 4 (2011), pp. 162–73.
14. Jonathan Sothcott, personal communication, 1 May 2012.
15. Rehling, '"It's about Belonging"', p. 172.
16. See C. P. Lee and Andy Willis, *The Lost World of Cliff Twemlow: The King of Manchester Exploitation Movies* (Manchester: Hotun Press, 2009).
17. Available at <http://www.youtube.com/watch?v=ofige4BgRw4&feature=related>.
18. Danny Dyer, *Straight Up* (London: Arrow, 2011), p. 215.
19. Dyer, *Straight Up*, p. 220.
20. Hannah Cole, 'Question Time: Nick Love', *Guardian*, 1 March 2007, available at <http://www.guardian.co.uk/film/2007/mar/01/features.questiontime>.
21. Peter Bradshaw, 'The Irony about Nick Love's Outlaw DVD Commentary', *Guardian*, 23 September 2009, available at <http://www.guardian.co.uk/film/filmblog/2009/sep/23/nick-love-outlaw-dvd-commentary>.

22. On the notion of the 'anti-fan', see Jonathan Gray, 'New Audiences, New Textualities: Anti-fans and Non-fans,' *International Journal of Cultural Studies* vol. 6 no. 1 (2003), pp. 64–81.
23. Jeffrey Sconce, 'Trashing the Academy: Taste, Excess and an Emerging Politics of Cinematic Style', *Screen* vol. 36 no. 4 (1995), p. 392.

INDEX

Note: Page numbers in **bold** indicate detailed analysis. Those in *italic* refer to illustrations. *n* = endnote.

8½ (1963) 140, 146
9 Songs (2004) **120–2**, 196*n*67
9½ Weeks (1987) 121, 122
20 Million Miles to Earth (1957) 88
28 Days Later ... (2002) 56, 73, 78
28 Weeks Later (2007) 56
43 Pounds see How to Make a Film for £43
1984 (1956) 50
1984 (1984) 56
2001: A Space Odyssey (1968) 21, 26, 49, 50, 53, 56, 57, 58, 60–1, 91

A
'AA' certificate 64, 110
The Abominable Dr Phibes (1971) 42, 136, 152
The Abominable Snowman (1957) 50, 86
Acid Demons (unmade to date) 79
The Acid Eaters (1968) 130
Adair, Hazel 64, 188*n*3
The Adventurers (1970) 18
The Adventures of Robinson Crusoe (1954) 130
Adventures of a Taxi Driver (1975) 110
The Aerial Anarchists (1911) 49
The African Queen (1951) 20
Ahmed, Michael 103, 106, 130
The Airship Destroyer (1909) 49
Aldiss, Brian W. 27, 51
Alexander, Chris 67

Ali G Indahouse (2002) 122
Alien (1979) 49, 56, 70, 73
All in the Game (2006) 171
All the Right Noises (1971) 106
All That Jazz (1980) 148
Allen, Irwin 98
'Allo 'Allo (TV 1982–92) 188*n*3
Altered States (1980) 153, 155
American Pie (1999) 122
American Psycho (2000) 156
An American Werewolf in London (1981) 75
Amicus Films 28, **42–3**, 100
Amis, Martin 56
Anatomy of Hell (2004) 120
Anderson, Gillian 171
Anderson, Lindsay 137–8
Anderson, Sophie 77
Andress, Ursula 84, 191*n*6
Andrew, Prince 114
Angel, Angel, Down We Go (1969) 25
Anger, Kenneth 22, 125, 135, 137, 149
The Anniversary (1968) 85
anti-establishment themes 65, 67, 68, 102, 126, 156–7, 159
Antonioni, Michelangelo 73, 141, 143–4
Aqua Sex (1967) 129
Ardrey, Robert, *African Genesis* 91
Argento, Dario 30, 64, 71
Armstrong, Michael 92, 96, 111
Armstrong, Neil 62
Arnold, Andrea 15, 171

Arnold, Jack 110
art cinema 24, **140–63**
 overlap with pornography 120–2, **128–31**
 trash films redescribed as 144
Ash Wednesday (1973) 143
Askwith, Robin 111, 136, 138
Asylum (1972) 42
At the Earth's Core (1977) 100
Attack the Block (2011) 56
Attack of the Killer Tomatoes (1978) 73
Attenborough, Richard 1
Attwood, Feona 110
Atwill, Lionel 136
Au hasard Balthasar (1975) 125
Au Pair Girls (1972) 35
Austin, Ray 64
Avatar (2009) 91, 94
The Avengers (TV 1961–9) 56, 142, 156
Avenging Angel (1985) 169
The Awakening (2011) 74

B
Baby Love (1968) 43, 106
The Baby of Mâcon (1993) 141, **158–63**
 critical commentaries 159–60
bad films **164–77**
 big-budget 164, 166
 celebrated examples 164–5
 cult appeal 95–7, 102, **175–6**
 distinguished from 'badfilm' 95

bad films *cont.*
 favoured categories 165, **166–75**
 intentional 135, 163
 see also 'badfilm(s)'
Bad Taste (1987) 75
'badfilm(s)' 95–6
Baise-moi (2000) 120, 169
Baker, Roy Ward 47, 57
Bakhtin, Mikhail 110
Balch, Antony viii, 22, 27, 34, 97,
 102, **123–39**, *124*, 140, 152
 collaborations with Burroughs 123,
 125–8, 132–5, 149, 197*n25*
 early career 123–5
 personality/sexuality 123, 132
Balch, Delta 123
Balcon, Michael 5
Ballard, J. G. 63, 67, 98–9, 193*n53*
Band, Charles 74
Barbarella (1967) 58
Barber, Glynis 70, *71*
Barber, Sian 64, 111
Barker, Martin 30
Barnes, Alan 58
Barr, Charles 3
Basic Instinct (1992) 168–9
Basic Instinct 2 (2006) 165
Bass, Alfie 111
Bath, Marquis of 157
Batman & Robin (1997) 165, 202–3*n1*
Battle beyond the Stars (1968) 58
Battlefield Earth (2000) 164
Bava, Mario 64, 70
BBFC (British Board of Film
 Censorship/Classification) 30,
 35, 64, 112, 114, 119–20, 126, 133,
 203*n9*
Bean, Sean 173
The Beast from 20,000 Fathoms (1953)
 88
Beasts (TV 1976) 68
Beauty by Night (?1965) 129
Behemoth –the Sea Monster (1959) 89
Behind the Green Door (1974) 30, 117
Bellini, Vincenzo, *Norma* 85

Belmondo, Jean-Paul 123
Ben and Arthur (2002) 164
Benshoff, Harry 136, 138, 141–2, 143
Bergman, Ingmar 7, 146
Berkeley, Busby 100
Berle, Milton 146
Berova, Olinka 84
Beswick, Martine v, *vi*, 84, 90, 91,
 92–3, 96, 191*n7*, 192*n32*, 192*n44*
The Betsy (1978) 18
Betty Blue (1986) 121
Beyond the Valley of the Dolls (1970)
 142
Big Zapper (1974) 4, 177
Bill and Tony (1972) 127–8, 197*n25*
Billson, Anne 11, 170, 203*n10*
Binoche, Juliette 122
Birdemic: Shock and Terror (2010) 78,
 96, 97
The Birds (1963) 73
Birkinshaw, Alan 68
Bitter Moon (1992) 122
Bizony, Piers 63
The Black Panther (1977) 33
Blackstone, Timothy 116
Blade Runner (1982) 56, 59
Blair, Tony 160
The Blair Witch Project (1999) 79
Blake, Linnie 73, 78
Blake, William 151
Blake's 7 (TV 1978–81) 56
Bloch, Robert 42
Blood Feast (1963) 23
Blood from the Mummy's Tomb (1971)
 85
Blood on Satan's Claw (1971) 43, 48,
 66, 156
Bloodbath at the House of Death
 (1984) 74
Bloody New Year (1985) 80
Blow Job (1964) 133
Blue Blood (1973) 44
Blue Movie (1969) 133
'body genres' 16
The Body Stealers (1969) 53

Bodysong (2003) 2
Boehm, Carl 9, *9*
Bond films 3, 4, 55–6, 191*n7*
Boom (1968) viii, 4, 140, **141–5**, *144*,
 200*n24*
 cult status 142–3
Boorman, John 55, 141
Bordwell, David 159, 161
Bottomley, Mo 27
Boudicca 85–6
Bourdieu, Pierre 20–1, 144
Bowie, David 55
Bowie, Les 57
Brando, Marlon 167
Bread (1971) 106, 149
Breaking Glass (1980) 149
Brecht, Bertolt 161
Bresslaw, Bernard 53
Bresson, Robert 125
Breton, André 9, 95
The Brides of Dracula (1960) 85
Brief Encounter (1945) 14
The Brigand of Kandahar (1965) 84
Brighton Rock (1947) 167–8
Britannia Hospital (1982) 138
British cinema 1–14
 criticisms 1, 10–11
 cult cinema 26–31
 'dark side' 5–7
 exploitation 35–9
 generic characteristics/range 1–2,
 8, 10
 horror, characteristics of 40
 'new revisionism' 10–14
 'official' qualities/traditions 1–2,
 10–11
 representation on 'worst film' lists
 164–5
 studies 7–8, 26
 'trash' traditions 2–7, 30–1
Bronson, Charles 167
Brook, Peter 158–9
Brottman, Mikita 16, 23, 95
Brown, Paul J. 28
Brown, Robert 87–8

Index

Brown, Roy 'Chubby' 56, 122
Browning, Tod 108, 125
The Brute (1977) 33
Brute Force (1914) 82
Bryant, Michael 44, *45*
Bryce, Allan 28, 184*n67*
A Bucket of Blood (1959) 22
Bugs Bunny 130
Bulger, James 203*n9*
The Bulldog Breed (1960) 53
Bullseye! (1990) 167
Buñuel, Luis 94–5, 125, 130
Buring, MyAnna 75, 163
Burns, Mark 168
Burroughs, Edgar Rice 89, 100, 191*n17*
Burroughs, William S. 123, **125–8**, 130, 149
 Naked Lunch 125, 127, 128, 132–3, 134–5, 136
 Nova Express 125–6, 133
 The Ticket That Exploded 125–6
 The Wild Boys 150
Burton, Richard 142–3
Bush, George W. 160
The Business (2005) 171
Butch Cassidy and the Sundance Kid (1969) 174

C

Café Flesh (1982) 28
Camp on Blood Island (1958) 84
Campbell, Martin 111, 114
Can Heironymus Merkin Ever Forget Mercy Humppe and Find True Happiness? (1969) 4, 140, **145–8**, *147*, 157, 200*n24*
 autobiographical elements 145–7
 critical response 148
 cult qualities 148
 cuts 148
Can You Keep It Up for a Week? (1974) 110
Cannibal Holocaust (1980) 23, 30, 159
The Canyons (2013) 79

Captain Clegg (1962) 84
Captain Kronos – Vampire Hunter (1974) 48
Carita 85
Carreras, Enrique 40
Carreras, James 34, 35, 40, 193*n48*
Carreras, Michael 40, 57, 58, 60, 84, 87, 91–2, 96, 99
Carry On films 3, 109, 110, 166
Carry On Cleo (1964) 85
Carry On Emmanuelle (1977) 110
Carry On England (1976) 110
Carry On Screaming (1966) 75
Carter, Angela 73
Casablanca (1942) 21
Cash, Johnny 25
Casino Royale (1967) 35
Cassavetes, John 130
Castle, William 35
Cat Girl (1957) 31, 32, 36
Cat People (1942) 32
Cat People (1982) 73–4
Cat Women of the Moon (1953) 52
Catwoman (2004) 164
Cave, Peter 67
censorship/cuts
 obscene language 108, 126
 sexual content 64–5, 108, 114, 122, 133, 148
 violence 189*n19*, 203*n9*
Chaffey, Don 85, 87, 99–100
Chambers, Karl 55
Chandon, Alex 157
Chang Cheh 47
Chariots of Fire (1981) 10, 30
Chegwin, Keith 75
Chibnall, Steve 65, 184–5*n73*
Un Chien andalou (1929) 95, 130, 150
Child Bride (1938) 33
The Children (2008) 43
Children of the Damned (1963) 51
Children of Men (2006) 56
A Chorus of Disapproval (1989) 167, 170
Christensen, Benjamin 131

Christian, Kurt 138
Christie, Ian 179*n28*
Churchill, Winston 162
The Cinema Show: The Strange World of Planet UK (TV 2006) 179*n24*
Cinematograph Films Act 1927 32
City Rats (2009) 171
The Clangers (TV 1969–74) 56
Clarke, Alan 161
Clay, Thomas 160, 161
A Clockwork Orange (1971) 26, 27, 28, 49, 50, 55, 66, 69, 136–7, 138, 150, 161, 162
Clooney, George 202–3*n1*
Close, Glenn 156
Clouzot, Henri-Georges 129
Cocteau, Jean 137
Coen, Guido 36
Cohen, Herman 35, 39–40
Cold War, (implied) referencing 40–1, 51, 60, 87, 88
Cole, Adam 119
Coleridge, Samuel Taylor 153
Colin (2008) 74, 78–9
Collins, Joan 146, *147*, 147–8
Colloca, Silvia 75
Colonel Winterbottom's Ladies (1981) 118
Come and See (1985) 162
Come Play with Me (1975) 3, 7, 26, 102, 103, 110, 111, 114
Commuter Husbands (1972) 113–14, 116
Compton (production company/cinema chain) 103, 105–6, 130
Comus (band) 107
Confessions of a Pop Performer (1975) 138
Confessions of a Sex Maniac (1974) 6, 11, 68, 110
Confessions of a Window Cleaner (1974) 10, 28, 35, 110–11
Connery, Sean 55
Conrich, Ian 110
Cook, John R. 55

Cook, Peter ('The Cambridge Rapist') 68
The Cook, the Thief, His Wife and Her Lover (1989) 159
Cooke, Ivor 116
Cool It Carol! (1970) 65, 109
The Cool Mikado (1963) 167
Cooper, Chloe 119
Cooper, Fiona 119, 196*n*62
Cooper, Ian 182*n*36
Corden, James 75
Corman, Roger 8, 22, 35, 73, 102, 131, 136
The Corpse Grinders (1971) 136
Corri, Adrienne 56
Coulouris, George 36
counterculture *see* anti-establishment themes; horror films
Countess Dracula (1971) 85
Courage, Carolyn 70
Coward, Noel 142, *144*
Cox, Alex 150
Craven, Wes 155
Crawford, Joan 40
Creation of the Humanoids (1962) 96
Creatures the World Forgot (1971) 82, 99–100
Creep (2004) 56, 78
crime films 13
Crimes of Passion (1984) 153
Cronenberg, David 156
Crook, Mackenzie 2
Crossroads (TV 1964–88) 64
Crowley, Aleister 131
Cruel Passion (1977) 114–15
Cry of the Banshee (1970) 43
Cule, Michael 168
Culler, Jonathan 17
cult cinema viii, 4, 8, 13, **20–31**, 164
 acquisition of cult status 28
 British 26–31
 magazines 28
 (potential) examples 92–3, 142–3, 148, 152, 167
 studies 26, 30

Curry, Tim 138
Curse of the Crimson Altar (1968) 70, 184*n*65
The Curse of Frankenstein (1957) 32, 40
Curse of the Mummy's Tomb (1964) 85
Curtis, Richard 11, 165
Cushing, Peter 41
The Cut-Ups (1966) 123, 127, 128

D

Daleks: Invasion Earth 2150 AD (1966) 50
Dalle, Beatrice 121
Daltrey, Roger 201*n*60
Damage (1992) 122
Damaged Goods (1937) 129
The Damned (1961) 49, 50
Danforth, Jim 82, 98
Danger: Diabolik (1968) 142
The Dark Knight Rises (2012) 28, 176
The Dark Side (magazine) 28
Dark Terrors (magazine) 28
Daubigny, Robert 107
Daughters of Darkness (1971) 24, 64
Davies, Rhys 78, 79, 81
Davies, Terence 11, 158
Davis, Bette 85
Dawson, Jan 135, 136
Day, Vera 38, 39
The Day of the Triffids (1963) 50
The Day the Earth Caught Fire (1961) 50, 51, 54
The Day the Earth Stood Still (1951) 50, 51
De Grunwald, Dmitri 123–5
De Montfort University 78
De Palma, Brian 73
Dead Cert (2010) 170–1
Dead Man's Shoes (2004) 171
Dead of Night (1945) 32
The Deadly Bees (1966) 42
Death Line (1972) 48, 136
Death Race 2000 (1975) 73

The Death Wheelers see Psychomania
Death Wish (1974) 161, 167, 168, 169, 174, 175
Death Wish 2 (1982) 169
Death Wish 3 (1985) 167
Deeley, Heather 116–17
Deep Throat (1972) 28, 117
Le Déjeuner sur l'herbe (1959) 125
Del Vecchio, Deborah 92
Deliverance (1972) 75
DeMille, Cecil B. 92
Demons of the Mind (1972) 43
The Descent (2005) 56, 73, 78
Destination Moon (1950) 50
Devereaux, Marie 85, 191*n*8
Devil Girl from Mars (1954) 3–4, 26, 49, 51–2, *52*, 92, 96, 175
The Devil Rides Out (1968) 41, 44, 91
The Devils (1971) 141, 151, 153, 158
The Devil's Advocate (1996) 18
The Devil's Chair (2007) 29
Devils of Darkness (1965) 91
The Devil's Playground (2010) 56
Diamonds Are Forever (1971) 142
Digby, the Biggest Dog in the World (1973) 68
Dirty Weekend (1993) viii, 4, 161, **167–70**, *169*, 172, 175, 203*n*9
Distant Voices Still Lives (1988) 14, 176
Diversions (1975) 116–17
Divine 30, 143
Dixon, Wheeler Winston 41
Doctor Faustus (1967) 143
Doctor in the Nude see Traitement de choc
Doctor Who (TV 1963–) 56, 57
Dog Soldiers (2002) 77
Doghouse (2009) 76–7
Doherty, Thomas 34
Doing Rude Things (TV 1995) 179*n*24
Donleavy, Brian 50
Donnelly, Kevin 149
Donohoe, Amanda 154, *157*

Index

Don't Look Now (1973) 12, 28
Doomwatch (1972) 55
Door to Door Maniac (1961) 25
Dotrice, Roy 54, *54*
'Dover, Ben' *see* Honey, Lindsay
Doyle, Arthur Conan, *The Lost World* 89
Dr Dolittle (1967) 146
Dr No (1962) 84
Dr Terror's House of Horrors (1965) 42–3
Dr Terror's Vault of Horror (TV 1993–4) 184n65
Dr Who and the Daleks (1963) 50
Dracula (1931) 39
Dracula (1958) 3, 5, 13, 40–1
Dracula AD 1972 (1972) 47
The Draughtsman's Contract (1982) 158
Dressed to Kill (1980) 73
The Driller Killer (1979) 168
Driscoll, Julie 58
Driscoll, Richard 74
The Driver's Seat (1974) 143
Duchamp, Marcel 17
Durgnat, Raymond 6, 13, 27, 191n8
d'Usseau, Arnaud 65
Dyall, Valentine 133, *134*
Dyer, Danny 160–1, 170–5, *172*
Dynamation 88

E

Eady Levy 1–2, 32–3, 42, 101
The Earth Dies Screaming (1964) 51
Earth vs. the Flying Saucers (1956) 88
Easy Rider (1969) 67, 108, 141
Eco, Umberto 21, 44, 70
Eden Lake (2008) 43, 174
Edward II (1991) 158
Edwards, Gareth (film director) 80
Edwards-Behi, Nia 163
Egan, Kate 4–5, 17
Ege, Julie 99
El Topo (1970) 21
Electric Blue 119

Elgar (1962) 153
Elgar, Edward 161
Elizabeth: The Golden Age (2007) 159
Ellis, Bret Easton 79
Elsaesser, Thomas 13
Embarrassing Bodies (TV 2008–) 119
Emily (1976) 114–15
Emin, Tracy 17
Emmanuelle (1974) 114, 115
Emmanuelle in Soho (1981) 101
Emotional Backgammon (2003) 2
Empire (magazine), 'worst films' poll (2010) 165, 202–3n1
Eragon (2006) 165, 166
Erotic Inferno (1977) 3, 114, 115
The Erotic Touch (1964) 130
Eskimo Nell (1975) 92, 102, 110, 122
Essex, David 148
'Eurohorror' 64–5
Event Horizon (1997) 56
Eves on Skis (1963) 103
Evil Aliens (2005) 23, 56, 75, 140
Evil Calls: The Raven (2008) 74
The Evil Dead (1981) 29, 73, 75
The Exorcist (1973) 40
exploitation cinema **33–9**
 British style 34, 35–9
 'classical' 33–4
 definitions 33–4, 73, 74
 and home video 73–4
 links with trash 20–1
 pseudo-moralistic tone 109
 studies 184–5n73
 'upscaling' 73
 US style 33–5
Exposé (1975) 29, *29*
The Exterminating Angel (1962) 25
Extremes (1971) 105

F

F (2010) 43
The Fall of the Louse of Usher (2002) 152, 157–8, 201n60
Faludi, Susan 62
Fanatic (1965) 40

Fanny Hill (1983) 114–15
Fantasia (1940) 88
Fantômas (1913) 94
Farber, Manny 19, 20, 143, 181n22
Fat Slags (2004) 122, 164
Fatal Attraction (1987) 156
Fear in the Night (1972) 40
Fellini, Federico 140, 145, 146
Female Trouble (1974) 22, 135
Fenton, Harvey 28
Film Studies 18–19
The Filth and the Fury (2000) 149
The Final Programme (1973) 193n52
Fire Maidens of Outer Space (1956) 6, 49, 52, 62, 165
The Firm (1993/2009) 170
First Man into Space (1959) 39
First Men in the Moon (1964) 53
Fisher, Terence 9, 13, 27, 35, 44, 48, 51, 85, 138
Flash Gordon (1936) 61
Flesh (1968) 149
Flesh & Blood (magazine) 28
Flesh for Frankenstein (1973) 136
The Flesh Is Weak (1957) 101, 103, 195n43
Flint, David 118–19
The Fly (1986) 74, 156
The Football Factory (2004) 170, 174
Forbidden Planet (1956) 50, 60
Ford, Derek 113–14, 115, 116–17, 132
Ford, John 58
Forever More (band) 107
Forsyth, Bruce 146
Fosse, Bob 148
Four Sided Triangle (1954) 50
Four Weddings and a Funeral (1994) 10
Fox, Kerry 120
Foxy Brown (1974) 169
Francis, Freddie 43–4
Franco, Jess 24, 159
Franju, Georges 130–1
Frankenstein (1931) 39, 137
Franklin, H. Bruce 58
Freaks (1932) 21, 108, 125

Freeman, Mike 116, 118–19
French, Nicci 122
French, Philip 12
Freud, Sigmund, impact of theories 93, 94, 96, 154
Frightmare (1974) 11, *12*, 69
From beyond the Grave (1973) 42
From Russia with Love (1963) 191*n*7, 192*n*32
Fry, Rob 173
Fryer, Emma 163
Fuest, Robert 193*n*52
Fulci, Lucio 4, 30
Fuller, Sam 19, 170
Funny Games (1997) 162
Furie, Sidney J. 38

G

Galvin, Liam 171
The Games (1970) 167
gangster films **170–5**
 target audience 171
Garbo, Greta 94
The Garden of Eden (1954) 101, 103
Gavin and Stacey (TV 2007–) 75
GBH (1983) 171
'generation gap', treatments of 43–4, 55
Genesis P-Orridge 197*n*9
genre movies viii, 5
Get Carter (1971) 8, 13, 115, 170
The Ghost Goes Gear (1966) 33, 96
The Ghoul (1933) 32
Gidal, Peter 6
Gigli (2003) 164
Gilbey, Ryan 190*n*43
Girl Guides Rape (1976) 117
A Girl's Guide to the 21st Century (TV 2006) 119
Girly (1970) see *Mumsy, Nanny, Sonny and Girly*
Give My Regards to Broad Street (1984) 165
Gladiatress (2004) 122
Gladwell, David 137

The Glass Table Orgy (1980) 118
Glen or Glenda? (1953) 135
Glitter, Gary 173
Go Go World (1964) 129
Godard, Jean-Luc 96, 125, 130, 143–4, 159
Golding, William, *The Inheritors* 90
Goldman, William 11
Gonks Go Beat (1965) 53, 96
The Goodies (TV 1970–82) 68
Gordon, Richard (producer) 133, 135–6
Gorgo (1961) 89
The Gorgon (1964) 38, 41, 85
Gorrie, Allan 107
Gothic (1986) 153, 157
Gough, Michael 136–8, *137*
'Gould, Terry' see Grant, David
Grade, Lew 165, 166, 167
A Grand Day Out (1992) 53
Grant, Barry Keith 156
Grant, David 112
Grant, Hugh 154
Gray, Charles 41
The Great Ecstasy of Robert Carmichael (2005) viii, 141, **160–3**, 172, 173, 175
The Great Rock 'n' Roll Swindle (1980) 140, 149–50
 novelisation 200*n*27
Greaves, Tim 28
Green, Pamela 103
Green Street (2005) 170
Greenaway, Peter 4, 141, **158–63**
 comments on own work 159–60
Greenberg, Clement 144–5
Gregory, Nigel 68
Griffith, D. W. 82
Groupie Girl (1970) 106, 108–9, 149
Grundy, Bill 152
Guerrilla Conditions (1964, unfinished) 126–7
Guest, Val 35, 54–5, 97, 110, 193*n*48
Gysin, Brion 125–8, 132–3, 134–5, 197*n*25

H

Hagbard and Signe (1967) 25
Hair (stage musical) 148
Halevy, Julian 65
Hallenbeck, Bruce G. 98, 192*n*32
Halloween (1978) 71
Hamilton, Richard 17
Hammer Films v, 3, 33, 34–5, **39–42**, 44–8, 50, 57–8
 depictions of women 84–5, 89–90, 93
 ethos 41, 47–8, 62, 82–4, 89–91, 100, 155
 origins 40
 parodies 70–1, 75
 prehistoric films **82–100**
Hammersmith Is Out (1972) 7, 143
Handl, Irene 111, 200*n*27
Haneke, Michael 161, 162
Hannibal Brooks (1969) 167
The Happening (2008) 97
Harold and Maude (1971) 21, 67
Harper, Sue 94
Harry Brown (2009) 43
Harry Potter franchise (2001–11) 2, 8, 49
Harryhausen, Ray 82, 87, 88–9, 98, 190*n*1, 191*n*16
Hassell, Imogen 55
Hawkins, Joan 24, 30, 131, 159
Hawtrey, Charles 53
Häxan (1922) 130, 131
Hearn, Marcus 28, 58
Heat (1995) 174
Heavens Above! (1963) 53
Henry: Portrait of a Serial Killer (1986) 162
Henson, Nicky 66, 67, 189*n*15
Hentzi, Gary 20
Hepburn, Katharine 20
Her Private Hell (1968) 7, 105
Herbert, James 68
Herbert, Percy 88
Herostratus (1967) 6
Heterosexual see *Juliette de Sade*

Index

High Noon (1952) 58
Highlander II: The Quickening (1991) 165
Higson, Andrew 8, 179*n27*
The Hike (2011) 74, 174
Hill, Derek 9
Hillier, Jim 34–5
Hillier, Sean 173
Hinds, Anthony 98–9, 193*n53*
Hinds, William 40
Hinwood, Peter 138
Hitchcock, Alfred 9, 73, 182*n36*
The Hitch-Hiker's Guide to the Galaxy (2005) 56
The Hitch-Hiker's Guide to the Galaxy (TV 1981) 56
Hitler, Adolf 162
Hoberman, J. 15, 18, 95
Hollywood cinema
 criticisms 17–18, 19–20
 domination of 'worst film' lists 164–5
Honey, Lindsay (Ben Dover) 6, 119, 122
Hopper, Dennis 132–3, 141
Horne, Matthew 75
horror films 5, **32–48, 64–81**
 comic/ironic 23, 73, 74–8
 critical commentary 13, 33
 decline/revival 73
 relationship with 60s counterculture 43–8, 132
The Horror of Frankenstein (1970) 47
Horror Hospital (1973) 123, **136–9**, 152
Horrors of the Black Museum (1959) 5, 40
Hoskins, Bob 173
Hostel (2005) 74, 77
The Hot Girls (1974) 117
Houghton, Don 47
Houllebecq, Michel, *Platform* 121, 196*n67*
The House on the Edge of the Park (1980) 161

House of Whipcord (1974) 65, 136, 137
The House That Dripped Blood (1970) 42
How to Make a Film for £43 (2013) 79
Howard, Vanessa 45
Howards End (1992) 11
Howerd, Frankie 167
The Human Centipede 2: Full Sequence (2011) 162
Hunt, Leon 15–16, 27, 69, 110–11
Huntley, Ian 173
Hutchings, Peter 41, 42
Hutton, Ronald 155
Hyman, Elliott 87
Hyman, Kenneth 87

I, Monster (1971) 42
I Bought a Vampire Motorcycle (1990) 74
I Spit on Your Grave (1978) 30, 169
I Start Counting (1969) 106
I Want Candy (2007) 122
I Was a Teenage Werewolf (1957) 39–40
The Ibiza Connection (1984) 171
The Idiots (1998) 120
If.... (1968) 1, 26, 102
I'll Never Forget What's'isname (1967) 167
I'm Not Feeling Myself Tonight (1975) 110, 117
Image of Love (?1968) 129
The Immoral Mr Teas (1959) 101
In the Realm of the Senses (1976) 28, 120, 121–2, 196*n67*
The Inbetweeners Movie (2011) 10
Incense for the Damned (1972) 43, 137
incompetence, aesthetic of *see* badness
Infestation (2009) 50
Inseminoid (1981) 49, 70
Intimacy (2001) 120
Intimate Teenage Secrets see It Could Happen to You

Invasion (1966) 53
Invasion of the Body Snatchers (1956) 50, 51
Invasion of the Body Snatchers (1978) 59
The Iron Lady (2011) 11, 156, 177
Iron Sky (2012) 79
Irons, Jeremy 122
irony, approach (allegedly) based on 21
Irreversible (2002) 23, 159
The Island of Dr Moreau (1977) 137
It Came from Beneath the Sea (1955) 88
It Could Happen to You (1975) 113
The Italian Job (1969) 13
It's Trad, Dad! (1962) 42
Ives-Hamilton, Elaine 72
Ivory, James *see* Merchant–Ivory films

J

Jacey cinema chain *105*, 106, **128–31**, *129*
Jack Said (2009) 171
Jackson, David 68, *69*
Jackson, Peter 75, 80
Jacobs, W. W. 66
Jaeckin, Just 114
Jagger, Mick 132, 138
James, Lennie 173
Jameson, Fredric vii, 156
Jancovich, Mark 25, 51
Jarman, Derek viii, 28, 140, **149–52**, 153, 158, 163
 Dancing Ledge 151
Jason and the Argonauts (1963) 87, 89
Jaworzyn, Stefan 28
Jaws (1975) 73
Jessel, George 146
Joanna (1968) 7
Jodorowsky, Alejandro 21, 141
John Carter (2012) 94
Johnson, Tom 92
Johnson, William 142

The Jokers (1967) 167
Jolly Hockey Sticks (1974) 117
Jones, Chris 79
Jones, Neil 'Napoleon' 77
Jones, Steve 149
Jubilee (1978) 140, **149–52**, 163
Juicy Lucy (band) 106
Jules et Jim (1962) 121
Julian, Chuck 70
Juliette de Sade (1969) 125
Jurassic Park (1993) 88
Jürgens, Curt 42
Just for the Record (2010) 170
Juvenile Sex (1974) 117, 118

K

Kael, Pauline 15, 19–20
Kaminsky, Stuart 99–100
Kannibal (2001) 74
Karloff, Boris 43
Katzman, Sam 35
Kauffman, Stanley 143
Keen, Jeff 6
Keith, Sheila *12*
Keith Lemon: The Film (2012) 166
Keller, Sarah 70
Kendrick, James 16
Kermode, Mark 162, 172
Kern, Richard 152
Kern, Roger 25
Kerpel, Tony 189*n19*
Kevin and Perry Go Large (2000) 122
Kill Keith (2012) 7, 23, 75
Kill List (2011) 12, 163
Killer Bitch (2010) 171, 174, 175
Killer's Moon (1978) **68–70**, *69*, 172, 189*nn19–20*
Killing Me Softly (2002) 122
King Kong (1933) 40, 87, 88, 90–1, 94–5, 96
The King's Speech (2010) 2, 11
The Kinky Darlings (1964) 129
Kinnear, Roy 111
Kirshner, Don 53–4
kitsch, repackaging as art 143–5

Klinger, Michael 35, 105–6, 167
Kneale, Nigel 40, 50
Knight, Charles R. 88, 191*n21*
Knightley, Keira 1
Konga (1961) 40, 89
Kreski, Connie 146
Kretzmer, Herbert 145
Kubrick, Stanley 28, 55, 56, 161, 167
Kuchar, George 22, 135
Kuchar, Michael 22
Kumel, Harry 64
Kyrou, Ado 19, 95

L

Lacy, Steve 132
Lady Chatterley's Lover (1981) 114–15
Laffan, Patricia 51–2, *52*
The Lair of the White Worm (1988) 74, 140–1, **152–7**, *157*, 163, 175
 political implications 156–7
 religious/national ideology 154–7
 treatment of source novel 153–4
The Land That Time Forgot (1975) 100, 193*n52*
Landis, Carole 87
Landy, Marcia 86
Lanza, Joseph 154, 158
Larkin, Mary 67
Larraz, José 64–5, 114
The Last of England (1987) 151
The Last Horror Movie (2003) 74, 162
The Last House on the Left (1972) 30, 64, 162
The Last Movie (1971) 141
The Last Seven (2010) 171
Last Tango in Paris (1972) 121
The Late Show (TV 1989–95) 159
Latimer, Michael 91
Lawrence, Stephen 174
Lawrence of Arabia (1962) 1
Lee, Bruce 47
Lee, Christopher 41, 47
The Legend of the Seven Golden Vampires (1974) 47

Leggott, James 11, 75
Leigh, Mike 158, 161
Leon, Valerie 85
Lesbian Vampire Killers (2009) 23, **75–7**, 78, 166, 190*n35*
Lethal Impact (1991) 171
Letts, Don 149
Levy, Ori 56
Licensed to Kill (1965) 177
Licensed to Love and Kill (1979) 177
Lifeforce (1985) 49
Lindberg, Kimberly 143
Lindsay, John 11, 116, 117–18
Lister, James 117
Lisztomania (1975) 153
Little Nell 150
The Little Shop of Horrors (1960) 22, 36
Little Shoppe of Horrors (fanzine) 28
The Living Dead see *Psychomania*
Lloyd, Phyllida 177
Loach, Ken 158
'loathsome cinema' **140–5**
 defined 141–2
Lock, Stock and Two Smoking Barrels (1998) 170
London, Jack, *Before Adam* 90
London to Brighton (2006) 167–8
London in the Raw (1964) 104, 129
Long, Stanley 104, 106, 112–13, 116, 117
The Long Good Friday (1980) 13
The Long Ships (1958) 85
Longford, Lord/Longford Committee 117
The Lord of the Rings (2001–3) 49
Losey, Joseph 28, 140, 143
The Lost Continent (1968) 4, 84, 192*n35*
The Lost World (1963) 98
Lottery money, films funded by 2, 32–3, 79, 166–7
Love, Nick 171, 172–5, *174*
Love Actually (2003) 11, 165
Love and Marriage (1970) 111–12

The Love Pill (1971) 117
Love Story (1970) 121
Love Thy Neighbour (1973) 48
Love Variations (1969) 111–12
Lovecraft, H. P. 51, 155
Lovelace, Linda 111
Lovell, Alan 6, 11
The Lover's Guide (1991) 119, 120
Loving Feeling (1968) 105, 109
Luckett, Moya 8
Luigi, Pierre 82
Lumley, Joanna 167
Lust for a Vampire (1971) see *To Love a Vampire*
Lydon, John (Johnny Rotten) 149
Lynch, David 142

M

M. Hulot's Holiday (1953) 129
Madonna 165
The Magnificent Seven (1960) 58
The Magus (1968) 141, 148, 200*n*24
The Mahabharata 161–2
Maine, Charles Eric 50
Malle, Louis 129
Mamma Mia! (2008) 165, 177
Man and His Mate see One Million BC
The Man Who Fell to Earth (1976) 26, 49, 55
Man's Genesis (1912) 82
Manhattan (1979) 122
Maniac (1963) 40
Manson, Charles 43, 66
Manville, Lesley 161
Marcus, Steven 118
Mark of the Devil (1970) 92
Marks, Harrison 103, 111, 116, 193*n*4
Martin, Skip 136
Marx, Groucho 132
Marx Brothers 94
Mary Millington's True Blue Confessions (1980) 111
Maskell, Neil 163
Mason, Adam 29

Massey, Daniel 42
Matheson, Richard 41
Mathijs, Ernest 19, 24
Mature, Victor 86–7
Maurice (1987) 180*n*37
McCallum, David 168, *169*
McCartney, Paul 165
McCarty, John 155, 156
McDowell, Curt 22
McDowell, Malcolm 136
McFarlane, Brian 122
McGill, Donald 16
McGillivray, David 65, 71, 72, 101, 102–3, 109
McLaren, Malcolm 149, 151
Meadows, Paula 119
Meadows, Shane 171
Mekas, Jonas 131
Méliès, Georges 100
Memoirs of a Survivor (1981) 56
Men Behaving Badly (TV 1992–9) 28
Mercer, Suzanne 106
Merchant–Ivory films 10–11, 158, 159, 165, 180*n*37
Merrick, Helen 24
Metropolis (1927) 49
Meyer, Russ 19, 84, 101, 113, 125, 150
Michelle, Ann 188*n*3
Michelle, Vicki 188*n*3
Mighty Joe Young (1949) 88
Mikes, George 110
Miles, Barry 123, 139
Miller, Arnold Louis 104, 116
Millington, Mary 111, 117, 149
Mills, John 1
Milton, Ruby 168
Mind Your Language (TV 1977–86) 110
Miss Bohrloch (1970) 117
Mistress Pamela (1974) 115
Mitchell, Warren 53, 56
Mnene, Charles 160
Modesty Blaise (1966) 96–7, 142
Mom and Dad (1947) 33
Mona (1970) 109

Mondo Cane (1962) 104
'mondo' films 104–5
Monique (1969) 106
Monk, Claire 149, 151, 180*n*37
The Monkees 53–4
Monroe, Marilyn 111
Monster on the Campus (1958) 100
Monsters (2010) 80
Monty Python's Flying Circus (TV 1969–74) 67
Monty Python's Life of Brian (1979) 28
Moon Zero Two (1969) 49, 53, **56–63**, *59*
 budget/special effects 57–8
 soundtrack 58
 treatment of colonialism 60–2
 treatment of femininity/morality 61–2
 Western-style elements 56–7, 58–61
Moonraker (1979) 56
Moorcock, Michael 193*n*52, 200*n*27
Moore, Alan 156
Moore, Roger 167
Morocco (1930) 19
Morons from Outer Space (1985) 53
Morris, William 151
Mosco, Maise 43
Mouse on the Moon (1963) 53
Mower, Patrick 43
Ms 45 (1981) 169
Muir, John Kenneth 155
Mulheron, Ashley 75
Mulheron, Tiffany 75
Mulvey, Laura 6
Mum & Dad (2008) 33
The Mummy (1959) 41
The Mummy's Shroud (1967) 85
Mumsy, Nanny, Sonny and Girly (1970) 7, **43–4**, *45*, 64, 106
Munich (2005) 173
Murdoch, Rupert 110–11
Murphy, Robert 57, 82, 100
The Music Lovers (1970) 141, 153

The Mutations (1974) 55
My Darling Clementine (1946) 58
Myra Breckinridge (1970) 142
The Mystery of the Wax Museum (1933) 136

N

Naked (1993) 107
Naked – As Nature Intended (1961) 102, 103
The Naked World of Harrison Marks (1965) 103
The Nanny (1965) 85
Naremore, James 18
Nature's Paradise (1959) 103, 130
Naughty! (1971) 112–13, 115, 118
Neal, Patricia 50
The Neanderthal Man (1953) 100
Negatives (1968) 141
Neilson, Donald 33, 68
Nekromantik (1987) 30
Never Let Me Go (2010) 56
New Wave cinema 11, 104
The New York Ripper (1982) 30
Newley, Alexander 146
Newley, Anthony 140, **145–8**, *147*, 157
Newley, Tara 146
Newton-John, Olivia 53–5, *54*
Night of the Living Dead (1968) 66
The Nightcomers (1970) 167
Nine Ages of Nakedness (1969) 103
No Blade of Grass (1970) 137
No Orchids for Miss Blandish (1949) 178*n11*
No Sex Please – We're British (1973) 101–2
Noé, Gaspar 159
Nolan, John 70, *71*
Nolan, Margaret 55
Not Now Darling (1973) 7, 101–2
nudist films 6, 101, 103
Nudist Memories (1959) 6
Nudist Paradise see Nature's Paradise
Nuttall, Jeff 123

The Nutty Professor (1963) 100
Nyman, Michael 120, 122

O

O Lucky Man! (1973) 137–8
O'Brien, Kieran 120
O'Brien, Richard 150
O'Brien, Willis 88
O'Hara, Gerry 33, 114–15
Oliver Twist (1948) 145
Olson, James 56, 57
O'Mara, Kate *46*
The Omen (1976) 71
On the Buses (1971) 10, 48, 110
On the Buses (TV 1969–73) 110
On the Game (1973) 113, 133
One Flew over the Cuckoo's Nest (1975) 137
One Million BC (1940) 86–7, 191*n21*
One Million Years BC (1966) v, 41, 82–4, *83*, **86–91**, 93, 97–8, 99, 191*n6*, 191*nn16–17*, 192*n32*
 ethos 89–91
 special effects 88–9, *89*
O'Neal, Ryan 121
Onibaba (1964) 130
O'Pray, Michael 153
Ordinez, Karl *see* Lindsay, John
Orphée (1950) 137
Orwell, George 16, 17
Oscars, awards/nominations 82
Oshima, Nagisa 121
The Others (2001) 74
Our Incredible World (1966) 104–5
Outer Touch (1979) 49
Outland (1981) 58, 59
Outlaw (2007) viii, 171, **172–5**, *174*
The Outward Urge (1959) 53
Oxenberg, Catherine 152
Ozu, Yasujiro 7

P

'paracinema' 23, 30–1, 159
Parajanov, Sergei 131
Paranormal Activity (2007) 79

Park, Nick 53
Parting Shots (1999) 165
Pascoe, David 159–60
Pasolini, Pier Paolo 44, 106, 159
Pattern of Evil (1967) 103
Paul Raymond's Erotica (1981) 6, 101
Peary, Danny 26, 30
Peeping Tom (1959) 5, *9*, 13, 26, 28, 116, 162
 critical/popular responses **8–10**, 18
Pegg, Simon 29
Penelope 'Pulls It Off' (1974) 110
Penry, Ken 189*n19*
The People That Time Forgot (1976) 100
Percy (1971) 110
The Perfect Woman (1949) 52
Performance (1970) 13, 26, 28, 44, 102, 108, 127, 142
Permissive (1970) **106–9**, *107*, 149
 cuts/certification 108
 'permissive drama' 106–10
 pseudo-moralistic tone 109
The Persecution and Assassination of Jean-Paul Marat as Performed by the Inmates of the Asylum of Charenton under the Direction of the Marquis de Sade (1967) 158–9
Pertwee, Jon 42
Pervirella (2002) 23, 157
Peterson, Richard 25
Petley, Julian 4, 5, 7, 110, 165, 179*n20*
Peyton Place (1957) 18
Phillips, 'Big Jeff' 116
Pickpocket (1959) 125
Piece of the Action (1965) 130
The Pillow Book (1996) 159
Pink Flamingos (1972) 21, 30
Pink Floyd 128
Pink Floyd – the Wall (1982) 148
Piranha (1978) 73
Piranha 3DD (2012) 80
Pirates of Blood River (1962) 84
Pirates of the Caribbean: At World's End (2007) 166

Index

Pirie, David vii, 32, 39, 41, 44, 82, 86, 92, 94, 96, 99, 138
 A New Heritage of Horror 33
Pitt, Ingrid *46*
The Plague of the Zombies (1966) 86
Plan Nine from Outer Space (1959) 92, 96, 102, 164, 165
Planet of the Apes (1968) 57
Polanski, Roman 33, 132
Pollock, Ellen 136
Ponty, Jean-Luc 131
Popdown (1968) 53
The Pornbrokers (1973) 117–18
pornography 6, 35, 109, **115–19**, 133
 documentaries about 112–13, 117–18
 export market 116–17
 juvenile 117, 118
 legalisation 119–20
Porter, Vincent 41, 94
Powell, Dilys 55
Powell, Michael 4, 5, 6, 9, 151, 176
Preaching to the Perverted (1997) 122
Prehistoric Women (1950) 82
Prehistoric Women (1967) *see Slave Girls*
Pressburger, Emeric 4, 6, 176
Pretty but Wicked (1965) 130
Prey (1977) 70
Price, Dennis 138
Price, Vincent *22*
Primitive London (1965) 7, 104
The Prisoner (TV 1967–8) 56
Prometheus (2012) 56
Prospero's Books (1991) 159
Psycho (1960) 9–10, 40, 42, 73, 150
Psychomania (1973) 4, 6, 14, 26, 28, 66, 68, 94, 137, 175, 176, 189*n*15
The Psychopath (1966) 42
Pull My Daisy (1959) 125
Punk in London (1977) 149
punk rock 149–50, 151–2
The Punk Rock Movie (1978) 149
Purcell, Henry 161

Pussy Galore (1965) 116
The Pussycats (1967) 129

Q

Q Planes (1939) 53
Quadrophenia (1979) 26
Quatermass (TV 1953) 40, 56
Quatermass 2 (1957) 50, 51
Quatermass and the Pit (1958) 50, 53, 91
The Quatermass Xperiment (1954) 6, 40, 49, 50
Queen Kong (1976, unreleased) 7, 68, 72
Quest for Fire (1981) 90

R

'R18' certificate 119–20, 122
Radio On (1980) 149
Raimi, Sam 80
Rainbow, Joe 77
Raise the Titanic (1980) viii, 166
Rattee, Paul 68
Ray, Fred Olen 74
Ray, Robert 19, 21
Rayns, Tony 123
Razor Blade Smile (1998) 75
Red Dwarf (TV 1988–) 56
Red Road (2006) 169, 171
The Red Shoes (1948) 26, 176
Reed, Dan 171
Reed, Oliver 167
Reefer Madness (1936) 33
Reeves, Michael 13, 22, 27, 138, 182*n*36
Rehling, Nicola 171
Reid, Beryl 4, 6, 66
Reid, Jamie 149
Reign of Fire (2003) 77
The Remains of the Day (1993) 10
Renoir, Jean 125
Repo Man (1984) 150
The Reptile (1966) 38, 86
Repulsion (1966) 33
Requiem for a Village (1975) 137

Resident Evil (videogame series) 78
Revolution (1985) 165, 203*n*2
Rhys Jones, Griff 53
Richards, Jeffrey 7
Richardson, Ian 168
Richardson, John 87–8
Richardson, Tony 115
Richmond, Fiona *29*
The Riddle of the Sphinx (1977) 6
Rigby, Jacky 117
Rigby, Jonathan vii
 English Gothic 33
Rigg, Diana 156
The Rise and Fall of a White Collar Hooligan (2012) 170
Ritchie, Guy 165
Roach, Hal 86
The Roar of the Greasepaint, the Smell of the Crowd (1964) 146
Robbe-Grillet, Alain 130
Robbins, Harold 17
Robot Monster (1953) 96, 165
The Rocky Horror Picture Show (1975) 3–4, 26, 27, 79, 136–7, 138, 150, 152
Rodger, Struan 163
Roeg, Nicolas 12, 28, 55, 127, 157
Rollin, Jean 64
The Rolling Stones 132
Romance (1999) 120
Romero, George A. 78
Ronay, Edina 91
The Room (2003) 97
Rose, James 47–8
Rosemary's Baby (1968) 132
Rosenberg, Max 42
Rosny, J.-H. aîné 90
Rotten, Johnny *see* Lydon, John
Rowles, Kenneth 109, 114
Rude Boy (1980) 149
The Ruling Class (1972) 44
Runacre, Jenny 150
Russell, Ken viii, 4, 6, 8, 11, 28, 74, 94, 140–1, 151, **152–8**, 167, 201*n*60

Russell, Ken *cont.*
 cinematic style/ethos 152–3, 157–8
 Fire over England 156
 religious beliefs, influence on films 154–6
 Violation 201n61
Russell, Robert 22
Ryall, Tom 5
Ryan, Madge 137
Rylance, Mark 120

S

S Club Seeing Double (2003) 165
Sacred Flesh (2000) 122, 152
Sade, Marquis de 9, 114, 162
Salò, or the 120 Days of Sodom (1975) 28, 159
Salome's Last Dance (1988) 152, 157, 158
Saltzman, Harry 54
Samhain (magazine) 29, 30, 65
Sanders, George 66, 67
Sangster, Jimmy 40, 41, 50
Santa Claus Conquers the Martians (1964) 102
Sapphire (1959) 103
Sargeant, Jack 135
Sarris, Andrew 18, 19
Sasdy, Peter 44
The Satanic Rites of Dracula (1974) 47, 137, 156
Satan's Children (1975) 116
Satan's Slave (1976) 70, 71
Satellite in the Sky (1956) 53
Saturn 3 (1980) 56, 165
Saunders, Charles 36
Savage Messiah (1972) 151
Savile, Jimmy 68
Saving Private Ryan (1998) 162
Scala (cinema) 27, *27*
The Scarlet Blade (1964) 84
Schaefer, Eric 34, 114
Schell, Catherine von 57
School for Sex (1968) 65, 109
Schrader, Paul 79

Schulman, Richard 105
science fiction 39, **49–63**
 overlap with horror 49, 56
 political context/implications 51
 themes 51
Sconce, Jeffrey 23, 30, 37, 176, 180–1n2
Scorpio Rising (1963) 137
Scorsese, Martin 9
Scott, Ridley 56, 73
Scream … and Die! (1974) 64
Scream of Fear (1961) *see Taste for Fear*
The Seashell and the Clergyman (1928) 95
Seawright, Roy 87
Secret Paris (1965) 129
Secret Rites (1971) 132
Secrets of Sex (1970) 102, 123, 130, **133–6**, *134*, 139, 150
 screenings/critical response 135–6
 sexual ethos 134–5
Secrets of a Windmill Girl (1966) 103
Selfe, Ray 104
Sellers, Peter 53
Sen, Bachoo 105
A Serbian Film (2010) 163
The Servant (1963) 44
sex, depictions/exploitation of 6, 7, **101–22**
 censorship 64–5, 108, 114, 126, 133, 148
 documentaries **111–15**, 119, 133
 gratuitous 72
 history 101–2, 103–6
 niche cinemas *105*, 105–6, **128–31**
 non-simulated 119–20
 as selling point viii, 10
 studies 101, 102–3
 see also 'permissive drama'; pornography; sex comedies
Sex and the Other Woman (1972) 113
sex comedies **109–11**, 122
 commercial success 10
 studies 7–8

Sex Express (1975) 116
Sex Games see Commuter Husbands
Sex Lives of the Potato Men (2004) 2, *2*, 33, 122, 165, 166–7, 171, 175
The Sex Pistols 140, 152
The Sex Thief (1973) 114
The Sexplorer (1975) 49, 53, 59
Shadows (1959) 130
Shail, Robert (ed.), *Seventies British Cinema* ix
Shakespeare, William
 A Midsummer Night's Dream 69
 Romeo and Juliet 87
Sharp, Don 65
Shatter (1974) 47
Shaughnessy, Alfred 32
Shaun of the Dead (2004) 51, 73, 76, 77
Shaw, Run Run 47
Shaw, Vanessa 136
Shaye, Bob 135
She (1965) 41, 62, 84–5, 87, 92, 94
Shelley, Barbara 32
Sheridan, Simon vii, 104, 105, 195n37
The Shining (1980) 74
Shock Xpress (magazine) 28, 29
Shontoff, Lindsay 28, 106, 108, 109, 177, 184n67
Shortbus (2006) 120
Siegel, Don 182n36
The Silence of the Lambs (1991) 168–9
Simon, John 19, 141
Simon, King of the Witches (1971) 132
Simpson, Harry 163
Simpson, M. J. 74, 79, 201n60
Singleton, Gay 107
Sir Henry at Rawlinson End (1980) 44
Sirk, Douglas 96, 140, 142
Skin Skin (1968) 129
The Skull (1965) 42
Skyfall (2012) 2
Slade in Flame (1975) 33, 107, 149
Slaughter, Tod 178n11

Index

Slave Girls (1967) **v–vii**, *vi*, 82, 84–5, 91–7, 100, 142, 155, 175, 176, 192*n32*
 camp/parodic elements 96–7
 critical/popular responses 92–3, 96, 135
Sleepy Hollow (1999) 74
The Slipper and the Rose (1976) 7
Smiley, Michael 163
Smith, Doug 189*n20*
Smith, Jack 22, 135
Smith, Justin 18, 27, 48, 183*n58*
Smith, Mel 53
The Snakewoman (1966) 38–9, 153
Sobchack, Vivian 58–9
Soft Machine 128
'Solomons, Ralph' 64
Some Like It Cool (1962) 167
Some Like It Sexy (1969) 109
Sommerville, Ian 126
Son of Godzilla (1967) 97
Sondheim, Steven 145
Sontag, Susan 24–5, 135
The Sorcerers (1967) 43
Sothcott, Jonathan 74, 80–1, 170
The Sound Barrier (1952) 53
The Sound of Music (1965) 146
Space: 1999 (TV 1975–7) 58
'space race' 53, 62–3
Spaced Out (1979) see *Outer Touch*
Spaceflight IC-1 (1965) 53
Spaceways (1953) 50, 53, 57, 58
Span, Anna 6, 122
Spencer, Dan 160
Spice World (1997) 165
Spicer, Andrew 154–5
Spielberg, Steven 73, 173
The Spirit Level (2009) 79
Spraggon, Peter 68
Spurrier, Linda 150
Stag Night of the Dead (2011) 2, 15, 77–8, 79, 140
Stagecoach (1939) 58
Stalker (2011) 74
Stanley, Richard 27, 73

Star! (1968) 146
Star Wars (1977) 56, 59
Stardust (1974) 148
Stark, Koo 114
Stein, Elliot 139
Stevenson, Jack 131
Stilley, Margot 120
Stoker, Bram 41, 85, 153–4
Stop the World – I Want to get Off (1961) 145–6
Storage 24 (2012) 56
Straight on till Morning (1972) 40, 43
Straightheads (2007) 2, 161, 171–2, *172*, 174, 175
The Strange World of Gurney Slade (1960) 145, 146
The Strange World of Planet X (1957) 50, 52–3
Stranger from Venus (1954) 49, 50
The Stranglers of Bombay (1959) 62, 84, 85, 86, 93
Straw Dogs (1971) 161, 171–2
Street, Sebastian 77
Stride, Maggie 107
Strippers vs Werewolves (2012) 7, 23, 74, 78, 81
The Studio That Dripped Blood (TV 1987) 34
Subotsky, Milton 42
Suburban Wives (1971) 113–14, 116, 133
Sullivan, David 110, 111, 115
Summer Scars (2007) 43
Sunset Boulevard (1950) 72
Sunswept (1961) 103
surrealism 94–5, 192*n35*
Survivors (TV 1975–7) 56
Susann, Jacqueline 17
Suspiria (1977) 30, 71, 72
Sutcliffe, Peter 196*n62*
Suzy Gold (2004) 2
Swanson, Gloria 72
Sweet, Matthew 67, 130, 179*n22*
Sweet Wounded Bird (1970) 130
Swept Away (2002) 165

Swinging with the Finkels (2011) 122
Symptoms (1974) 64

T

Take an Easy Ride (1976) 102, 109, 114, 115, *115*, 179*n20*, 195*n37*
Take Off Your Clothes and Live (1963) 7
Tales from the Crypt (1972) 42
Tales of the Unexpected (TV 1979–88) 42
Tarzan of the Apes (1932) 90–1
Taste the Blood of Dracula (1969) 44–7
Taste for Fear (1961) 40
Tati, Jacques 129
Taxi Driver (1976) 9, 168, 173, 175
Taylor, Elizabeth 140, 141, *144*
 screen persona **142–3**
Taylor, Greg 19, 144, 145, 183*n51*
Taylor, John Russell 22, 135, 142
Temple, Julien 149, 151
Tenser, Tony 7, 35, 103–4, 105–6, 111
Terror (1978) 68, **70–2**
 referencing of other films 70, 71
Terry-Thomas 42
The Texas Chain Saw Massacre (1974) 30, 64, 70, 71, 78
That Kind of Girl (1963) 103
Thatcher, Margaret 11, 30, 65, 68, 101, 102
 cinematic deconstructions 156–7, 159
Theatre of Blood (1973) 42, 152
Thelma and Louise (1991) 169
Theorem (1968) 44, 106
They Came from beyond Space (1967) 49
Things to Come (1936) 49
The Third Man (1949) 1
This Is Not a Love Song (2002) 2
This Shocking World (1964) 129
The Thomas Crown Affair (1968) 19
Thompson, Dave 118
Thompson, Michael 16

Thomson, David 47
Thornton, Sarah 21
Thoughts of Chairman Mao (1968) 125
Thunderball (1965) 191n7
Thunderbird 6 (1968) 50
Thunderbirds (2004) 50
Thunderbirds Are GO (1966) 50
Thundercrack! (1975) 22, 135
Tigon Films 7, 28, 64, 106, 109, 149
Titus Groan (band) 107
To Love a Vampire (1971) 34
To the Devil – a Daughter (1976) 40
Today (TV 1968–77) 152
Todd, Mike 143
Tom Jones (1963) 115
Tommy (1975) 153
The Tomorrow People (TV 1973–9) 55
Tony: London Serial Killer (2009) 74, 78–9
Toomorrow (1970) 4, 7, 49, **53–5**
 critical/popular response 55
Torture Garden (1967) 42
Touch of Evil (1958) 21
Tower of Evil (1972) 136
Towers Open Fire (1963) 123, **125–7**, 128, 131
Trainspotting (1996) 26
Traitement de choc (1975) 125
Trans-Europ Express (1967) 130
Transformers (2007) 18, 166
Trash (1970) 149
trash cinema
 American 19–20
 (calls for) re-evaluation 13–14, 30
 cinematic/retail outlets 10, 27, 29–30
 class associations 15–17
 commercial successes 10
 cultural influence vii, viii
 cultural subversiveness 17
 defining characteristics v–viii, 2–7, 23
 de-marginalisation 72

trash cinema *cont.*
 generic trends viii, 22–3
 national characteristics 2–4
 nature of appeal **15–31**, 37–8
 self-referentiality 22–3
 target audience 15–16
Travelling Light (1960) 103
Trevelyan, John 112, 133, 194n29
The Trip (1967) 35
The Trip to Gas-s-s (1971) 102
Triumph of the Will (1935) 162
Trocchi, Alexander 126
Trog (1970) 40, 55, 100
Troll 2 (1990) 164
The Trollenberg Terror (1958) 50–1
Truffaut, François 10
Truly Madly Cheaply: British B Movies (TV 2008) 179n24, 189n15
Truth or Dare (1980) 118–19
Tucker, Forrest 50
Twemlow, Cliff 171
Twilight (2008) (and sequels) 24
The Twilight Zone (TV 1959–64) 42
Twinky (1970) 106
Twisted Nerve (1968) 43
Twitchell, James 16
Two Lane Blacktop (1971) 67
Tyler, Parker 15, 19, 96
Tynan, Kenneth 94

U

UFO (1993) 56, 122
UFO (TV 1970–1) 58
UKFC (UK Film Council) 1, 2
Unearthly Stranger (1963) 52–3
Upton, Julian 110, 170

V

Valley of the Dolls (1967) 18, 142
The Valley of Gwangi (1969) 98
The Vampire Lovers (1970) 44, *46*, 47–8
Vampyres (1974) 28, 64–5, 114
Vanishing Point (1971) 67

Vaughn, Jimmy 36
Vault of Horror (1973) 42
Vegas, Johnny 2
The Vengeance of She (1965) 84, 92
Verhoeven, Paul 142
Vertue, Beryl 188n3
Vetri, Victoria 97
Vice Versa (1948) 145
Vicious, Sid 149
Victim (1961) 103
'video nasties' 29–30
Video Recordings Act 1985 29, 118
Videodrome (1983) 162
vigilante films 168–9
The Viking Queen (1967) 84, 85–6, 87
The Vikings (1958) 85
Village of the Damned (1960) 50, 51
Virgin Witch (1971) 6, 64, 114, 115, 188n3
Visions of Ecstasy (1989) 122, 152
Vivre sa vie (1962) 125

W

The Wages of Fear (1953) 129
Walkabout (1971) 28
Walker, Johnny 29, 74
Walker, Pete 28, 35, 65, 69, 70, 81, 109, 116, 150
Walsh, Tricia 70
Walton, Kent 64
Warhol, Andy 17, 22, 96, 119, 133, 135, 143
Warren, Bill 38
Warren, Norman J. 28, 70, 71, 72, 79, 80, 81, 105, 106, 109, 123–5, 126, 138
Waters, John 22, 25, 141, 143
Watson, Alan 136
Wayn, Peter 38
We Need to Talk about Kevin (2011) 176
Weekend (1967) 130
Welch, Raquel 82, *83*, 88, 99, 191n6
Weldon, Fay 68
Weldon, Michael 3

Wells, H. G. 49, 51, 53
Went the Day Well? (1942) 51
West, Jake 75
West End Jungle (1961) 104
Westerns, sci-fi plot elements derived from 56–7, 58–61
Westwood, Vivienne 149
Wet Dream (1973) 117
Whatever Happened to Baby Jane? (1962) 143
Wheatley, Ben 163
Wheatley, Dennis 40, 84, 155
Wheeler, Brian 77
When Dinosaurs Ruled the Earth (1970) 54, 82, *97*, **97–9**, 193*n*48
Whitaker, Gavin vii
Whitehead, Peter 158
Whitehouse, Mary 65, 111, 137
Whiteley, Gillian 17
The Who 153
Who's Afraid of Virginia Woolf? (1966) 143
Whoops Apocalypse (1988) 56
The Wicked Lady (1945) 101
The Wicked Lady (1983) 167
The Wicker Man (1973) 8, 12, 13, 26, 28, 93, 132, 156, 163
Wicking, Chris 138
The Wife Swappers (1969) 113
Wilcox, Toyah 149
The Wild Angels (1966) 35, 67, 102
The Wild Bunch (1969) 60, 174
Wild Horses (1965) 131
The Wild One (1953) 105
Wild in the Streets (1968) 19
Wild Women of Wongo (1958) 82
Wilde, Oscar 152, 157
Wilhemus, Joop 117
Williams, Deane 122

Williams, Lia 168, *169*
Williams, Linda 16, 120
Williams, Linda Ruth 121
Williams, Tennessee 142
Williams Committee 119–20
Wingrove, Nigel 28, 122, 152
Winner, Michael 11, *169*
 badness **167–70**
Winsley, Ryan 160
Winterbottom, Michael 120, 121, 196*n*67
Wisdom, Norman 53
Wishman, Doris 8, 167
Witchcraft through the Ages (1967) 123, 130, **131–2**, 134
Witchfinder General (1968) 13, 22, *22*, 26, 28, 43, 48, 132, 182*n*36
 films influenced by/referencing 71, 75, 138
Withnail and I (1987) 8, 26, 28, 107
Wladon, Jean 88
Wojnarowicz, David 152
Wollen, Peter 9
The Woman in Black (2011) 73, 74
Womaneater (1957) **36–9**, *37*, 41, 44, 52, 80–1, 96
 cult following 39
 presentation of women 37–8
Wombling Free (1977) 7, 72
women
 colour-coding 89–90
 as dominant/threatening 52–3, 61–2, 75–6, 85, 93
 exploitative portrayals 37–9, 103–4
 misogynistic presentation 37–9, 68–9, 108–9, 134–5
 as passive 84–5
 prehistoric 84–5, 89–90
Women in Love (1969) 153

Wonderwall (1968) 141
Wood, Edward D., Jr 4, 80, 96
Wood, Robin 27, 30
Wright, Peter 191*n*17
Wuthering Heights (2011) 2, 15
Wyndham, John 51, 53
Wynne, Gilbert 109

X
'X' certificate 32, 64
 raising of age limit 109
Xtro (1982) 49

Y
The Yellow Teddybears (1963) 103, 106
The Yes Girls (1971) 109
Les Yeux sans visage (1960) 130–1
York, Jon 114
You Only Live Twice (1968) 56
Young, Aida 98–9, 193*n*53
Young Aphrodites (1963) 130

Z
Zabriskie Point (1970) 67, 141
Zapper's Blade of Vengeance (1974) 28, 177
Zardoz (1974) 26, 55, 141
Zazie dans le métro (1960) 129
Zedd, Nick 152, 158
Zee and Co (1972) 143
Zeta One (1969) 53, 134, 177
Zimet, Julian *see* Halevy, Julian
Zombie Undead (2011) **78–81**, *80*, 190*n*43
 screenings 79
 shooting/budget 79
Zombieland (2009) 77
Zurbrugg, Nick 126

LIST OF ILLUSTRATIONS

While considerable effort has been made to correctly identify the copyright holders, this has not been possible in all cases. We apologise for any apparent negligence and any omissions or corrections brought to our attention will be remedied in any future editions.

Slave Girls, © Hammer Film Productions; *Sex Lives of the Potato Men*, © Devotion Films/© Entertainment Film Distributors Ltd/© UK Film Council; *Peeping Tom*, © Michael Powell (Theatre) Ltd; *Frightmare*, © Peter Walker (Heritage) Ltd; *Witchfinder General*, © Tigon British Productions Ltd; *Exposé*, Norfolk International Pictures Ltd, courtesy of Steve Chibnall Collection; *The Woman Eater*, © Columbia Pictures Corporation; *Mumsy, Nanny, Sonny and Girly*, © Brigitte Films, courtesy of Steve Chibnall Collection; *The Vampire Lovers*, © American International Productions; *Devil Girl from Mars*, Gigi Productions Ltd, courtesy of Steve Chibnall Collection; *Toomorrow*, Lowndes Productions/Sweet Music; *Moon Zero Two*, © Hammer Film Productions Ltd; *Psychomania*, © Benmar Productions Ltd; *Killer's Moon*, © Rothernorth, courtesy of Steve Chibnall Collection; *Terror*, © Crystal Film Productions/Bowergange Productions, courtesy of Steve Chibnall Collection; *Zombie Undead*, © Hive Films; *One Million Years B.C.*, © Hammer Film Productions; *When Dinosaurs Ruled the Earth*, © Hammer Film Productions; *Permissive*, © Shonteff Films Limited, courtesy of Steve Chibnall Collection; *Take an Easy Ride*, © Midas Films; *Secrets of Sex*, © Noteworthy Films; *Horror Hospital*, © Noteworthy Films; *Boom*, © Universal Pictures Limited; *Can Heironymus Merkin Ever Forget Mercy Humppe and Find True Happiness?*, © Universal Pictures Limited; *The Lair of the White Worm*, © Vestron Pictures Inc.; *Dirty Weekend*, © Michael Winner Ltd, courtesy of Steve Chibnall Collection; *Straightheads*, © Straightheads Limited; *Outlaw*, © Dekker Limited.

Printed in China